The
Sound
on the
Page

ALSO BY BEN YAGODA

About Town: The New Yorker and the World It Made

Will Rogers: A Biography

All in a Lifetime: An Autobiography
(coauthored with Dr. Ruth Westheimer)

*The Art of Fact: A Historical Anthology
of Literary Journalism* (coedited with Kevin Kerrane)

BEN YAGODA

The
Sound
on the
Page

Style and Voice in Writing

HarperResource
An Imprint of HarperCollins*Publishers*

HarperCollins books may be purchased for educational, business, or sales promotional use. For information please write: Special Markets Department, HarperCollins Publishers Inc., 10 East 53rd Street, New York, NY 10022.

FIRST EDITION

Designed by Sarah Maya Gubkin

Library of Congress Cataloging-in-Publication Data

Yagoda, Ben.
 The sound on the page : style and voice in writing / by Ben Yagoda.—1st ed.
 p. cm.
 ISBN 0-06-621417-3
 1. English language—Style. 2. Authors, American—20th century—Interviews.
3. Authors, American—21st century—Interviews. 4. Authors, English—21st century—
Interviews. 5. Authors, English—20th century—Interviews. 6. Voice in literature.
7. Authorship. I. Title.

PE1421.Y34 2004
820.9—dc22

 2003062557

 04 05 06 07 08 WB/RRD 10 9 8 7 6 5 4 3 2 1

Dedicated to Russell Baker . . .

for inspiration

CONTENTS

INTRODUCTION

The Argument

This book began with a single and simple observation: it is frequently the case that writers entertain, move and inspire us less by what they say than by how they say it. *What* they say is information and ideas and (in the case of fiction) story and characters. *How* they say it is style.

For the first of many times, I present as an example Ernest Hemingway. What is Hemingway's content? He has some fishing and war stories that are pretty good, if a little short in the action department, and some ideas about honorable and dishonorable behavior that would puzzle many contemporary readers. His characters, especially in the novels and most especially in the later novels, tend to be tiresome. But his style! Take a look at the first paragraph of one of his first stories, "The Three Day Blow":

> The rain stopped as Nick turned into the road that went up through the orchard. The fruit had been picked and the fall wind blew through the

bare trees. Nick stopped and picked up a Wagner apple from beside the road, shiny in the brown grass from the rain. He put the apple in the pocket of his Mackinaw coat.

The first striking thing about this passage is the action it describes appears to be in no way dramatic, significant, or interesting. The second is that it could only have been written by Hemingway. (I was going to add, "or by one of his imitators," but his imitators, with all their talk about how "the fishing was good," miss the subtlety and mangle the tone of the original.) Even if by some chance you have not read his work, you will, if you are at all an attentive reader, be struck by the unified, consistent, and ultimately hypnotic sound and _feel_ of it. We note the plain words and short sentences, of course—so pronounced that the comma in the third sentence feels like a consoling arm around our shoulder and the three-syllable _Mackinaw_ at the end a gift outright—but also the way these technical features create a mood. The reluctance to commit to a complex sentence, a Latinate word, an adverb, or even a pronoun (repeating _Nick_ and _the apple_ instead of substituting _he_ or _it_), the urge to describe the world precisely, even at the risk of using eight ungainly prepositional phrases in one paragraph: the more familiar one is with this writer, the most one understands that his stylistic choices express a state of mind, a philosophy of perception, and a morality that we now communicate with one word—_Hemingway_.

Consider, next, the most popular novelist in the English language— Charles Dickens. His characters are types, not people. With some honorable exceptions like _Great Expectations_ and _David Copperfield_, his plots are unwieldy and ultimately uninvolving. He exposed alarming social conditions, but these have, for the most part, been taken care of. His comic set pieces, no doubt side-splitting in their day, are coming up on 150 years old and read like it; his sentimentality handed Oscar Wilde his best moment in _Bartlett's Familiar Quotations_. ("One must have a heart of stone to read the death of Little Nell without laughing.") So why could you roam the Contemporary Fiction shelves at Barnes & Noble for a year and still not find a writer as stirring and alive? Benjamin Disraeli suggested the answer when he observed, "It is style alone by which posterity will judge of a great work." Here is how Dickens opens _Bleak House_:

London. Michaelmas term lately over, and the Lord Chancellor sitting in Lincoln's Inn Hall. Implacable November weather. As much mud in the streets as if the waters had but newly retired from the face of the earth, and it would not be wonderful to meet a Megalosaurus, forty feet long or so, waddling like an elephantine lizard up Holborn Hill. Smoke lowering down from chimney-pots, making a soft black drizzle, with flakes of soot in it as big as full-grown snowflakes—gone into mourning, one might imagine, for the death of the sun. Dogs, undistinguishable in mire. Horses, scarcely better; splashed to their very blinkers. Foot passengers, jostling one another's umbrellas in a general infection of ill temper, and losing their foot-hold at street-corners, where tens of thousands of other foot passengers have been slipping and sliding since the day broke (if this day ever broke), adding new deposits to the crust upon crust of mud, sticking at those points tenaciously to the pavement, and accumulating at compound interest.

It is a muddy day, all right—that much is clear. But that's not the point. The point is that Dickens, or, rather, the narrator of *Bleak House*, knows it is a muddy day. He knows it so completely and profoundly, and is so eager to tell us about it, that he can't contain himself, much less take the time to place into complete sentences all the images and similes and words that are nearly overwhelming him. Reading this paragraph the traditional way is too fast—it may not be possible to catch all the facets of this teller's personality. Flaubert used to submit his sentences to what he called *la guelade*—the shouting test. He would go out to an avenue of lime trees near his house and proclaim what he'd written at the top of his lungs, the better to see if the prose conformed to the ideal that was in his head. Try that with Dickens's words. Or, maybe better yet, type them out (as I just did), the better to fall under the spell of this mordant, funny, metaphor-mad, and itchily omniscient voice.

The style of *Bleak House* is not exactly the same as that of *Our Mutual Friend* or *Great Expectations*, and indeed, looking in fiction for an author's idiosyncratic and identifiable style, sometimes called *voice* for reasons that are explored later in this book, can be a tricky maneuver. A novel has to include plot and characters and dialogue, making the writer a ventriloquist, periodically compelled to pick up a dummy and throw his voice

without moving his lips. (A first-person novel or story is *all* disguise, an extended monologue by a made-up someone.) Theme and setting will vary from book to book, perhaps leading the novelist to adopt a different style each time out. An essayist or critic, on the other hand, is figuratively talking to us from the beginning of a piece of writing to the end, and so his or her voice should in theory be more consistently evident. Put the theory to the test in this opening to an essay:

Some of us who live in arid parts of the world think about water with a reverence others might find excessive. The water I will draw tomorrow from my tap in Malibu is today crossing the Mojave Desert from the Colorado River, and I like to think about exactly where that water is. The water I will drink tonight in a restaurant in Hollywood is by now well down the Los Angeles Aqueduct from the Owens River, and I also think about exactly where that water is: I particularly like to imagine it as it cascades down the 45-degree stone steps that aerate Owens water after its airless passage through the mountain pipes and siphons. As it happens my own reverence for water has always taken the form of this constant meditation upon where the water is, of an obsessive interest not in the politics of water but in the waterworks themselves, in the movement of water through aqueducts and siphons and pumps and forebays and afterbays and weirs and drains, in plumbing on the grand scale. I know the data on water projects I will never see. I know the difficulty Kaiser had closing the last two sluiceway gates on the Guri Dam in Venezuela. I keep watch on evaporation behind the Aswan in Egypt. I can put myself to sleep imagining the water dropping a thousand feet into the turbines at Churchill Falls in Labrador. If the Churchill Falls Project fails to materialize, I fall back on waterworks closer at hand—the tailrace at Hoover on the Colorado, the surge tank in the Tehachapi Mountains that receives California Aqueduct water pumped higher than water has ever been pumped before—and finally I replay a morning when I was seventeen years old and caught, in a military-surplus life raft, in the construction of the Nimbus Afterbay Dam on the American River near Sacramento. I remember that at the moment it happened I was trying to open a tin of anchovies with capers. I recall the raft spinning into the narrow chute through which the river had been temporarily diverted. I recall being deliriously happy.

That's right, Joan Didion (from a 1977 essay, "Holy Water," collected in *The White Album*). The California references are a giveaway, but Didion readers would be able to spot this one even if all the place names were whited out. The telltale signs: no contractions (a stylistic formality that's a striking contrast to the way the narrator invites us to share her experiences and mental landscape). The repetition of *I recall* in the final two sentences. No commas in passages like "As it happens my own reverence for water has always taken the form of this constant meditation upon where the water is." The very words *As it happens* and other formal and subtly distancing phrases. The long sentences such as the one begun by *As it happens*, constructed with a precision that borders on the compulsive and thus hints that language is a construction erected to protect a vulnerable self against many unnamed assailants. In particular, the list "aqueducts and siphons and pumps and forebays and afterbays and weirs and drains": the terms of art are such a fortification, and meanwhile the use of *and*'s rather than commas to link them subtly raises the emotional volume and stakes. In Didion, style generates its own meaning, so that the words *I can put myself to sleep*, innocuous in any other writer's work, here calls forth intimations of insomnia and the dark night of the soul.

And what of Dave Barry? My reading suggests that this humorist has four principle themes: airline food is bad, it's hard to live with an adolescent, males and females are essentially different, and the United States sure is a weird country. When I interviewed Barry in his office at the *Miami Herald*, he did not claim that these or any of the other points he makes are profound. Referring to Robert Benchley, he said:

> If there was anybody whose style I patterned myself after, it's him. He's silly. I love silly humor. There are a lot of people who cannot deal with silly humor. They say you have to be making some coherent, meaningful point for it to be of worth. I don't believe that.*

In humor more than any other form of writing other than poetry (and in Barry more than most humor), style trumps content. Here is the opening of one of his pieces relating to theme three:

*Block quotations in Helvetica type, and every other quote attributed to authors listed in the Appendix, starting on p. 243, came from my interviews with those authors. Quotations attributed to anyone else came from previously published sources.

It began as a fun nautical outing, 10 of us in a motorboat off the coast of Miami. The weather was sunny and we saw no signs of danger, other than the risk of sliding overboard because every exposed surface on the boat was covered with a layer of snack-related grease. We had enough cholesterol on board to put the entire U.S. Olympic team into cardiac arrest. That is because all 10 of us were guys.

I hate to engage in gender stereotyping, but when women plan the menu for a recreational outing, they usually come up with a nutritionally balanced menu featuring all the major food groups, including the Sliced Carrots Group, the Pieces of Fruit Cut into Cubes Group, the Utensils Group, and the Plate Group. Whereas guys tend to focus on the Carbonated Malt Beverages Group and the Fatal Snacks Group. On this particular trip, our food supply consisted of about 14 bags of potato chips and one fast-food fried-chicken Giant Economy Tub o' Fat. Nobody brought, for example, napkins, the theory being that you could just wipe your hands on your stomach. This is what guys on all-guy boats are doing while women are thinking about their relationships.

If you put the passage under the microscope, you can fairly easily enumerate Barry's trademark stylistic techniques. He likes to sedate you with a conventional sentence or two, then sucker-punch you with something like *snack-related grease*. That phrase also shows his skill for plucking pieces of bureaucratese or other forms of cliché or dead language out of the linguistic ether, teeing them up, and knocking them 300 yards or so: *gender stereotyping, recreational outing, nutritionally balanced*. He hyperbolizes with a surgeon's precision. There are subtle things, too, like the repetition of the word *guys*, which after being said or read a certain number of times becomes inexplicably funny, and the way he sticks a redundant *particular* in the third-to-last sentence and an unnecessary *for example* in the next one for no reason other than to enforce a pause. But readers are devoted to Barry, and to other estimable humor writers, such as Fran Lebowitz, Calvin Trillin, Roy Blount Jr., Nora Ephron, David Sedaris, and Sandra Tsing Loh, not merely because they are efficient laugh-delivery machines. Barry is no Hemingway, no Dickens—I guess not even a Didion—but his style, like theirs, is distinctive, suggestive, and the best manifestation of his particular genius. In the above passage, Barry aficionados will focus in on the middle of the second

paragraph—the "food groups" bit. They will note (more likely subliminally than consciously) the capitalization, the word choice (*carrots* instead of *vegetables*, *fruit* instead of, say, *cantelope*), the pacing—the way that the women's list has four items and the guys', only two, and how in each list, the items get shorter and funnier, leading up finally to the formulation that only Dave Barry would have or could have devised—the Fatal Snacks Group.

So my observation became a premise: style matters. On further review, it accumulated two corollaries. The first is that for writers of the first rank (and many of the rest of us as well) style is unique and irrefutably identifiable, like a fingerprint, or like the sound of close friends' voices, even if they're only saying, "Hi, it's me" on the telephone. Samuel Coleridge, in a letter to his friend William Wordsworth, describing reading some lines from Wordsworth's poem "There Was a Boy" for the first time, wrote: "That 'Uncertain heaven received/Into the bosom of the steady lake,' I should have recognized any where; and had I met these lines running wild in the deserts of Arabia, I should have instantly screamed out 'Wordsworth!' " In the same way, on reading the above passages for the first time, readers familiar with the respective authors' work would instantly scream out *Hemingway, Dickens, Didion,* and *Barry!*

For the second corollary, shift the analogy from fingerprints, which identify us but have no bearing on any other aspect of ourselves, to handwriting, which not only identifies us but, we are told, reveals our essence. George de Buffon famously encapsulated the idea in 1753: *Le style c'est l'homme même* ("Style is the man himself"). Style in the deepest sense is not a set of techniques, devices, and habits of expression that just happen to be associated with a particular person, but a presentation or representation of something essential about him or her—something that we, as readers, want to know from that writer and that cannot be disguised, no matter how much the writer may try. "Our style betrays us," Robert Burton observed in *The Anatomy of Melancholy.* Our style advertises the extent to which we are (or are not) self-absorbed, generous, solicitous, obsessive, conventional, funny, dull, stuffy, surprising, impatient, boring, slovenly, intelligent, or insecure. In his memoir, *Experience*, Martin Amis recounts a long-standing debate he

had with his father, Kingsley Amis, about the merits of Vladimir Nabokov. When Martin read aloud a Nabokov passage he particularly admired, Kingsley said, "That's just flimflam, diversionary stuff to make you think he cares. That's just style." Martin: "Whereas I would argue that style *is* morality: morality detailed, configured, intensified. It's not in the mere narrative arrangement of good and bad that morality makes itself felt. It can be there in every sentence. To Kingsley, though, sustained euphony automatically became euphuism: always."* Young English novelist Zadie Smith recently observed, "Every genuinely literary style, from the high authorial voice to [David] Foster Wallace and his footnotes-within-footnotes, requires the reader to see the world from somewhere in particular, or from many places. So every novelist's literary style is nothing less than an ethical strategy—it's always an attempt to get the reader to care about people who are not the same as he or she is." This can work for ill as well as good. Wilde, in another *Bartlett's* moment, once remarked that the chief argument against Christianity was the style of St. Paul.

That the *how* is more important and revealing than the *what* goes without saying when it comes to many other creative endeavors. Think of Michael Jordan and Jerry West each making a twenty-foot jump shot, of Charlie Parker and Ben Webster each playing a chorus of "All the Things You Are," of Julia Child and Paul Prudhomme each fixing a duck à l'orange, of Mies van der Rohe and Philip Johnson each designing a twenty-story office tower on the same corner of the same city, or of Pieter Brueghel and Vincent van Gogh each painting the same farmhouse. Everyone understands that the content is constant, frequently ordinary, and sometimes banal; that the (wide) variation, the arena for expression and excellence, the fun, the art—it's all in the individual style.

Encouraged by my premise and corollaries, I began haunting bookstores and libraries. I emerged with a paradox: as important as personal style is in writing, it is strangely overlooked in books that purport to be about style in writing. Exhibit 1 is an 84-page volume called *The Elements of Style*. I didn't even need to go to the library to read it; like millions of other Americans, I

*Euphuism: "An elegant Elizabethan literary style marked by excessive use of balance, antithesis, and alliteration and by frequent use of similes drawn from mythology and nature." *Merriam-Webster's Dictionary*.

own a copy. It grew out of a self-published pamphlet that William Strunk, a professor of English at Cornell in the early decades of the twentieth century, handed out to his students, one of whom was E. B. White. In 1959, White updated the manuscript and added an introduction and a new chapter. It has been in print ever since. At the moment, it's number 48 on the Amazon.com best seller list of the roughly two million titles the online bookstore offers for sale, just ahead of *Wild at Heart: Discovering the Secret of a Man's Soul* and just behind *Weight Watchers New Complete Cookbook*.

One odd thing about Strunk and White (as everybody calls the *The Elements*) is the way it uses *style* in different, sometimes seemingly contradictory, senses. At the outset we are in the world of *The Chicago Manual of Style*, *The Associated Press Stylebook and Libel Manual*, and the sixth and final definition in the *Merriam-Webster's Dictionary*: "a convention with respect to spelling, punctuation, capitalization, and typographic arrangement and display followed in writing or printing." Thus the first sentence of chapter I in Strunk and White is "Form the possessive of nouns by adding 's." Subsequent rules or customs include "Place a comma before a conjunction introducing an independent clause" and "A participial phrase at the beginning of a sentence must refer to the grammatical subject."

Later on, the conception of style broadens a bit, to mean something like elegance or, more broadly, propriety and effectiveness in written communication. "Use the active voice," the reader is advised, and, "Place the emphatic words of a sentence at the end." In the chapter White wrote himself, he offers a list of guidelines, including, "Place yourself in the background," "Do not affect a breezy manner," and "Do not inject opinion." (All that *placing* calls to mind someone dropping little people and houses into a model-railroad layout.) "The approach to style," White concludes, "is by way of plainness, simplicity, orderliness, sincerity."

This meaning for the word *style* doesn't exactly correspond with any of the dictionary definitions. The one that comes closest is: "a mode of fashion, as in dress, esp. good or approved fashion; elegance; smartness." Strunk and White aren't talking about clothing, but that *good or approved* hits home. They purport to be talking about "style," but they are really advocating a particular style. They define this almost completely in negative terms, as an absence of faults—an elimination of all grammatical mistakes and solecisms, of breeziness, opinions, clichés, jargon, mixed metaphors, passive-voice constructions, wordiness, and so on. The implicit and sometimes

explicit goal is a transparent prose, where the writing exists solely to serve the meaning, and no trace of the author—no mannerisms, no voice, no *individual* style—should remain. They think of writers the way baseball's conventional wisdom thinks of umpires: you notice only the bad ones. One measure of this doctrine's weirdness is that its absolute inapplicability to E. B. White's own prose style, which, although outwardly plain, simple, orderly, and sincere, is also idiosyncratic, opinionated, and unmistakable.*

Simplicity, clarity and invisibility are, in any case, the gospel in almost all post–Strunk and White writing manuals, whether or not they invoke the word *style*. Richard Marius, in *A Writer's Companion*, advises, "Don't show off; avoid drawing unnecessary attention to yourself. . . . When we blatantly insert ourselves into our story, we are like thoughtless people who invite friends to a movie and then spend so much time talking that they can't enjoy the show." (An odd metaphor—it forgets that when we write we *are* the movie.) In *Style: Ten Lessons in Clarity and Grace*, Joseph Williams states, "The only reliable rule, I think, is 'Less is more.'" Edward Corbett and Robert Connors in *Classical Rhetoric for the Modern Student* (fourth edition, 1998): "The prime quality of prose style is clarity." William Zinsser's *On Writing Well*, Jacques Barzun's *Simple & Direct*, Peter Richardson's *Style: A Pragmatic Approach*: each time, it's the same minimalist and impersonal doctrine.

But this is a chimera based on a fallacy. Perhaps transparency is possible, or at least a useful metaphor, when one is composing an instruction manual. Dowel A is 10 inches long, no more, no less. It should be inserted in hole B, and nowhere else. This is the information that must be conveyed, and any intimations of personality by the writer would be misplaced and counterproductive. But in communicating ideas, opinions, impressions—indeed, in any attempt to describe or imagine the wide world—content does not exist separate from the words in which it is expressed. Each one depends on the other. When you remove the wrapping of the language, you see that the box is empty.

*The dictionary offers other meanings for *style*, including "a distinctive quality, form, or type of something" and "the state of being popular." Both can be and are applied to prose. Someone who goes heavy on the fancy words and figures of speech might be said to write with a lot of style. And a magazine writer who knows all the current catch phrases and can adopt the fashionable ironies and attitudes is definitely writing *in* style.

When I arranged to interview Yale literary critic Harold Bloom, I told him beforehand that my intention was to write a book that looked at style from a perspective different from the one found in *The Elements of Style*. When he met me in the living room of his New Haven house, he said:

> I put that book away from me with some loathing twenty years ago, but I looked at it earlier today, and I just burst out laughing. If I were asked to sum up its teachings, they would be: put yourself in the background, avoid all figurative language if possible, and don't be opinionated. The first half, the rules of grammar and so forth, is perfectly sensible, but you could not write two pages in which you try to say anything that matters to you and obey what is going on in the second half of that little manual. It outlaws everything that I care for in writing, in literature, in the act of writing. It tries to pretend it's against the overly baroque, but what it's against is what I would say is imagination itself.

Bloom gestured to the bound galleys of his soon-to-be-published book *Genius*, sitting on a table next to him. "There isn't a single paragraph of that eight-hundred-page monster that could pass muster in Strunk and White. Never does its author keep himself in the background, never does he avoid his own opinions, and he goes from one figuration to the another." Bloom went on:

> It is a shirtsleeve doctrine of writing. It's based upon a kind of false social contract, a mock civility, combined with that wretched thing, a mock humility. Why the appeal? I'm afraid it's a social dialectic. If you can get yourself to write like that and admire writing like that, then you must be a gentleman or gentlewoman, rather than a parvenu. I had a creepy feeling as I browsed in it. Those qualities which the latter half is rejecting, and which are my essence as a human being, a writer and a teacher—those are exactly the qualities that Yale would not tolerate in me. That tells me what this is. The genteel tradition—or the Gentile tradition—is what Strunk and White comes down to.

One doesn't need to accept Bloom's entire critique to agree that there are limitations to the Strunk and White dogma. They come down to this:

by pursuing transparency, you miss out on a whole lot of other things. Joseph Williams, author of *Style*, demonstrates this in his scrutiny of the following passage from George Orwell's famous essay "Politics and the English Language":

> The keynote of a pretentious style is the elimination of simple verbs. Instead of being a single word, such as *break, stop, spoil, mend, kill*, a verb becomes a phrase, made up of a noun or adjective tacked on to some general-purpose verb such as *prove, serve, form, play, render*. In addition, the passive voice is used in preference to the active, and noun constructions are used instead of gerunds. . . .

Williams endorses the sense 100 percent but correctly notes that Orwell's practice flouts his preaching: the passage is loaded with noun constructions and impersonal syntax. So Williams offers a new and improved version:

> Those who write pretentiously eliminate simple verbs. Instead of using one word, such as *break, stop, spoil, mend, kill*, they turn a verb into a noun or adjective and then tack it on to a general-purpose verb such as *prove, serve, from, play, render*. Whenever possible, they use the passive voice instead of the active and noun constructions instead of gerunds. . . .

One must have an ear of tin to read both versions and not realize that Williams has wrecked the passage. Yes, the revised version is logically consistent where the original is not: Orwell talks about "the elimination of simple verbs" without saying who is doing the eliminating, and writes "a verb becomes a phrase" as if verbs do this kind of thing on their own, and criticizes the passive voice *in the passive voice!* Yet the Orwell version is stronger for three reasons. First, the subject Williams has created for the first sentence and thence for the paragraph ("those who write pretentiously") is vague and indeterminate; we squander a bit of our mental energy wondering who these miscreants are and are slightly disappointed when we realize they are straw men and women. Second, the passage actually suffers from the elimination of the passive voice, which admittedly has its flaws (most egregiously, evasions of responsibility along the lines of "mistakes were made") but is sometimes spot-on. Orwell's impersonal

approach has a cosmic accuracy, in that the kind of writing he is talking about *does* seem to have a mind of its own; it spreads without human agency. Third, Orwell's version sounds like Orwell—and why would anyone ever want to flatten out one of the most distinctive voices of the twentieth century?

A while back, I said it was odd that Strunk and White and other writing pundits adopted a constricted meaning of *style*. Actually, they have had at least four sound reasons for doing so. The first is tactical, the second practical, the third generic, and the fourth philosophical.

Number 1 is a matter of triage. To put it bluntly, our citizens have for some time been poor writers. When they are moved or required to put words to paper, their prose is likely to be (choose one or more): muddy, sloppy, pretentious, meandering, obfuscatory, jargon- and cliché-laden, and filled with errors of spelling, grammar, and diction. In addressing students or prospective writers, it would be loony to give such maladies a pass and concentrate on the finer points of style or voice.

But consider: there are books for golfers whose main goal is to hit the ball, and others for the more advanced players who are trying to get a little more backspin on their sand shots. Why isn't it the same in writing? This leads me to the second reason: individual style really is hard to talk about, much more so than sand shots, and is even harder to teach. One can see the difficulty in White's chapter of *The Elements of Style*. There (unlike many of his epigones) he does make appreciative gestures toward "style in its broader meaning: style in the sense of what is distinguished and distinguishing." But having said that, he immediately backs away from the abyss. "Here we leave solid ground," he observes, and goes on:

> Who can confidently say what ignited a certain combination of words, causing them to explode in the mind? Who knows why certain notes in music are capable of stirring the listener deeply, though the same notes slightly rearranged are impotent? These are high mysteries, and this chapter is a mystery story, thinly disguised. There is no satisfactory explanation of style, no infallible guide to good writing, no assurance that a person who thinks clearly will be able to write clearly, no key that unlocks the door, no inflexible rule by which the young writer may steer his

course. He will often find himself steering by stars that are disturbingly in motion.

This manuever, of acknowledging the existence of individual style, then shielding the eyes before the bright light of its overwhelming mystery (White does it with rhetorical questions) is not an uncommon one. Indeed, it is understandable. There *is* something mysterious about style; it *is* hard to pin down. One *does* sometimes have the romantic sense that a distinctive writing style is genetic and immutable, precisely like fingerprints. So why write about it? Books about fingerprints do exist but are always about how to identify or interpret them, never how to make yours better.

Another option for dealing with individual style, besides White's bowing to the ineffable, is a "you know it when you see it" pragmatism, exemplified in William Zinsser's *On Writing Well*, which has been through so many editions since its original publication in 1985 that its subtitle has become *The Classic Guide to Writing Nonfiction*. In one of the handful of paragraphs he allots to the subject, Zinsser tells us that the "fundamental rule is: be yourself." This is plausible and encouraging, but it demands definition, exemplification, explication, maybe even peroration. Zinsser gives us just three sentences: "No rule, however, is harder to follow. It requires the writer to do two things which by his metabolism are impossible. He must relax and he must have confidence." It's the same advice a Little League coach might give to an 11-year-old about to face a curve ball for the first time, and just as helpful.

The third reason for the paucity of books on individual style is that in writing, it is always challenging and sometimes nearly impossible to separate what writers are saying from how they say it—that is, to separate content from style. Writers are messengers, and we tend to kill them or love them or merely make use of them more for what they have to tell us than for the way they express it. And when content is emphasized, a style that doesn't get in the way of it—a transparent style—will be sought after and valued. (Contrast the art of painting, where content is immaterial and style is paramount. That is, if your style is original or artful enough, your work can hang in the Museum of Modern Art whether it depicts a sunset, a vase of flowers, or a geometrical pattern.)

I called the fourth reason "philosophical." Another word for it might be *proprietary*. We all would probably grant that the prose of Dickens or

Dave Barry is unmistakable. But would it be wise—or sane—to suggest that as a goal for the average English Composition student or aspiring romance novelist? The idea that *every* written passage should make a reader scream out the author's name summons up the prospect of a cacophonous Tower of Babel. In his 1924 book *English Prose Style*, Herbert Read contended, "A personal style in the sense in which we have defined it is a very rare achievement. . . . For one erratic genius of this kind, there are a hundred who adopt a code. It is a more possible and a more politic faith." Sir Walter Raleigh, in his 1897 treatise, *Style*, set even longer odds and attributed them to the forces of conformity, cliché and linguistic inflation: " 'The style is the man'; but the social and rhetorical influences adulterate and debase it, until not one man in a thousand achieves his birthright, or claims his second self. . . . We talk to our fellows in the phrases we learn from them, which come to mean less and less as they grow worn with use. Then we exaggerate and distort, heaping epithet upon epithet in the endeavor to get little warmth out of the smoldering pile."

Whatever the actual chances of achieving your stylistic birthright, more pressing questions present themselves. Who gets to *be* one of those erratic geniuses who are entitled to a style, and who is better off sticking to what Read calls "a code," or what Strunk and White and Williams call style? And who decides which writers belong in which camp? Difficult questions indeed, and the temptations to leave them alone is certainly understandable.

My bookstore wanderings revealed to me a group of commentators who are not just willing but eager to take a stab at them. If White, Williams, and Zinsser are on the faculty of a button-down school of writing instruction, these authors belong to an alternative academy, dressed, as it were, in Hawaiian shirts, drawstring hemp pants, and sandals. They believe that everyone should have a style. Except they prefer the word *voice* and usually put it in the titles of their books: *Developing a Written Voice*; *The Intuitive Writer: Listening to Your Own Voice*; *Writing and Personality: Finding Your Voice, Your Style, Your Way*; *Let the Crazy Child Write: Finding Your Creative Writing Voice*; and (my favorite) *Writing the Mind Alive: The Proprioceptive Method for Finding Your Authentic Voice*. The general tack can be seen in a passage from another of the many volumes in this genre, Natalie Goldberg's *Wild Mind: Living the Writer's Life*: "Style in writing . . . means becoming more and more present, set-

tling deeper inside the layers of ourselves and then speaking, knowing what we write echoes all of us; all of who we are is backing our writing. . . . We are each a concert reverberating with our whole lives and reflecting and amplifying the world around us."

If "turning in his grave" weren't already a cliché, one would have to invent it to imagine E. B. White's reaction to those two sentences. Yet when you get past the muddy syntax and mixed metaphors and confusing or downright meaningless formulations (when she writes "all of us," does she mean all of us, or all of the particular person who is putting the words on paper?), everything Goldberg says is more or less true. The same, as far as I was able to bring myself to read them, with the other voice manuals. What limits them, even more than the mushy way in which they are written, is their therapeutic approach. The object, from page one till the end, is self-expression, self-fulfilment . . . I almost wrote *self-abuse*. The goal of setting down words that could or should be of interest to a *reader* never comes up. But consider: the traditional purpose of writing is communication, equally true in an e-mail message and a published book. If it leaves the person on the other end bored, bothered, or bewildered (or if it permanently remains locked up in a diary), it is of limited use.

Premise, corollaries, paradox, and finally a proposal. The Strunk and White posse privileges readers (sorry for the neologistic vogue-verb, E. B.), viewing them as delicate invalids, likely to scurry off to their bedchambers when faced with any sentence diverting in the slightest from the plain style. At the other extreme, the Goldberg group coddles the writer the way a overindulgent parent would a sensitive child: Are you *sure* you've shared everything that's on your mind or in your heart? But there didn't seem to be a book that held two different but hardly contradictory ideas about style in its head: writers express themselves through it, and readers draw pleasure and sustenance from it. A book that although not a how-to manual gave both aspiring and experienced writers a solid toehold as they negotiated the steep, winding, and sometimes perilous path of identifying and developing their own style.

That is the book I decided to write.

The decision did not change the fact that style is so darned difficult to talk about. I will be more precise. Addressing style philosophically, histori-

cally, lexicographically, and analytically didn't present a problem. My preliminary investigations told me this was a rich subject. They formed the basis for what became Part I of this book, which, in the process of defining style, looks at how conceptions of it have changed through the centuries. This material shed a lot of light on recent developments. It turns out, for example, that the (virtual) debate between Natalie Goldberg and E. B. White is merely the latest installment in a battle that has been repeatedly replayed since Gorgias and Plato started it 2,500 years ago. The battle is between style as personal expression (Gorgias, Goldberg) and style as vehicle for content and a moral litmus test (Plato, White), and it seems to flare up every hundred years or so.

But approaching the subject practically—looking at the process by which a contemporary writer acquires and nurtures his or her own style—proved to be harder. As White says, this makes you feel as if you are leaving solid ground. I had inklings and my own experience and the testimony of those writers who had addressed the question in essays, books, or interviews. But all that seemed an inadequate safeguard against ending up in the diaphanous realm of psychobabble. An obvious tactic was to identify some writers with a strong style, seek them out, and ask them questions. And that is what I did.

I looked these people up on the Internet or in the phone book; e-mailed them, faxed them, wrote them, or phoned them; at home or care of their publisher or their English department or the publication they wrote for. Some still haven't responded, but most of them did, and of these, most agreed to take some time out of their lives to talk with a stranger about style. The positive response was striking because writers, as a rule, are solitary and shy and much more comfortable putting words on paper than producing spoken ones on demand.* What explains it? A cynic would cite the power of flattery. A realist would observe that it is often much easier to say yes than no. Both true, but I think a third reason is more important: writers are fascinated and mystified by style. They realize, consciously or not, that it is essential and fragile. Kenneth Tynan once despaired to his diary, "One reason I cannot write nowadays is that I no longer have a *stance*, an attitude, what Eliot called in a letter to Lytton Strachey 'the core

* This fact was clearly relevant for some of those who graciously declined. One e-mailed me, "I am tired of hearing myself as an interviewee."

of it—the *tone*.' I used to have a sign by my desk: 'Be light, stinging, insolent and melancholy.' But I am no longer any of these things, except melancholy." Virginia Woolf, moving in the other direction, noted in *her* diary, "There's no doubt in my mind that I have found out how to begin (at 40) to say something in my own voice; and that interests me so that I feel I can go ahead without phrase."

The writers I contacted had kept company with that elation and that dejection. A couple of those who declined gave me to understand that they were afraid that if they talked about style, it would ruin some kind of necessary magic. Some who accepted said something to the effect that, perhaps by being forced to talk about style, they would learn something about it. Novelist Elizabeth McCracken, in accepting, said she was obsessed with style and voice and wanted to try out her "pet theories" on me. When we met in her apartment atop Johnny D's nightclub in Somerville, Massachusetts, she expressed one of them this way:

> A writer's voice lives in his or her bad habits. That's the heart of a voice. The trick is to make them charming bad habits. You have to leave some of them alone—basically, leave enough in, so that, if you're Grace Paley, readers *know* it's Grace Paley.

Great stuff, but I wasn't naïve enough to expect pet theories from everybody. Indeed, I had a carefully thought-out plan designed to draw my subjects out. I'd choose a representative passage from the writer's work, make photocopies, and bring them to the meeting. Then we would go through it line by line, and the writer would tell me how he or she got it to "sound" like him or her.

It was a stupid plan. I found that out in the third interview, with Jonathan Raban, an author of essays, travel books, and sometimes nonclassifiable nonfiction who is my idea of a terrific all-around writer. This was actually one of the more trying interviews I have ever conducted. We met in a restaurant overlooking Puget Sound in Seattle, where Raban has lived for 10 years or so. He arrived first and (intentionally or not) situated himself so that I would be looking directly at both the sound and the sun, which, on the West Coast, turns out to set over the water. The air in the restaurant seemed to be composed of equal parts smoke, most of it emanating from Raban's cigarette, and remarkably loud jazz music, which I

feared would foul my tape recording. Over and above all that, Raban was antagonistic, or at least aggressively Socratic, in the manner of the class-rooms of his native England. What, he demanded, did I mean by *style*? I found myself blabbing out inarticulate inanities and realizing, for the hundredth time in my stay on this planet, that I would much rather ask questions than answer them.

Either the inanities somehow passed muster or Raban took pity on me: before too long he was telling me with considerable insight and animation what *he* meant by *style*. But then trouble struck again. I was (truthfully) telling him how glad I was to have him represented in the book, because his style was so compelling and immediately identifiable, and he was looking bemused. It turned out that the "immediately identifiable" part bothered him. In his view, all of his books had different styles. He said:

> I've been haunted the past few days by a phrase which is new to me but is probably part of the cliché jargon of psychotherapy, a discipline for which I usually have no time at all.

(I interrupt Raban to aver that he really talks this way. He continued:)

> But there have been a couple of articles in the *Observer* lately about boarding schools, pro and con. I have a distinct interest in the subject, having gone to an English boarding school of the most hideous kind and suffered at times and got ruined for life one way or another. One of the articles referred to a book called *The Making of Them*, by a psychotherapist who says that the effect of boarding school on kids who don't fit in, kids like me, is that they develop "strategic survival personalities." In other words, the usual product of boarding schools has an outward self-confidence, an assurance, a mask or persona that is constructed to deal with the world and stop the other kids from doing their worst.*
>
> When I heard that, I realized it was true of my personality, and that it applied to writing as well. Every one of my books requires a "strategic personality" before I can write it at all. Obviously, there is a connection between the language of *Hunting Mister Heartbreak*, the language of *Bad*

*The author of *The Making of Them* is Nick Duffell. He is also the founder of an organization called Boarding School Survivors.

Land, the language of *Passage to Juneau*, the language of *Old Glory*. But they don't begin to be writable until I've found the strategic personality for the experience of the book. The one for *Arabia* is the Englishman abroad, the old mask. In Britain the book was always called *Arabia Through the Looking Glass*, and the persona at the center of it was essentially Alice, who is a terrifically important figure in English writing—someone full of innocence while knowing what is right and what is wrong, and being prim and easily surprised but at the same time having a very clear and English sense of where you stand. Traveling Englishmen abroad tend to see the rest of the world as consisting largely of mad queens and talking rabbits and the rest.

Now the strategic personality of *Hunting Mister Heartbreak*, which is about trying out identity in the United States, is this hopeful, would-be sunny fictional immigrant who wants to try out life in New York. The book became writable once I found the voice for *him*. And the style changes in the course of the book. I set up myself or a version of myself in seven different American landscapes, and the language distinctly changes through these seven chapters, so you see it as a progression from the hopeful innocence of the would-be immigrant at the beginning to the know-it-all bum who orders his own tomb in Key West at the end.

I had a great deal of difficulty beginning *Bad Land*, finding the voice in which to write it. I looked at the first page earlier today because I knew we were going to have this conversation, and I saw exactly how I managed to kick it off. In the previous books of mine that had been set in the United States, the emphasis was on my Englishness, on being a foreigner to it. In the voice of the person narrating *Bad Land*, the Englishness has gone. The important thing is that, like the people the book is about, he is urban, his experience is of the city, and he's out in this rural area. There was the voice, there was the strategic personality. That allowed the language to happen, that enabled the story of the book to take place.

Everybody knows the strategic personality of Gore Vidal, the essayist—the tone, the verbal pirouettes. I met Vidal in private once, and I have to say his personality in conversation is rather different from his personality on the page. I mean, he did not speak as he writes. So strategic personality seems to be a necessary acquisition of any stylist, not necessarily related to his social personality. Only when he slips inside

this persona, this mask, does the language-making machine in him begin to function. There are a whole lot of other times—and I know this from my own periods of block at the typewriter—that I can think of tons of things to say, but they are not within the rhetoric of the book, so they won't fit.

All this was credible and tremendously interesting. But the paradox it suggested took a sledgehammer to the foundations of my research plan. Raban saw the style of his books as essentially different, with minor similarities, whereas I saw it as essentially the same, with minor differences. When we looked at a passage from *Hunting Mister Heartbreak* together, we both agreed it was a brilliant bit of prose, but beyond that our perspectives were at odds. He focused on how it fit into his "strategic personality" for the book; I focused on the Raban-like qualities: the paired and meticulously chosen adjectives, the veiled self-portrait, the understated sardonic humor.

Over the next few days, I tried to digest the implications of my four-hour dinner with Jonathan. What helped me eventually resolve the apparent contradiction was *voice* (so common a metaphor in discussions of style) and in particular one characteristic of literal speaking voice. Until the moment when we first hear it come out of a tape recorder, we don't know what our speaking voice sounds like; even after that first experience, it retains the power to shock or surprise. To repeat a distinction Harold Bloom made in my interview with him, we hear ourselves hundreds of times a day; only a couple of times a year (if that many) do we *overhear* ourselves. Speaking voice is not premeditated: it emerges from the architecture of our vocal cords and our facial structure and from some other qualities within us. People do alter their voice—to "lose" an accent, perhaps, or to lower the pitch so as to sound more authoritative. But for most people, once the change is made, it's made, and you don't think about it anymore. *Voice* is not a perfect metaphor for writing style, which is why it's just a metaphor. Writing is much more premeditated than speaking: we are allowed to mull over our words for an awfully long time before setting them down, and once they are down, on the page or screen, we can look at them, puzzle over them, revise them. (This is much less true of Internet chat, which is why some people say it's not writing.) Yet even the most thoughtful writers can stare at a sentence for a whole day and not realize

precisely how readers will "hear" it. A part of style is unintentional or even unconscious; as Robert Burton said, it betrays us. In the sentence you just read, it would have been equally correct for me to put down a semicolon or a period after the word *unconscious*. As I look at the sentence and read it to myself in my head, I realize in composing it I didn't think about which punctuation mark to use but that they have a slightly different sound, and the semicolon, with its subtle but strong disinclination to allow a breath, sounds like "me." It is a small, insignificant, but undeniable component of my voice.

I ended up interviewing more than 40 writers, and all, like Raban, were deaf to at least some of the sounds on their own pages. I quickly understood that even the most cooperative of them weren't going to be able to cogently explain why they used *their* version of a semicolon, in the manner of a football coach analyzing his calling of a screen pass in a third-and-long situation. E. B. White termed individual style a "high mystery" and maintained that there was "no satisfactory explanation" of it. Though this book tries to refute that position, it does so in a way that borrows from White's metaphor when he wrote, "the young writer . . . will often find himself steering by stars that are disturbingly in motion." Like a distant star, style, I found, is most clearly discernible when you don't look straight at it but keep it at the periphery of your vision. In the interviews, this translated into talk about semicolons, influences, reading habits, feelings about number 2 pencils and the computer, and bedside reading. The underlying movement is a circling around the subject, until finally it is securely roped and tied to the ground.

The interviews inform Part II of the book. Chapters V and VI are about the conscious and unconscious ways writers approach style, and in it you will find the interviewees as voices in a physics-defying conversation. So Cynthia Ozick, Harold Bloom, and John Lukacs will grumble together about the word processor and its discontents. And so if the subject is "influences," we may hear from Elmore Leonard on Richard Bissell, Susan Orlean on Ian Frazier, James Wolcott on Manny Farber, and Frank Kermode on William Empson. Chapter VIII takes a close-up look at particular genres—from opinion-writing to poetry—offering in-depth testimony from outstanding practitioners.

I said earlier that *The Sound on the Page* isn't a how-to manual. It isn't. On the other hand, every page has implications for writers who are inter-

ested in discovering and developing their own style. A hunch that hardened into a conviction as my investigation proceeded—and that was refuted by none of my interviewees—is that personal style is more democratic than it might first appear. To be sure, most of us neither can be nor want to be a Hemingway. But all of us have within us a quieter sort of stylistic distinctiveness. Anyone who is serious about writing in any form is engaged in a lifelong waltz with this capability. Especially at first, one's steps are clumsy and all over the place. Even the most proficient and experienced writers often find that the style takes the lead, and they only follow. But if they are aware of what's going on, they can achieve a sort of dance within the dance, which is one of writing's greatest satisfactions. Chapter IX respectfully offers advice on the daunting task of identifying and bringing out one's own style.

Between chapters, you will find brief Interludes, following up on tangential themes and ideas. There could have been more of them. When the subject is style, I have found, the links are infinite and the conversation never ends.

Part I

STYLE FROM THE OUTSIDE: THEORY

CHAPTER I

The History of an Idea

We can turn to etymology to understand the origin of the meaning of style—but only at the risk of being seriously misled. The English word *style* is derived from the Latin *stilus*, meaning a pointed instrument for writing. It later came to refer to what was done *with* the instrument—that is, the way words are arranged.* Here's the misleading part: the concept of style was invented by the Greeks (they called it *lexis*), and they would *never* have named it after a writing tool. All ancient notions about putting words together assumed that the primary means of communicating them was speech. Sometimes

*The English equivalent was originally spelled *stile* and as early as 1300, according to the *Oxford English Dictionary*, was used to mean "a written work or works." The first use in the sense of a manner of writing, according to the OED, the Clerk's Tale, where Chaucer says that Petrarch wrote the story "with heigh stile." The spelling of the word changed to *style* in the early eighteenth century, apparently because of the mistaken belief that the word derived from the Greek *stûlos*, meaning "column."

the words were written down, to aid memory or ensure future availability, but the ultimate means of delivery was oration, not publication. Thus style for both the Greeks and the Romans was a branch of the art of oratory.

The founder of that art is traditionally considered to be Gorgias, a native of Sicily who became ambassador to Athens in the fifth century BCE and who was known for his elaborate figures of speech and hypnotic cadences. He was associated with the school of the Sophists. The name only later picked up the negative connotations by which we now know it, but even at the time, Gorgias's emphasis on eloquence and persuasiveness, allegedly at the expense of truth, brought him criticism from the philosopher Isocrates, who advocated the study of "eloquent wisdom," rather than rhetoric, and especially from Socrates and his disciple, Plato. In the dialogues *Gorgias* and *Phaedrus*, Plato set up a distinction between truth (the ultimate value) and verbal skill (which will tend to obscure truth). In *The Republic*, Plato shows Socrates denigrating the very practice of writing; words that are written in stone, figuratively or literally, can manipulate emotions and ideas with near impunity, because they cannot be challenged, and actually obscure or block the path of truth.

These debates took place well over 2,000 years ago, but they have been replayed ever since. On the one side are Socrates and Plato and their heirs, who mistrust language from the start because of the irresponsible way it verges from reality. Words are a necessary evil, they acknowledge—how else could we communicate?—but have to be used cautiously. This camp conceives of the truth as a series of invisible beings who walk through our world; the aim of speaking or writing is to dress these forms with perfectly fitting garments that allow us to see them for the first time. A flamboyant epaulet or a colorful sash would be extraneous, unseemly, and maybe even immoral.

On the other side is the school of Gorgias, which has been less militant and organized and has made its case more by example than by pronouncement. A pillar of its position is that the arrangement of words—that is, style—can be an agent not only of persuasion but of beauty and expression as well. And truth, this side implies and sometimes states, is not as simple a matter as Plato would have you believe. Instead of imagining language and reality as separate entities, they ask us to consider the possibility that neither one can exist without the other.

As was often the case, it fell to Plato's student Aristotle to mediate

between the two positions. He devoted an entire treatise, *On Rhetoric*, to the subject of eloquence and persuasion; one of its three books concerned itself with style. Aristotle defended rhetoric as not merely a series of ornaments or tricks but instead as an essential part of argument, investigation, and communication. At the same time, his view of style was conservative, emphasizing clarity, transparency, and decorum. Indeed, some of the precepts in *On Rhetoric* could have come straight from Strunk and White:

> Style to be good must be clear. . . . Clearness is secured by using the words (nouns and verbs alike) that are current and ordinary. . . .
>
> A writer must disguise his art and give the impression of speaking naturally and not artificially. Naturalness is persuasive, artificiality is the contrary; for our hearers are prejudiced and think we have some design against them, as if we were mixing their wines for them. . . .
>
> Strange words, compound words, and invented words must be used sparingly and on few occasions. . . .
>
> A good writer can produce a style that is distinguished without being obtrusive, and is at the same time clear.

Cicero, a Roman and the greatest ancient commentator on rhetoric and style, swung the pendulum back the other way. He claimed that Socrates "separated the science of wise thinking from that of eloquent thinking, though in reality they are closely linked together." Going further, Cicero called for a union of *res* (thought) and *verba* (words); one cannot speak of expressing the same thought in different words, he said, because in that case the thought would be different. Language and style are therefore not a utilitarian vehicle with which to deliver truth or meaning but an essential and organic part of both. And consequently, rhetoric is the ultimate art: "the consummate orator possesses all the knowledge of the philosophers, but the range of philosophers does not necessarily include eloquence; and although they look down on it, it cannot but be deemed to add a crowning embellishment to their art."

In addition to defending rhetoric, Cicero codified the discipline. He wrote that the orator "must first hit upon what to say; then manage and marshal his discoveries, not merely in orderly fashion, but with a discriminating eye for the exact weight . . . of each argument; next go on to array

them in the adornments of style; after that keep them guarded in his memory; and in the end deliver them with effect and charm." And thus he laid out the five faculties of classical rhetoric: invention, arrangement or structure, style, memory, and delivery. A world-class divider, Cicero also named and described the three levels of style: high or vigorous ("magnificent, opulent, stately, and ornate"), low or plain (informal diction, conversational), and middle or tempered (not surprisingly, a blend of the two). He did not favor any of the three but felt that each was appropriate in different circumstances: "He in fact is eloquent who can discuss commonplace matters simply, lofty subjects impressively, and topics between in a tempered style."

Cicero's emphasis on versatility suggests a key distinction: in common with all the ancient rhetoricians, he thought of style as one of several arrows in the orator's quiver, rather than as a distinctive and distinguishing personal means of expression. There was indeed such a manifestation of the speaker's *ethos*, or moral character—but it was best seen in another one of the five faculties: delivery, or the performance of the speech. A Renaissance treatise on classical oratory (Thomas Wilson's *The Art of Rhetorique*) recounted that Demosthenes, when "asked what was the chiefest point in all Oratorie, gave the chief and only praise to Pronunciation; being demanded, what was the second, and the third, he still made no other answer till they left asking, declaring hereby, that art without utteraunce can do nothing, utteraunce without art can do right much." So to Demosthenes, the three most important things in oratory were locution, locution, and locution.

Style, as it has commonly been perceived in the modern world, and as it is perceived in this book, is closely related to the classical idea of delivery. In reading strong stylists, one "hears" their cadences, one senses their ethos. That recognition has to do with more than the choice and arrangement of words. Voice is the most popular metaphor for writing style, but an equally suggestive one may be delivery or presentation, as it includes body language, facial expression, stance, and other qualities that set speakers apart from one another.

These are figures of speech now, but once they were literal. Today, texts are written and published and then sent to a global metaphorical library, where readers pluck them from the shelves and read in silence. In the ancient world, a written text was like a play script: only in performance

did the words come to life. Silent reading took a long time to become the dominant mode. It was still a rarity in the fourth century AD, when Augustine was surprised by the way Ambrose (the bishop of Milan and another future saint) consumed a book: "When he read, his eyes scanned the page and his heart sought out the meaning, but his voice was silent and his tongue was still. Anyone could approach him freely and guests were not commonly announced, so that often, when we came to visit him, we found him reading like this in silence, for he never read aloud."

In the Middle Ages, writing was a craft, one involving not composition but inscription: anonymous scribes copied classic or religious texts, along the way employing their own individual style—the shape of a letter or a characteristic flourish. Then, in a span of about 100 years in the fourteenth and fifteenth centuries, a series of cosmic changes occurred. There appeared on the scene "authors," such as Dante, Petrarch, and Chaucer, who were anything but anonymous and part of whose vocation was to express the glory not just of God but of themselves. Equally radically, they set down their words in the vernacular languages—English, Italian, French—instead of Latin. In 1440, Gutenberg invented the printing press, and the wide distribution of books that resulted meant a change in the character of texts: they could and would be read silently, not listened to. And that development had a bearing on the general understanding of style. With words now confined to books' pages—not necessarily alive and resonating in the marketplace, square, or church—ethos, emotion, irony, and meaning itself could no longer be expressed through delivery. And so it followed that writers began to pack more figurative language and rhetorical devices—more *style*, in the generic, rather than personal, meaning of the word—into the choice and arrangement of words.

This dovetailed with the entire project of Renaissance humanism—the exaltation and exploration of all human capacities. The era ushered in a revival of classical rhetoric, with special emphasis on how the artful use of language let man exercise his protean quality: eloquently expressing any idea, using any figure of speech (Renaissance rhetoricians compiled endless lists of them), adopting the cadences and style of any model. It was writing as costume: one could put on any outfit that suited one's mood that day, and the more flamboyant the better.

The glorious result of this idea was the plays of Shakespeare, which, more than anything else, are about humankind's use of language: how it

lets people adopt any guise, shapes their actions and ideas, sometimes lets them reach the heights of insight and expression, and sometimes snares them in the cruellest traps. The inglorious result was the phenomenon of writers and speakers who got drunk on their own words, most notoriously John Lyly (1554–1606), the ornate prose of whose two-part romance *Euphues* led to the coining of the word *euphuism*—that of which Kingsley Amis accused Nabokov.

The backlash against their excesses was inevitable and forceful. Cicero had yoked together *res* and *verba*, thought and speech; post-Renaissance thinkers such as Francis Bacon and Montaigne pulled them apart again. The latter commanded: "Away with that Eloquence that so enchants us with its Harmony, that we should more study it than things." The Enlightenment, with its conviction that reason could shine a light on truth and Truth, carried the argument all the way back to Plato. John Locke wrote, rather harshly, in 1700, "We must allow, that all the Art of Rhetorick, besides order and Clearness, all the artificial and figurative application of Words Eloquence hath invented, are for nothing else but to insinuate wrong *Ideas*, move the Passions, and thereby mislead the Judgment; and so indeed are perfect cheat."

In his 1721 "Letter to a Young Clergyman," Jonathan Swift brought these ideas to bear on style, which he defined as "proper words in proper places." The concise elegance of the definition is matched only by the colossal question it begs, to wit, How do you tell when the words and the places are proper? Swift never gives a full answer (in a classic feint, he immediately follows his formulation with, "But this would require too ample a disquisition to be now dwelt on"), but he does implicitly offer a moral conception of style. To him, an excellent manner of expression is not merely an aid in communication and persuasion but a reflection of good character and judgment. Following Aristotle and anticipating Strunk and White, Swift puts forth simplicity, clarity, and humility as the great values in prose:

> When a man's thoughts are clear, the properest words will generally offer themselves first, and his own judgment will direct him in what order to place them so as they may be best understood. Where men err against this method, it is usually on purpose, and to show their learning, their ora-

tory, their politeness, or their knowledge of the world. In short, that simplicity without which no human performance can arrive to any great perfection is nowhere more eminently useful than in this.*

The next swing of the pendulum carries us to a vantage point from which we can see the present. The nineteenth century was the age of the stylist. Like Coleridge with his line from Wordsworth, a reader (and this was also the age in which the reading public reached a truly significant size) could immediately name the author when presented with an unsigned line from Thomas De Quincey, Charles Lamb, Charles Dickens, Thomas Carlyle, Thomas Macaulay, Walter Savage Landor, Robert Louis Stevenson, John Ruskin, Walter Pater, Oscar Wilde, Ralph Waldo Emerson, Walt Whitman, Henry James, or maybe even a relatively obscure or eccentric writer, such as Charles Doughty or Frederick Rolfe (aka Baron Corvo). The attention to individual style had commercial underpinnings (it was a key part of an author's self-marketing) and also philosophical ones—the Romantic faith in and emphasis on the irreducible essence and genius of individual human beings. By the 1860s, when George Henry Lewes published *The Principles of Success in Literature*, style as garb was a fatally passé metaphor, and style-is-the-man was a commonplace: "Genuine style is the living body of thought, not a costume that can be put on and off. . . . No style can be good that is not sincere. It must be the expression of its author's mind. There are, of course, certain elements which must be mastered as a dancer learns his steps, but the style of the writer, like the grace of the dancer, is only made effective by such mastery; it springs from a deeper source."

Flaubert was the century's most eloquent spokesman for style. He saw it not so much as a vessel for individual expression but as a supreme aesthetic quality, to be valued in and for itself. In an 1852 letter to Louise

*I can't resist quoting Swift's indignant riff on bad style, in which he includes two persistent faults, unnecessary adjectives and clichés: "It would be endless to run over the several defects of style among us; I shall therefore say nothing of the mean and paltry (which are usually attended by the fustian), much less of the slovenly or indecent. Two things I will just warn you about: the first is the frequency of flat, unnecessary epithets; and the other is the folly of using old, threadbare phrases, which will often make you go out of your way to find and apply them, are nauseous to rational hearers, and will seldom express your meaning as well as your own natural words."

Colet (which anticipated the 1990s sitcom *Seinfeld*, a show "about noth-ing") he mused, "From the point of view of pure Art, you could almost establish it as an axiom that the subject is irrelevant, style itself being an absolute manner of seeing things. . . . What I would like to write is a book about nothing, a book without exterior attachments, which would be held together by the inner force of its style, as the earth without support is held in the air."

The rage for style culminated in Pater, who saw it as a way to achieve a mystical oneness. In his 1888 essay "Style," he fairly chanted, "To give the phrase, the sentence, the structural member, the entire composition, song, or essay, a . . . unity with its subject and with itself:—style is in the right way when it tends towards that. . . . Such logical coherency may be evi-denced not merely in the lines of composition as a while, but in the choice of a single word." For strong writers, he concluded, it was a matter of soul: "the way they have of absorbing language, of attracting it into the peculiar spirit they are of, with a subtlety which makes the actual result seem like some inexplicable inspiration."

No one who has followed the saga this far will be surprised to hear that all this could not stand. Starting shortly before the turn of the twen-tieth century, people began chafing at the mystification and glorification of individual style perpetrated by the likes of Pater. Like previous reac-tions, this was both pendulum swing and paradigm shift, and quite pow-erful: almost everyone who has essayed the subject of style since the start of the twentieth century has taken same neo-Aristotelean tack that cor-rectness, clarity, and simplicity are to be prized, and verbal ostentation and self-indulgence to be avoided. At the forefront of the shift was Matthew Arnold, who in his 1880 essay "The Study of Poetry" declared that "the needful qualities for a fit prose are regularity, uniformity, preci-sion, balance." Samuel Butler, writing in his notebook in 1897, expressed the coming sentiment by using a very old metaphor in a slightly new way: "A man's style should be like his dress—it should attract as little attention as possible." Butler went on to boast, "I should like to put it on record that I never took the smallest pains with my style, have never thought about it, and do not know or want to know whether it is a style at all, or whether it is not, as I believe and hope, just common, simple straightforwardness."

Books and essays explicating this idea became a genre unto themselves; the typical mode was bemused scolding, and a typical structural device the list of precepts or rules. A key early text was *The King's English*, by brothers H. W. and F. G. Fowler, published in 1906. The book, which was a precursor to H. W.'s better-known *A Dictionary of Modern English Usage* of 1926, announces in the preface that "the positive literary virtues are not to be taught by brief quotation, nor otherwise attained than by improving the gifts of nature with wide or careful reading." What *can* be taught is the elimination of stylistic blunders and infelicities, and *The King's English* is an entertaining catalogue of them, complete with examples taken from major and minor authors and an assortment of periodicals. But before the hall of shame come first principles. Chapter I begins:

> Any one who wishes to become a good writer should endeavour, before he allows himself to be tempted by the more showy qualities, to be direct, simple, brief, vigorous, and lucid.
>
> This general principle may be translated into practical rules in the domain of vocabulary as follows:—
>
> Prefer the familiar word to the far-fetched.
>
> Prefer the concrete word to the abstract.
>
> Prefer the simple word to the circumlocution.
>
> Prefer the short word to the long.
>
> Prefer the Saxon word to the Romance.

A reader with a grounding in the classics, or the eighteenth century, could be forgiven for wondering, "Where have I heard that before?"

As the genre developed, the ideas remained the same. What changed were the particular needs and circumstances of the individual writer. Sir Arthur Quiller-Couch, addressing Cambridge University students in 1913, presumably aware that war was imminent, wanted to link prose style with a muscular and distinctly "gendered" code of character: "Though personality pervades style and cannot be escaped, the first sin against Style as against good Manners is to obtrude or exploit personality. . . . believe me, Gentlemen—so far as Handel stands above Chopin, as Velasquez above Greuze, even so far stand the great masculine writers above all who appeal to you by means of personality of private sentiment." Somerset

Maugham included in his 1938 memoir, *The Summing Up*, a long account of the development of his unobtrusive, journalistic style that implicitly served as a defense of or justification for it. "To write simply is as difficult as to be good," he concluded.

Robert Graves and Alan Hodge wrote *The Reader Over Your Shoulder* in 1943, a moment, they explain, when prose has been debased by the fast pace and, yes, the bloody racket of modern life. ("Normally, except for those who work in the early hours of the morning, or who live up a long country lane, it is almost impossible to avoid being disturbed by incidental noises of traffic, industry, schools, and the wireless, or by the telephone, or by callers.") But the descriptions of these circumstances is merely the overture to a familiar argument for clarity (the chapter entitled "The Principles of Clear Statement" is so long it has to be divided into three parts) and stylistic anonymity: "Men of letters usually feel compelled to cultivate an individual style—less because they feel sure of themselves as individuals than because they wish to carve a niche for themselves in literature, and nowadays an individual style usually means a peculiar range of inaccuracies, ambiguities, logical weaknesses and stylistic extravagancies."

As the title implies, Orwell's "Politics and the English Language" (1946) is concerned mainly with ideology's baleful effects on style. "Orthodoxy, of whatever color, seems to demand a lifeless, imitative style," he writes, and, "political language has to consist largely of euphemism, question-begging and sheer cloudy vagueness." His proposed solution is, in essence, the familiar one of clarity and simplicity, and he closes with a list of "rules" that precisely mirror the Fowlers', with additional warnings against the temptations of cliché and jargon. In an essay published the same year, "Why I Write," Orwell stated, ". . . one can write nothing readable unless one constantly struggles to efface one's personality. Good prose is like a windowpane."

The reader will note that all of the above examples are from England. Briefs appeared with less frequency in the United States, whose citizens were less protective of the language and had not invested several centuries debating these issues. However, Americans, with their Puritan and agrarian heritage, have always had a thing for muscular plainness and periodically made cases for its linguistic equivalents. As early as 1650, in his *History of Plymouth Plantation*, William Bradford wrote that his goal was "a plain style with singular regard unto the simple truth in all things." The

most prominent and eloquent nineteenth-century exemplar of the creed was Thoreau, who preached,

> Steady labor with the hands, which engrosses the attention also, is unquestionably the best method of removing palaver and sentimentality out of one's own style, both of speaking and writing. If he has worked hard from morning till night, though he may have grieved that he could not be watching the train of this thought during that time, yet the few hasty lines which at evening record his day's experience will be more musical and true than his freest but idle fancy could have furnished.

Mark Twain's literary ventriloquism should not obscure the fact that he was a purist when it came to the English language. According to his famous 1895 screed, most of "Fenimore Cooper's Literary Offenses" stem from Cooper's not employing (in Twain's words) "a simple and straightforward style." When Twain's essay was published, William Strunk had already been teaching at Cornell University for four years. He self-published the first edition of his *Elements of Style* in 1918.

In their own way, Ernest Hemingway, H. L. Mencken, and Harold Ross (who founded *New Yorker* magazine in 1925) all issued stylistic critiques of current usage and habits. Hemingway, adapting lessons he had learned from Gertrude Stein and Sherwood Anderson, fetishized plainness, in sentence structure, (absence of) metaphor, and vocabulary. Mencken's masterpiece, *The American Language*, published in 1919 and regularly revised and updated over the next 30 years, was dedicated to exposing the euphemisms, vogue words and linguistic idiocies his countrymen were inexplicably drawn to. Ross was devoted to Fowler's *Modern English Usage* and edited the *New Yorker* with a fanatical zeal to keep its pages pure of solecism, cliché and "indirection"—Ross's term for prose that tries to slip in meanings in an implicit or suggested way, instead of laying them out one by one. Perhaps coincidentally, or perhaps not, Mencken, Hemingway, and the *New Yorker* all had unmistakable styles.

To grossly generalize, Americans truly warmed to the theme after World War II, just as the English seem finally to have gotten the point. The galvanizing agent in the United States was evidently the arrival on the scene of Rudolf Flesch, who emigrated from his native Austria in 1938. Flesch wrote a doctoral dissertation about readability and in 1946

expanded it into a book, *The Art of Plain Talk*. The great appeal to Americans of this and Flesch's subsequent works—*The Art of Readable Writing*, *The Art of Clear Thinking*, *How to Be Brief*, and so forth—was that they broke the issue of writing and style down into a formula and thus made it seem scientific. Flesch and his progeny also wrote with a Dale Carnegie, Kiwanis Club breeziness, full of italics and direct address, that made achieving a good style seem nothing fancy, just good business sense. It was so simple! To arrive at the "reading ease" score of a piece of writing, you multiply the average sentence length by 1.015, multiply the number of syllables per 100 words by .846, add the two figures, and subtract the sum from 206.835. (I am not making this up.) The result will be on a scale from 100 (easy) to 0 (exceedingly difficult). Thoreau would be pleased to learn that a passage from his work gets an 83 ("easy"); the Gettysburg Address is graded 70 ("fairly easy"), and a paragraph from a life insurance policy gets a −12. This nonsense at least provided a novel route to a familiar message, which in Flesch's words was the "simple style—the style that meets the scientific tests of readability—is *the* classic style of great literature. . . . If you start to analyze what style is, the only possible general rule is that the reader must be able to understand what the writer says; and the surest way to that is simplicity." Flesch was silent on nature of the general rule when the writer is trying to say something subtle and complicated.*

Flesch led the way to Strunk and White, and, as described in the Introduction, Strunk and White led the way to the current consensus that style equals clarity, simplicity, and no mistakes.

*Flesch also devised an even loonier Human Interest Index. To get this, you have to count the "personal words" and "personal sentences" in a passage. Personal words are all pronouns referring to people, proper names, words that have a "masculine or feminine natural gender" (including *iceman* but, for reasons that escape me, *not* including *teacher*), and the words *people* and *folks*. Personal sentences are direct quotations; questions, statements or commands directly addressed to the reader (Flesch's example: "Does this sound impossible?"); exclamations; and "grammatically incomplete sentences whose full meaning has to be inferred from the context," such as, "Handsome, though." To get the Human Interest Score, you multiply the number of Personal Words per 100 by 3.635, multiply the number of Personal Sentences per 100 sentences by .314 and add the results. Flesch died in 1986. Today he is remembered less for his work on writing style than for his 1955 book *Why Johnny Can't Read*, which in addition to having one of the catchiest titles of all time, argued that the whole-language method of teaching reading was less effective than phonics.

Why was this story told so incessantly in the twentieth century? A few factors are apparent. Perhaps the most cogent and sensible book ever written about style is Cyril Connolly's *Enemies of Promise*, published in 1938. One of Connolly's lasting contribution to the debate is a one-word designation for prose that does *not* strive for the classical virtues of simplicity and clarity. He called it Mandarin. "It is the style," he explains, "of those writers whose tendency is to make their language convey more than they mean or more than they feel, it is the style of most artists and all humbugs, and one which is always menaced by a puritan opposition." Against this, Connolly describes the disparate revolts of a wide variety of "colloquial" writers or realists, influenced by journalism and the talking pictures; he includes among them Hemingway, Maugham, Orwell, E. M. Forster, D. H. Lawrence, and Christopher Isherwood. Perhaps uniquely, Connolly sees both the good and the bad in the Mandarin style, and appreciates that it goes in and out of fashion. Against the prevailing wisdom, that "style seems something artificial, a kind of ranting, or of preening," he bluntly states that "there is no such thing as writing without style."

Connolly describes the Mandarin style's reign in the nineteenth century, when its "last great exponents" were Pater and Henry James, and he has a plausible explanation for why James's late novels, with their tortuous sentences and endless strings of metaphors, went virtually unread. James's early works

> reached a small leisured collection of people for whom reading a book—usually aloud—was one of the few diversions of our northern winters. The longer a book could be spun out the better, and it was the duty of the author to spin it. But books got cheaper, and reading them ceased to be a luxury, the reading public multiplied and demanded less exacting entertainment, the struggle between literature and journalism began. Literature is the art of writing something that can be read twice; journalism what will be read once, and they demand different techniques. There can be no delayed impact in journalism, no subtlety, no embellishment, no assumption of a luxury reader, and since the pace of journalism is faster than that of literature, literature found itself in a predicament. It could react against journalism and become an esoteric art depending on the sympathy of a few, or learn from journalism, and compete with it.

What Connolly recognized was a fissure between "high" and "low" writing. It had existed for a long time but until, roughly, the time of Henry James, it was always bridgeable. That is, writers were encouraged to produce essays and poems and novels and books of history; their audience was both the reading public (a group of modest size and fairly homogeneous education and sensibility) and posterity—or, as it would later be known, "art." As the twentieth century proceeded, it became apparent that wide readership and artistic distinction were, except in rare cases, mutually exclusive. The stylistic reformers wanted to knock some sense into literature and writing in general so that they could hold their own in these fast-paced times.

But reformers like the Fowlers, writing in the early decades of the century, didn't know the half of it. Ever since Gutenberg, the written word had been the only way of communicating to a substantial number of people; it thus held a privileged position in any *discourse* about communication. That is, when you talked about the expression of ideas, you talked about writing. (Painting, sculpture, and music reached comparatively tiny audiences and weren't really about ideas anyway.) One by one, all the new media of mass communication colonized the Earth in the twentieth century: photography, many kinds of sound recordings, radio, silent and sound film, television, the Internet. As each one emerged, it struck writing with a new body blow; the cumulative effect was devastating. By the end of the century, few people read extensively, fewer still could write well, and hardly anybody had any interest in a debate about the proper role of style. No wonder, then, that a Robert Graves, an E. B. White, a Jacques Barzun, or a William Zinsser would successively take a look at the once mighty, now increasingly quaint, discipline, proscribe flights of fancy and "style," and prescribe a return to basics.

There was a concurrent and parallel history of writing in the twentieth century, of course—a body of work to which the strictures of the reformers did not and could not apply (but for which they occasionally expressed their impatience or disdain). This was the stuff on the other side of the fissure, the work of the heirs of Henry James, otherwise known as literary modernists. Proust, Stein, Pound, Eliot, Kafka, Joyce, Woolf, and Beckett made no attempt to make things easy for the reader and weren't interested in journalism of any kind; they didn't even allow themselves to think about sales. (The alternatives: starvation, an inheritance, a day job, a

spouse with same, or, in the second half of the century, tenure and Oprah's Book Club.) And so the neo-Aristoteleans were content to let this group labor in a gilded ghetto of high prestige and few readers. These writers were intently interested in style, but not quite in the same way as the nineteenth-century Mandarins had been. That is, far from seeking a "signature style," novelists like Joseph Conrad, Ford Madox Ford, and Virginia Woolf and poets like Ezra Pound and T. S. Eliot strove to forge a different style and form for each succeeding work, the better to suit its particular artistic needs and their own urge to "make it new." If you consider a selection of their contemporary heirs—say, novelists Don DeLillo, Martin Amis, Margaret Atwood, Salman Rushdie, Peter Carey, Joyce Carol Oates, and John Banville—you will observe the same assumption that every book is a thing apart, requiring a distinct formal and stylistic strategy.

I want to wander down one more historical path before returning, permanently, to practical matters. The twentieth century saw the rise of literary criticism as an academic discipline. And in the long effort to shift criticism from Victorian impressionism to a more scientific stance and stature, style was always a reliable specimen to put under the microscope. True, the New Critics, who dominated the field, took pains to avoid "the biographical fallacy" and so would customarily focus on works rather than authors. But there was a healthy line of critics who were willing to take a more personal approach, so one could discuss personal prose style in these decades, but—in contrast to the nineteenth century, when it was a vital topic of public discourse—only as it pertained to a dead or "canonical" writer. I hasten to say that this led to some prime stuff. For instance, William Wimsatt's 1941 *The Prose Style of Samuel Johnson* not only describes Johnson's style elegantly and precisely but also analyzes the ways it related to Johnson's character and themes. ("Johnson's inversion is intrinsically an expressive word order," Wimsatt writes at one point. "It is part of his inclination to logic, his interest in the pattern of premises and conclusion, which sometimes sacrifices the quality of his premises. It happens not to be idiomatic in English; it is idiomatic in some other languages.") The subfield of "stylistics" emerged in the 1950s and became so popular that Louis Milic's 1967 bibliography listed 534 articles and books published in the preceding 17 years. That doesn't even count all the articles that would appear in the journal *Style*, which was founded in 1967.

Milic and other practitioners borrowed terminology and techniques from linguistics (which helped stylistics's stature as science), including complicated computer-aided means of quantifying style. (I quote at random from a 1976 text: "We cannot properly consider [Phillip] Sidney's habits of modification without first observing that he is the least nominal writer of our four. Figure 6.11 compares Sidney, with a mean total of 629 nouns per sample, with the control writers, who average a total of 711 nouns per sample.")

Today, in university English departments in the United States and the United Kingdom, stylisticians are few and far between and tend to be approaching retirement. What happened? In a word, post-structuralism. Perhaps the most influential of many influential ideas of the deconstructionists and other theorists who emerged in France in the 1960s was that "privileging" writers, as the Romantic tradition had done for more than 150 years, was a grave mistake. All they were doing, after all, was unconsciously inscribing power relations in society and other circumstances beyond their control. That being the case, wasn't it silly for critics to sit at their feet endlessly describing their attributes, one of which was style? One might as well analyze a magazine advertisement or a comic book, and, in fact, the deconstructionists did so. In a famous 1968 essay announcing "The Death of the Author," Roland Barthes marked the passing by using a new word for (not the writer but) the "scriptor" of (not books but) "texts": "the modern scriptor is born simultaneously with the text, is in no way equipped with a being preceding or exceeding the writing. . . . There is no other time than that of the enunciation and every text is eternally written *here and now*." The scriptor doesn't write the text, in other words; the text writes the *scriptor*. The following year, Michel Foucault closed his essay "What Is an Author?" with a quotation from Samuel Beckett: "What difference does it make who is speaking?" Cultural studies, gender studies, queer studies, the new historicism, postcolonial studies, and the other subdisciplines that have dominated the academic study of literature since the 1970s take widely varying approaches but agree on one thing: Style is not the man. It is not even the woman. It is, rather, the manifestation or symptom of core trends or truths next to which the personal projects of individual authors are puny and irrelevant.

Stylistics lives on as a subdivision of linguistics, and in an endeavor

that has been termed "literary forensics" or, in deference to its number-crunching proclivities, "stylometrics." The prime practitioner is Donald Foster, a professor of English at Vassar, whose first book argued, on stylistic evidence culled from a computer database, that an anonymous 1612 poem, "Funeral Elegy by W. S.," was in fact by William Shakespeare. Foster became a celebrity in the wider world in 1996, when he accurately fingered Joe Klein as "anonymous," the author of *Primary Colors*. His evidence was numerous stylistic similarities between the novel and Klein's journalism, including the habit of forming adjectives by adding a *y* to nouns, as in *dorky, slouchy,* and *cottony*. Subsequently, Foster was consulted by investigators in the Unabomber, Olympic bombing in Atlanta, JonBenet Ramsey, and anthrax-letter investigations. All this gave his stylometrics a certain sideshow quality, as if he were living out a real-life spinoff of the old *Quincy* TV series. This sense was furthered in 2002, when a competing scholar, based on his own stylistic analysis, "proved" that the actual author of "Funeral Elegy by W. S." was dramatist John Ford, and Foster conceded the point.

So it has come to pass that personal style is generally abused, ignored, marginalized, or subsumed under a definition of *style* that is more or less its opposite. How odd, then, that so many current writers have such strong, distinctive, and affecting styles! I hope that by now, the truth of that statement will be apparent. If not, all I can do is direct the reader to the names of the authors interviewed for this book, and happily throw out a couple of dozen more: Roger Angell, Paul Auster, Saul Bellow, Roy Blount Jr., William F. Buckley Jr., J. M. Coetzee, Joan Didion, Maureen Dowd, Dave Eggers, Jonathan Franzen, Ian Frazier, Elizabeth Hardwick, Seamus Heaney, John Irving, Molly Ivins, Garrison Keillor, Stephen King, Anthony Lane, John le Carré, John Leonard, John McPhee, David Mamet, Lorrie Moore, Toni Morrison, V. S. Naipaul, Grace Paley, Annie Proulx, Philip Roth, Ron Rosenbaum, David Sedaris, Zadie Smith, Calvin Trillin, Gore Vidal, Kurt Vonnegut, David Foster Wallace, and Tom Wolfe.

The disconnect is bemusing but not ruinous; clearly, discourse has not crippled practice. But the time is ripe for style to reclaim its full meaning.

It should be possible, in other words, to absorb the points of the Strunk-and-Whiters, on the one hand, and the post-structuralists, on the other, and still construct a brief for personal style.

In the 1930s, perceiving an analogous incongruity, Cyril Connolly made the case that it was possible to have it both ways: to take the best from the Mandarins and from those who had revolted against them. Connolly's conclusions provide such a sensible model—and such a good specimen of his own splendid style—that they are worth quoting at length:

> For a book to be written at the present time with any hope of lasting half a generation, of outliving a dog, or a car, of surviving the lease of a house or the life of a bottle of champagne, it must be written against the current, in a prose which both makes demands on the resources of our language and the intelligence of the reader. From the Mandarins it must borrow art and patience, the striving for perfection, the horror of clichés, the creative delight in the material, in the possibilities of the long sentence, the splendour and subtlety of the composed phrase.
>
> From the Mandarins, on the other hand, the new writer will learn not to capitalise indolence and egotism, not to burden a sober and delicate language with exhibitionism. There will be no false hesitation and woolly profundities, no mystifying, no Proustian onanism. He will distrust the armchair clowns, the easy philosophers, the prose charmers. He will not show off his small defects, his preferences or his belongings, his cat and pipe and carpet slippers, bad memory, clumsiness with machinery, absent-mindedness, capacity for losing things, ignorance of business, of everything which will make the reader think he wrote for money. There will be no whimsy, allusiveness, archaism, pedantic usages, wrong colloquialisms, or sham lyrical outbursts. . . .
>
> From the realists, the puritans, the colloquial writers and talkie-novelists there is also much that he will take and much that he will leave. The cursive style, the agreeable manners, the precise and poetical impact of Forster's diction, the lucidity of Maugham, last of the great professional writers, the timing of Hemingway, the smooth cutting edge of Isherwood, the indignation of Lawrence, the honesty of Orwell, these will be necessary, and the touch of those writers of English who give every word in their limited vocabulary its current topical value. . . .
>
> But he will not borrow from realists, or from their imitators, the flat-

ness of style, the homogeneity of outlook, the fear of eccentricity, the reporter's horror of distinction, the distrust of beauty, the cult of a violence and starkness that is masochistic. . . .

What I claim is that there is action and reaction between these styles, and that necessary as it was, and victorious though it seems, the colloquial style of the last few years is doomed and dying. Style, as I have tried to show, is a relationship between a writer's mastery of form and his intellectual or emotional content. Mastery of form has lately been held, with reason, to conceal a poverty of content, but this is not inevitable, and for too long writers have had to prove their sincerity by going before the public in sackcloth and ashes, or, rather, a fifty-shilling suit and a celluloid collar. Now the moment has come when the penance is complete, and they may return to their old habit.

Interlude
Style's Greatest Quotes

It is not surprising that, like love and war, style should have inspired the best writers and thinkers to say interesting and memorable things. It is, after all, the medium in which they exist. Here is a selection, arranged alphabetically by author surname.

WHEN A PHRASE IS BORN, it is both good and bad at the same time. The secret of its success rests in a crux that is barely discernible. One's fingertips must grasp the key, gently warming it. And then the key must be turned once, not twice. . . . No iron spike can pierce a human heart as icily as a period in the right place.
—*Isaac Babel, in the short story "Guy de Maupassant"*

STYLE IS NOT MUCH A MATTER OF CHOICE. One does not sit down to write and say: Is this poem going to be a Queen Anne poem, a Beidermayer poem, a Vienna Secession poem or a Chinese Chippendale poem? Rather it is both a response to constraint and a seizing of opportunity. Very often a constraint is an opportunity. . . . Style enables us to speak, to imagine again. Beckett speaks of "the long sonata of the dead"—where on earth did the word *sonata* come from, imposing as it does an orderly, even exalted design upon the most disorderly, distressing phenomenon known to us? The fact is not challenged, but understood, momentarily, in a new way.
—*Donald Barthelme*

FOR MYSELF, if you will excuse a rather cheap little image, I suppose style is the mirror of an artist's sensibility—more so than the content of his work. To some degree all writers have style—Ronald Firbank, bless his heart, had little else, and thank God he realized it. But the possession of style, a style, is often a hindrance, a negative force, not as it should be, and as it is—with, say E. M. Forster and Colette and Flaubert and Mark Twain and Hemingway and Isak Dinesen—a reinforcement. Dreiser, for instance, has a style—but oh, *Dio buono!* And Eugene O'Neill. And Faulkner, brilliant as he is. They all seem to me triumphs over strong but negative styles, styles that do not really add to the communication between writer and reader.
—*Truman Capote*

THE MOST DURABLE THING IN WRITING IS STYLE, and style is the most valuable investment a writer can make with his time. It pays off slowly, your agent will sneer at it, your publisher will misunderstand it, and it will take people you have never heard of to convince them by slow degrees that the writer who puts his individual mark on the way he writes will always pay off.
—*Raymond Chandler*

STYLE IS A RELATION BETWEEN FORM AND CONTENT. Where the content is less than the form, where the author pretends to emotion which he does not feel, the language will seem flamboyant. The more ignorant a writer feels, the more artificial becomes his style. A writer who thinks himself cleverer than his readers writes simply, one who is afraid they are cleverer than he, will make use of mystification: good style is arrived at when the language chosen represents what the author requires of it without mystification.
—*Cyril Connolly*

THE STYLE IS THE MAN. Rather say the style is the way the man takes himself; and to be at all charming or even bearable, the way is almost rigidly prescribed. If it is with outer seriousness, it must be with inner humor. If it is with outer humor, it must be with inner seriousness. No other way will do.
—*Robert Frost*

FOR THE GENUINE AND SINCERE WRITER, everything he writes is in high style: he means every line with the maximum of intensity, and is apt to become exasperated with readers whose reception of his work is tepid or selective.
—*Northrop Frye*

A STYLE IS A RESPONSE to a situation.
—*Richard Lanham*

IF ONE MEANS BY STYLE THE VOICE, the irreducible and always recognizable and alive thing, then of course style is really everything.
—*Mary McCarthy*

THE TEST OF A TRUE individuality of style is that we should feel it to be inevitable; in it we should be able to catch the reference back to a whole

mode of experience that is consistent with itself. If this reference is perceptible to us, it will be accompanied by a conviction that the peculiarity of style was necessary, and that the originating emotion of which we are sensible demands this and this alone.
—*John Middleton Murry*

AN ORIGINAL STYLE is the only true honesty any writer can ever claim.
—*Vladimir Nabokov*

STYLE IS A THINKING OUT into language.
—*John Henry Cardinal Newman*

THE ATTAINMENT OF A STYLE consists in so knowing words that one will communicate the various parts of what one says with the various degrees and weights of importance which one wishes.
—*Ezra Pound*

IT WAS FROM HANDEL THAT I learned that style consists in force of assertion. If you can say a thing with one stroke, you have style.
—*George Bernard Shaw*

IT IS ONLY THROUGH STYLE FINALLY—through language—that any writer can be original. All the themes are old.
—*Lee Smith*

STYLE IS THIS: to add to a given thought all the circumstances fitted to produce the whole effect which the thought is intended to produce.
—*Stendhal*

YOUR OWN WINNING LITERARY style must begin with interesting ideas in your head. Find a subject you care about and which you in your heart feel others should care about. It is this genuine caring, and not your games with language, which will be the most compelling and seductive element in your style.
—*Kurt Vonnegut*

THE THREE NECESSARY ELEMENTS OF STYLE are lucidity, elegance, individuality; these three qualities combine to form a preservative which ensures the nearest approximation to permanence in the fugitive art of letters. . . .

Style is what makes a work memorable and unmistakable. We remember the false judgments of Voltaire and Gibbon and Lytton Strachey long after they have been corrected, because of their sharp, polished form and because of the sensual pleasure of dwelling on them. They come to one, not merely as printed words, but as a lively experience, with the full force of another human being personally encountered—that is to say because they are lucid, elegant and individual.
—*Evelyn Waugh*

STYLE IS THE ULTIMATE MORALITY of mind.
—*Alfred North Whitehead*

STYLE IS A VERY SIMPLE MATTER; it is all rhythm. Once you get that, you can't use the wrong words.
—*Virginia Woolf*

CHAPTER II

Writing, Speech, and the Middle Style

Contributing to the difficulty of classifying, comparing, or even talking about prose style is that writing itself is so *different*. No other creative endeavor comes in such a multiplicity of guises: writing can be art, craft, protocol, or something even less than that. That is to say, Vladimir Nabokov used the same materials as the author of the latest Coors Light advertising campaign. My next-door neighbor and I also use them when we talk about the weather, suggesting another singularity: We (all of us) use words in two amazingly different ways. Speaking takes place in real time and is an improvisational performance; writing permits, encourages and to some extent requires reflection and revision. It is an artifact.

Everybody who writes is engaged in the remarkable enterprise of making consciousness manifest—catching the slipperiest of substance, a thought, and nailing it to a page. It is amazing, when you think about it, that people should even try to do such a thing; that they would occasion-

ally succeed, nearly miraculous. And, indeed, there is something spiritual about the act of writing. When it's done in a slovenly manner or in bad faith, it seems somehow sacrilegious. When it's done well we should stand back and regard it with a kind of reverence.

Writing is also alone in the level of mediation it requires its consumers to make. Hold this book with your arms extended and stare at the page until your eyes almost glaze over. The page becomes a hieroglyphic, an abstract pattern of characters combined into units of varying shape and size, not unpleasant to look at but meaningless, the way a blackboard covered with differential equations would be to an English major walking into a classroom. A film, a play, a painting, or a piece of music can wash over you and at least make you wet, so to speak, but you can't receive a piece of writing passively; it requires work, an act of translation called reading.

Work: the notion implies that the reader has a hand in creating the meaning of the text, and thus that the end product is open to interpretation. And so it is with texts. Reader A will get the irony in a line of dialogue or an author's comment; reader B will take the statements literally. A description of a sun-baked desert will make A start to sweat and leave B cold. Readers often report that too much physical description of characters in novels bothers them; they prefer to imagine these people themselves. Sometimes writers feel that way too. John le Carré, author of a trilogy of novels about the spy George Smiley, ended the series after Alec Guinness played Smiley, magnificently, on television; le Carré said he could no longer write about the character without seeing Guinness moving about and saying the lines. Music and images, being less subject to subjectivity, are more stable and dependable manipulators, which is why propagandists and the creators of advertising use them whenever possible.

Yet oddly enough, writing is also unique in presenting at least the prospect of transparency, of seeming to be a means of communicating ideas and information and only ideas and information, with no authorial intrusion. That is one of the things that makes talking about writing style so hard. It's understood that in all texts (except maybe poems), sometimes, the content is the most important thing; readers will focus on it to the exclusion of all other concerns. As a result, if you have something to say that somebody wants to hear, you can have a horrendous style, or a style that is all over the map, and still be a successful writer. There is no shortage of writers in this category, because many readers are nearly or

completely deaf to style and focus all their attention on trawling the text for meaning. Some readers even *like* bad styles, in the comforting warmbath feel of their clichés, woodenness, or purple prose.

Style can ebb and flow in this way because all writers use the identical building blocks. Any two English speakers who sit down at the computer and write the word *tree* are using precisely the same symbols to communicate precisely the same thing, with no suggestion of any personal interpretation or fingerprint. That will not be the case if two people say the word; the speaking voice, or idiolect, of every human being in the history of the world is unique and, theoretically, identifiable. It will not be the case two people paint or draw or even photograph the same tree.* And, leaving trees aside for the moment, it will not be the same if they are asked to execute a particular pirouette, play the F-sharp above middle C on a trumpet, or mime being trapped in an elevator. Their style will betray them.

Even in writing the possibility of transparency recedes—and the inevitability of style arrives—as words get combined into phrases, sentences, and paragraphs. And so I might write "The boy sits next to the tree" and think I was being concise, clear, and completely unobtrusive— that is, transparent. But consider all the other ways I could express this piece of data. I might name the boy and/or describe him in any of thousands of ways. I might name the tree and/or describe *it* in any of thousands of ways. I might specify how far away from the tree he is or how long he has been sitting there and how much longer he expects to do so. I might throw in an alliterative adverb ("silently") or a prop ("sits in a chair") or a simile ("Like a pint-sized Buddha, the boy . . .") or an introductory clause ("As hundreds starved to death in Sudan . . ."). I could change the verb to the past tense or the future or a gerund ("The boy is sitting . . ."—a small shift but a significant one) or make the sentence a rhetorical question. I could go for irony. ("The boy didn't sit next to the tree. Not much.") With a tip of the hat to Jay McInerney, I could dust off the second person and write, "You sit next to the tree." Short as the sentence is, I could still break it in two: "The boy sits. The tree is next to

*Photography comes the closest, but even if the same camera set precisely the same way and at precisely the same distance is used to photograph a tree twice in a row, it will always be a different tree—two leaves will be gone, the light will be infinitesimally brighter, or the tree will merely be five minutes older and that much closer to death.

him." Or I could go the other way and throw in some Tom Wolfe pyrotechnics: "Hold on! Wait a minute!!! The boy . . . he's sitting—no, it can't be right—it *is*—he's *sitting next to the tree*!!!!!"

With the possible exception of the last one, all of these changes are grammatically correct, and, although some of them adjust the meaning of the original sentence, all are consistent with it. But each one radically alters the feel, the attitude, the cadence—the *style*—of the prose. Every time we write a word, a phrase, a sentence, we have to choose from what seems like an infinite number of acceptable candidates. Then, just as significantly, we choose how to link the sentences together into paragraphs. Together, these decisions constitute a style.

But here's where it gets tricky. Some of those decisions are conscious. (Consider the first sentence of this paragraph. I had the sense that this discussion was creeping toward intellectualization or excessive abstractness. So I wanted to make the sentence short and conversational: hence the *But* opener, the contraction *here's*, the colloquial *gets tricky* instead of a highfalutin combination like *becomes problematical*. After trying out numerous possibilities, I settled on what you see in front of you, despite my misgivings about the vague antecedent for the word *it*.) But many more of them are unconscious. (Getting back to that first sentence, what I wanted was a transition to the idea that writers make stylistic decisions without being aware they are doing so. Me being who I am as a person and writer, the vast majority of potential ways of expressing that thought would not even occur to me. [Here's an example, generated after an effort that felt like trying to dress myself using only my left hand: "However, the unconscious also holds sway in this process." For some reason, I almost never use personification or the word *however*. Go figure.] Of the limited number of possibilities that did enter my brain—some of them clichés I share with my generational, cultural, and class cohort, others lame formulations that only I would come up with—I tried them out on my inner ear. I put the ones that seemed the least bad on the computer screen and, one by one, rejected them: some because I could identify a problem or lack, but more because of a vague and inchoate sense that it wasn't sufficiently "readable" or "well-phrased" or that it didn't "flow" or "scan" or that it just wasn't "right." *But here's where it gets tricky* was the least of many evils.)

And indeed, unwitting execution of a half-acknowledged inner scheme is an essential component of style. We don't generally like it when we per-

ceive that an artist of any kind spends too much time thinking and fussing about these things, and we designate the result as precious or arch or self-indulgent. Yet writers who lack an inner ear, the Dostoyevskys, Theodore Dreisers, Doris Lessings, and their lesser counterparts, who seem to dump the contents of their brain onto the page, producing work that (as Truman Capote observed of some Beat writers) "isn't writing at all—it's typing," eventually wear on us, as compelling or fresh as their ideas may sometimes be. Style depends on the blend of instinct (discussed in Part I of this book) and intent (discussed in Part II).

For now, let's move on to another paradox. On the one hand, the innumerable conscious and unconscious decisions made in the act of composition would seem to be like the millions of water molecules in a snowflake. They would seem, that is, ultimately to come together to describe a unique style—what Billy Collins calls "a printout of idiolect"—for every person who puts pen to page. On the other hand, the notion of transparency persists, strongly: writing style not as unique snowflake but as sturdy multipurpose template, never wearing out even as it's shared by hundreds of thousands of practitioners. Strunk and White et al. are not delusional or simple when they maintain that we can and should write in a self-effacing way; if they were, such vast populations would not have bought their books. I have mentioned the names of a lot of authors who are read for their styles, but the fact is that usually when we pick up newspapers or magazines and sometimes books, we don't care about or even notice the name on the byline or the title page. We are after content—information or story—and we really don't want the writer to get in the way. We want transparency.

To make sense of the paradox, I retrieve Cicero's idea of the middle style. This particular rhetorical road, you will recall, lies between the ornateness and perorations of the grand or vigorous style (used for persuasion) and the simple words and conversational manner of the plain or low style (used for proof and instruction). Cicero designated the middle style as a vehicle for pleasure and defined it by what it is not—not showy, not highly figurative, not stiff, not excessively simple or terse. By its own name and others, it has had considerable and continuing appeal through the years. Aristotle and Swift and Thoreau were talking about the middle style, and so was William Hazlitt in his essay "On Familiar Style," published in 1821: "To write a genuine familiar or truly English style, is to write as any one would speak in common conversation, who had a thor-

ough command and choice of words, or who could discourse with ease, force, and perspicuity, setting aside all pedantic and oratorical flourishes. . . . You must steer a middle course." The twentieth-century reformers, up to and beyond Strunk and White, were and are advocating and teaching their version of the middle style. Richard Lanham, who as far as I know is the first critic to apply this classical idea to current writing, wrote in his book *Analyzing Prose*, "The middle style is the style you do not notice, the style that does not show, ideal transparency. . . . The 'middleness' of the middle style will lie . . . in the expectedness of the style."

The phrase bears repeating: *the expectedness of the style*. There are many kinds of middle styles, each one having evolved to suit a particular purpose and audience and each one speaking to that audience in a predictable idiom. For example, if you pick up a slick magazine, such as *Vanity Fair* or *Premiere*, and read a profile of a movie star, you will expect the writer to employ the first person and the present tense and an ironic, highly conversational voice with a lot of current catchphrases. In the 1960s, when Tom Wolfe and others began to write this way, it was a stylistic innovation; now it is a convention or code.* An accepted middle style exists for any form of writing you can think of: news stories in the *New York Times*, scholarly articles in the sciences or humanities, historical narratives, Web logs, legal decisions, romance or suspense novels, CD reviews in *Rolling Stone*, medical case studies.

Learning a middle style, any middle style, isn't easy. When you start out, you will have in your head diction and cadences from the *other* styles you have sampled or that are in the cultural ether, many of them barbarous, plus (possibly) some personal formulations of your own. A student handed in to a colleague of mine a newspaper feature story that began as follows (I have changed the name of the subject):

> The fierce atmosphere of a construction worker seems unimaginable
> to the naked eye. However, a day in the life of John Hamilton sheds more

*In a 1987 interview, Wolfe said, "Now, even though I made the historical present my trademark at the outset, I find that it's self-parody for me to lean on it. This can happen. Your own inventions can become deflated currency. How can you start another magazine piece with 'Madonna sits there fidgeting with a forelock that just won't act right. She pouts, she pivots on her seat, she gives me a look through tiger-tongue lick-on eyelashes and says . . . ?' Somehow, you just can't start a story that way anymore." Maybe Wolfe can't, but a nation of hacks can and does.

light on such a career. The day begins at 5 a.m. as Mr. Hamilton packs a
lunch and heads to the construction sight.

Here's the problem: the student has no familiarity or competency with the
written word, so she trowels on a soupy mixture of words, phrases, and syn-
tactical ploys that seem vaguely lively and stylish but are actually nonsensi-
cal. (How can a worker have an atmosphere? How can an eye, even a naked
one, imagine?) Peering through them, we vaguely sense what she means to
write, which in more experienced hands might be something like, "Are you
now or have you ever been a construction worker? If not, you have no clue
what life on this particular job is like. Trust me on this one: I recently spent a
day with John Hamilton." (The student's third sentence is fine newspaper-
feature-story middle style, once you change *sight* to *site*. I put all the blame
for that mistake on a pernicious invention called Spell Check.) This student
was lucky enough to have a teacher willing and able to flush the "good writ-
ing" from her system. Other people get the help of an editor or maybe even
a book, spend a lot of time reading aloud to themselves and ripping up their
first and second drafts, and eventually pick up the skills needed to deliver the
content they have to or want to communicate.

Strunk and White is a manual instructing readers in the middle style for
what might be called public or occasional prose: the kind of thing Joseph
Addison did in his contributions to the *Spectator*, Hazlitt and Orwell in
their essays, White in his "Notes and Comment" editorials for the *New
Yorker*, and college students in their freshman English courses (hence the
appeal of Strunk and White to that crowd). As Hazlitt recognized, the style
has a deep and indestructible connection to the spoken word. He was nei-
ther the first nor the last to observe this, as the following quotes attest:

> Writing, when properly managed, is but a different name for con-
> versation.
> —*Laurence Sterne*, Tristram Shandy

> Many writers have been extraordinarily awkward in daily exchange,
> but the greatest give the impression that their style was nursed by the
> closest attention to colloquial speech.
> —*Thornton Wilder*

Good prose should resemble the conversation of a well-bred man.
—*Somerset Maugham*

Sentences are not different enough to hold the attention unless they are dramatic. No ingenuity of varying structure will do. All that can save them is the speaking tone of voice somehow entangled in the words and fastened to the page for the ear of the imagination.
—*Robert Frost*

The writers interviewed for this book agree:

BILLY COLLINS: You can drive a wedge in all poetry. On one side are poems that sound like people talking, on the other are ones that look like people writing. My preference is the former. I'm always listening for someone to *talk* to me.

DAVE BARRY: When I started with all this, I remember thinking that I wanted to sound like me. Except with the pauses and long moments of silence when I have absolutely nothing to say. I always try to sound, as much as possible, like a regular person talking to the reader and as little as possible like a professional newspaper columnist. Some of the stylistic things I've always done are meant to create the sense of me talking. I'll write, "Now, I know what you're saying," as though I can hear or see them. I use italics a lot. I use capital letters a lot. It lets you know I am raising my voice.

MARGARET DRABBLE: I always hear everything I write as if it were spoken, and for that reason I find it quite difficult to listen to the people reading my work, because they misemphasize, or they haven't got the rhythm right.

ANNA QUINDLEN: I'm convinced that if there is such a thing as reincarnation and I run into the person who was Jane Austen in a past life, I will recognize her instantly by her syntax, delivery, and turn of phrase.

CAMILLE PAGLIA: I think of writing as a performing art. I believe that there is at the center of every text a living, breathing human being. My writing voice is intimately connected to my speaking voice, and a lot of sounds went into it. I grew up in an immigrant Italian culture—the earliest language I heard was Italian. I was influenced by Whitman's "barbaric yawp," the Beats, Ginsberg's

chanting, hybrid adjectives and nouns, Dylan's electric period—"How does it feel?"—long strings of invective and surreal imagery. I was always impressed by Jewish culture, that confrontational style of self-presentation. And I love slang and clichés—they're like folk poetry.

JAMES WOLCOTT: I never use words in print that I wouldn't use in conversation. There are all these words you see in print but in fact nobody ever says. Words like "hauntingly lyrical" or "indefatigable," which is even hard to say. If somebody said that to you when you were talking, you'd be embarrassed, but critics write it all the time. Then there are hedge-words they use in negative review—"given such and such, it's unfortunate . . ." Or "it's lamentable . . ." Come on, you don't think it's lamentable, you're enjoying it. And then they begin to believe that it's okay to say these words. If you've ever been to a literary panel discussion, you'll see people who actually do talk as pretentiously as they write. You think, "Oh my God, they've convinced themselves."

Just yesterday, I read a short article in *New York* magazine making fun of the *New York Times* book critic Michiko Kakutani for overusing the verb *limn*, which is basically a fancy synonym for *describe* and is more or less impossible to say. Thanks to the merciless LexisNexis database, the writer was able to quote nine examples, including five separate cases where, in Kakutani's estimation, authors did or did not adequately limn their characters' "inner lives." That's some limning.

Kakutani shouldn't feel too bad. Samuel Johnson, acknowledged to be one of the greatest stylists in the history of English literature, has been nailed for this kind of thing for centuries. Hazlitt complained that Johnson "always translated his ideas into the highest and most imposing form of expression." Fulke Greville, on coming upon a Johnsonian reference to "a gloomy, frigid, ungenial summer," scribbled in the margin of the book, "why cant you say *Cold* like the rest of us?" Johnson's elaborate writing style presents a stark contrast with his plain-spokenness in conversation, on continual display in James Boswell's biography of the great man. And any time his prose took on a conversational spark, he was quick to stamp it out. At one point Boswell describes his subject writing the sentence (in reference to the author of the play *The Rehearsal*) "It has not wit enough to keep it sweet." Boswell: "This was easy:—he therefore caught himself and pronounced a more rounded sentence: 'It has not vitality enough to

keep it from putrefaction.' " Thomas Macaulay commented that Johnson wrote "in a learned language . . . in a language in which nobody ever quarrels, or drives bargains, or makes love, in a language in which nobody ever thinks. . . . As respected style, he spoke far better than he wrote."*

Johnson's Latinate diction, a critic's going out on a limn, the wooden bureaucratic memos held up to scorn in composition texts, and contemporary academic prose (pilloried in various "bad writing" contests) . . . all give offense because they flout a undeniable truth: even though silent reading may have become standard a thousand years ago, the process of absorbing words on a page still has a deep connection to *hearing* them through the air. When we "get into" a book, the pleasant, enveloping feeling brings us back to the childhood state of being read to by our parents. Bad writing keeps clearing its throat to wake us from our reverie. Psychologists report that all of us, whether or not we move our lips when we read, *subvocalize*, or silently recite the text to ourselves. (One ingenious piece of evidence for this is a study showing we are more likely to recognize misspelled words that look similar and sound different ["borst" and "burst"] than ones that are homonyms ["hurd" and "heard"]. Another is the loss in comprehension suffered by speed readers, who read too fast to subvocalize.)

Just as reading is like listening, the act of writing is, or should be, linked to speaking. The connection is especially evident among poets, descendants of Homer who are still expected to sing for their supper by reading their work aloud at festivals and poetry slams. In Charles Olson's view, "The line comes from the breath, from the breathing of the man who writes, at the moment that he writes." But writers of all kinds are always whispering to themselves as they compose. Eudora Welty reported, "The sound of what falls on the page begins the process of testing it for truth, for me. . . . My own words, when I am at work on a story, I hear too as they go, in the same voice that I hear when I read in books. When I write and the sound of it comes back on my ears, then I act to make my changes. I have always trusted this voice." Even for the least colloquial of authors, there is connection between writing and speech. William Allen White, who hung with Henry James, said that the novelist "talked, as he wrote, in long

*Posterity bears out Macaulay's judgment. Of the 146 quotations from Johnson in the sixteenth edition of *Bartlett's Familiar Quotations*, 94, or 65 percent, are things that he said (as taken down by Boswell and others) rather than wrote.

involved sentences with a little murmer-mum-mum-mum standing for parenthesis, and with these rhetorical hooks he seemed to be poking about in his mind, fumbling through the whole basket of his conversational vocabulary, to find the exact word, which he used in talking about most ordinary matters. He seemed to create with those parentheses."

After all my years of teaching and being taught, I am convinced that there is only one specific, consistently reliable tip writers in training can be given: read your stuff aloud, if not literally, then with an inner voice attended to by the inner ear. It is the only sure way to spot the clinkers, the rum rhythms. The merit and effectiveness of the practice stems from this link between the written and the spoken word. In *Modern English Usage*, Fowler says that doing it can teach you to differentiate between

> what reads well and what reads tamely, haltingly, jerkingly, lopsidedly, topheavily or otherwise badly; the first is the rhythmical, the other the rhythmless. By the time the reader aloud has discovered that in a really good writer every sentence is rhythmical, while bad writers perpetually offend or puzzle his ear—a discovery, it is true, not very quickly made— he is capable of passing judgment on each of his own sentences if he will be at the pains to read them, too, aloud ("My own voice pleased me, and still more the mind's Internal echo of the imperfect sound").*

But only the most extreme and specialized style would ever mimic actual speech, with its hesitations, verbal tics and mumbles, repetitions, pardoned grammatical mistakes, and frequent desperate resort to body language and facial expressions. The two idioms are essentially different. Even though they subvocalize, readers are perfectly capable of dealing with words that are pronounced differently than they appear, like *Mr.* and *10,052*. (However, shrewd writers will sometimes spell them out in dialogue so we can "hear" it better.) We read words faster than we would be able to say them,[†] and as a result our mental "breath" has greater capacity than our physical one. Linguist Wallace Chafe handed a group of people a

*The quotation in parenthesis is from Wordsworth's *The Prelude*.
[†]Unless the text is difficult, in which case we slow down to the speed of speech and subvocalize like crazy.

variety of texts whose "punctuation units" (the words between punctuation marks) were an average of 9.4 words long. When the subjects were asked to recite the texts, their "intonation units" (the words between pauses) averaged just 5.5 words. They ignored the punctuation.

It is not just a matter of the rhythm of sentences (also known as prosody)—some words and formulations are strictly in the domain of writing, others in that of speaking. On the one extreme are words like *limn* and *lamentable*; on the other, slang, colloquial, and nonstandard locutions like *ain't, gonna,* and *whack* (both the adjective and the verb). In English, one often can choose between two words to express the same meaning: one that sounds fancy and is usually longer and of Latin origin (*difficult, lengthy, possess, humorous, frequently, additionally, fortunate, individual, position, require, attempt, concerning/regarding, et cetera*) and one that sounds plain and unpretentious, is usually shorter, and is of Anglo-Saxon origin (*hard, long, have, funny, often, also/too, lucky, person, job, need, try, about, and so on*). The first word is native to the world of writing, the second to the world of speech. Most writing books advise you to go for the simpler word whenever it can be used without losing or changing meaning. That's good advice but not all-embracing. For one thing, sometimes the longer, more formal or more literary word will convey a nuance that's simply beyond the grasp of any shorter substitute. For another, if you only use simple words, you risk sounding like a simpleton. Virtually any effective style will have some room for locutions of each type. In other words, James Wolcott is employing (or using) poetic license when he says he refuses to commit to print anything he wouldn't say out loud. (I picked up the recent issue of *Vanity Fair* and found the following in the first three sentences of Wolcott's column: *notion, colleague, notorious, pedestrian, sensibly, rhetorical, regarding, docile,* and *christened.* I have passed the time with Mr. Wolcott and can attest that formulations such as these are not the building blocks of his conversation.) Think about contractions—*can't, won't,* and so on. In speech, there is an expectation that anyone who's not prissy or pretentious or is emphasizing a point will use them whenever possible. But just as a prose style with no contractions sounds stiff, a style filled with them sounds oddly and uncomfortably informal. As Voltaire complained back in 1745, "Somebody once upon a time said that we ought to write as we speak. . . . It has been urged so repeatedly upon our good

writers to copy the tone of good company that the most serious authors have grown jocose, and in order to be *good company* for their readers, have come to say things that are decidedly bad mannered."

As Hazlitt, Maugham, and all thoughtful practitioners of the middle style recognize, it requires an elevated or purified *version* of conversation. Supreme Court Justice Stephen Breyer, who believes so strongly in straightforward writing and clarity that he does not put footnotes in his opinions, says his principal compositional principle is to write "not the way I speak, but how I would like to speak." Philip Roth said in an interview, "Beginning with *Goodbye, Columbus*, I've been attracted to prose that has the turns, vibrations, intonations and cadences, the spontaneity and ease, of spoken language, at the same time that it is solidly grounded on the page, weighed with the irony, precision and ambiguity associated with a more traditional literary idiom."

Of all the middle trails the middle style blazes, the most important is between the "written" and the "spoken." On the one hand, the prose must have a certain conversational quality; you must be able to read it aloud. On the other, it must implicitly acknowledge that it is *not* speech. Literary critic Robert Alter defines literary style as "a manifestation of writing that elaborately embodies the essential discontinuities between writing and speaking." In his book *Ferocious Alphabets*, Denis Donoghue goes Alter one better, describing style as "compensation for defects in the condition of writing, starting with the first defect, that it is writing and not speech."

The middle style doesn't merely alternate between the literary and the colloquial: it plays them off against each other, juxtaposing, for example, a Latinate word such as *juxtaposing* that almost no one would say out loud with a conversational phrase such as *plays them off against each other*, alternating the spoken *doesn't* with the written *will not*, and following a long, complex sentence with a short one. Learning to carry it off is a little like learning to rollerskate. In the process, it's hard to keep your balance. But once you've got the hang of it, you can glide indefinitely.

Kurt Vonnegut once observed, "The writing style which is most natural for you is bound to echo speech you heard when a child. . . . Lucky indeed is the writer who has grown up in Ireland, for the English there is so amus-

ing and musical. I myself grew up in Indianapolis, Indiana, where common speech sounds like a band saw cutting galvanized tin, and employs a vocabulary as ornamental as a monkey wrench."

This phenomenon Vonnegut describes presents a special challenge for writers who grew up in environments where the common forms of speech are especially far removed from literary usage. To the extent they use conventional "proper" English in their prose, they can be seen (by others and themselves) as inauthentic sellouts. To the extent they use the vernacular, they can be marginalized and, worse, not understood.

African-American writers have always been confronted with this dilemma. Traditionally and maybe inevitably, they have solved it by mastering two forms of discourse and strategically alternating between them. The back-and-forth is like the one I've been describing as a quality of all middle-style writing. But each time these writers make the shift (within a paragraph, a work, or over the course of a career), the change is packed with emotion and meaning.

That's because it's an issue in their lives as well as their work. Novelist Bebe Moore Campbell says:

> I'm a civil rights black person. I lived enough time during segregation to have tasted it. My choirmaster, my teachers, everybody told me I had to be two times as good as a white person. For black people who enter the "white world," that creates a need to be precise, to speak and write perfectly. (My daughter does not feel that burden. She listens to rappers.) At the same time, when I meet someone like that, or create a character, I assume there is a lot of black English in that person. It comes out at different times, usually when emotion is involved. Maxine, in my novel *Your Blues Ain't Like Mine* can come right down to the level of whoever. She's ambidextrous in terms of language.

Campbell periodically contributes commentaries to National Public Radio, and it is fascinating to hear her own cadences abruptly shift from standard to funky. She says:

> I find myself using black English when I'm moved enough to tell people what I think. One of my pieces grew out of seeing that Ike Turner

was appearing at a blues festival. He was on the comeback trail. Ike
Turner, out here playing music. Am I supposed to buy that? I give him
props because he is the architect of rhythm and blues, but I'm not buy-
ing that CD—he never apologized to my girl.

Toni Morrison said in an interview that when she was coming of age,
she felt that African-American fiction, written by men like Ralph Ellison
and Richard Wright, was too literary, with all that the term implied:

> I didn't feel they were telling me something. I thought they were
> saying something about it or us that revealed something about us to you,
> to others, to white people, to men. Just in terms of the style, I missed
> something in the fiction that I felt in a real sense in the music and poetry
> of black artists. When I began writing I was writing as though there was
> nobody in the world but me and the characters, as though I was talking
> to them, or us, and it just had a different sound to it. . . . There is a mask
> that sometimes exists when black people talk to white people. Some-
> times it seems to me that is spilled over into the fiction.

Morrison makes a conscious attempt to use a black literary style,
which, she said, is a more complicated project than it might first appear:

> Some of the writers think it's dropping g's. It's not—it's something else.
> It's a putting together of all sorts of things. It's cleaning up the language so
> the old words have new meanings. It has a spine that's very biblical and
> meandering and aural—you really have to hear it. So that I never say, "She
> says softly." If it's not already soft, you know, I have to leave a lot of space
> around it so a reader can hear that it's soft.
>
> When I do a first draft, it's usually very bad because my tendency is to
> write in the language of everyday speech, which is the language of busi-
> ness, the media, the language we use to get through the day. If you have
> friends you can speak to in your own language, you keep the vocabulary
> alive, the nuances, the complexity, the places where language had its origi-
> nal power, but in order to get there, I have to rewrite, discard, and remove
> the print-quality of language to put back the oral quality, where intonation,
> volume, gesture are all there.

John Edgar Wideman relates the proper-vernacular dichotomy to one opposing thinking and feeling:

> One of the things I do as I'm composing is read stuff aloud to myself and look for a kind of music, the music that I remember from my primal language. I think everybody has a primal language. By primal language, I mean the language in which you learn feeling. For some people, like myself, we're kind of bilingual. We speak a standard English, but we speak some other variety as well. It's usually that other variety that is our primal language—not because it's less sophisticated or less expressive but because that's the language in which we learn to feel. And it's as much nonverbal as it is verbal. In other words, a mother rocking you or the way a father walks away from you when you're a child or the music that you hear when you're a child or the sounds that somebody makes when they're crying or laughing—all that's part of the primal language. And that primal language is the one that as a writer, I'm always trying to get back to. That's the one I'm trying to recover.

As a member of the generation that came after Campbell, Morrison, and Wideman, Touré doesn't have to fight some of the battles they fought and won. Black English is accepted on the page; it's there, a formidable instrument, for him to use as he sees fit. He says:

> Black English has so much sound, double and triple meaning. It relates you to a community and a history. Black conversation is so stylized, it has so many tones. What I try to do is put the black way of talking on paper—not just record, but *evoke*, so I get the essence. It's so easy to caricature. I sometimes knowingly caricature the subject, but the style, I *never* caricature.

Yet he knows that he is faced with certain decisions that a white writer would not have to make:

> You cannot be writing for white people and black people. You've got to choose one audience first. I chose black people. Others are welcome, but they have to understand that they're not the primary audi-

ence. There are absolutely certain words that resonate in the black community. "Promised Land"—that's a dog whistle. You can whistle as much as you want, but whites won't understand it in the same way.

Language becomes like the keys of the piano. Which key do you play at which time—the black note or the vanilla note? You have to balance it. You don't want to lose anyone. If you hedge it, blacks could go, "Man, I thought he was for us." You want to open it up. Nabokov teaches that you can do anything you want. You can tell a joke that requires you to understand French, Russian, and German. So you press ahead.

Interlude
"Looking for a Click in My Head": Music and Style

As H. L. Fowler points out in *Modern English Usage*, "in a really good writer every sentence is rhythmical, while bad writers perpetually offend or puzzle" the ear. For some good writers, the connection with music goes beyond that: they think of their prose in terms of melody, dynamics, harmony, and even orchestration. Here is a sampling:

> When I was young, I was attracted to the idea of being a composer. I was never a very good musician, never a natural musician. In the eleventh grade I realized I would never be a composer, when I tried to write these little piano pieces: I could come up with interesting new harmonies but I couldn't hear them in my head. The only reasonably musical thing was I had a certain feel for rhythms—I wrote some percussion pieces and could always notate rhythms. So there's a similarity of some of the things I wrote in music to the cadences in my prose, especially the delaying of a dying fall. When you come to the end of a phrase in a piece of music and you think that it's going to close, but then there's a further little progression and then it closes, that gives it a kind of conclusiveness it wouldn't have had otherwise.
> —*Nicholson Baker*

> I've always been fascinated by the greatness of American jazz. I was a kid in the late '40s when bop was breaking on the scene. I would come down from Cornell and haunt Birdland, and Minton's and so on, because I was fascinated by what Bud Powell and Charlie Parker were doing. It started with Armstrong—these sort of creative agons they engage in that they actually call cutting contests, where you're playing against one another. That is almost exactly the same thing as I see in literature. It fascinates me to listen at length to Coltrane, and the ghost of Charlie Parker is always there. It's the sound in his head.
> —*Harold Bloom*

> I always employ music in all my books. I'm always looking for rhythm, looking for a click in my head. I listen to a lot of music. I am passionate about a lot of singers, and I try to infuse my books with the passion that the best singers had.
> —*Bebe Moore Campbell*

From 1966 till 1980, I played drums. That taught me different things—for one thing, that Kerouac and those guys didn't understand improvising. I came to New York in '75, and I heard so much jazz. There were so many people playing. Within a couple of years, I had in place the sound I wanted to have.
—*Stanley Crouch*

My father is a composer, and I played the oboe all through my childhood and youth. In my family, we listened to music as the primary culture. In writing, I always have to have a sense of the way the piece *sounds*. Finding the voice initially is like a musician finds how her instrument sounds, through different chord changes.

I could sit down and go through every essay I've written, and see how it would correlate to some kind of musical piece. I'm always aware of how many beats are in a sentence. I use a lot of short sentences—I like staccato. And after a long riff, I always have short one after it, for readers to catch their breath. I see writing as very much about riffs—to the point where, after I've written something, I need to make sure it tracks logically. The first priority is how it sounds.

I tend to overdo adverbs, and that's a musical thing. I always want to stick something in front of a verb, just for rhythm. I feel it needs a grace note.
—*Meghan Daum*

El clave is the mother of all rhythms in Cuba. It underlies all musical forms. The beat is 1-2, 1-2-3. It's the one instrument that doesn't improvise. Everything else is on top of it. If you're not attuned, you miss it, because of all the other pyrotechnics going on. I realized at one point that my sentences have the rhythm of *el clave*. There's a *boom-boom*, then the comma, then a variation.
—*Cristina Garcia*

Jazz has had a big effect on my sense of structure—the relationship between theme and variation, the rhythm. Most of the writing I like has that quality.
—*David Thomson*

Sometimes I'll do quadruple alliterations, rhyming with words and within words, three phrases in a row that match. The style pulls you

through first. It's a lot like listening to music. When I'm listening to a hip-hop MC for the first time, the first thing that grabs me is the flow. You have to have a cadence. It changes multiple times within each voice. You create the rhythm with your voice. The beat is under it. The rapper will "flow"—that's the timing you use to accentuate your beat. The counter-rhythm is the voice, like a second or third drum. The better the rapper, the more complex your relationship with the beat. You'll change it two, three, four times before the chorus comes. I've been listening to that for twenty years, and it can't help coming out in my writing.

—*Touré*

CHAPTER III

A Field Guide to Styles

What I have been arguing is that no truly transparent or anonymous style can exist: the many choices the act of writing requires will sooner or later betray a stance, an attitude, a tone. But middle styles, in following an established code and meeting established expectations, especially in the way they mix the spoken and the written, give the illusion of transparency. An author who is fluent in a middle style allows us to believe that he or she is merely delivering information, without prejudice.

But this is a book about something else, writers who are or want to be visible. What distinguishes their prose from that of the middle stylists? A lot of things, as this chapter tries to explain. Start with bad writers: the indifferent, inconsistent, the dull, the utterly conventional, the tone deaf, and the grammatically, verbally, and orthographically incompetent. Their prose is certainly noticeable, filled as it is with clichés of all kinds, mistakes

of all kinds, rhythmless sentences and paragraphs, repetition in sentence structure, and unintended word repetition. It has a sound, but it is the sound of fingernails on the blackboard, or, at best, a droning monotone. To the extent that there is any hope for this contingent, it is to achieve (with the help of Strunk and White or other aids) enough competence to go incognito.

At the other extreme are the stylists who for one reason or other feel compelled to trouble the waters, to shout their name, and who are conspicuous even to untutored readers. Instead of transparency, their find themselves strangely and strongly drawn to opacity. As Richard Lanham says, they do not want their prose to be looked *through*; they consciously or unconsciously want it to be looked *at*. So let's look at a few of them:

> Upon the rocks hereabout some told me they had seen inscriptions. At six on the morrow, ascending from that belt of low sandstone hills, we marched anew upon the plain of shallow sliding sand. The sun rising I saw the first greenness of plants, since the brow of Akaba. We pass a gravel of fine quartz pebbles; these are from the wasted sand-rock. Fair was the Arabian heaven above us, the sunny air was soon sultry. We mounted an hour or two in another cross-train of sand-rocks and iron-stone: at four afternoon we came to our tents, pitched by a barren thicket of palms grown wild; and in that sandy bottom is much growth of desert bushes, signs that the ground water of the Hisma lies not far under. Here wandered already the browsing troops of those nomads' castles which followed with the caravan.
> —*Charles Doughty,* Travels in Arabia Deserta, *1888*

> Every one then is an individual being. Every one then is like many others always living, there are many ways of thinking of every one, this is now a description of all of them. There must now be a whole history of each one of them. There must then now be a description of all repeating. Now I will tell all the meaning to me in repeating, the loving there is in me for repeating.
> —*Gertrude Stein,* The Making of Americans, *1925*

Like two lilies in a pond, romantically part of it but infinitely remote, surrounded, supported, floating in it if you will, but projected by being different on to another plane, though there was so much water you could not see these flowers or were liable to miss them, stood Miss Crevy and her young man, apparently serene, envied for their obviously easy circumstances and Angela coveted for her looks by all those water beetles if you like, by those people standing round.
—*Henry Green*, Party Going, *1938*

When all goes silent, and comes to an end, it will be because the words have been said, those it behoved to say, no need to know which, they'll be there somewhere, in the heap, in the torrent, not necessarily the last, they have to be ratified by the proper authority, that takes time, he's far from here, that brings him the verbatim report of the proceedings, once in a way, he knows the words that count, it's he who chose them, in the meantime the voice continues, while the messenger goes toward the master, and while the master examines the verdict, the words continue, the wrong words, until the order arrives, to stop everything or to continue everything, no, superfluous, everything will continue automatically, until the order arrives, to stop everything.
—*Samuel Beckett*, The Unnamable, *1954*

In each case the style is way, way outside normal expectations. It's out there far enough to suggest that the authors are slightly or more than slightly unhinged. Thus one wonders if Charles Doughty, in addition to his clear wish for conspicuous composition, Arabic overtones, and biblical portent, has an undiagnosed learning disability that prevented him from absorbing consistency of tenses, punctuation rules, noun-verb sentence order, and the other conventions of standard English. Thus Gertude Stein seems to need to act out in words a regression to infancy. Thus it makes sense that Henry Green (who acknowledged a debt to Doughty) should have been severely hard of hearing, so far does his prose wander from the normal cadences of speech. (There was slightly more to it than that. Frank Kermode says, "Henry Green was very rich, drunk, odd, and deaf, which contributed to his style.") And thus Samuel Beckett would appear to have been beset by a kind of despair or at least desperation that com-

pelled him to continue, the little phrases advancing like spiders, and only reluctantly accept the brief respite of a full stop.

Big-foot stylists such as these don't have a particularly enviable lot. For one thing, although critics pay them a lot of attention, they're unpopular with publishers and readers, who seem to prefer good stories in clean prose. Hence the fame achieved by B. R. Myers's 2001 essay in the *Atlantic Monthly*, "A Reader's Manifesto," which, according to the magazine, generated more comment than any other article in its history, most of it approving. (An expanded version was published as a book in 2002.) Myers pointed his accusatory finger at "the cult of the sentence," perpetrated by critics out of touch with the reading public, which encourages contemporary novelists—Myers focused on Annie Proulx, Don DeLillo, David Guterson, Paul Auster, and Cormac McCarthy—to fixate on style at the expense of matter. In the "literate past," he argued, plot and character rightfully dominated: "We have to read a great book more than once to realize how consistently good the prose is, because the first time around, and often even the second, we're too involved in the story to notice." This is an idiotic statement. Losing oneself in a story is, certainly, a consummation devoutly to be wished, but you can't credibly deny that the experience of literature or art of any kind is enhanced by an awareness and appreciation of formal achievement, even on the level of a sentence. (Myers's blurb for *Bleak House*: "Great read! A real-page turner. I couldn't put it down.")

But despite his limited conception of literature and his tendency toward hyperbole and the setting up of straw men, Myers did get in a few legitimate shots. Some esteemed novelists, prodded on by critic-enablers, are indeed guilty of sloppiness, preciousness, and/or self-indulgence. More important, the essay recognized (albeit thickly) an essential tension between personal style, on the one hand, and plot and exposition, on the other. The stronger or more idiosyncratic a writer's style is, the more trouble he or she is going to have with these undeniably important functions of the printed word. Let's say you were writing a biography and wanted to explain in a few paragraphs the family background of your subject's spouse. Or, in a novel, you had character X and character Y on opposite sides of the party and just wanted to get them to the middle of the room, where they would recognize each other from a barroom encounter three years ago. Style would just get in the way. Style invokes the extraordinary, and so much of life is ordinary. As a result even strong

stylists, short of the Gertude Stein–Charles Doughty level, usually develop pretty efficient strategies for going undercover when the text calls for it.

A certain egotism is a healthy and necessary component of all styles. In styles-that-shout-their-name, this can get out of control. In his book *The Art of Fiction*, John Gardner put together one of the most sustained and cogent briefs against what he called "mannered writing," which he defined as prose "that continually distracts us from the fictional dream by stylistic tics that we cannot help associating, as we read, with the author's wish to intrude himself, prove himself different from other authors. . . . The mannered writer feels more strongly about his own personality and ideas—his ego, which he therefore keeps before us by means of style—than he feels about any of his characters—in effect, all the rest of humanity."

Excessive idiosyncrasy makes things tough over the long haul as well. Writers defined by their styles all eventually have to come to terms with the same question: In the course of a career, how do you avoid repeating yourself? In different ways, such diverse writers as Hemingway, Faulkner, and Joyce all fell victim to this syndrome.

For all those reasons, let's return, permanently, to styles that are noticeable but not excessively so, and to the question posed at the beginning of the chapter: What makes them distinctive? A middle style is a series of compromises or negotiations that leads a reader not to notice it. To the extent that a writer is drawn to a certain manner of expression and either repeats it to the point where it becomes noticeable or is unwilling or unable to balance it out with its counterparts, then he or she will have a distinctive style. As Robert Alter puts it, "Style is, among other things, the deviation from a norm, or at least from statistically preponderant usage."

An important character has been lurking and sometimes popping up in this chapter, most recently three sentences ago. Anybody can notice the difference between Gertrude Stein and Charles Doughty, but a more conventional style depends on the sensitivity (and sometimes the kindness) of readers. Just as a speaking voice is meaningless or solipsistic unless it is *heard*, so a style will not exist without someone on the other end to register the way it is different from the norm. And the nature of the transaction will sharply change according to whom that someone is. The more sophisticated readers are, and the more intimate they are with the writer—if

they speak the same language, inhabit the same temporal moment and cultural milieu, and, best of all, if they have read and paid attention to his or her work—the more readily they will apprehend the style.

And for that reason, all readers will respond to a given piece of writing in different ways. To the extent that they are familiar with the writer, the genre, or the period, their ears will be developed and they will note its particular stylistic qualities. To the extent that they're on unfamiliar ground, they will be deaf to differences and will focus on the content; style will become an issue only if it's incompetent or unclear. For example, for a casual reader of the newspaper, just about everything, except maybe a favorite sports columnist, movie critic, or op-ed writer, sounds alike. On the other hand, a graduate student in English literature would instantly pick up on the special sounds of major novelists of the nineteenth and twentieth centuries.

Ideal readers are hard to come by, so let's posit a feasible figure—a Pretty Good Reader (PGR), intelligent, attentive, and reasonably familiar with the writer, the genre, or both. For the sake of pronoun simplicity— and because my examples will tend to be writers of whom *I* am a PGR— let's make him male. He will not be so dull and inexperienced that everything he reads sounds alike, but not so well read and sharp that he could, for example, spot the style of every *New York Times* arts critic in a blindfold test. So how does a PGR note a stylist? Most commonly, by the manner in which that writer negotiates the discrepancy between the written and the spoken. As Jonathan Raban puts it, "On the whole, modern style has tended to be a conflation of the high and the low. Most writers who are interesting at all veer spectacularly between, as it were, the rolling period and the deflating 'fuck you.' " David Thomson says:

> I love the literary style. I was certainly brought up on nineteenth-century English novels, and can go back with enormous pleasure. But I love the idea of a more modern interruption of it too. Nabokov's *Pale Fire* starts with this very learned disquisition, and then the narrator interrupts himself by saying something about the damned amusement park outside his window. It's an intrusion from a completely different world. I like that device and I use it in different forms. It's a very natural and energetic thing, and it can be wonderfully stimulating. I love the dia-

logue in Howard Hawks films because people are always interrupting each other. That's very lifelike. In my experience the best way to tell if two people are in love is if they interrupt each other a lot.

And Andrei Codrescu:

The one principle I have, among a total lack of principles otherwise, is "high and low." In fact, the motto for *Exquisite Corpse*, the journal I publish, is "Aim high, hit low." I love nothing better than the mix of high and low language. I love the sentence that starts to feed on its own grandeur, and then you bring it low with a piece of slang or street talk. I also find that this comes in handy teaching, because very often a teacher's voice will put students to sleep. You go on and on about theory or other, and then you jolt them by saying, "And then, that's all the motherfucker said."

The veering, as Raban calls it, between two very different modes can be used to most immediate effect in humor. There has never been a more spectacular veerer than S. J. Perelman, who verbally pushed the sublime and ridiculous about as far as they would go—patrolling the über-literary heavens, then making swan dives to the vulgate, viz., to wit:

If you were born anywhere near the turn of the century and had access at any time during the winter of 1914–15 to thirty-five cents in cash, the chances are that after a legitimate deduction for nonpareils you blew the balance on a movie called *A Fool There Was*. What gave the picture significance, assuming it had any, was neither its story, which was paltry, nor its acting, which was aboriginal, but a pyrogenic half-pint by the name of Theda Bara, who immortalized the vamp just as Little Egypt, at the World's Fair in 1893, had the hoochie-coochie.

More measured print humorists over the past three-quarters of a century, from Robert Benchley through Stephen Leacock, James Thurber and P. G. Wodehouse, and up to Dave Barry, have distinguished themselves by the particular way they pull off idiomatic discord, describing something common or ridiculous in a fancy or literary way. Barry, in a move that endears him to adolescents of all ages, will periodically punctuate the mock-formal exposition with a word like *booger*. Calvin Trillin's

trademark is describing everyday things with elaborate similes. (From his book *American Fried*: "People outside of Louisiana, in fact, often scoff when they hear of people eating crawfish—the way an old farmer in Pennsylvania might scoff at a New York antique dealer who paid fourteen hundred dollars for a quilt that must be at least a hundred years old and doesn't even look very warm.") Damon Runyan contributed a neat twist, by having his gangster and lowlife characters speak in a fractured, contraction-less version of Victorian prose. (In his story "Dancing Dan's Christmas," the title character says: "I know where a stocking is hung up. It is hung up at Miss Muriel O'Neill's flat over here in West Forty-Ninth Street. This stocking is hung up by nobody but a party by the name of Gammer O'Neill, who is Miss Muriel O'Neill's grandmama. Gammer O'Neill is going on ninety-odd, and Miss Muriel O'Neill told me that she cannot hold out much longer, what with one thing and another, including being a little childish in spots.")

As Raban suggests, no writer today would be able to thrive without some degree of cross-pollination. However, notable stylists usually end up spending more time on one side or the other—end up adhering to, in Cyril Connolly's terminology, the Mandarin or the colloquial style. Vladimir Nabokov wrote and John Updike writes famously literary prose, with a preponderance of long, complex sentences and, on every line, a word or a phrase that will cloud up the windowpane and remind the Pretty Good Reader he is in fact reading. Hunter Thompson, Nicholson Baker, movie critics Anthony Lane and A. O. Scott, Michael Chabon, and Trillin, in their very different ways, are contemporary upholders of the periodic sentence—long, complicated, perfectly crafted affairs that contain multitudes of subclauses and stop on a dime.

The use of metaphor and other figures of speech is a fairly dependable indicator of a writing-based style. Like water flowing downhill, talking finds its way to the easiest path—literalism and words and expressions in the current lexicon. But expressing something metaphorically (other than in a cliché) or, more strikingly, in a classical rhetorical figure such as zeugma or homoioptoton, is an act of labor.* A metaphor is also (again,

* *Zeugma*: using a different sense of the same word in different grammatical constructions—for example, "He took his time and the good silver." *Homoioptoton*: the repetition of end sounds—for example, "If it doesn't fit, you must acquit."

unless it is a cliché) likely to be a personal or individual representation. Every common word in the English language has been used millions of times to express roughly the same meaning, but when you fashion a fresh metaphor, you are making a connection for the first time. Aristotle wrote in *The Poetics*, "The greatest thing by far is to be a master of metaphor. It is the one thing that cannot be learned from others; and it is also a sign of genius, since a good metaphor implies an intuitive perception of the similarity in dissimilars."

James Wolcott's criticism is suffused with inventive metaphors, sometimes extended and sometimes as small as one word (see *murmurs*, below). He has a particular knack for translating ideas into visual scenarios, where his notions are played out like the action in an animated cartoon. Despite his disapproval of words such as *indefatigable* and *lamentable*, his style is anything but transparently conversational. He uses few contractions and a lot of complex sentence structure and, though he rarely writes in the first-person singular, we are always aware of his presence—if only a sense of his having gone to the trouble to make the writing so entertaining. Here, reviewing Susan Faludi's book *Stiffed: The Betrayal of the American Man*, he uses figuration, humor, repetition, and inventive diction to skewer a writer who shows how metaphor can go terribly, terribly wrong:

> Incapable of poison-dart wit or flat assertion, Faludi employs hypnotic repetition as her chief power of persuasion, massaging the reader into trance-like submission. Whether the reader is nodding in agreement or just plain nodding off seems lost on her. As she murmurs the same phrases over and over and as her metaphors become fruitful and multiply ("Lured from my intended course, I sometimes lost sight of the bright beacons and media buoys marking the shoals where men and women clashed, and also lost sight of that secure shore . . ."; "its surge had washed all the men of the American Century into a swirling ocean of . . ."; "its Tsunami forces had swamped . . . ," "If ever there was an enemy behind this cultural sea change . . ."; "Navigating the ornamental realm . . ."), every chapter becomes longer than it needs to be, and every chapter seems longer than the one before, creating the illusion of a book feeding on itself and engulfing unsuspecting visitors.

Wolcott says:

> You can't try to *craft* metaphors—you have to let them pop out nat-
> urally. I'll just be walking along and think, "That's the way to say it, that's
> the image." In the Faludi review, I just had the image of her gripping the
> steering wheel. I think it came from a Susan Sarandon movie I saw once,
> where there was a shot of her gritting her teeth and gripping the wheel.
> In this, it's a sort of Warner Brothers cartoon image, a way of under-
> mining the solemnity or seriousness of the subject. Metaphors are one
> of the things I got from Mailer. In *American Dream*, almost every sen-
> tence has this incredible metaphor. And Philip Larkin and poetry in gen-
> eral. In poetry you get things across through metaphors, rather than flat
> statement. When you make your point through the visual image, and the
> reader can see it in his mind, it's much more convincing than if you sim-
> ply lay it down as an opinion. It comes naturally to me, though maybe it
> seems unusual, because people don't see anymore, even through we're
> supposedly in a visual age.

For Jamaica Kincaid (a native of Antigua), the literary character of her
writing relates not to metaphors or other figures of speech but to a non- or
anticonversational quality. As she explains, this is so powerful a force for
her that it has, in effect, taken over her speech:

> When people meet me, they say, "Oh, you speak the way you write."
> It is not the other way around. I am always writing in my head. Every-
> thing I do, I'm thinking of writing. I may have grown up in an oral tradi-
> tion, but that had no influence on me at all. For me, the oral part of
> writing comes from having things read out to me at an early age; for me,
> voice is more about hearing than about just speaking. I am unable to
> interest myself in plot, because I love to hear. When I create sentences,
> I am hearing them in my head. Trying to make them beautiful takes over
> everything.

Speech-based styles tend to be generic (tough-guy newspaper colum-
nists, slick magazine writers, Web bloggers) rather than individual, unless
they go whole-hog and position themselves completely in the world of

demotic talk, as in the plays of David Mamet and the novels of George Higgins. This kind of writing can be idiomatically discomfiting, like a symphony orchestra playing Rolling Stones songs. We wonder: If this author wants to *talk* to us, why is he doing it in print? A rich American tradition eliminates the problem through a premise that someone actually *is* talking to us: *Adventures of Huckleberry Finn*, many of the short stories of Ring Lardner, Hemingway's "My Old Man," Eudora Welty's "Why I Live at the P.O.," John Updike's "A&P," *The Adventures of Augie March*, *Catcher in the Rye*, *On the Road*, *Portnoy's Complaint*, and hundreds of other works. Even when the narrator is supposedly writing the story (as in *Catcher*) rather than telling it to an unseen auditor, the style is still usually infused with the slang, cadences, and all-around attitude of talk.

In third-person fiction, such disparate writers as Stanley Elkin, Toni Morrison, and Junot Díaz make artful use of the rhythms and vocabulary of particular groups of speakers. David Foster Wallace is a hectoring guest at a dinner party, grabbing your coattails and unloading his pet theories. David Halberstam and Gay Talese are at the same party, old army buddies of the host who clear their throats a lot and have lengthy, perhaps too lengthy, stories to tell. Tom Wolfe emulates a special kind of speech in his journalism and essays, a kind of side-show barker's spiel. (The trademark italics, ellipses and exclamation points are his Step-right-up!)

The spoken–written interchange is different in publications with fairly rigid "literary" house style, such as the *New York Times*, where rock critics have to refer to "Mr. Dylan" and "Mr. Jagger"; there, critics, columnists, and feature writers can distinguish themselves merely by including some colloquial phrasing now and again. It's like trying out fancy English on your shots while hitting a tennis ball against a backboard. Jon Pareles, who has written "Mr. Dylan" hundred of times, says he tries to "hover between the spoken and the literary." That created problems with copyeditors at the *Times*, when he started as a pop music critic in the 1980s. "Back in the day, it was Vincent Canby and me," he says, referring to the late *Times* film critic. "We would put in contractions, and the copyeditors would take them out. That would completely flatten the sound of the writing. The *New York Times* for a while was speaking Klingon."

The spoken–written scale is extremely useful but hardly all-inclusive. A related continuum applies to many if not most of the distinctive Amer-

ican writers since the 1920s. On one end is a terseness, or a strategic plain-
ness, that has many of the characteristics of speech but doesn't really
emulate it. The captain of this team would be Hemingway, of course, with
Gertrude Stein as éminence grise; their squad would include John
O'Hara, Dashiell Hammett, James M. Cain, John Hersey, Irwin Shaw,
Raymond Carver, Pete Hamill, Joan Didion, Jim Harrison, Tom
McGuane, Tobias Wolff, and a big compliment of bench players. Terse-
ness is not merely a matter of writing short sentences. Dick and Jane
primers are not terse. Rather, this effect is achieved when we sense that the
author is leaving a lot out, almost daring us to make inferences and con-
nections. Critic L. A. Sherman wrote that a collection of short sentences
achieves terseness "according to the leap of omission of thought between.
It is the length of the leap rather than the shortness of the period that
makes an author seem laconic." Hemingway's whole approach to writing,
as he often said, was to leave out essential facts and feelings, so that the
words that remained filled in for them, charged with a special kind of
energy. On the level of the writing itself, following Stein's lead, he
aggressively omitted adjectives, metaphors, commas, and connecting
words and phrases. In Hemingway you almost never find subordinate
clauses or transitional words and phrases such as *moreover, consequently,*
and *in fact.* Instead, there is a period and a new sentence, or else a single
noncommittal connecting word: *and,* just as in the King James Version of
the Bible.*

As everyone knows, Hemingway's style was and continues to be enor-
mously influential. Some writers merely copied the sound and the effects.
Others adapted it, and their particular spin on the style had to do with
what was being omitted. Kurt Vonnegut writes and Richard Brautigan
wrote in short sentences, short paragraphs, and short sections and chap-
ters that actually affected, at times, a Dick and Jane kind of sound—omit-
ting, as it were, grown-up words and thought processes. The result is a
sometimes nifty faux-naïf irony. And so it goes.

*Although Hemingway had many penetrating things to say about writing and the other arts, not
many of them addressed the distinctiveness of his own style. One exception was this, from *Death
in the Afternoon*: "In stating as fully as I could how things really were, it was often very difficult
and I wrote awkwardly and the awkwardness is what they called my style. All mistakes and awk-
wardnesses are easy to see, and they called it style."

Vonnegut, incidentally, has given an interesting chronicle of the development of his style:

> I went to a high school that put out a daily newspaper and, because I was writing for my peers and not for teachers, it was very important to me that they understand what I was saying. So the simplicity, and that's not a bad word for it, of my writing was caused by the fact that my audience was composed of sophomores, juniors and seniors. In addition, the idea of an uncomplicated style was very much in the air back then—clarity, shorter sentences, strong verbs, a de-emphasis of adverbs and adjectives, that sort of thing. Because I believed in the merits of this type of prose, I was quite "teachable" and so I worked hard to achieve as pure a style as I could. When I got to Cornell my experiences on a daily paper—and daily high school papers were unheard of back then—enabled me to become a big shot on Cornell's *Daily Sun*. I suppose it was this consistent involvement with newspaper audiences that fashioned my style. . . . The theory was that large, sprawling paragraphs tended to discourage readers and make the paper appear ugly. Their strategy was primarily visual—that is, short paragraphs, often one-sentence paragraphs. It seemed to work very well, seemed to serve both me and the readers, so I stayed with it when I decided to make a living as a fiction writer.

The fact that Vonnegut doesn't mention Hemingway's name doesn't mean that the earlier writer wasn't an influence, only that his influence was so great as to go without saying.

Hammett and many detective writers and newspaper folk appear to have a specific stylistic motive for terseness: they leave out transitions, semicolons, four-syllable words, and other sissified aspects of language to show they are tough. From Elmore Leonard's *Pagan Babies*: "He pushed the button next to *D. Dewey* and waited in the light over the doorway to hear her voice on the intercom or for the door to buzz open. She would know who he was. He pushed the button again and waited and then stepped back on the sidewalk to look up at the windows." (Like Toni Morrison, Leonard has a particular dislike for adverbs. "I would never use a word like *quietly*," he says. "There's a pause with the *ly* that stops everything. I'll say, 'He used a quiet voice.'") Even in the three sentences

above, one can see that though Leonard took classes at the School of Hemingway, he managed to avoid some of its traps. He says, "I studied Hemingway till I realized he didn't have a sense of humor. Then I found Richard Bissell, and W. C. Heinz"—writers a generation older than Leonard who had followed Hemingway's ideas about paring down the language but balked at his portentousness.

At the other end of the line is Faulkner, whose style is certainly not colloquial but has overtones of oratory and the pulpit. From *The Hamlet*:

> After a time, Mrs. Armistad raised her head and looked up the road where it went on, mild with spring dust, past Mrs. Littlejohn's, beginning to rise, on past the not-yet-bloomed (that would be in June) locust grove across the way, on past the schoolhouse, the weathered roof of which, rising beyond an orchard of peach and pear trees, resembles a hive swarmed about by a cloud of pink-and-white bees, ascending, mounting toward the crest of the hill where the church stood among its sparse gleam of the marble headstones in the sombre cedar grove where during the long afternoons of summer the constant mourning doves called back and forth.

You get the impression of Faulkner starting out on the sentence as if on a journey, with no idea how it will end but with a determination to follow it to its ineluctable conclusion, classical proportions and the capacity of the human lungs be damned. In classical rhetoric, running sentences are rambling affairs that pursue one thought and then another. (They are opposed to the periodic sentence as practiced by Samuel Johnson and Henry James, which is laboriously shaped in order to most elegantly *express* an idea, with a kind of single-word punch line at the end.) Faulkner's running style borrows from Joyce's stream of consciousness in imitating or at least intimating the process of human thought. For Faulkner, *everything* is a link— a synonym, a simile, a sense memory—and he puts no limits on himself in pursuing these connections.

In interviews over the years, Faulkner gave varying, sometimes contradictory, explanations for his style. In 1957, he said, "Any writer who has a lot to say, hasn't got time to bother with style," and, on his sentence structure, "It comes from the constant sense one has that he only has a short time before he is going to die." Five years later he said:

I think that any artist, musician, writer, painter would like to take all of
the experience which he has seen, observed, felt, and reduce that to one
single color or tone or word, which is impossible. . . . And the obscurity,
the prolixity which you find in writers is simply that desire to put all that
experience into one word. Then he has got to add another word, another
word becomes a sentence, but he's still trying to get it into one unstoppable
whole—paragraph or page—before he finds a place to put a full stop.

Faulkner's style is intoxicating, in the way it invites one to luxuriate in
the language and all its possibilities, but it's not surprising that his follow-
ers are outnumbered by Hemingway's. A maximal style is harder to carry
off than a minimal one; and it can make you look a lot sillier.

A few stylists have borrowed a bit from each presiding genius. Because
of its verbal inventiveness and its recipe of conviction-minus-pretension,
there is no style more entertaining than that of Raymond Chandler, who
spoke through his narrator-detective Philip Marlowe. It alternates between
just-the-facts-ma'am terseness (mostly used for exposition) and highly
rhetorical figuration, usually deployed when Marlowe is emotionally
invested in the subject at hand, as in this great riff from *The Long Goodbye*
(1953), which suggests Chandler as an inspiration for the clever second-
person present-tense style of Jay McInerney's *Bright Lights, Big City*:

There are blondes and blondes and it is almost a joke word nowadays.
All blondes have their points, except perhaps the metallic ones who are as
blond as a Zulu under the bleach and as to disposition are as soft as a side-
walk. There is the small cute blonde who cheeps and twitters, and the big
statuesque blonde who straight-arms you with an ice-blue glare. There is
the blonde who gives you the up-from-under look and smells lovely and
shimmers and hangs on your arm and is always very tired when you take
her home. She makes that helpless gesture and has that goddamned
headache and you would like to slug her except that you are glad you found
out about the headache before you invested too much time and money and
hope in her. Because the headache will always be there, a weapon that never
wears out and is as deadly as the bravo's rapier or Lucrezia's poison vial.

Rick Bragg, the Pulitzer Prize–winning journalist, alternates, to excel-
lent effect, among a trio of voices derived from Hemingway, Faulkner,

and journalistic convention. He set one article in a New Orleans cemetery and began it this way:

> In a graveyard where rows of crosses lean left and right, where one-inch-thin headstones bow to the earth or tilt toward the sky and misspelled missives to the dead are inked onto rotted plywood markers, Cleveland Cobb spent a long time making sure he got the flowers just right.
>
> Mr. Cobb, 75, first pounded the dirt of the family plot as smooth as he could with the flat of his shovel, then, with his hands, scooped a hollow place just big enough to root a small clutch of white flowers.
>
> "My mother," he said, in explanation. "Mary. I like to see her grave looking good. Nothing else I can do for her."

Bragg violates the Hemingway code right away, with oratorical cadences, with personification, with alliteration, with general Faulknerian purple. But the mention of Cleveland Cobb toward the end of the first sentence seems to pull the writing taught and ward off any verbal overreaching. From that point on, there are no adverbs, only plain adjectives like *hollow* and *big*, and only two words longer than two syllables (*family* and *explanation*).

Then there is Cormac McCarthy. From *Cities of the Plain* (1992): "He worked long into the nights and he'd come in and unsaddle the horse and brush it in the partial darkness of the barn bay and walk across the kitchen and get his supper out of the warmer and sit and eat alone at the table by the shaded light of the lamp and listen to the faultless chronicling of the ancient clockworks in the hallways and the ancient silence of the desert in the darkness about."

It's pure Hemingway until the word *faultless*. Everything after that is Faulkner—the personification of the clockworks (and is there a difference between clockworks and clocks?), the repetition of the rather gratuitous *ancient*, and the curious word *about*, which in this sense is archaic or otherwise nonstandard. The complete absence of punctuation within the sentence is McCarthy's own shot at being even more conspicuous than his two forebears.*

*The final of the Big Three early-twentieth-century American novelists, F. Scott Fitzgerald is a conversational middle-stylist (his best book, *The Great Gatsby*, is in the first person) and thus not

What I have been discussing are personal stylistic imperatives, an attitude made manifest in language, and noticeable in everything a particular writer produces. But in other cases style works on a microlevel. That is, a writer's calling card will be a particular verbal habit, the way Michael Jordan will go to his fallaway jumpshot or John Coltrane to the modal scale. Sometimes this usage or device will be indicative of the writer's approach to writing or the world; sometimes it will just be a usage or device. And, naturally, you have to be a PGR of the writer to notice it.

A nonstandard gerund at the end of sentences is an Elmore Leonard trademark. ("Today he watched from the wicker chair, the green shirt on the stick figure walking toward the road in the rain, still in the yard when Terry called to him.") If in no other way, you could tell apart the criticism of John Leonard and Martin Amis because the former characteristically layers on lists and allusions, usually without much explanation, and the latter has a similar fondness for quotation. (Amis explains: "You proceed by quotation. Quotation is the reviewer's only hard evidence. Without it, in any case, criticism is a shop-queue monologue.")

The English novelist Anthony Powell had an abiding predilection for the rhetorical device of litotes, a form of understatement in which one describes something by saying what it is not. The linguistic habit defined the voice of Nicholas Jenkins, the narrator of Powell's 12-part novel sequence, *A Dance to the Music of Time*, and, indeed, of Powell himself. Even for Powell, the five separate uses of litotes in this paragraph from *At Lady Molly's* is unusual and, together with the two uses of the passive voice, the style reaches a rare level of bemused diffidence:

> Although never exactly handsome, Mrs. Conyers was not without a look of sad distinction. In public she deferred to her husband, but she was known to possess a will of her own, displayed in that foxy, almost rodent-like cast of feature, which, resembling her sister's in its keenness, was not disagreeable. It was said that she had entirely reorganised the General's

nearly so distinctive as Hemingway or Faulkner. His biggest stylistic influence, I believe, was his essays of the 1930s, collected in *The Crack-Up*. One can hear direct echoes of their direct, mordant and unsparing tone in Joan Didion and dozens of other later essayists.

life after he had left the army; and much for the better. When I went across the room to speak with her, she raised her eyebrows slightly to indicate, if not precise disapproval, at least a secret signal that she felt herself not altogether at home.*

Continuing to move along the macro–micro scale, individual words can be reliable stylistic markers. (The nineteenth-century French critic Sainte-Beuve observed, "Each writer has his favorite word which recurs in his style and inadvertently betrays some secret wish or weakness of the user.") Pauline Kael was partial to slang expressions of obscure provenance; only in one of her pieces would you find a film described as "a crumbum farce." Another trademark (presumptuous to some) was using a character she called "you" to be the mouthpiece for her own reactions to a movie. (About John Carpenter's horror film *Halloween* she wrote, "Carpenter keeps you tense in an undifferentiated way—nervous and irritated rather than pleasurably excited—and you reach the point of wanting someone to be killed so the film's rhythms will change." To which the appropriate response would have to be, "Who, me?") Russell Baker is a naturally modest stylist; he refers to himself as well as his ostensible subject, Joseph Mitchell, when he writes, "He was trained in the hard discipline of an old-fashioned journalism whose code demanded self-effacement of the writer." Yet Baker reveals himself despite himself, and one way is his use of antique terms and expressions, as in this line from a review of a Joe DiMaggio biography: "It is eloquent testimony to the cheapness of baseball owners that the finest players of the DiMaggio era can now earn more as geezers peddling gimcracks than they did when they were golden lads bringing glory to the game." The phrase "geezers peddling gimcracks" is especially fine. Unlike Elmore Leonard and Toni Morrison, English provocateur Christopher Hitchens has a thing for adverbs, perhaps an example of his championing of unpopular causes. Adverbs are rightfully scorned because of all the people who use weaselly modifiers like *rather/pretty* and *somewhat/a little* to avoid coming out and saying what they mean, or empty intensifiers such as *really*, *incredibly,* and *profoundly* to do their work for them. Hitchens is more precise. In an essay

*Another Powell habit evident here is the nonstandard semicolon, followed by less than a complete clause, after the word *army*.

about anti-Semitism he writes, "Even as a wretchedly heretic and bastard member of the tribe [he did not discover his mother was Jewish until he was an adult], I perhaps conceitedly think that there may be something about Jews' being inherently and intuitively smart." *Wretchedly, perhaps, conceitedly, inherently, intuitively*: maybe there's one too many, but the basic idea is sound. Each word palpably nudges an adjective or noun until it falls into its proper place with a satisfying *click*. Collectively the modifiers define a stance and a style.

Neurologist and medical writer Oliver Sacks's estimable middle style reveals him as intelligent and sympathetic, in an unextraordinary way. (I am not speaking of Sacks's insights and achievement, only his style.) But even in his "transparent" prose, if you are familiar enough with it, there are markers. Here is a paragraph describing his conversation with a woman who had suddenly lost the ability to mentally process letters and numbers:

> I wondered how she could read the time, since she was wearing a wristwatch. She could not read the numbers, she said, but could judge the position of the hands. I then showed her, mischievously, a strange clock I have, in which the numbers are replaced by the symbols of elements (H, He, Li, Be, etc.). She did not perceive anything the matter with this, as for her the chemical abbreviations were no more or less unintelligible than numerals would have been.

There are several notable things about the paragraph. The first is the very subtle way Sacks scruffs up the prose, counters the PGR's expectations, and keeps him on his toes. In sentence 1, the word *wondered* gives us a jolt because we initially read it to indicate a mental process, not an action; the expected phrasing would be "I asked her how . . ." Indeed, both the first two sentences would conventionally be rendered in dialogue form, with quotation marks. Paraphrasing slightly distances us. The parenthesis and the word *etc.* in the third sentence are literary; but *the matter* instead of *wrong* in the fourth sentence is pleasingly colloquial. Having said all that, I'm not familiar enough with Sacks's work to know if these stylistic maneuvers are characteristic. But I have read enough to hear the one word in the paragraph that shouts his name. The word is *mischievously*. It makes me say to myself, *Yes, his stylistic self-presentation is exactly such that he would act mischievously and call himself mischievous.*

That he puts the word by itself, in an unnatural place (one would expect it to be the first word in the sentence or to come after *then*), clinches the case.

Remember Richard Lanham's epithet about the middle style: *expected*. As the PGR reads along, he is always coming upon standard words, words that, like 10-year-old quarters, are no longer shiny and do not require or inspire a reaction. A first-rate literary stylist—an Updike, a Martin Amis, a Nicholson Baker, a Jonathan Raban, a Cynthia Ozick, a Clive James— will continually present us with words that we do not expect, that have not been in everyone's hands and are consequently sometimes unfamiliar, that are precise and correct for the circumstances, and that brand the sentence as the author's work. The first sentence of the second paragraph in Jonathan Franzen's novel *The Corrections* reads, "Three in the afternoon was a time of danger in these gerontocratic suburbs of St. Jude." *Gerontocratic*: a truly unusual word, with only 580 hits at www.google.com, but we understand its meaning ("pertaining to a society ruled by an elderly elite"), and that the word is Franzen-like. On page 368 of Michael Chabon's novel *The Amazing Adventures of Kavalier & Clay*, which mixes real events and characters with fictional ones in telling the story of some creators of comic books in mid-century America, is this sentence: "The sudden small efflorescence of art, minor but genuine, in the tawdry product line of what was then the fifth- or sixth-largest comic book company in America has usually been attributed to the potent spell of *Citizen Kane* acting on the renascent aspirations of Joe Kavalier."

Chabon says:

> As a kid I used to read the dictionary for fun in the bathroom. I'm still fascinated by synonyms, antonyms, etymology. So I have a big vocabulary at my disposal. When I'm writing, I'm also listening. I'll hear a rhythm; a pattern will beat in my mind that will encapsulate what I'm trying to say. Then the words will pop in. When I was writing that sentence, I heard it in looping swags of words. Dit-da-dit-da. *Efflorescence* and *renascent* dropped in because I knew them. Then I go over the sentence and ask myself, are the words accurate for the meaning I'm intending, and would that narrator know them? If the answer is clearly no, I'll take them out.

A word doesn't have to be unusual to be distinguishing. Think of the writer as a saxophonist in a band that's providing the music for a bar mitz-

vah party. In other words, Charlie Parker need not apply. Audience members will take note of a neophyte or just plain rhythmless player who doesn't have the skill to play the expected note at the expected time, the way they can't avoid being aware of a writer who doesn't know the meanings of words, who doesn't even notice the clanging of repetition, or who sends out a steady stream of clichés. They will not notice a saxophonist who has mastered his instrument sufficiently to hit the proper note in the proper rhythm (the middle stylist). But some musicians will stand out and make things a little bit interesting by playing slightly in front of or behind the beat, or by "bending" a note to make it ever so slightly discordant. That's what writers can do with words. In the Oliver Sacks paragraph quoted above, take a look at the unusual, precise, and unexpected word *judge*; it distinguishes the sentence. In the next sentence, the transparent adjective would have been *unusual*, but Sacks uses *strange*, which has a faint and pleasing scent of science fiction and adventure stories.

The routes by which writers find their mots justes are various.

> I often find myself desperately looking for a word. Sometimes I close my eyes tight and find myself clawing the air. Sometimes I find it with that kind of physical pressure. Sometimes I don't, and then I do what every writer does, which is take out the thesaurus. Sometimes the word is there, and sometimes what helps is the experience of a tour through words. I do love the thesaurus. It is such a work of genius. I'm seduced by adjectives. It can be a flaw, and one has to be very careful.
> —*Cynthia Ozick*

> In rewriting, what I put in are adjectives—they speak to the senses, to drama, to emotion. I use *Roget's* and the dictionary, and what I am looking for is not only the right word, but the surprising word—maybe for something in the rhythm that is a bit abnormal for English prose. I'm very conscious of drawing on certain French or Italian things.
> —*Camille Paglia*

> I have this philosophy—I like plain words, like *tall* and *guy*. I like rehabilitating words that have been so overused they they don't get used anymore.
> —*Susan Orlean*

I could fill up the rest of this book with examples of words that are redolent of their author but will content myself with one,* which involves two more of the writers named above. I still remember reading the *New York Times Book Review* one morning in 1991 and jumping to attention when I read Amis describing Updike's *Odd Jobs* (919 pages long) as "his fourth cuboid volume of higher journalism."

If you pay close enough attention, style peers out from all sorts of doorways. Consider the series: a list of nouns or adjectives. Winston Weathers devoted an ingenious essay† to demonstrating that by forming series of various lengths, writers present greatly different tones of voice. A series of two parts will suggest "certainty, confidence, didacticism and dogmatism"; one of three parts "the normal, the reasonable, the believable and the logical" (also, in our terminology, transparency); and one of four or more parts "the human, emotional, diffuse and inexplicable." Thomas Hobbes uses all three types in a famous sentence from *Leviathan*: "No arts, no letters, no society [3]; and which is worst of all, continued fear and danger [2] of violent death; and the life of man, solitary, poor, nasty, brutish and short [6]." Weathers points out that the use of conjunctions—*and* or *or*—can vary the style even more. Normally, there's one before the last item in the series. By omitting it, a writer can give a sense of integration, inevitability, and/or speed: "I came, I saw, I conquered." And inserting a conjunction between all elements can suggest portent or, as in Hemingway, an increase in rhetorical volume, conveying agitation on the narrator's part.

Getting about as micro as it's possible to get, certain writers are identifiable by their use of punctuation and other typographical features. Poet W. S. Merwin and James Joyce (at times), who eschew punctuation, are obvious and radical examples. But you can also spot Henry James for the 'inverted commas' he uses to put a special stress on a term, Emily Dickin-

* Well, maybe two. Writing a profile of the late jazz musician Lester Bowie, I labored mightily on a description of his singular beard and finally emerged with "the lacustrine reflection of twin lake peaks."

† "The Rhetoric of the Series," *College Composition and Communication*, XVII (December 1966), 217–221.

son for her dashes and nothing but dashes, and John Irving for his italics, exclamation points, and semicolons. George Eliot was a semicolon virtuoso as well, recognizing it as a piece of punctuation that allows a gradual landing from a thought and takeoff to another one, rather than the abrupt and sometimes bumpy full stop of a period. (Donald Barthelme, by contrast, once said, "Why do I avoid, as much as possible, using the semicolon? Let me be plain: the semi-colon is ugly, ugly as a tick on a dog's belly. I pinch them out of my prose. The great German writer Arno Schmidt, punctuation-drunk, averages eleven to a page.") J. D. Salinger is probably the king of italics—his specialty being italicizing just one *syl*lable of a word. For Pauline Kael, parentheses served as a kind of wise-guy Greek chorus to the main line of exposition. (Her protégés Elvis Mitchell and James Wolcott carry on the tradition.) Nicholson Baker started a vogue for footnotes in his novels *The Mezzanine* and *Room Temperature*. He liked the idea, he says, of "sometimes just to glance on something, but to then have these observations that would flow from that one moment in time, without having to explode the paragraph and make it five pages long."*

The use of quotation marks to indicate spoken dialogue came into being at the same time as the novel itself, the eighteenth century. By the turn of the twentieth, it was a purely subliminal signal; readers did not notice them, merely understood by their presence that the words within were meant to be "heard" as dialogue. (Even so, the double marks [" "] customary in the United States definitely have a different feel than the single marks [' '] used in Britain: they are a little ungainly, a little literal, a little American.) Perhaps because he wished to disrupt the equilibrium, perhaps because he wanted his writing to be less transparent, or perhaps just because it felt right, Joyce left out the quotation marks in his novel *Portrait of the Artist as a Young Man* and his short-story collection,

*You may have noticed that I like footnotes and parentheses too. One reason is that both are devices for digression, a verbal action that mirrors my belief that the world is multifarious and knotty. But another is that I get a strange satisfaction from reminding people that they are reading, not listening. I imagine a Henry James assignment strikes fear into the hearts of the actors who read books on tape: it cannot be easy to master the pauses and pitch changes required to render a parenthesis in speech. Not even Laurence Olivier could "say" a footnote, and that, for me, is part of its charm. The first draft of this book had twice as many parentheses as this version. One key to style is to be yourself but not too much like yourself.

Dubliners, using a dash to indicate a line of dialogue. He repeated the technique in *Ulysses*. Since then, writers including William Gaddis, Donald Barthelme, Grace Paley, E. L. Doctorow, Cormac McCarthy, William Vollman, Margaret Atwood, and Junot Díaz have (consistently or sporadically) opted out of quotation marks and made that decision part of their respective styles. By doing so they don't alter meaning; we still understand that a certain character has said the words on the page. But the sound and the feel of the prose are different; it's a move away from the fiction of transparency and toward the acknowledgment of artifice.

Punctuation itself began roughly the same time as silent reading became dominant, in the late middle ages; when a text was read aloud, the pauses and emphases suggested themselves, but silent readers needed guidance for their subvocalization. Generally speaking, commas are the best punctuational style gauge because a good deal of the time, even within the rules of standard English, they are optional. That is, it's a question of style, not correctness, whether to put a comma between independent clauses ("I was there, but he wasn't"), after introductory or transitional clauses or phrases ("the next day, we went home"), or around borderline nonrestrictive modifiers ("when he graduated, in 1954, he went to work as an insurance adjuster" or "my best friend, Bobby").*

When commas are put in more than we are used to, we hear the result as overcultivated or prissy or painfully slow. Consider the so-called serial comma. If we uttered a phrase like "ready, willing and able," we wouldn't pause after "ready." So the comma is there to aid not subvocalization but comprehension: "ready willing and able" is initially confusing, the kind of thing you might see in a deliberately opaque avant garde style or in a Joycean stream of consciousness. But a comma after *willing*—the serial comma—isn't necessary for us to follow the sense. It slows our reading down and sounds pedantic.

Not surprisingly, the house style of the *New Yorker* magazine mandates the serial comma. This is the publication where, as E. B. White once said,

*The most prominent example of a comma used strictly to help with subvocalization, and not with grammar or sense, is one that comes between a compound subject and a verb: "All the students who happen to arrive at school early, should report to the auditorium." This comma was universally used in the eighteenth century and into the nineteenth but is now considered incorrect.

"commas . . . fall with the precision of knives in a circus act, outlining the victim." The serial comma was taken on the counsel of Fowler's *Modern English Usage*, which was founding editor Harold Ross's Bible. More commas came as a result of Ross's mania for accuracy, matched and indeed intensified by his successor, William Shawn. In the *New Yorker*'s heyday from the end of World War II to the 1980s, each bit of meaning was punctuationally divided, so that nothing could possibly be ambiguous and no bit of a sentence contaminated by any other. This led to formulations that couldn't be imagined in any medium other than the *New Yorker*. From a 1948 article: "When I read, the other day, in the suburban news section of a Boston newspaper, of the death of Mrs. Abigail Richardson Sawyer (as I shall call her), I was, for the moment, incredulous, for I had always thought of her as one of nature's indestructibles." That's seven commas when only two are necessary (after *her* and *incredulous*).

English writers tend to use fewer discretionary commas than do Americans, with their weakness for literalness and their ambiguity complex. Evelyn Waugh writes in *A Handful of Dust:* "Mrs. Beaver [the proprietress of an antique shop] was able to descend to the basement where two dispirited girls were packing lampshades. It was cold down there in spite of a little oil stove and the walls were always damp. The girls were becoming quite deft, she noticed with pleasure, particularly the shorter one who was handling the crates like a man." Waugh *could* (and according to most style guides should) have put commas after *basement, stove,* and *one.* But if he had it wouldn't be Waugh. By contrast, P. G. Wodehouse uses almost all optional commas, possibly because he was born two decades earlier than Waugh (in 1881) and came of age in a calmer, more leisurely time. Also, the commas helped Wodehouse poke fun at his dim, prim and proper upper-class narrators, notably Bertie Wooster. From *The Inimitable Jeeves*: "In fact, the only event of any importance on the horizon, as far as I could ascertain, was the annual village school treat. One simply filled in the time by loafing about the grounds, playing a bit of tennis, and avoiding young Bingo as far as was humanly possible."

When Americans omit commas, it's often to conjure up untutored narrators who would presumably be flummoxed by their classroom mustiness and tricky protocol. (They often put in superfluous quotation marks for the same reason.) Huck Finn memorably writes that one of the books he came upon in the Grangerford house was "Pilgrim's Progress, about a

man that left his family it didn't say why."* The opening lines of Ring Lardner's "A Caddy's Diary": "I am 16 of age and am a caddy at the Pleasant View Golf Club but only temporary as I expect to soon land a job some wheres as asst pro as my game is good enough now to be a pro but to young looking. My pal Joe Bean also says I have not got enough swell head to make a good pro but suppose that will come in time, Joe is a wise cracker." (The comma Joe does use is called a comma splice, in that it improperly splices together two clauses or sentences. Beckett and Michael Herr, in his Vietnam book *Dispatches*, are masters of the comma splice.) Peter Carey is not an American but an Australian, which is the next best thing. When he finished a draft of his novel *True History of the Kelly Gang*—in the form of a document written by the nineteenth-century outlaw Ned Kelly to his daughter—he used a function of his word processor to search for and remove every single comma. The opening sentence of the published book reads: "I lost my own father at 12 yr. of age and know what it is to be raised on lies and silences my dear daughter you are presently too young to understand a word I write but this history is for you and will contain no single lie may I burn in Hell if I speak false."

Gertrude Stein disdained commas, and Hemingway certainly got the idea. In *The Autobiography of Alice B. Toklas*, Stein wrote (referring to herself in the third person), "[Stephen] Haweis had been fascinated with what he had read in the manuscript of The Making of Americans. He did however plead for commas. Gertrude Stein said commas were unnecessary, the sense should be intrinsic and not have to be explained by commas and otherwise commas were only a sign that one should pause and take breath but one should know of oneself when one wanted to pause and take breath. However, as she liked Haweis very much and he had given her a delightful painting for a fan, she gave him two commas. It must however be added that on rereading the manuscript she took the two commas out."

*"I read considerable in it now and then," Huck goes on. "The statements was interesting, but tough."

Interlude
Engendering Style

UNTIL WOMEN CAN FIND an openly lustful, quick, impatient feral hunger in themselves, they will never be liberated, and their writing . . . in pallid imitation of the master, will lack that blood congested genital drive which energizes every great style.
—*William Gass, 1976*

THE FIRST VIRTUE, the touchstone of the masculine style, is its use of the active verb and the concrete noun. When you write in the active voice, 'They gave him a silver teapot,' you write as a man. When you write, 'He was made the recipient of a silver teapot,' you write jargon.
—*Sir Arthur Quiller-Couch, 1913*

THE FEMALE STYLE I was discovering and defining for myself seemed in many ways more attractive than the masculine style which aimed at and so often led to achievement. Women seemed more responsive, more expressive, more flexible, more considerate, more iconoclastic and more irreverent than men. But were these traits innately, inevitably, biologically a part of women's nature? Or were they characteristic of any group of people privileged in some ways but excluded from power? . . . I came to think that much of what I valued as female nature was not nature at all but a style created by cultural circumstances and historical circumstances.
—*Phyllis Rose,* Writing of Women, *1985*

IT APPEARS TO ME THAT the usual style of letter-writing among females is faultless, except in three particulars. . . . A general deficiency of subject, a total inattention to stops, and a very frequent ignorance of grammar.
—*Mr. Henry Tilney, in Jane Austen's* Northanger Abbey, *1818*

I WRITE IN SHORT paragraphs because when I began there were always children around, and it was the most I could do to get three lines out between crises.

[Style is] how you say what you want to say in the shortest time available, so you can all go home. . . . It is rather like the way women conduct meetings. I always find that men conduct meetings very long-windedly, they sort of wander off, whereas women get straight to the point, then go home to look after the children.
—*Fay Weldon, 2002*

... IT WAS DELIGHTFUL TO READ a man's writing again. It was so direct, so straightforward after the writing of women. It indicated such freedom of mind, such confidence in himself. One had a sense of physical well-being in the presence of this well-nourished, well-educated, free mind, which had never been thwarted or opposed, but had had full liberty from birth to stretch itself in whatever way it liked. All this was admirable. But after reading a chapter or two a shadow seemed to lie across the page. It was a straight dark bar, a shadow shaped something like the letter "I." One began dodging this way and that to catch a glimpse of the landscape behind it. Whether that was indeed a tree or a woman walking I was not quite sure. Back one was always hailed to the letter "I." One began to be tired of "I." Not but what this "I" was a most respectable "I"; honest and logical; as hard as a nut, and polished for centuries by good teaching and good feeding. I respect and admire that "I" from the bottom of my heart. But—here I turned a page or two, looking for something or other—the worst of it is that in the shadow of the letter "I" all is shapeless as mist.
—*Virginia Woolf*, A Room of One's Own, *1928, referring to a novel by "Mr. A, who is in the prime of life and very well thought of, apparently, by the reviewers."*

Do men and women have substantially different writing styles? This question is so loaded that anyone standing within several miles of it is in profound danger of getting blasted to smithereens. It subsumes within it a nexus of thornily interrelated questions, having to do with biological difference, gender-based socialization, literary prejudice, generic apartheid, and the very meaning of style. Which is to say . . .

Yes. If (as is generally agreed) men and women exhibit certain broad personality differences based on biology, socialization, or some combination of the two, and if (as is somewhat less generally agreed), style reflects personality, then it stands to reason that men and women would tend to write in a noticeably different way. But it's difficult to get beyond such a broad statement, partly because most commentary on the question has been subjective and impressionistic, and very often invidious (see the above quotations).

However, in recent decades a number of studies have attempted to measure the differences scientifically. All but two of those I've been able to track down took the written work of undergraduate college students for their sample. One study had testers evaluate every sentence according

to whether it was "very bold," "bold," "tentative," "very tentative," or "evaluative." Men had about a third more "bold" sentences than the women and 15 percent more "tentative" sentences; the rest of the categories were about equal. A second study found that males wrote more simple sentences, used more numerals and drew explicit conclusions using logical connectives like *therefore*, whereas females employed more exclamations, questions, figurative language, color terms and more connectives generally. A third, focusing on "stylistic and discourse features associated with women's writing," found that women in the sample used three times as many exclamation points as the men and used expressions such as *I think*, *I guess*, and *I feel* twice as often. In an argumentative essay, half of the women studied "acknowledged the legitimacy of opposing concerns," whereas only a quarter of the men did. On the other hand, the researchers found no gender effects relating to verbosity, inclusion of nonessential information, numerals, markers of audience acknowledgement, or the kinds of hedges and qualifiers that Robin Tolmach Lakoff, Deborah Tannen, and other linguists have discerned in women's speaking styles.*

A clear drawback to these studies is the nature of their samples. That is, although undergraduate papers probably do show us something about baseline writing inclinations among men and women, they reveal very little about stylistic differences in the higher or even the middle reaches of literature. Mary Hiatt's 1978 book *The Way Women Write* tried to do exactly that. Hiatt made a fairly random selection of 100 current paperbacks equally divided into four categories: nonfiction books by women (from Joyce Brothers's *The Brothers System for Liberated Love and Marriage* to Joyce Maynard's *Looking Back*), nonfiction books by men (Hunter Thompson's *Fear and Loathing: On the Campaign Trail '72*, Gary Carey's *Brando!*), novels by women (Joan Didion's *Play It As It Lays*, Rona Jaffe's *The Other Woman*), and novels by men (Kurt Vonnegut's *Slaughterhouse Five*, Irving Wallace's *The Seven Minutes*). She took sizable chunks from all, ran them through the computer, and emerged with predictably mixed

*The first study mentioned was Francis, B., Robinson, J., and Read, B. An Analysis of Undergraduate Writing Styles in the Context of Gender and Achievement. *Studies in Higher Education*, 26 (2001), 313–326. The second was Scates, C. *A Sociolinguistic Study of Male/Female Language in Freshman Composition*. Unpublished doctoral dissertation, University of Southern Mississippi, 1981. The third was Rubin, D. L., & Greene, K. Gender-Typical Style in Written Language. *Research in the Teaching of English*, 26 (1992), 7–40.

results. In most of her measures, which ranged from sentence length to amount of simile use, there was no significant difference between the men and women writers. However, men used 50 percent more illustratives (*for example*) and illatives (*therefore*) than women, whereas women used 50 percent more causatives (*because, for, since*) and substantially more parentheses. Several adverbs showed up multiple times in the men's work and not at all in the women's: *consequently, exactly, strictly, surely,* and *wryly.* And numerous women but no men used *these* adverbs: *cheerfully, desperately, scarcely.* Women showed a particular fondness for the word *really,* using it twenty-six times compared with nine for the men. One striking finding was related to the rhetorical figure of polysyndeton—using a conjunction such as *and* or *or* rather than a comma to separate the elements in a series. Women used it three times as often as men.

A study published in the summer of 2003 took advantage of a larger sample and a quarter-century's technological advances. Three Israeli computer scientists fed 604 current texts—half written by men, half by women—into a computer. When they crunched the numbers, they emerged with an algorithm that, they claimed, could predict the gender of any text's author with 80 percent accuracy. The formula is based on word use. Certain words seem to come more frequently to men and women, respectively. The biggest single difference is that women use personal pronouns far more often than men, who in turn are partial to determiners (*a, the, that,* and *these*), numbers and quantifiers such as *more* and *some. With, if,* and *not* are heavily female words; *around, what,* and *are* are male.

It seems a little kooky, but it seems to work. I know that because a Web site (http://www.bookblog.net/gender/genie.html) allows anyone to type or paste in any text of 500 words or more, indicate whether it is fiction, nonfiction, or a blog entry, and have it instantly analyzed according to the algorithm, including a numerical account of the usage of the key words. Then you're asked to indicate if the computer was right or wrong, allowing it to keep a running tab of the results. When I last checked, more than 110,000 samples had been submitted, and the correct answer had been given 75.67 percent of the time. I'm not surprised by the 110,000 figure, because this is seriously addictive. I started entering texts that I pulled from the Web at random—the first chapters of Willa Cather's *O Pioneers!, Moby-Dick,* and George Eliot's *Middlemarch,* and an F. Scott

Fitzgerald short story called "Baby Party." The only one the computer got wrong was the Fitzgerald story, evidently because of the author's frequent use of the "feminine" words *with* and *and*. The exercise became seriously depressing when I started entering things *I* had written—articles, book chapters, personal essays—and found that every single one of them was tabbed as male.

It's tempting to throw all these studies, and any generalizations about men's and women's writing differences, into a trash heap labelled ARL (for Anachronistic, Reductive, and Limiting), and to say, with Joyce Carol Oates, "the serious artistic voice is one of individual *style*, and it is sexless." Tempting, but—in a book about distinctiveness of style—imprudent. Though one can find writers of either gender composing in any conceivable manner, some differences do appear when you look at men's and women's writing in the aggregate. The only gender-based difference that consistently shows up in Myers-Briggs Type Indicator personality testing is that 60 percent of men characteristically employ a "thinking" style rather than a "feeling," style, whereas 60 percent of women are "feelers." This divergence seems to carry over into writing. A "female" writing style would tend to stress emotional and personal connections (and connections of all kinds—think of all that polysyndeton); a "male" style hierarchical, logical ones (think of all the *therefore*'s).

It also appears to be the general case that compared to women, men try harder to be noticed as writers and as a result more often have noticeable prose styles. First-class female writers do have distinctive styles, but often in a subtler, less ostentatious way. William Gass, rather unhelpfully, attributes this disparity to men's "blood congested genital drive." A feminist writer, Darsie Bowden, describes the very concept of "voice" as "inherently masculinist . . . powerful, distinctive and resonant."

Another way of putting it is that whereas men display, women reveal. Women, in any case, tend to put their cards on the table a bit more reluctantly than men do. Mary Hiatt writes, "The style of the women writers appears conservative, somewhat cautious, and moderate as compared with the style of the men writers. . . . It is, in general, a middle-of-the-road style, not given to extremes of length and brevity, not given to extremes of emotion and action."

Maybe Fay Weldon had it right: women need to get home to the children and other duties, and just don't have time to diddle around.

CHAPTER IV

"Style Is the Man Himself ":
Style and Personality

When we encounter a natural style, we are astonished and delighted; for we expected to see an author, and we find a man.
—Blaise Pascal

If any man would write in a noble style let him first possess a noble soul.
—Goethe

Style is nothing but the mere silhouette of thought; and an obscure or bad style means a dull and confused brain.
—Arthur Schopenhauer

Write, and after you have attained some control over the instrument, you write yourself down whether you will or no. There is no vice, however unconscious, not virtue, however shy, no touch of

meanness or generosity in your character, that will not pass on to
the paper.
—*Sir Walter Raleigh*

The spirit of personality permeates every word that he writes. The
triumph is the triumph of style. For it is only by knowing how to
write that you can make use in literature of your self, that self which,
while it is essential to literature, is also its most dangerous anatago-
nist. Never to be yourself and yet always—that is the problem.
—*Virginia Woolf, on Max Beerbohm*

[Good style is] an intimate and almost involuntary expression of
the personality of the writer, and then only if the writer's personal-
ity is worth expressing.
—*Bertrand Russell*

A really good style comes only when a man has become as good as
he can be. Style is character. . . . I think good style is a matter of
rendering out of oneself all the cupidities, all the velleities.
—*Norman Mailer**

I've always admired David Thomson's writing, even when I don't agree
with it. Researching a biography of Will Rogers, I took special interest in
Thomson's entry on my subject in his quirky and indispensable reference
book, *A Biographical Dictionary of Film.* Thomson opined, "Rogers' phi-
losophy was reactionary, dispiriting and provincial, despite every affecta-
tion of bonhomie and tolerance. It scorned ideas and people who held
them, it relied on vague evolution rather than direct action, its fixed smile
concealed rigidity of opinion that middle America need not be disturbed
from its own prejudices and limitations."

 If I had to pick one word for this position, it would be *erroneous.* Rogers
was a creature of his time and place, as are we all, but his bonhomie and
tolerance were real and his smile was natural. And, right, he didn't advo-
cate "direct action." Would it have made Thomson happy if the Ziegfeld
Follies star and easygoing movie personality had stormed the capitol, a

* *Velleity*: A mere wish, unaccompanied by effort to obtain.

dagger between his teeth and machine guns in his mitts? Yet the kernel of truth in the two sentences is large enough to allow even me to admire their force and fluency. Adjectives get a bad press, but a smart and artful use of them always captures my attention, and Thomson's triplet in the first sentence is fine. Each epithet gives the thought an interesting turn, most of all *dispiriting*, an underused and good word. The bit about Rogers scorning ideas and the people who hold them is Thomson's most supportable point, and he rams it home with some shrewd hyperbole. (More accurate but less forceful alternatives would be *disdained* or *had little interest in*.)

Thomson's writing on cinema and other subjects ranges widely, but a touchstone of his critical style is this kind of bold assertion, arguable but brooking no argument. It infuriates some readers. When a new edition of the *Biographical Dictionary* came out in 2002, the online magazine *Slate* ran a "Reader's Club" feature where three journalists took turns hurling brickbats at Thomson for arrogance, haughtiness, sloppiness, and other crimes. One of them, David Edelstein, wrote, "Even Thomson's most interesting formulations usually need to be unpacked. There is in his writing a regal sense of entitlement toward both his subjects and his readers. The implication is that we should treat these little essays as knotty poems whose meanings will emerge with careful rereading and scrutiny."*

Imagine my surprise, then, when I met Thomson in his San Francisco house and found him to be shy, solicitous and about as unregal as human beings get. A head cold had done a number on his voice, but it was obvious that even in the pink, he is no bellower. He explained that he was well aware of the contrast between his personalities on the page and in the flesh, and that in fact he had developed the former as a way of coming to terms with the latter:

> Writing has been the form in which something inside me can come out that does not come out as easily in real life. As a child, and up until the age of 18, I stammered very, very badly, to the point of being hardly able to communicate. It had lots of effects. It increased a natural shyness, but as I think most people who stammer find—and I was helped by being sent to speech therapy classes—the condition made me think

*It is no coincidence that Edelstein's critique sounds oddly Thomsonesque. In writing about a strong stylist, one often finds oneself mimicking his or her cadences and approach.

a lot about words. Stammerers need to know what they want to say,
very carefully. They know certain sounds and words that they will have
trouble with. They rarely speak spontaneously.

I went to an English public school with twelve hundred boys. It was
enormous and terribly intimidating. I was always afraid of making a fool
of myself. Emotionally, the wish to be articulate was tremendously
important in my youth. The stammer also repressed and made me angry
over not being as assertive as I wanted to be, and some of those things
have come out in my writing. I don't stammer now, haven't for years, but
the pleasure, the relief of being articulate on the page, still means a lot.

David Thomson is a poster boy for the Biographical Fallacy: the
assumption that you know a person when you know only his or her writ-
ing. The fallacy has trapped many commentators over the years, includ-
ing, Samuel Johnson reports, an admirer of eighteenth-century poet
James Thomson: "She could gather from his works three parts of his char-
acter: that he was a great lover, a great swimmer, and rigorously abstinent;
but, said [Richard Savage, an intimate of Thomson's], he knows not any
love but that of the sex; he was perhaps never in cold water in his life; and
he indulges himself in all the luxury that comes within his reach."

For both Thomsons, reality not only differs from readers' expectations
but is pretty much the exact opposite. That is significant. In an essay on Karl
Popper, Adam Gopnik noted that Popper's system was based on the value
and necessity of criticism but that the philosopher had a ferocious temper
and was unable to deal with any criticism of himself, no matter how appar-
ently benign. To explain the paradox, Gopnik proposed what he called the
Law of the Mental Mirror Image, which he defined as, "We write what we
are not. It is not merely that we fail to live up to our best ideas but that our
best ideas, and the tone that goes with them, tend to be the opposite of our
natural temperament." In an interview, Gopnik expanded on the idea:

> The law may not always be true, but when it's true it's profoundly true,
> and it tends to be the case the more interesting a writer is—bad writers
> tend to believe that you should tell the truth in simple sentences. The only
> exception to the rule I've ever known among good writers was Brendan
> Gill, who was exactly the same in person as he was on the page. Other-
> wise, the most urbane stylists are anxious, inarticulate. One of the funniest

people I know is my brother Blake [an art critic for the *Washington Post*]. But on the page he's deadly serious. I'm humorless in person but funny in writing. That's because my brother is relaxed in life and doesn't need to be relaxed in print. I do.

There are many reasons why the person on the page (let's call him Glen) would be different from the person in person (Glenda). Most people want to put on their best face when they go out in public, and so it follows that Glen will usually be more genial and judicious than Glenda, more modest and more willing to give opponents their due. Glenda will contradict herself, think aloud, use *hopefully* to mean *I hope*, and leave half-made points suspended in the air; Glen will neatly tie up each idea and use the king's English. The contrast is especially striking in the case of novelist Peter Carey. He says:

> I'm always in the process of trying to figure out what I think and feel, struggling to express myself in conversation. People who know me, then read the work, are astonished. It's just beyond belief. As a young man, going to literary dinner parties, I felt very inarticulate, poorly educated, ill equipped to deal with where I was. Writing a novel is suddenly like having ten chances to contend with that dinner party. Writing is a process of elevating oneself; it's like building a stepladder or staircase to yourself. You end up with someone who's more eloquent, more intelligent than yourself, and certainly knows more. After I had started to be published, I knew something had changed when people started waiting for me to finish my sentences.

In all prose, the reader develops a sense of a character—the person who is doing all the talking. A special case is first-person essays, narrative or humor, in which that character is shoved on center stage, in the middle of a spotlight. Writers who work in the first person agree that this character is a version or a subset of themselves.

BILLY COLLINS: The person in the poems is fairly close to me. If you're a novelist, you have to invent many characters. A poet invents one character, the voice you're going to speak in. It's kind of a cousin of the real you. It reminds me of a story about a Corkman named Michael James O'Neill, who was notoriously evasive. Someone who was looking for him once asked him if he was

indeed Michael James O'Neill. And he replied, "Near enough." Well, I feel the person in the poems isn't me, but he's near enough.

MEGHAN DAUM: I sometimes get accused of being solipsistic. I feel that I'm using myself as a tool to get at something outside myself. There's a persona in my essays, but I don't consider that it's really me. It's an inquisitor, asking all the questions. She's more dramatic than me, more vulnerable, more malleable. I'm not as emotional, or flaky. The persona has to be those things to convey experiences, to provide a level of drama. It's a version of me pitched at a different level. I conceive of some of my essays as stand-up comedy, an extended riff. Readers are so literal, they're so saturated with memoir culture, that they sometimes get mad at me.

DAVE BARRY: Definitely the person in my pieces is wackier. Sure, I've done strange things. I've shot Barbies off the roof of the building I work in with a potato gun. I've hung upside down on a meat hook. I've set fire to a pair of underpants on the David Letterman show. But my life isn't really wacky. What I often do is take something that is not only an ordinary part of life, like buying a house or renewing my automobile registration, but is actually annoying. Like the house has a problem or there's a huge line at the Department of Motor Vehicles. So when I go to write it, I don't take out the anger. I turn the anger into something where the reader relates to the frustration, we both see how funny it is.

The reader may come away thinking, "Oh, he must be funny when he's standing in line waiting to have his car registered." No. If you talk to me while I'm in line waiting to have my car registered, I'm just as annoyed as the rest of them. I'm probably even *more* annoyed because I have to get a column in. So, in a sense, you are no more seeing the real me in my columns than you're seeing the real Jerry Seinfeld when you watch *Seinfeld*. Everything you see in the column came from me, but there is just much more to me. What people know is a role. It's a part of me, but I wouldn't call it me.

There are people who are much darker, like David Sedaris. He has a real, honest humor that is upsetting at times. The things he tells you—assuming they're true—are the kinds of things I would never tell. He cuts a lot closer—again, assuming they're true.

ELIZABETH MCCRACKEN: I find essays much, much harder to write than fiction, partly because I'm morbidly private. Both my novels are in the first person, and I think I've chosen to do them that way so I can put on a mask. Writ-

ing in the third person, even in fiction, is writing about yourself. You have to come out and state things. It's a struggle. My inclination is always to be invisible, to pretend that I'm uninteresting. It's almost like an excess of politeness. First-person narrators can be rude.

In my own voice, I come out as way too tentative. I keep saying things like "I think" or "it seems to me," and I have to keep cutting them out. I'm working on a book review right now, and I have to keep rewriting the point I'm trying to make, so I come right out and say it. I have to keep telling myself that I became a writer because I want to persuade people. The dilemma is to be strong enough to persuade people but still polite enough not to be assaultive.

In one particular way all writers, even McCracken, are less polite on the page than in society. While Glenda will (implicitly and explicitly) pause for responses to her statements, express interest (real or feigned) in what the other person has to say, Glen has no qualms about going on extended monologues. That is all he does, in fact. Shy or subdued people are often drawn to writing, as Thomson was. It allows them to take as much time as they need to formulate what they want to say and then to say it without fear of interruption—it lets them unleash their inner loudmouth. Joan Didion is famous for being shy. She is so shy, she has said, that sometimes, when working as a journalist, she cannot bring herself to start the interview, so that she and the subject just sit there looking at each other in uncomfortable silence. There is not a hint of shyness or diffidence in her writing voice (although it does have a note of "so there!" defiance). I don't know whether Tom Wolfe is shy or not, but I suspect he is, a bit, and the white suit and the exclamation points are ways of cheering himself on.

Cynthia Ozick comes across in print as assured as David Thomson, albeit not as deliberately provocative. That image is deceptive, she says.

I write in terrible fear. When I'm writing fiction, it is really terror. It comes from knowing that there is this ceiling in my writerly DNA, and I can't ever be E. M. Forster or Evelyn Waugh. The attempt is fear-making, the failure is depressing, and so between the two, it's rotten. What do I do about it? I hide it. You can't write with fear showing, and you can't write with depression showing. You need to construct a mask.

Since 1953 I've kept a diary, and I write in it almost every day. It's a record of humiliation. The voice in it is my speaking voice. It carries all of

life in it, all the dross and all the bad feelings, the humiliations, the anger, the envy, all that garbage. I know that is a real voice, and that's how I discover that all the other voices are constructs or masks. I think all writing is impersonation. In fiction, you're impersonating a character. In an essay, you're impersonating a voice that's certainly part of your being but that's also better than you are—more sure of things.

In rare cases, the literary persona is shyer than the social one. Junot Díaz says:

> When I write raw, it tends to be elliptical, passive. I write *around* an issue. Something about the act of writing stands in the way of me and my material. I have problems saying what I need to say. That's odd, because my personality tends to be blunt, straightforward, outspoken. My written personality is nowhere near as dynamic. I have a hundred failed stories in my drawer, and they all have the mark of the writerly person I for some reason need to be.

For this book and previous projects I have conducted in the neighborhood of a hundred in-depth interviews with authors. I also know a lot of writers. And I have sometimes noted an obvious chasm between the person and the persona, either as a function of Gopnik's Law or through some not immediately apparent reason. But in even more cases, style really does seem to be the woman or man. Russell Baker is modest, intelligent, funny, and skeptical in person; he is modest, intelligent, funny, and skeptical in print. Occasionally—and this is the case with Nicholson Baker, Harold Bloom, Andrei Codrescu, Jamaica Kincaid, John Lukacs, Stanley Crouch, Calvin Trillin, and Greil Marcus among those I've interviewed and with John Updike, David Sedaris, Sarah Vowell, and William F. Buckley Jr. among those I've merely heard on television or radio—it goes beyond such a congruence of attitude and approach to an apparent integration of voice and prose. When you meet and talk with the person, you can almost see the words on the page. Later, reading the work, you feel that the person is in front of you, saying the sentences out loud.

The relationship between the two personalities is, if nothing else, complicated. Like David Thomson, Anna Quindlen stuttered as a child. She also had a terrible lisp. And like Thomson, she became a writer partly to

try to compensate for those difficulties. But unlike Thomson, she eventually was able to merge the two personalities. Quindlen says:

> I think there's clearly a link between trying to create a charming, erudite and coherent "voice" on the page and being unable to use your voice easily in real life. In my case there may be a chicken-and-egg effect. I don't know whether I developed the written voice and then imitated it, once I had speech therapy, or vice versa. But in any case I know that I have a distinctive voice on the page, and that it's intimately related to my actual voice—that is, the way I speak now. In fact, one of the most constant comments I get when I give speeches is, "You talk just like you write."

Thomson and Quindlen are hardly alone. Other writers who stutter or stuttered, according to the Web site "Famous People Who Stutter" (http://www.mankato.msus.edu/comdis/kuster/famouspws.html), include Aesop, Arnold Bennett, Jorge Luis Borges, Elizabeth Bowen, Lewis Carroll, Cervantes, Winston Churchill, Margaret Drabble, Steve Erickson, Robert Heinlein, Edward Hoagland, Alfred Kazin, Philip Larkin, Somerset Maugham, Jonathan Miller, Budd Schulberg, David Shields, Nevil Shute, Peter Straub, Kenneth Tynan, and John Updike. I doubt that any of them would regard the speech impediment as coincidental to the vocation they took up. Erickson, an American novelist, has provocatively observed, "A lot of stutterers have become writers. Lately I have begun to wonder if I had it reversed. I have always assumed that a stutterer becomes a writer. Lately I have begun to wonder if the writer becomes a stutterer, if a writer is born a writer—if there is something about the writer from the very beginning that makes him a writer and if that's what gets in the way of his speech."

The sort of convergence Quindlen talks about, between persona and personality, is common among actors. The boy born Archibald Leach to working-class English parents had a horribly unhappy childhood and a long, slow professional apprenticeship before the world came to know him as the epitome of what that can only be called Cary Grant. "I pretended to be somebody I wanted to be until finally I became that person," he once said. "Or he became me."

Writers *are* actors, and they too can become what they perform. Judith Thurman says:

> People say my writing gives the impression of naturalness. That is so untrue of me. A friend once said to me, "You don't have a spontaneous bone in your body," and he was right. I'm secretive and hard to know, but on the page I give the impression of being warm and easy to know. Over the years, the distinction has narrowed between the pretensions and myself, between the artificial and the natural. I come across as a fairly cultivated European woman of the world; I come from Queens. That polish I sought for so long has been assimilated. I have a good friend in Paris who comes from a cultivated upper-class background. When I met his parents, they assumed I came from the same kind of background. I was delighted and appalled. I was an impostor and it had worked—but I had denied something of who I was and where I came from.

Of course, style is not the only relevant factor in considering a literary persona. The other is content—what the writer has to say—and this is often more relevant. If we think of novelists as generous or caustic, it's usually because of what they show or tell us about their characters; we consider essayists smart, foolish or confused because of their ideas; we form our opinion of first-person writers like Bill Bryson on the basis of their accounts of their actions and reactions. But in all cases the style is there all the same, even if it flies under the radar of our attention. Most of the time, it works in tandem with the content. One is not surprised when conservatives write in the cadences and vocabulary of 50 or a 100 years ago, or when radicals break grammatical rules and semantically overreach. People expressing outrage tend to shout; people conveying satisfaction with the world or themselves will likely speak in well-modulated tones. Arnold Bennett observed, "How often has it been said that Carlyle's matter is marred by the eccentricities of his style. But Carlyle's matter is harsh and eccentric to precisely the same degree as his style. His behavior was frequently ridiculous, if not abominable." The form–content link helps explain the connection between the two meanings of the word *irony*: one referring to a situation (a character in a play planning a vacation on the day after the audience knows someone plans to kill him), the other to a manner of expression (saying "What a swell joint!" at a mediocre restaurant). Reading some writers—Stephen Crane, Kafka, Hemingway, Joseph Heller—we quickly catch on that their expression is other than sincere, and gradually realize this is because they see the world as animated by a cosmic irony.

Sometimes writers consciously or unconsciously exploit a discordance between style and content. Astute journalists know that if their material is funny, poignant, or dramatic, they will most efficiently get the emotion across if they write straightforwardly or even blandly. (And if the content is dull or ordinary, giving it the full symphonic approach can create a nice piquancy.) Donald Barthelme had radical notions about literature, language, and the oddness of the world. His plots, if you could call them that, were surreal. But he communicated all this much more effectively because, sentence by sentence, his prose was precise, immaculate, and correct.*

So: Glen is the personality on the page, Glenda the personality in social interaction. This leaves out a third member of the party—the "real" personality, the core self. The quotation marks are a clue that my omission is intentional. The word *personality* is derived from the Greek *persona*, itself a compound of *per* ("through") and *sona* ("sound"), and meaning "a mask worn by actors." I am sympathetic to psychological conceptions that stress the constructedness and adaptability of personality, and hence the role-playing or mask-wearing function, and to critical conceptions that think of authors as wearing masks and playing roles. As Billy Collins says:

> The romantic view is that style is the manifestation of your core. I'm closer to the idea that it's a set of mannerisms, arrived at through trial and error, that work and give you pleasure. As Frost said, "The fun's in how you say a thing."

There's obviously a long and distinguished tradition in literary criticism of putting authors on the couch and putting their motivations, fears and inner being on the table for discussion. An example (I could

*Barthelme's novel *Paradise* begins: "After the women had gone Simon began dreaming with a new intensity. He dreamed that he was a slave on a leper island, required to clean the latrines and pile up dirty-white shell for the roads, wheelbarrow after wheelbarrow, then rake the shell smooth and jump up and down on it till it was packed solid. The lepers did not allow him to wear shoes, only white athletic socks, and he had a difficult time finding a pair that matched. The head leper, a man who seemed to be named Al, embraced him repeatedly and tried repeatedly to spit in his mouth." Strunk and White would give the passage an A, with a gold star for not splitting an infinitive in the last sentence. Barthelme's shipshape prose partly explains his longtime presence in the *New Yorker*, traditionally the most formally conservative of magazines.

have picked any of ten thousand others) is Camille Paglia's take on Henry James's late style: "In his Romantic withdrawal from masculinity, James wraps each act of remark in an immobilizing sheath of excess words. The prose is the medium but not the message. It reproduces the density of ambiguous circumstances in which the characters are caught. It is a large, humming, *hovering* mass." That is ingenious and, as a description of the prose, irrefutable. But in it dependence on character-izing James's feelings about masculinity, it is presumptuous and inescapably speculative.

Leaving aside the legitimacy of the approach, it's unnecessary for the rest of this chapter, which tries to analyze the ways a writing style puts forth a coherent and compelling personality and not to prospect for links between that personality and the writer's inner being. I will say one thing on the subject: A style will never be memorable or robust without a connection between "Glen"—the personality of the style—and *something* elemental in the writer. It could be a direct one-to-one correspondence, it could be a Gopnikian mirror image or it could be a complicated transformation that may escape the notice of everyone except the writer him- or herself and some close friends. Ann Beattie says:

> The narrative voice often is an interesting improv on the person's real method of delivery, and sometimes it's quite close. That is, while Annie Dil-lard doesn't talk in compound, complex sentences, she does make bright, unexpected analogues and have major and minor points, with some unex-pected observations thrown into the way she's telling a story. About myself, one thing I'd say is that I think I'm funny. When people meet me and have a conversation or get to know me, they often comment that they are surprised that I'm funny. I can't stand jokes and find most come-dians not at all funny, but I find many other people inadvertently funny. I guess I like to think that in my writing, a big part of what I'm doing is dis-covering funny things—odd mannerism, turns of phrase—and this is a reflection of the way I am.

But if there is no connection—if the writerly persona is wholly artificial, disingenuous or conventional—the prose will be like invisible ink, vanish-ing into the air a second after it is read.

I have been speaking about style, and personality, as masks. Let me refine the metaphor and ask you to think of the most lifelike mask imaginable, so lifelike that it doesn't look like a mask but a real person's features. So I offer style as countenance, or, in Schopenhauer's words, "the physiognomy of the mind." Like a face, a style is partly meaningless as a gauge of character, but partly very meaningful indeed. And although it may seem that one's style is more malleable than one's face—in writing, all you have to do is delete a word and replace it with another, as opposed to the fuss and bother of plastic surgery—it is in fact unexpectedly hard to alter. Coco Chanel said, "Nature gives you the face you have at twenty. Life shapes the face you have at thirty. But at fifty you get the face you deserve." The age milestones are much less precise when it comes to style, but the general progression is the same.

Just as a face is a collection or cluster of features, a style can be seen as a collection of traits. A toy called Pin Art might help illuminate the analogy. You've probably seen Pin Art—it's a small bed of about 2,000 thin nails, each of which can be depressed all the way, partway or not at all. When you press the entire bed with something—your hand, a tangerine, your face—a perfect image of that thing appears on the other side. Literary style works in something like that way. Each of the nails in the Pin Art of style represents a specific quality. And in every style, the pins are pressed (or not pressed) in a particular configuration, creating a unique and unmistakable visage.

Most—if not all—systems of personality evaluation start with a small number of important or elemental traits from which all other traits derive. Aristotle talked about the sanguine, melancholic, and choleric personalities; Nietzsche the Dionysian and Apollonian. Schopenhauer thought the "master traits" were muscular and vital energy, on the one hand, and sensitivity, on the other. Jung's system (the basis for the Myers-Briggs personality test, still widely used) put forth introversion and extraversion as the essential polar opposites, with thinking, feeling, sensing, and intuiting as the primary modes of perception. Currently, the most widely applied standard among psychologists is the Five-Factor Model, which categorizes people according to the extent to which they are open to experience, conscientious, extroverted, agreeable, and neurotic.

All of the above are germane to style. So is just about any attribute of human beings. A style can be immaculate or sloppy, pompous or humble,

generous or mean, empathetic or egocentric, formal or convivial, elated or depressed, witty or dull, diligent or lazy, self-conscious or reflexive, intelligent or simple, sincere or disingenuous, and so on and on and on.

But it's possible to funnel these traits into a small number of clusters with special applicability to the peculiar demands and protocols of writing. Henri Morier, in his 1959 book *La Psychologie des styles*, named eight classes of style, each corresponding to a particular temperament: weak, delicate, balanced, positive, strong, hybrid, subtle and defective. I have no objection to this scheme, but fancy taking my own crack at it, and I offer seven tendencies: competence, iconoclasm, extroversion, feeling, single-mindedness, tension, and solicitousness. Each one is a continuum or scale, and a particular style can be low in it, high in it or somewhere in between. Together, the tendencies make up a style, a profile, a face.

Competence: This is our first impression of writers: Do they know how to put words together? Are they able to say what they mean, punctuate, and spell? If the answer is yes, we file away a sense of efficacy, settle in to listen to what they have to say, and make a mental note to observe their other qualities. If the answer is no, we're put on our guard. If the author doesn't quickly offer something of value—humor, information, a good story, a worldview—the reader is more than likely outta here.

Iconoclasm: The key standard for distinctive style. Conformists dress like everyone else, watch the television shows in the top 10, and, at the keyboard, aspire to a transparent middle style. Their prose is neat, proper, and correct—anything to avoid a commotion. They are partial to subliminal clichés—the ones you can comfortably slip into, like a warm bath. But memorable writers, if they have nothing else in common, hear the rhythm of different drummers. In content, that means comprehending realities and making connections that most people don't. In style, it means giving the reader a bumpy ride: with unexpected words, blunt phrasing, abruptly curtailed sentences or paragraphs, never-*ending* sentences and paragraphs, or deliberate word repetitions, awkwardness, or flatness.

Some hint, at least, of unexpectedness or irregularity is necessary for a distinctive style. But taken too far, it leads to a style that continuously changes tones and gears, so that readers are unable to get their bearings. This is the country of the avant-garde. When the inclination goes too far—*Finnegans Wake* is the classic example—it results in a kind a vertiginous quicksand: literary schizophrenia.

Extroversion: To publish one's words necessitates a certain amount of exhibitionism. Beyond that, people bare themselves and show off to wildly varying degrees. Gnomic prose, short sentences, wide margins, and short books are introverted; verbosity, whether in the form of long words, long sentences, or long books, is extraverted. Some styles shout, and not just the ones that use CAPITAL LETTERS, *italics,* and exclamation points! Diction, or word choice, is a reliable way to control the volume: words that overstate the case and edge toward hyperbole reveal an extrovert. Short sentences with no qualifications can do the same thing. John Lukacs's characteristic mode is aphoristic. Pulling one of his books from the shelf at random (*Confessions of an Original Sinner*) I need to flip pages only twice before I come to: "It is easier to write a first-rate novel than a first-rate history, but it is easier to write a mediocre history than a mediocre novel." Lukacs comments, "Aphorisms are crystallizations of thought. They are suggestive and the essence of something." He acknowledges that he's a sucker for them. "My wife says I don't have opinions, only convictions. That is an exaggeration."

A quiet style, in contrast, will qualify, amend, employ the passive voice and many commas, elliptically revolve around the subject, and pursue understatements but not quite to the point of irony. (That's aggressive.)

Feeling: The classic left brain–right brain opposition is between thought and feeling. Rational styles are hierarchical, logical, orderly, precise, and dominated by nouns. Emotional styles are discursive, impressionistic, gossamer, loose, and dominated by verbs. As described in the last Interlude, women are more likely to have a style that follows the logic of emotions, and men one that follows the logic of logic.

Essay-writing and other forms of nonfiction tend to the rational, and fiction and poetry to the emotional—which is the best way of explaining the huge stylistic difference between Virginia Woolf's novels and Virginia Woolf's criticism. Any writer in any genre always needs to create a balance between the demands of the two ways of absorbing the world. Judith Thurman says, "Great writing is always a synthesis of feeling and thought. It has the illusion of spontaneity, yet it is very clear: the directness of blurting something out, the refinement of something that's worked over and over again."

Single-mindedness: In his book *The Hedgehog and the Fox*, Isaiah Berlin posited two classes of thinkers: the ones who know one big thing (hedge-

hogs) and the ones who see many little things (foxes). Style is a good measure, maybe the best, of the way an intelligence encounters the world. Some writers will put down a word or phrase and almost always find that it brings something to mind: connections and implications, possible contingencies and contradictions, and assorted points of varying relevancy. Their style will be a bit on the messy side; the long sentences and paragraphs will be filled with dependent clauses, parentheses, and all kinds of punctuation marks, frequently concluding with a footnote. One thinks of Nicholson Baker, David Foster Wallace, and Dave Eggers—or, going back to an earlier era, of Laurence Sterne and his sprawling novel *Tristram Shandy*. As these examples suggest, literary foxes will also tend to be incidentally funnier than hedgehogs: their alertness will lead them to puns, wordplay, and sidelong comments. And their inclination to see multiple points of view will lead them to be charitable and authentically empathetic—the critic who rarely gives raves and pans, the columnist who anticipated and respects the opposing viewpoint.

We don't think in language, and it's just a conceit to talk of words precisely mirroring thoughts. But for some writers it can be a very strong conceit. V. S. Naipaul, a fox whose fastidious, unsparing style does reflect the way he sees the world, once defined style as "essentially a matter of hard thinking." When the interviewer commented that Naipaul's prose had become "more structured, your sentences more syntactically involved," the writer replied: "I think this represents the way one thinks. . . . It is also becoming harder to make simple, straightforward statements. One always wants to go back, to correct, to qualify. One is saying more difficult things as well."

"Foxness," with its awareness of implications and connections and exceptions, is clearly related to what is popularly known as intelligence. That doesn't mean all hedgehogs are dummies. Some, in fact, are geniuses—but of the plowing-through, blinders-on variety, the sort who would work through the night and forget to go to sleep. Quite a few are rock-ribbed conservatives, bleeding-heart liberals, or ideologues of some other stripe. Whatever their affiliation, they will generally write straight ahead, moving from one point to the next with no detours, their figurative finger raised high in the air. If they do attempt humor, the results will not be pretty.

Writing in the style of a hedgehog even when you're not can be effective, both stylistically and therapeutically. Raymond Carver, who struggled with alcoholism, once said, "If your life is in shambles and chaos, there's the desire to exercise some kind of control. And I think maybe I was doing that in the prose of the stories which I tried to make so precise and exact. It was some arena, some place on the map where I could exercise complete and total control."

Either style can be taken to excess. Citing David Shapiro's book *Neurotic Styles*, linguist Robin Tolmach Lakoff has written that Shapiro's "basic determinant of style was the mode of attentiveness"; the obsessive is transfixed by detail, whereas the hysterical person sees the universe as a large undefined blur. Verbally, the obsessive will burrow deeper and deeper into, and eventually be paralyzed by, detail. The hysteric will rage from the rooftops, making grand statements about the forest but not noticing the trees.

Tension: Style reflects attitude. There are as many attitudes as there are writers, but most (if not all) can be grouped along a continuum—absolute contentment on one end, extreme agitation on the other. Contentment can show itself in a near transparent style (E. B. White), as well as in a smug or self-satisfied one (George Will). In both cases, the style communicates that the writer is pleased with the essential order of things. As Richard Lanham observes, this mode can be cultural as well as individual. "Styles conceived, like the British Empire, in a fit of absence of mind, tend to be noun styles," Lanham writes in *Analyzing Prose*. "The 'is + prepositional phrase' formula, at least in our time, seems to come naturally."*

Discontent troubles the stylistic waters. When a writer is consistently ironic (like Kurt Vonnegut or Joan Didion or the late Dickens) or terse

*In a noun style, the writer turns the key words in a sentence (no matter what their natural part of speech) into nouns, through frequent use of the passive voice and prepositional phrases, and employs few verbs other than *to be*. Lanham quotes an example from a scholarly book: "To regard the same evolutionary pattern as part of the process of secularisation is to shift to a perspective which is significantly but not qualitatively different." That's four nouns, four prepositions and two uses of *to be* in one relatively short sentence. Lanham also points out the unintentional alliteration of *p* and *s* sounds and says that if we attend to them, "the prose becomes almost unreadable."

(like Hemingway) or biblically grandiloquent (like Faulkner) or speaks so much in any particular cadence that we cannot ignore it, we sense that something is the matter. There is an edge. The mode of expression is the means of delivering a brief against the world. Faulkner said in a 1944 interview, "I can write prose as simple as anybody, but when you're trying to say, well, that desires and dreams are in the final scoring incompatible, you have to have between you and the reader a kind of veil that forms the mood and the color, that sets the fact that life is studded with pain, and to seek it is to expand one's agony in a way, I suppose."

Dave Eggers's *A Heartbreaking Work of Staggering Genius*, a memoir about the early death of Eggers's parents, which left him to raise his young brother, has been accused of being gimmicky and precious, what with its endless digressions and self-consciousness about its own workings. Defending it, James Surowiecki wrote in *Slate*, accurately, "I thought all the stylistic gambits reflected something real, which was the struggle to find a way to say something that really, you don't want to have to say: These people are dead, and I am not."

Sometimes Eggers's style permits his resentment and grief and everything else to pour out more or less directly. At other times he, like Vonnegut and Didion and Hemingway and Faulkner (to an extent) expresses it through indirection. I would characterize this manner of utterance as irony. *Irony* is an over- and often misused word, and, in the introduction to the paperback edition of *A Heartbreaking Work of Staggering Genius*, Eggers devotes a long section, in tiny type, to slamming everyone who invoked it while discussing the book.* But his writing *is* ironic. In the introduction he defines *irony* as "the use of words to express something different from and often opposite to their literal meaning." The *opposite to* is sarcasm, a special form of irony, and indeed not much present in the book. The *different from* is the kind of irony most often evident today. It is a sort of speaking in quotation marks, the self-conscious adoption of a

*I quote from it (in part because I am proud to be able to read it without glasses): "You can't know how much it pains me to even have that word, the one beginning with *i* and ending with *y*, in this book. It is not a word I like to see, anywhere, much less type onto my own pages. It is without a doubt the most over-used and under-understood word we currently have. I have that *i*-word here only to make clear what was clear to, by my estimations, about 99.9% of original hardcover readers of this book: that there is almost no irony, whatsoever, within its covers."

tone not natural to you: like taking a mask and holding it a foot in front of your face. Think of David Letterman saying the word *beverage* or a phrase like "the Nabsico Company's fine products"; Letterman *is* referring to a beverage, and he isn't trying to say that Nabisco makes crummy cookies, but he is being ironic nevertheless. Eggers uses this sort of irony often, to good effect. In describing his and his brother's Frisbee game on the beach, he writes, "We look like professionals, like we've been playing together for years. Busty women stop and stare. Senior citizens sit and shake their heads, gasping. Religious people fall to their knees. No one has ever seen anything quite like it." Whether Eggers likes it or not, that is irony, and one effect is the reader's sensation of a certain attitude in the narrator.

According to Cynthia Ozick, it was Kafka who introduced a generalized irony into twentieth-century writing. She says: "After Kafka, you can't be without irony. You can't be a thinker without irony. You can't have any influence without irony. You can't write a contemporary essay without irony. And you definitely cannot write contemporary fiction without irony."

For Ozick, it ties in with "an approach to the world" she learned from her father, an immigrant.

> He used that Yiddish phrase, "Amerikanerge-born," American-born, to show a lack of irony, a naïveté. He brought this European dark knowledge that we who are born here are innocent of. Luckily enough, we don't have the troubles that go with it. Yesterday, I was talking to someone from Kiev, who's been here no more than five years. Even now, she shakes her head with a little smile and says, "You don't know anything." That was my father's half-smile.

Gish Jen is also the child of immigrants (from China in her case), and irony is also everpresent in her work. Jen says:

> Some things are constant in my voice, and in the way I see things. There's an alertness to discrepancy, to irony. In *Mona in the Promised Land*, the number of words that can be put into quotation marks is astounding. I tend to stand *outside* events and language. *Irony* is my

middle name. It can turn into humor, but it doesn't always. People say that I'm funny. But as a person I'm not a barrel of laughs. What I'm really interested in [is] incongruity, the huge discrepancies between what we are and what we are supposed to be. Lionel Trilling, talking about the origin of the novel, said Cervantes was about the contrast between reality and illusion. And reality and illusion was funny for Mark Twain. I would add that the great new ground is migrancy. That's my territory.

When I started writing, in 1986, it was before multiculturalism. There was only one Asian-American novelist, Maxine Hong Kingston. It was widely recognized that someone like me could only write artifact, not artifice. Once a day, someone would say to me, "You must be writing an immigrant autobiography." (When it comes to Asian-Americans, people have no compunctions about expressing prejudice.) This was actually helpful to me. It was what Philip Roth calls "an amiable irritant." In my first book, Native American, you hear the big No. No, I am writing fiction. I am an American writing a novel. I will not be pigeonholed. The first word of the novel is No—the first word you see is actually the second word. There's the voice; already I am myself.

Roth says he spends a lot of time looking for "one live sentence." For me, the process of writing is looking for where the "no" is. It's looking for something irreverent in a time that's so fucking reverent.

For Harold Bloom (who grew up with his immigrant parents in the East Bronx, near the Ozick family's home), a sense of antagonism leads not to irony—Bloom is among the least ironic of writers—but to a sort of Whitmanesque fervor. He says:

My style comes from an oppositional stance. I started out as a fierce revivalist in the '50s of the romantic poets and the whole romantic tradition, which the New Criticism had almost destroyed. My writing style always had to be antithetical or adversarial, because I was arguing passionately against something. And then in a long second phase, I was arguing passionately against people with whom I was associated and were my personal friends but who had gone over to Derrida and French post-structuralism. Now in the third phase I'm arguing strongly against politicizing, this thing I've dubbed the school of resentment. I

like to say that I'm a true Marxist critic, following Groucho rather than Karl: Whatever it is, I'm against it. That produces necessarily a fiercely personal, rhetorical style. Sometimes I know it is pitched too high, which I know is rhetorically dangerous. It asks a great deal of the reader. I write very personally, I write very directly. And, you know, I always remember what Gertude Stein said: "One writes for oneself and for strangers."

Solicitousness: This is a big one, because it points up the main way stylistic personality differs from real-world personality. The latter is a continuous presence in an individual's life. Awake or asleep, alone or in company, the personality is functioning. Literary personality exists only in the act of writing, which implies the act of reading, which implies someone else. This trait concerns the attitude toward that someone else, the reader. Sometimes, it's a matter of explicit acknowledgment or address ("Reader, I married him"). Most of the time it is implicit: a function of style.

Northrop Frye wrote in *The Well-Tempered Critic*:

> A piece of continuous prose, whatever its tone, looks at first sight like a dictatorial form in which there is a one-sided and undisturbed monologue proceeding from the author. Looking more carefully, however, we can see that in adopting an expository form the author is really putting himself on a level with his reader, with whom the continuity of his rhythm keeps him in a point-for-point relation. If a writer wishes to suggest a kind of aloofness; if he wishes to suggest that it is the reader's business to come to him and not his business to come to the reader; if he wishes to suggest that there are riches in his mind which his actual writing gives no more than a hint of, he will have to adopt a different kind of prose style.

If stylistic traits correspond to facial features, this one is the eyes. Writers who are unaware of or uninterested in readers are like people who do not look at you when they're speaking to you; their eyes are directed at the horizon, glazed over. The syndrome can have sundry results in writing, none of them good. Murkiness, flatness, clumsiness, and awkwardness all convey an implicit disregard, even a contempt, for

the reader. Thus four prepositional phrases in a row or a word repeated three times in a paragraph *feels* like an affront. In his essay "On Style," Schopenhauer wrote:

> As neglect of dress betrays want of respect for the company a man meets, so a hasty, careless, bad style shows an outrageous lack of regard for the reader, who then rightly punishes it by refusing to read the book. It is especially amusing to see reviewers criticizing the works of others in their own most careless style—the style of a hireling. It is as though a judge were to come into court in dressing-gown and slippers!

Frye felt that a disregard for the reader led to what he called "bastard speech," and as one reads his description of it, the work of numerous published authors comes to mind:

> Genuine speech is the expression of a genuine personality. Because it takes pains to make itself intelligible, it assumes that the hearer is a genuine personality too—in other words, wherever it is spoken it creates a community. Bastard speech is not the voice of the genuine self: it is more typically the voice of what I shall here call the ego. The ego has no interest in communication, but only in expression. What it says is always a monologue, though if engaged with others, it resigns itself to a temporary stop, so that the other person's monologue may have its turn to flow. But while it seeks only expression, the ego is not the genuine individual, consequently it has nothing distinctive to express. It can express only the generic: food, sex, possessions, gossip, aggressiveness and resentments. Its natural affinity is for the ready-made phrase, the cliché, because it tends to address itself to the reflexes of the hearer, not to his intelligence or emotions.

Some styles are patently pompous and arrogant, almost baiting the reader as they force one assertion after another on the reader. And some styles—J. M. Coetzee's, for example—are parsimonious, holding the reader at arm's length by systematically withholding connections and emotion. Difficulty is more, well, difficult. Some subjects or arguments are complex, knotty, and abstruse, and it would be impossible to do them justice in "readable" prose. But it's obvious when a writer has not made his or her best effort, or, indeed, any effort at all. Jargon does the work of

explanation, sentences barrel on to the vanishing point and the overall impression is of exclusionary obfuscation.

A solicitous writer always seeks eye contact and maintains a respectful bearing. Schopenhauer says that a writer must be "careful to remember that thought so far follows the law of gravity that it travels from head to paper much more easily than from paper to head; so that he must assist the latter passage by every means in his power." The minimal courtesies an author can offer are clarity and brevity, so the reader will not have to expend excessive labor and time. The next steps on the ladder include transitional words and phrases (as if leading the reader by the hand from sentence to sentence and paragraph to paragraph), direct address, use of the first person (when I acknowledge myself, I am implicitly acknowledging you), and a general tendency to second-guess a reader's reaction: defining or explaining possibly unfamiliar words and concepts, and replying to anticipated questions or objections. Hazlitt said that one of the main strategies of his "familiar style" was, "after stating and enforcing some leading idea, to follow it up by such observations and reflections as would probably suggest themselves in discussing the same question in company with others." It's the same notion that Michael Kinsley is getting at when he says, "When I read columnists like Charles Krauthammer, who's a good friend of mine, and George Will, who's his model—I feel they're saying, 'I'm here to tell you what the answer is, and I have contempt for anyone who feels differently.' I hope I write with a different attitude: something like 'I hope to convince you of this,' or, 'Let's think this through together.' I want to make an argument rather than a *pronunciamento*."

Billy Collins is so aware of audience that he has opened or ended every collection he's published with a poem about the reader. "Lyric poetry is an isolated speaker talking to himself or herself, and overheard by the reader," he says. "The reason I read out loud as I'm writing is that I can't process unless I think someone is accepting it."

The very act of publication is significant in terms of a writer's stance toward readers, Judith Thurman says: "You're giving something to someone. It's an old-fashioned thing—offering someone something that you've worked hard on, so that it has become precious."

Kenneth Burke wrote, "In its simplest manifestation, style is ingratiation." Some styles always have a smile on their face, and their natural mode is performance. Rather than merely offer a fact, an insight, an

action, they will present it in a glittering package: a joke, a metaphor, a
pleasing alliteration. They give the impression, sometimes subtle, some-
times overt, of wanting readers' approval or fearing their abandonment.
James Wolcott says:

> To me writing has always been communication. If it's not, you don't
> need to publish it. The contract I have in mind with my reader is "I
> promise not to bore you." I've also always been aware that writing is a
> commercial transaction. People are buying the paper, the magazine.
> You've got to give them something for their time and money. You can't
> simply preen. I've heard novelists say things like "I write for myself." If
> that's true, you wouldn't publish. You'd just set it in a drawer some-
> where. But you're writing to be read, you're writing to be heard.

Like Wolcott, Clive James matches his erudition and provocative
insights with consistently entertaining prose, but he is careful not to serve
too rich a dish. He says:

> I work on the assumption, or let it be the fear, that the reader will
> stop reading if I stop being interesting. The best reason not to overdo
> the hoopla, then, is that the result would lack interest: an excess would
> be even worse than a deficiency, because it would look nervous, and
> nervousness, in prose as in seduction, repels. Otherwise, I try to make
> every sentence as attractive as the first.

As James says, being oversolicitous can sometimes make one appear
nervous or desperate. Oversolicitous writers overuse the second person,
transitions (as if the reader always needed a helping hand from thought to
thought), or puns, which have the appearance of humor but are rarely
funny. In a 1979 essay, "Stylistic Strategies Within a Grammar of Style,"
Robin Tolmach Lakoff asserts that "the basic determinant of personal
style" is a speaker's perception of the relationship between him- or herself
and a listener. (Lakoff is referring to speech, but her model works for
writing as well.) As the relationship moves from minimal (for example,
someone writing a legal notice) to maximal (an e-mail between lovers or
best friends), the "communicative strategy" proceeds, in Lakoff's terms,

from clarity to distance to deference and finally to camaraderie. A person's or a culture's style is defined by the particular matching of the style to the relationship—for example, how close a friend needs to be before the camaraderie mode is taken up. And, adapting Lakoff's framework to the subject of this book, a mark of a noticeable or distinctive style might be a strikingly unconventional matching: using formal language in a love letter or referring to the readers of an academic paper as "you guys."

For each of the seven scales, there's a certain zone of expectation—a place where "transparent" writers congregate and presumably look right through each other. Styles that are close to one or the other pole begin to attract readers' attention. And styles that are all the way to one side seem odd, or maybe even pathological. Robin Lakoff, for example, associates a too-quick move to camaraderie with the narcissistic character, who, she writes "is desperately concerned with his reception by others and therefore must feign interest in others."

Normally, writers with extreme tendencies will mute them in the process of revisions; others, however, will retain or even aggravate them. Writers of this kind face one of two prospects: a life of rejection notes and marginalization, or the hope that somewhere along the line, an editor, critic, or reviewer will decide they are a genius and start the ball rolling.

Part II

STYLE FROM THE INSIDE: PRACTICE

CHAPTER V

Finding a Voice, Finding a Style

Writers read for style. That, more than anything else, is what separates the professionals from the civilians. When a reader fancies a particular author, it could be for any of a hundred reasons—the characters' names, the product placement, the political slant, the exotic locales, the sex scenes, the happy endings, the typeface on the dust jacket. But when one writer falls under another's spell, it is generally because of the way the progenitor uses language to forge or reflect an attitude toward the world—that is, it is because of style.

I asked about personal influences in every interview for this book. Every interviewee had at least one name to offer. For two reasons, I take it as significant that Manny Farber was mentioned as often as Ernest Hemingway. The first reason is that, as in so much having to do with style, the currents that flow beneath the surface are more powerful than the ones the eye can see. That is to say, Hemingway obviously had a greater impact on twentieth-century writing than did Farber (a film critic who published in

various periodicals in the 1940s through the 1970s and now works exclusively as a painter). He permeates the literary ether, so that anyone coming after him needs to imitate, reject, or in some other way negotiate his presence. But his influence is so pervasive that it goes without saying—just as, if you were asked what you did when you woke up this morning, you might say that you tried a new radio station, but you probably wouldn't mention that you got dressed. Particular genres have their own 800-pound gorillas whom all that follow have to contend with, whether they know it or not: Tom Wolfe in feature journalism, Raymond Chandler in detective novels, George Orwell in higher journalistic criticism, Joan Didion in personal essays, and so on.

Even so (and this is the second reason), Manny Farber really did influence James Wolcott and Greil Marcus—and, earlier, Pauline Kael, who in turn was a model for Wolcott and Marcus. With remarkable frequency, relatively obscure or otherwise unexpected voices will insinuate themselves into the souls of writers-in-development. Joseph Heller discovered the voice that allowed him to write his first novel, *Catch 22*, by reading Louis-Ferdinand Céline's *Journey to the End of the Night* and a novel by Vladimir Nabokov in the same week. ("What I got from Celine is the slangy use of prose and the continuity that is relaxed and vague rather than precise and motivated; from Nabokov's *Laughter in the Dark*, the flippant approach to situations that were filled with anguish and grief and tragedy.") Norman Mailer has said that an "immense influence" on *The Naked and the Dead* was the work of James T. Farrell, and John Updike that *The Poorhouse Fair* was inspired by Henry Green's *Concluding*. Asked to name an influence in one interview, Pauline Kael cited the academic critic R. P. Blackmur, which is a bit like Charlie Parker giving props to Tommy Dorsey. Raymond Carver said his "greatest hero" was William Carlos Williams, Walker Percy named Albert Camus, and William Kennedy, in his early years, was under the spell of Damon Runyan. Never one to be topped, even in citing obscure stylistic forebears, Tom Wolfe has said on a number of occasions that the main influences for his use of multiple points of view were the "Serapion Brothers" group in the 1920s Soviet Union, which included Eugene Zamyatin, Andrei Sobel, Aleksie Remizov, and Boris Pilnyak.

Whitman wrote:

> I am the teacher of athletes,
> He that by me spreads a wider breast than my own proves the width
> of my own,
> He most honors my style who learns under it to destroy the teacher.

A century later, in a book called *The Anxiety of Influence*, Harold Bloom expounded on this idea and added a corollary: to "destroy the teacher" (i.e., to appropriate the style of an earlier writer) is painful and sometimes devastating for the student. My investigations support a different conclusion. For the writers I spoke to, acquiring an influence was exciting, and subsequently contending with it was kind of fun. To be sure, a necessary process of differentiation was involved. But this was generally seen as an intriguing and invigorating program—and one that, far from destroying the earlier writer, actually enhanced his or her stature (just as the second line in the Whitman quote has it).

In due time, after all, influence will be mitigated and eventually trumped by personality; therein lies the truth of "the style is the man himself." If you end up mimicking someone else, you're not a writer, you're a copycat. As novelist Richard Ford said, "Anyone's style is their intelligence. Their style is just a natural incarnation of their intelligence. You can't imitate someone's intelligence. You can't be someone else's mind. You might learn a trick. But finally it has to heat itself to your own intelligence and make something worthwhile, or it's useless."

Things are far more ticklish in forms like the visual arts or jazz performance, where style is all; once technical competence is achieved, originality and singularity are valued more than anything else. A saxophonist who sounds just like John Coltrane or a painter whose stuff can't be distinguished from de Kooning's will be seen as amusing but negligible novelty acts. Among the genres of writing, poetry fits this model the closest, and indeed, Bloom's work on influence focuses on poets. But there is not as much pressure on prose writers. For them, style is always paired with content—narrative, information, character, idea—which can at any moment pick up the burden of engaging the reader's attention. And so influence, along with all the other elements of style, can be viewed with a bit more equanimity.

Just listen:

TOURÉ: When you read certain styles, you can't help but be changed by them. It's like drinking a grape juice that gets all over your teeth and tongue. Nabokov was like that for me—he was a freight train that went straight into my head. Joan Didion and Ralph Ellison had strong, identifiable styles, but it wasn't the same. They were more textured, less overwhelming. Like apple juice.

JONATHAN RABAN: My one major, obsessive, dominating literary influence was Robert Lowell, and Lowell's poems sometimes had these marvelous, rich adjectival and adverbial piles. Like in "Man and Wife": "your old-fashioned tirade—/loving, rapid, merciless—/breaks like the Atlantic Ocean on my head." If I learned anything really practical from Lowell, it was not to be afraid if the textbooks said you should be afraid of reducing *loving, rapid, merciless* down to one adjective. Sometimes you can get away with three. The amazing thing is, you have *loving, rapid, merciless*, which you would think was linguistic explosion enough, and then you have this towering simile: "breaks like the Atlantic Ocean on my head." It adds excess to excess but with total, total conviction and power.

JUDITH THURMAN: When I'm stuck I'll read Didion—she calms me down.

ABRAHAM VERGHESE: Orwell was a tremendous influence—the sparseness and lack of emotion as he describes something, and yet that thing, the object, carries all the weight of the emotion.

JAMES WOLCOTT: Early on, I was a huge Norman Mailer fan. As a teenager I wrote an imitative Mailer style, from his *Advertisements for Myself* period, that tough, fighting, rhetorical overkill, the way he seemed to electrically take in everything. Then when I got to New York, I realized there were all these Mailer wannabes. The *Village Voice* alone had a lot of macho guys with five-year head starts.

Later, I read a lot of the Brits. Clive James's television column in the *Observer* was the must-read thing in England, the way [Kenneth] Tynan's theater column was earlier. People like Philip Larkin and Kingsley Amis, when they were talking about someone like Milton, had a certain offhand quality, like they weren't going to put on false airs. Anthony Powell's deadpan humor, particularly in his diaries. It's a good way to get across comedy, so that it's unforced; it's the opposite of wisecracking. Geoffrey Barnard had a column in the *Spectator* that

was about his gambling, his alcoholism, his bitter ex-wives. It had a real casual, shambling quality that I liked.

In New York, I was affected a lot by the Jewish hipsters—Seymour Krim, Manny Farber, Albert Goldman, Marvin Mudrick—a whole species of writer that is gone and never will return. These guys wrote a really fast conversational style. It was deceptive because I know they worked really hard on it, particularly Farber. He totally layered his stuff. He worked months and sometimes years on a piece. Goldman was the most brilliant talker I ever heard, but his brain worked so fast that when he sat down to write he got stymied. For his Lenny Bruce book, he got someone to sit in a room with him. He would talk it and the guy took it all down.

I learned about using quotation as evidence from Mudrick. He was brilliant at using the writer's own words to hang him. I remember once reading one of his collections where he had a review of an academic novel. He quoted a long description of oral sex, and at the end, he writes, "This is truly one of the most moving blow jobs in recent literature." At that point the book practically flew out of my hands, I was laughing so hard. I had no idea that was what he was going to do.

Pauline Kael came out of that tradition. Her writing was deceptively casual. No one pencilled over galleys the way she did. You would see blocks and blocks of very fine handwriting in the margins.

TOBIAS WOLFF: Hemingway was my dominant influence. I didn't like it pointed out to me, but I knew in my heart it was true.

NICHOLSON BAKER: As I've described in *U and I*, Updike was the big influence on me. He's the one. When I was starting out I took out a bunch of his books out of the library: *The Centaur, Of the Farm, Rabbit, Run*. I read more Updike than anybody else beginning. He's so hugely influential because he obviously has an ear. There was a feeling of just watching somebody ride a bicycle better than anybody else, up and down hills and doing things on that bicycle that nobody else could do. It was just immediately clear that it had to do with style, not just style but intelligence behind style, or a seeing eye behind style.

BEBE MOORE CAMPBELL: I like books where I can sense it, feel it, get in the middle of it. I like the turn-of-the-century writers, like Edith Wharton and Dreiser. Dreiser puts you right there.

JOHN LUKACS: My ideal as an English writer was Harold Nicolson. When I read him, I said, "Well, now, this is the way to write." There are still some sentences of his that ring in my ear.

FRANK KERMODE: Some of my tone derives from William Empson. I took a way of doing things that was not at all grandiose. Others took something else from Empson—an epigrammatic smartness, a woundingness.

PETER CAREY: I failed science at university and fell into advertising. It was then that I began to read literature for the first time in my life. I fell into modernism—Joyce, Kafka, Ezra Pound was where I went in, with nothing underneath it. I remember opening up *As I Lay Dying*—I didn't know combinations of words like that existed in the universe. I read Fitzgerald, John Irving, Márquez, who was the writer that must have had the greatest influence on me. I was living in Queensland [Australia] in the country. I would sit there every night in the gaslight, drinking and reading. I'd read until I couldn't see anymore, because of the alcohol. It must have been like blotting paper, sitting there reading every night.

CAMILLE PAGLIA: My parents read *Alice in Wonderland* to me when I was tiny. I loved the sound of Carroll's one-liners, the exclamatory, aggressive, abrupt sound of speech in that book. The flowers were so mean to her.

I loved the tone of the '20s and '30s, the Algonquin sound. I saw a drawing of Dorothy Parker hurling a giant pen like a spear, dripping ink like blood. I loved the idea of using speech as a weapon, of projecting your voice so the words struck home.

As a girl I got a secondhand book called *The Epigrams of Oscar Wilde*, and I just pored over his one-liners. Later I stumbled over Walter Pater, having no idea there was any connection between him and Wilde. I loved his most purple prose.

In graduate school, I loved Frazer's *The Golden Bough*—the dreamy quality and the juxtaposition of material, the way he would go from Greece to Rome to Polynesia to something he observed in Edinburgh. I adored Kenneth Clarke's *The Nude*—the simple sentences, the luminous way he introduces the reader to body types.

There was a style in British academic writing, in roughly the period 1890 to 1960, that I thought was fabulous. You saw it in people like Joan Harrison and C. M. Bowra. I thought, *This is the way a critic should write*. They wrote in a very relaxed manner. You had the impression that they had absorbed all learning but

knew how to present it to the general reader without being showy or ponderous, like the German academics. You heard the spoken voice, as if you were in a one-on-one tutorial.

MARGARET DRABBLE: Virginia Woolf, of course, in her novels. I think *To the Lighthouse* is one of the truly great novels. There's not a word over, or missing. It's just a heartbreakingly good novel. It's very curious, but one of the writers I most revere is Doris Lessing, whose style is terrible. She's a great writer without any question, an important writer, but her style is not her great quality. She's direct, she's abrupt, she hasn't got a very good ear. But she's got the matter.

MICHAEL KINSLEY: When I was at Oxford after college, I discovered the *Spectator* and the *New Statesman*, which were going through a glory period in the '70s and '80s. That whole British witty, ironic style opened my eyes. I hope I'm not just unconsciously ripping it off.

ANDREI CODRESCU: The people who were my contemporaries and influences were the New York poets, who were more sophisticated in some ways than the Beats. They had read and played with French surrealism and Dada and the avant-garde and they also had a really combative attitude toward mainstream American writing, which at the time was very provincial. It was the right crowd because what I knew and what I was doing made perfect sense to them. Certainly, there wasn't a demand to write in a very polished way. They welcomed experimenting, they loved it when things sounded awkward. Ted Berrigan said, "A great poem is a great mistake." He loved the idea of mishearing, reading the wrong words, hearing what happens if you keep up with the mistake.

Something I learned from Ted is that the American language insists on the present. It just simply insists on the spoken as a dimension that's as good as any transcendental or physical dimension. He was very insistent on the fact that you must use words in poems that haven't been used before. I don't know if that's true or not, but he always said he was the first American poet to use the word *Pepsi* in a poem. To this day there are teachers of creative writing who will try to forbid their students to use brand names in their poems. I don't know why—maybe because they're not elegant enough or they will be forgotten or whatever reason. It was quite the opposite of the New York school, because we were at the height of the Pop Art thing. It was actually tremendous

fun to bring into artistic production things like soup cans and words like *Pepsi*. Suddenly the range got much bigger.

CRISTINA GARCIA: My main man is Chekhov, for pleasure and despera-tion. Especially at crucial junctures—he's saved me again and again. I've gained a lot of sustenance from his humanity and characterizations.

HAROLD BLOOM: Johnson, always, with his antithetical style. Walter Pater and Hazlitt, who endlessly fascinate me, although obviously one cannot write with the baroque splendor of Pater, and one cannot write with that marvelous plain style of Hazlitt. Thomas De Quincey. Kenneth Burke, especially in *The Rhetoric of Religion*. And of course Emerson. When I was in a deep depression in the middle of the journey, in 1965, when I was 35, I came out of it essentially by reading two essayists, Emerson and Freud. But, today, who can be Johnson or Emerson or Hazlitt or De Quincey? It's too late in the day.

DAVID THOMSON: When I was in my twenties, I discovered a yellow French magazine called *Cahier du Cinéma*. My French was O-level French, and I had to look up every word in a sentence, but I was still affected by that flow-ery style. A little after that, I discovered Andrew Sarris. Tynan was a big influ-ence—his ability to "get" an actor in a sentence. John Berger wrote art criticism the way I thought movie criticism should be written.

MEGHAN DAUM: Certainly there's no young writer in the country who hasn't been influenced by Didion. It's like singer-songwriters and Joni Mitchell. When I was in graduate school, I would read "Goodbye to All That" again and again and try to redo it. But then the memoir culture came about, and the bar was moved in terms of how people respond to first-person writing. If Joan Didion were my age now, I'm not sure she could get away with writing the way she did.

STANLEY CROUCH: You begin as an imitator. Through imitations, one finds one's own way. I taught a theater class at Claremont [College] from '68 to '75. I was influenced by Beckett, Genet, Pinter. A lot of freedoms were avail-able. I studied Yeats, Eliot, and Pound for their rhythmic effects.

For a time I was heavily into Mailer's *Advertisements for Myself*, then Bald-win's *Another Country*. LeRoi Jones was doing something with Joyce that Bald-win had done with Henry James—they added African-American rhythms. After

Baldwin, the level Ralph Ellison was on was a whole other thing. He was an Olympian with coal dust on his shoes. There was no sense of limitation. He was a black person not as an outsider but as an unacknowledged insider.

JAMAICA KINCAID: The biggest influences on me are the things I read when I was learning to read: the Bible, Milton, Shakespeare. They had an obsession with the beginning and end of a person, which are always the same—you are born and then you die. This literature all has the sense of death as an inexplicable inevitability and takes on the challenge of thinking that there's something beyond it, even though you know there isn't anything.

CYNTHIA OZICK: My first novel, which nobody has ever read, had clear Jamesian footprints, even in the use of adverbs. I can see Jamesian tics all over. But when I look at it now, I don't think I've ever written better, or been more ambitious.

Later, I came under the influence of E. M. Forster. I keep on my desk as a kind of talisman a copy of *A Passage to India*. I make myself take it away every once in a while, then I take it back. I open it, I look at a sentence or two, and then I put it down again. It's like a drink from some holy fountain. Lately I've put on top of that one Waugh's *Brideshead Revisited*, which is a first-person narrator and so stunning, so intimate. To get that voice, which is both intimate and Mandarin, is astonishing—talk about tone in the first person. That is marvelous. Forster is just the opposite, because he's sort of a wise man, from the outside. He has these little essayistic moments which are brilliant. He does it all. He makes it come out in the dialogue, and he stops to comment. It's just extraordinary. He wants to include everything one can think of—plus, plus, plus.

As a critic, I was shaped by the prevalent view when I went to school: close reading, analytic reading—that reverence for literature. That's what shaped me. The sentence in a piece of prose has to be as perfectly constructed as a poem. [Lionel] Trilling's sentences are these little spirals—not admirable sentences. But [Alfred] Kazin's are. And [Allen] Tate, and [R. P.] Blackmur, and [F. W.] Dupee—the whole gang—they practiced what they preached.

GREIL MARCUS: Pauline Kael, Leslie Fiedler, D. H. Lawrence's *Studies in Classic American Literature*. They dove into their subjects, wrestled with them, brought them to life. I had never come across anything like it. The writer became an actor in his own work—whether humble, arrogant, angry, or

defeated. I got a sense of life from reading this stuff. I thought, *What would it be like to feel alive the way these people do?* (Mailer is different. It's always about him, and if you don't care about him, you're left out.) It told me I could address the object of my fascination as an equal, as a citizen. If something pissed me off, I could figure out why I felt that way. Why not? That's the way people respond in baseball or politics. They hate, they love, they scream.

Manny Farber was a complete thrill to read. He'd write a two-to-three-page piece on a director that captured everything that needed to be said. He wrote a bit like Chandler with hard-boiled puns—I remember him referring to "Jeanne Morose." I knew I could never write that way, but it still inspired me.

JON PARELES: The writers I love are the dense ones. People like DeLillo and Pynchon, who you feel have simultaneously applied a microscope to everything they see and are also looking at the giant world conspiracy. I try to take away a combination of closeup and grand insight.

Among rock writers, I like Robert Christgau. His style is the opposite of mine—it's dense and clotted—but he's really smart. Greil Marcus is a genius in extrapolating the entire seashore from a grain of sand. He hears a catch in somebody's voice, and that is the history of slavery, plus he was drunk the night of the session. Greil's amazing at that. He's like a seismograph. A tiny flicker and the world shakes.

ELIZABETH MCCRACKEN: Grace Paley. I have no idea what makes her short story "Gloomy Tomb" a short story, but it influenced me in a very strange, very mysterious way. There was a combination of a particular warm voice, a certain directness, and a certain prickliness. It was a little like Thelonius Monk's music.

JUNOT DÍAZ: Cormac McCarthy was an important model. When I found him, I was blown away. The whole time I was working on the stories in *Drown*, I was obsessed with Toni Morrison. She had it all. I was writing about Dominican masculinity, and it doesn't take a genius to see that no one knows more about masculinity than a woman. They have a handle on how utterly fucking nuts boys are.

I can't leave this topic without a word on negative influence—the writers you dislike so much that you resolve to do anything in your power *not*

to be like them. V. S. Naipaul provided an interviewer a list: "Santayana: almost unreadable. Gibbon lulls one to sleep. The King James Bible: unbearable, un*bear*able. The rhythm, and the killing of sense, the killing of sense. . . . And I don't like smooth things—I can't bear smoothness. Dryden is smooth."

Cynthia Ozick minces no words in describing her pet peeve:

> I hate Hemingway. I absolutely despise Hemingway. I can't tell you passionately enough how much I hate Hemingway. Those stories in *In Our Time*, cooking at the side of the river—those are housewife stories. They are so domesticated in an outdoor way. I can't stand the bareness of it. This naked prose . . . it seems to me so brutal. Grunt-grunt. There's no richness—no *mind*—to it. I mean, I think I understand why this was really refreshing when it first appeared, after all that fustian. It was probably such a breath of fresh air. But we're here now, at the start of the twenty-first century, and so many writers have bought into it. It's become so pedestrian. When I say I hate Hemingway, I hate him for his influence. What has he done to American writing? He's simply despoiled it. As opposed to Faulkner.

Writers often talk about finding their voice. It's an odd use of the common metaphor—a speaking voice is there for us all along and doesn't require a search party—but it's undoubtedly accurate. And so while it's true that some writers seem to be blessed with a style-by-birthright, needing only to refine or develop it, many others have a moment on their road to Damascus when, all of a sudden, the words tumbling out sound *right* for the first time.

Given youth's reputation for excess and revolt, one would think that the eureka moment would involve a taming of one's wilder impulses, an acceptance of convention. But in writing as in painting and music, it's more often the other way around—a movement from stiff correctness to the taking of liberties.

The shift from early conformity to mature liberation is especially common in people who come of age feeling that they are on the margins. African-American writer John Edgar Wideman said that in his early novels, he tried to "legitimize" the black characters and settings by "infusing echoes of T.S. Eliot, Henry James, Faulkner, English and Continental masters."

As I grew and learned more about writing, I found, or rediscovered I guess, that what Bessie Smith did when she sang, what Clyde McPhatter did, what John Coltrane did, what Ralph Ellison did, what Richard Wright did, what the anonymous slave composers and the people who spoke in the slave narratives did, what they were doing was drawing from a realm of experience, a common human inheritance. . . . As a writer I didn't need to go by way of the European tradition to get to what really counted, the common, shared, universal core. I could take a direct route and get back to that essential mother lode of pain, love, grief, wonder, the basic human emotions that are the stuff of literature. I could get back to that mother lode through my very own mother's voice.

In a similar way, Saul Bellow had published two "well-made novels" in the 1940s when he sensed something was not right. He later said:

I could not, with such an instrument as I had developed in the first two books, express a variety of things I knew intimately. Those books, though useful, did not give me a form in which I felt comfortable. A writer should be able to express himself easily, naturally, copiously, in a form in which frees his mind, his sensibilities. Why should he hobble himself with formalities? With a borrowed sensibility? With the desire to be "correct"? Why should I force myself to write like an Englishman of a contributor to the *New Yorker*? I soon saw that it was simply not in me to be a mandarin.

The result was *The Adventures of Augie March*, with its famous first sentence: "I am an American, Chicago born—Chicago, that somber city—and go at things as I have taught myself, free-style, and will make the record in my own way: first to knock, first admitted; sometimes an innocent knock, sometimes a not so innocent." In a later interview, in 1991, Bellow described the novel's style as "putting my own accents into the language. . . . I wanted to invent a new sort of American sentence. Something like a fusion of colloquialism and elegance. What you find in the best English writing of the twentieth century—in Joyce or e.e. cummings. Street language combined with a high style. I don't today take rhetorical effects so seriously, but at the time I was driven by a passion to invent."

Grace Paley—like Bellow, the child of Russian immigrants—took a

class with W. H. Auden at the New School in New York when she was still in her teens. Auden was impressed with her and asked to see some of her poems. A couple of weeks later Paley went to see him, and he began by asking about what struck him as some odd terms in her poetry. "He said to me, 'Do you usually use words like *trousers*?' I had never said anything but *pants* my whole life. 'And what about this word? *Subaltern.*' You know, like a sublieutenant. That was the beginning of the war. 'Well, once in a while.'" Paley said she didn't drop her "English-English" mannerisms until she began writing short stories: "Poetry is addressing the world, and fiction is getting the world to talk to you. When I was able to get into somebody else's voice, when I was able to speak in other people's voice, I found my own. Until then I did not have a voice that could tell a story."

Pauline Kael studied philosophy at graduate school, and when she began writing about movies, "I worked to loosen my style—to get away from the term-paper pomposity that we learn at college. I wanted the sentences to breathe, to have the sound of a human voice. I began, for example, to interject remarks—interrupting a train of thought, just as we do when we talk, and then picking it up again." In a later interview, she said that when she started, "I was conscious of the fact that I was writing about a popular art form. I don't think I would have written in the same way if I were writing about classical music. How can you deal with movies truthfully, in terms of your responses, if you don't use *you* instead of *one*? I mean, I'm not a goddamned Englishman. I don't say, 'One likes this movie very much.'"

Margaret Drabble *is* an Englishwoman, but she underwent a similar process of loosening up in the course of writing her first novel, *A Summer Bird-Cage*, which was published in 1964. She says:

> I just sat down one day and started off, in a very informal, chatty, first-person voice I really enjoyed. I know why I chose this voice. It was because I'd been at Cambridge studying English literature and I'd been writing essays and studying the grand designs of George Eliot, the Great Tradition, and I thought, *I can't write like that and I don't want to write like that. I'll write something very, very small and informal and try and get rid of this judicial tone we were all supposed to adopt.* You know, we were never allowed to use the word *I* or say *I think* or *it seems to me*. So I suppose when I started writing in the first person, which I also used for my next

two novels, it was a total throwing away of everything I'd been doing for three years at university. And it was a great liberation. I thought, *This is fine, this narrator can be as silly as she likes. She can just say whatever she feels.*

At the time that I wrote my first novel I had just married my first husband. I was living in Stratford-on-Avon; I didn't really know anyone there. I was sort of bored. Writing a novel was very much like talking to myself and trying to work things out.

What all these stories have in common is the idea of a true style being born of a certain comfort and ease. That feeling is not available if one is trying too hard. Frank Kermode's career as a scholar and teacher was delayed six years by his service in World War II. "I became a critic late in life, at twenty-eight," he says. "I was anxious to make my way. I needed to write a book, and that led to a certain amount of strain in the writing—I pushed too hard at the ideas. When you're young, you're writing for your life. You tend to be rather grandiose. Eventually, I learned to relax."

Early in a career, in order to get published, or hired, it is often important for a writer to master a middle style—to learn to do things the way everyone else is doing them. At that point, he or she can start becoming different. At some institutions and historical moments (say, *Time* magazine in 1953 or MSNBC.com right now), that is discouraged; in other circumstances, it is embraced. Anna Quindlen went to work as a feature writer for the *New York Times* in the late 1970s, "a moment," she says, "when newspapers suddenly permitted some sense of stylistic individuality. And overnight there was a group of us whose unspoken goal was to have the readers recognize us even if the composing room dropped the byline. I think you see that with [Gay] Talese and [Tom] Wolfe, of course, and Francis X. Clines and Maureen Dowd, whose voice is absolutely indelible. Certainly it was something I always tried for."

Paradoxically, the stronger the conventions and expectations, the more opportunity there is for a personal voice to emerge, and the more distinctly it can be discerned by sharp-eared readers. Not long after its founding in 1925, *New Yorker* magazine had established a formula for its biographical articles, called Profiles. The building blocks were long paragraphs, each one filled with a series of straightforward, mostly factual declarative sentences that could be deployed for the purposes of humor, irony, drama, poignancy, or merely information. In the 1930s, two young newspapermen, Joseph

Mitchell and A. J. Liebling, joined the magazine's staff. The first articles of each were conventional and competent. But within a couple of years, both men began to stretch the boundaries of the *New Yorker* profile while still honoring the essential values of the form. Mitchell used the lives of the marginal characters and "lowlife" of New York to pose the immortal questions of faith, death and meaning. Liebling insinuated his own hectoring, philosophizing cadences into his articles, so that what started as a profile of Governor Earl Long could detour into a discussion of Liebling's tastes in and theories about Louisiana cuisine. For 50 years hence, the same process, of initial conformity and eventual innovation in profiles, occurred over and over at the magazine—with Lillian Ross, Calvin Trillin, John McPhee, George Trow, Ian Frazier, Mark Singer, and Susan Orlean.

Helping George Kennan find his formal, almost mannered style were the conventions of the U.S. foreign service, where he worked in his younger days. Kennan told an interviewer:

> We were required to give a certain stately and dignified form to many of the things we wrote. Although this was never said by the ambassador overseeing the officer, the dispatches all had to begin with the salutation "The Honorable the Secretary of State." Then "Sir." And then the first sentence had to embody the phrase "I have the honor." So you had to say, "In my dispatch of such and such I had the honor to mention to you So-and-So." But you always had to put that into the first sentence. It was the way that George Washington and the other Founding Fathers wrote. And when you got to the end of one of these diplomatic dispatches you had to end, "I have the honor to be, sir, your humble and obedient servant." Well, there was something about the restrictions on the diplomatic writing which I think was good for me. It was a really good restraint, I thought, for young writers. Goethe said that literary mastery expresses itself only in the restrictions it accepts.

In the stories writers tell themselves about their own developments, there are all kinds of tipping points. John Lukacs found a key element of his style through being a teacher. He came to the United States from Hungary in 1947 and found work teaching history in a small Catholic women's college in Philadelphia. He remained there until his retirement nearly half a century later. He says:

The very fact that I taught undergraduates was an indirect but im-
mense help to my writing. You're very young, and you think, *How can I fill
a fifty-minute class? I have to tell them* everything." Then you realize that is
impossible, and you come to the conclusion that you have to describe
things simply, economically but not superficially. Suppose I am teaching a
course on twentieth-century European history. I have only four lectures
on the First World War. I have to choose what's important. And I learned
to approach writing the same way. If I had ended up a graduate profes-
sor at a big university, giving seminars on the things that interested me,
I would not have ended up the writer that I am today.

Abraham Verghese found *his* personal style through being, of all
things, a student. Born in Ethiopia, Verghese received his medical training
in his parents' native India and took his residency in the United States, all
the while writing stories and essays in his spare time. In 1991, at the age of
36, he decided to give writing his best shot and studied for a year at the
University of Iowa Writers' Workshop. He says:

To me, finding voice is about confidence. It was great to have these
fourteen people [his fellow students] respond to my work. It immedi-
ately became clear that what I had been doing—self-referential, clever
stuff that impressed my family and impressed me—was not going to
work. Typically, when your mother starts to dislike your writing, that's
when you've really found your voice. You've come to an honesty that's
maybe causing some discomfort to the people around you, as opposed
to writing pretty in an entertaining libretto way.

Initially, Verghese concentrated on fiction. But his first book, begun after
his year in Iowa, turned out to be *My Own Country*, an autobiographical
account of the patients with AIDS he treated as a doctor in rural Ten-
nessee, and his second, *The Tennis Partner*, a memoir of his relationship
with a troubled colleague. Switching genres proved a challenge:

My fiction is much more wild and exuberant, and I struggled when I
first started writing nonfiction. I had to speak as myself. There had to be a
sameness and a tameness to my voice. And I had to learn that this is one of
the great advantages of nonfiction: when something is true, you automati-

cally have the reader's interest, because we're all inherently curious about things that really happened. In fiction you have to work ten times harder to hold the reader's interest; there's an exuberance or excess that fiction has to have. If I were to make up a story based on the O.J. Simpson case, think how much effort I would have to expend to make it credible. As fiction, it's paltry, it's not even halfway interesting. And yet, because it really happened, look how much time you and I wasted on that miserable story.

As Verghese's experience suggests, finding a voice can be a matter of finding a genre. Jonathan Raban says:

> I spent five years doing nothing except write plays, plays for radio, plays for television, one play for the stage. I greatly liked writing for voices, but then I became more and more interested in my stage directions. I would set the scenery, the description of the room, pages and pages of description all underlined with my old-fashioned manual typewriter, before anyone began to talk. And I thought, *It is now time to stop being a playwright.*

For Andrei Codrescu, whose voice is absolutely distinctive in print or on the radio, a crucial change was a very simple one: writing in units just a few hundred words shorter. He had been writing a column for the *Baltimore Sun* for several years when he got a call from Art Silverman, a producer at National Public Radio, asking him to record one of his pieces for broadcast. Codrescu says, "Art said that for the radio, it needed to be a little bit shorter—four hundred words as opposed to seven hundred fifty. That was great, because as a poet I was used to concentrated language. The four hundred words felt more friendly to me—for seven hundred fifty words, I had to put in filler."

Novelist Richard Ford, who grew up in Mississippi and Arkansas, found that the key was where he hung his hat:

> One of the reasons I didn't want to stay in the South was that I didn't have much to offer from the standpoint of language. My language, I thought, was just like everybody else's language in the South. . . . I wanted to go off someplace where I had to make up my own language. . . . But now I have a different language that's almost my own, which is the kind of flat, uninflected language of the Great Plains, which I love.

Sometimes style lies in wait for theme, and vice versa. Here are three accounts of their coming together, the first laborious, the second instantaneous, and the third a kind of logical inevicbility. Working on his first book, a collection of interconnected short stories about the difficult boyhood of a young man named Yunior, Junot Díaz struggled to find the right style for Yunior's narration:

> Boys don't talk about themselves. I wanted a voice that was in your face, blunt, honest—but at the same time hiding a huge silence about himself and all the conflicts. That was the idiom that all the boys I know used.
>
> When I tried to mimic the language he would really use, it didn't work. You can't mimic silence. I had to give the impression of that silence underneath. I needed to get the final result, the effect, without necessarily using the exact language. Something can be false but still have "truth effects." I couldn't be very pyrotechnic in the language; that would betray my hand too much. This guy would never look into his heart. Sometimes I would generate language that was five hundred times too lush. Yunior would veto it. I wanted to be the storyteller, but Yunior also wanted to be the storyteller. If I just asked him to show up and read his lines, he'd say, "I can't do this."*

In 1968, Greil Marcus left graduate school for the life of a freelance rock and roll writer. He says:

> I'd been writing for about a year, but I never wrote anything really good till the fall of 1969, when I wrote a piece about *Let It Bleed*, which I

*A paragraph from Díaz's book, *Drown*, shows that he succeeded in achieving the truth effect he wanted: "Days we spent in the mall or out in the parking lot playing stickball, but nights were what we waited for. The heat in the apartment was like something heavy that had come inside to die. Families arranged on their porches, the glow from the TVs washing blue against the brick. From my family apartment you could smell the pear trees that had been planted years ago, four to a court, probably to save us all from asphyxiation. Nothing moved fast, even the daylight was slow to fade, but as soon as night settled Beto and I headed down to the community center and sprang the fence into the pool. We were never alone, every kid with legs was there. We lunged from the boards and swam out of the deep end, wrestling and farting around. At around midnight abuelas, with their night hair swirled around spiky rollers, shouted at us from their apartment windows. ¡Sinvergüenzas! Go home!"

still feel is the best record the Stones ever made. *Goodbye, Baby, and Amen*, David Bailey's book about swinging London, had just come out. I was so struck that the entire moment in the culture looked so phony, so old and contrived. I said to myself, *Something's over. Things are going to get rough.* I had the sense that we'd just been through something that we'd spend the rest of our lives trying to understand. I wrote a piece for *Rolling Stone* that had many subjects. There seemed to be a lot at stake. My writing was more clear, more blunt, than ever before. It was the first time I escaped from self-censorship. I had no thought of what people would think. That's a premise of writing, as far as I'm concerned—you have to cease to exist. It's irrelevant who you are. The best work I've done is when I care what I'm writing about, not about me.

In addition to the usual burdens of a young poet, Billy Collins says, he started out with the wrong influence:

You come to your style by learning what to leave out. At first, you tend to overwrite—embellishment instead of insight. You either continue to write puerile bilge, or you change. In the process of simplifying oneself, one often discovers the thing called voice.

When I started, I was under the spell of Wallace Stevens. I was writing intentionally difficult poems. It wasn't bad for obtuse poetry, but it was totally humorless. I thought that was me the poet. I didn't know what he was talking about, but that was suited to me, because I didn't know what I was talking about.

Richard Brautigan and Thom Gunn were important models for me in getting away from the knottier stuff. When I read Gunn's poem about Elvis Presley, I was shocked—I did not know you could write a poem about Elvis Presley. And Tom Clark's poems about the Beach Boys and Don Ho. They were hooded, and full of linguistic play and irony. They got me out from Stevens's influence.

All young poets put on poetry sunglasses. I took off the goggles, and then I could let in humor, personality, all the things I was excluding. The main thing was simplifying my vocabulary. Eventually, I was confident enough to write a simple sentence, and then I began to recognize the sound of my own writing.

Interlude
Progress in Works

The following reproductions of writers' manuscripts—a page from an essay by John Lukacs, a poem by Billy Collins, two pages of a novel by Cynthia Ozick, and a 1976 *New York Times* column by Russell Baker reveal, if nothing else, the varieties of the compositional experience. Lukacs' thoughts, apparently, flow from his mind to his fingers in running sentences that require little alteration in order to reach publishable form. Baker's additions, penciled in strong, clear block capital letters, are virtually all designed to make his prose stronger and clearer. Collins' revisions suggest an orderly process of refinement and improvement. The process continued, as you can see if you consult the final version of the poem as published under the title "In the Evening," in *The New Delta Review*. Almost every line has been changed from this manuscript, usually in subtle ways. For example, "I pick up a knife and an onion" has become, "I pick up an onion and a knife." Better, no? And the Ozick—from her novel *Lights and Watchtowers*—reminds us that for some artists, the process of creation is profoundly, almost sublimely, messy.

Popular & professional history.

In... David Mc Cullihuyg wrote the best history of the building of the Pan Canal. In... in a widely
adopted and best-selkloing (Fix) An history textbook by Harvard professor Freidel and Bnkley,
this work is listed in the Bilbiogr in these werds: "A lucis popular hoistory of the
building of the canal."

"Popular history"? What kind of nonsense is this? The P:ath Between the States is (was?0 not onl;y
well-written; Mc Cullough' s research and reading and scholarship was largely faultless —
indeed, surpassing in extent and judgrent that other contenporary... In
Mr&willcughxxwasxaxmastxaxpxxfesssiænxaixdxiskxxian The Path Between the Seas Mc C deonstrated, indeed,
he represeneted all of the qualifications and the desiderata of a h istorian; and then sore.
ButxxxassxxdixgxtexRxeidelxxxxxaixxxbwxxxx Indeed: a professional as well as a popular historian —
though x by vocation; tthough not an academic historian, by affiliation.

And Through this narrowing and desiccated and sickening devolution of history through professional
history tho academic history I rust now turn.

 * *

Modesm historical consciousness — as a modern phase (FIX) after Greek historical thinking —
evolved in Western Europe during the 16th and 17th centuries. "Historian", as distinct from
an annlist or a chronicler, appears in the English language, according to the O.E.D. somewhere
between 1531 and 16454A further evolution of our (until the 20th century, about exclusively
Western) historical consciousness was as follows) During the 18th century history was
regarded, and read, as literature. During the 19th century historyt was, foer thr first time,
regardedxxxxxxxxxx seen as a science. BuxringxtxhexxMbxxkentxnyxxxastxdxistexxiansxxxxxxxbyxxx
profexssienaixhisterixnssxxswelixasxbyxxxaxbxxfxxthe During the knewxitsssd 20th century.
hoistory became more and more as on of the principal forms of a social science. (I believe
— b elieve, and not only think — that in the 21st century history will become literature
again; but this will not be a reversal, rather than the contrary: whil;e history may become
less and less .1,iterary, all prose literature will become more and more historical. But
I am writing this as a shistorian, not as a prophet.)

Back to the 20trh century, during which we may detect (wiuthut much stratining of our eyes) a dual
development. As an expectable and naural consequence pof the denocratization of entire societies,
the scope of historical study and of historical description has broadened. This broadening
(widening)? involved many things: thge historical study and occasinaly reconstruction.of
the history of najorities and not only of minorities; of areas of study beyond and of description
and government; of the consideration of methods of naterials from other "sciences" (perhaps
my quptati0on-narks are perhaps intential) as sociology, statistic, psychjology,m etc. Tuhe
results have been mixed (often they amounted to nut much more than the dubiosu results quetsionable
of a retrospective socilogy), but this is not my ragument at his point My arfgurent is that
we are still in the presence of a dual developnent: for this by and .large inevitable and
even commendable., broadening of our historical perspective and scope of study has occurred togtehr
with a lamentable narrowing of the ategory (?)FIX of professional historianship, to the point extent
where the very tem nfxxprofessixonalbhxisterxianshxipxxxxx "academic" may be a nore telling
term (adjective) than mere "professional."

But Apart from this narrowing, The broadening of historical study and interest
in our denocratic age has been a welcome (though generally unrecognized) developnent. L et
me cite again one of my betes noires, , the first edition of the DICTIONARY OF THE F ACADEMY,
published in 1694, which dfined history as :"the narration of actions an d of matters worth
remembring." The eighth edition, in 1935, said nuch oif the same: "the account of acts, of
events, of matters worh tenembering." DIGNES DE MEMOIRE! Worh tremenbering! What nonsense this ius!
Is the historian a kind of professional whose training qualifis him to tell rodinary people
what is worth renembering, tpo label or autehnticate persons or eventrs as if they were fossil
fish or piueces of rock? Is there such a thing as a person and another such thing as a historical
person? Every event is a historical event. every source is a historical source. Every person is
ashsisstrpxéchxltpéisonecHistoirytalennow anetettiathehdehostatianage, shich simply n,eans (the neaning

Time of Day

In the every the ~~heads of the~~ roses ~~drops~~ droop
and the bee who has been hauling ~~too~~ gold
all day finds a hexagon ~~to sleep~~ in which to rest
~~Soon to be black~~ wide, The sky is ~~turning gray~~ ~~dull~~
~~The sky will soon be blackened~~
~~is dull growing dull~~ the water colors
~~but now it is~~ grey, except for ~~the bright~~
~~the water colors~~ of ~~red~~ pink and yellow ~~on~~ along the horizon.

I light ~~two~~ candles on the wood table.
The white cat sits facing a wall.
The ~~horse~~ horse in the field ~~sleeps~~ is sleeping on its feet.

~~I~~ pour ~~white wine into~~ a glass of white wine
I take a sip of white wine
~~I~~ pick ~~and for~~ up a knife and an onion.

The past and the future? a child with two masks.

153)

(25)

[Heavily revised handwritten manuscript page with extensive crossings-out and editorial marks; most text is illegible.]

Carter, by contrast, has a masterful Expector-General. He

has already ~~boasted~~ ANNOUNCED that Carter can expect nothing better than a third-

place finish in New York, and Udall's Expector-General has ~~taken~~ ACCEPTED this

WITHOUT PROTEST. ~~prediction in silence, which~~ THIS means that a third-place finish ~~killing~~ for Carter

~~will~~ will be interpreted as not too bad, while a third-place finish

for Udall will be a ~~small~~ disaster.

In Wisconsin Carter's Expector-General has ~~met the threat of~~ AGAIN DECLARED

~~polls showing him beating Udall by declaring~~ that Udall ~~has always been~~ IS

expected to win there. ~~Thus,~~ If Udall does win, ~~in spite of the polls,~~

Carter will have satisfactorily lived up to expectations. If, ~~the polls~~

~~are right and~~ Carter ~~does win, on the other hand,~~ WINS, he will be perceived

as an irresistible confounder of expectations whom the Convention cannot

(IN SHORT, CARTER CANNOT LOSE; EVEN IF HE LOSES.)

ignore. Once again Udall's Expector-General has played blandly into

(BY stating that Udall is expected to win,)

the Carter gambit, so that a loss in Wisconsin will be doubly damaging.

If all this political maneuver seems somewhat arcane to

the casual reader, it may be because in the primaries winning an election

TO THE PUBLIC.

is usually not what it seems. In most primaries, winning is only what

MEDIA

the ~~political reporters~~ say it is. (As in Jackson's "winning" Massachu-

OF THE VOTE

setts with 23 percent and Carter's "winning" New Hampshire with 29 percen'

(more)

CHAPTER VI

What Writers Talk About When They Talk About Style

I will never forget the look on Peter Carey's face. I was interviewing the novelist in the living room of his Greenwich Village apartment and had just asked him about the way he viewed style. Carey really wanted to help—his almost anguished expression told me that—but it was impossible for him to analyze or articulate this aspect of his craft. He said:

> The big thing for me in writing a novel is the voice of the teller. Almost all of those voices, I've never thought about it. I never considered how it would sound, or played with it. When it comes to all the other aspects of the novel, there are a lot of things that I consider. The voice, I never thought about. It's totally instinctive, really.

Like many types of beings, writers can be divided into two categories: those who obsessively pick apart what they do and those who flee from analysis as if it were a killer tidal wave. The latter group sees writing as art

(inspiration), the former as craft (perspiration). The choice has no bearing on a writer's merit: there are Nobel laureates who talk endlessly about their philosophy of punctuation, and hacks who take the Fifth on all writing-related questions, thinking it will spoil the magic. But it is very relevant to this volume, for obvious reasons.

To Peter Carey and the other instinctivists I interviewed, I offer my apologies for the irritating questions. And to the other group, I offer thanks for their remarkable testimony. This rarely came in the form of a philosophy of style, or any strictures that would fit nicely in a classroom or textbook. Rather, what was expressed was an *approach* to style, to voice, to the word, to the sentence, to writing itself. The emphases and ideas varied widely, as you can see. But what they had in common was that they were expressed with both passionate intensity and conviction. Listen:

JUDITH THURMAN: One of my favorite quotes is from Flaubert: "As if the soul's fullness didn't sometimes overflow into the emptiest of metaphors, for no one, ever, can give the exact measure of his needs, his apprehensions or his sorrows; and human speech is like a cracked cauldron on which we bang out tunes that make bears dance, when we want to move the stars to pity." A great sentence is always about what you *couldn't* say.

There's a line I wrote in my review of Bill Blass's autobiography, about the women who were devoted to Blass and always wore his clothes: "Beneath the surface dazzle, there is something extinguished about the Blass Ladies—a flame smothered by convention. When style burns true, it's cooler and more cryptic. You can't decode it at a glance." Style has a certain intensity, like a clean flame. All the garbage, the impurities you start with, the lighter fluid—it's all burned off. It's consuming something pure and clean. Isak Dinesen said that impure ingredients—eggshell, bone, and root—make a clear, pure soup. The memory of all that formed it is always there in the style.

At the same time, even though the impurities are burned off, the *sense* of impurity is essential to good style. Humility and rootedness are essential. As in Colette, the dialectic for me is the pure and the impure.

BILLY COLLINS: Poetry originally served as a mnemonic device—the rhyme, the alliteration, the meter, the stanzaic patterning all are memory aids for reciting a long text. When alphabets were introduced, poetry lost that function, rhyme and meter became demoted to options and the poet lost his

means of automatically establishing trust. Now, the important thing is the tone. The buy-in to a poem is, Do you trust the voice? A novelist invents many characters. A poet invents one character, the voice you're going to speak in.

JONATHAN RABAN: Style is a way of expressing a thought that one instinctively responds to. There is a sense of recognition, of saying, "God, that is true"—as if the thought had been there before the expression came to it. It gives the illusion of somehow having thought before. My favorite quotation of all time is Wittgenstein's "The world we live in is the words we use." Style is not an appliqué technique, a paintbrush with which we pretty something up. A good sentence alters the world.

I think, more than for any other single reason, one writes to entertain oneself. I'm not writing a report for someone, I'm not dutifully turning in my log, like Captain Vancouver, having to describe every single anchorage he dropped anchor in. I'm there to entertain myself at the typewriter—but with the cold, skeptical eye of the critic perched like a parrot on my shoulder, saying, "That doesn't work."

ABRAHAM VERGHESE: Writing represents putting words into the kind of internal dialogue that thoughtful physicians have. The bedside exam rests on the pillars of inspection, palpation and percussion. That level of observation brought to writing is a very good thing. The converse is true as well. It's rare that I come in with a special body of knowledge that unlocks the case. What I can do is take the history, and what helps me do that better, and be a better physician, is when I hear it as a story.

DAVE BARRY: There is a lot of what I call "God writing" in the newspaper. We're taught to sound authoritative and impartial and professional, and often to sound boring. I always wanted my column to look more like it was a total mistake that I had gotten hold of the word processor.

ANDREI CODRESCU: Somebody said to me one time, "I always get the impression when I read one of your stories that there is another story behind it." Well, sometimes that's literally true because I will write part of a story but won't write the rest of it. But sometimes there's a feeling that there's something else. I think that's true to an extent for all writers, because the language really does know more than you do. There is a sense that you write *outside* the words, that there is this other thing that now and then you come close to.

Today there is a required seriousness or gravitas in writing—it feels immediately threatened by humor and lushness and breaking up the rule of directness. It's certainly evident in writing programs—the old "write what you know, be direct, don't use adjectives." I go very much against the whole thing. In fact, I think the more games and the more bafflement and joy, the better. Lucian Blaga, who was my favorite poet when I was growing up, said, "I've always felt that my duty when faced with a mystery was not to explain it but to increase its mysteriousness."

ELMORE LEONARD: I want readers to be immersed in the story the same way I was when I was writing it. So I don't write the way I was taught to write. We were taught to make the sentence interesting by opening with a dependent clause: "Upon entering the room, he couldn't help but notice . . ." To me, that's distracting.

I love literary writers. Roth in *Goodbye, Columbus*—he's *writing* all the way through. Martin Amis, Updike—you're aware of them writing. They can do it; they have the language. I don't. Barry Lopez can describe snow and ice for four hundred pages. In a whole book, I'll take maybe a couple of shots at the ocean.

JOHN UPDIKE: Style as I understand it is nothing less than the writer's habits of mind—it is not a kind of paint applied afterwards, but the very germ of the thing. One has certain models of excellence, certain standards of prose evolved with the hope sometimes of teachers and editors, and certain readerly expectations that one hopes, as a writer, to satisfy. Just as one's handwriting tends to come out the same every time, with certain quirks of emphasis and flow, so does one's writing, with its recurrent pet vocabulary and concerns.

CAMILLE PAGLIA: I believe that the style of the critic should be suggested by the work of art. It's almost like ESP, or telepathy. We are drawn into the world of the work; it casts a spell on us.

A lot of my work comes out of poetry, where you need intuition, and attention to the power of words. I adore the individual word and the individual sentence. Any given sentence should be able to stand on its own, and contain everything. I always have the feeling that if one sentence were left, one could recreate the writer. The paragraph is a unit of thought. It should be a world of its own.

JUNOT DÍAZ: As a person of color growing up in the '70s and '80s, my idea of literature was programmed by white mainstream notions. That code,

that software—when I deploy it, it's guaranteed to produce disastrous results. I struggle with "the word" and everything I've learned about literature.

The subconscious preserves all memories that the conscious can't grasp. My early drafts are missives from my unconscious. I spend the rest of the time trying to decode it. A lot of times, this has nothing to do with publishing a story—it's about my life trying to send me this message.

Young writers try to take these messages and discipline them, make them conform. Anyone with a creative streak knows that if you wait with a bit and harness, there's a reason it doesn't show up. You need to want to play—waiting for something you can use, and being ready to catch it when it falls out.

GREIL MARCUS: People will say to me, "How can you make so much of a song? Aw, come on, it's just for fun." I've heard that all my life. It always means the same thing: Stop thinking.

I go over stuff that I've written, and sometimes I'm shocked by the pomposity, the stiffness, the plumminess. When I have that reaction, it means I wasn't engaged. I was just throwing out a judgment, getting something over with. When I read stuff and it works, I don't think, *This is well done*. I *do* have a great sense of event. I want to feel that writing something can *open* something for whoever is reading it. You don't start with a judgment but rather with a feeling that something is going on here. That becomes an event in itself.

Sometimes, as you're writing, you discover what you know. Sometimes you find out that you didn't have a clue. The task for me is to make that into drama. I'm not very good at analyzing, but I like to dramatize. You open the door of a theater, and if you're lucky, someone comes in. It speaks to them. It's so far beyond suspension of belief, it's suspension of identity. It's like going to see a great production of *Long Day's Journey Into Night*—you totally forget who you are and what you know.

In college, I never wrote a paper that wasn't an all-nighter. I would clutch it in my hands, bring it in to class, feel absolutely heroic. I wrote a lot of *Lipstick Traces* in a state of ecstasy and delirium. I felt I was the first person to feel what was special about all this—that it was a wild horse, and I was riding it.

It goes back to Pauline Kael. When I read *I Lost It at the Movies*, I couldn't believe how alive this person felt when she wrote it. I wanted to know how it felt to be engaged that way. In a way, I've yet to find out.

TOURÉ: The ear is essential. In writing, the first thing is, does it sound good, by itself and in relation to the other words? The subject is second. You have to say it in a funky way. In the African-American community, you've got to walk down the street in a funky way. As Nelson George says, it's not enough to score two points—you have to dunk backwards with two hands, embarrass the guy. Style is the most important thing.

DAVID THOMSON: Montage to me is one of the most fascinating areas of theory and practice. One of the few profound things that happened to me at film school was when we had someone talk to us about Russian editing. He put two objects on a table and asked, "How are these objects related?" Then he said, "I challenge you to find any two objects that I can't relate." The mind leaps to associate things. It's so inventive. That is the beginning of the theory of montage. In writing, you can throw an odd or invented word in a sentence, or an unexpected sentence in a paragraph, or make an abrupt end to a chapter, and the reader will say, "Why did he do that?" The good readers, anyway. And then they'll start thinking. I love that question.

This seems to work best in going from one sentence to another. A conventional opening might say, "It was the year so and so, and such and such was happening." And then you suddenly say something that was also happening in that year, something totally unexpected but that gives a sense of the context. The nature of the cut teaches the reader to look for those cuts in the future. If you start to do something odd with sentence form, like not having a main verb, readers will start to get used to that. They might not like it, but they'll get used to it. You can guide people how to read your book.

JAMAICA KINCAID: The great pleasure is hunting down my unconscious in writing. I don't know if I should be paid, it's such a pleasure. It's a process of hunting down what I mean, dragging the reader into my consciousness. I never have a second draft—it takes me so long to hunt this thing down. There is never anything more to come.

There is so much I ask of the sentence—the way history is made, is told, the way life forms people, the impact small things have on the bigger world, the impact the world has on one person. What I want is to write about those things. But I would rather jump off a bridge than write a historical novel. So the challenge is how to say those things without putting them into a boring form. Life is not like a beginning, middle, end. A novelist is a person who tries to

make order out of it. I'm not interested in order. I'm interested in the way things really happened.

Don Quixote didn't know that what he was looking at wasn't there. I would think that would be an admirable goal as a human being, to think that you will understand your end, even though no one never has. And, as a writer, to write the greatest sentence ever, but I won't. I will find something that no one else ever has, even though I won't.

Now we arrive at the land of the number 2 pencils and legal pads—of the practicalities of composition. These constitute, of course, the number-one cliché of the author-interview genre. Yet I asked questions along these lines, and I set down a selection of the responses here, because they illuminate style. Thus Harold Bloom says: "I write in record books with a Pentel black rolling ballpoint pen. It's the only way I can write—I've never learned to type." And suddenly one has an insight into Bloom's prose, with its—yes—rolling cadences, and pre–twentieth century tone. Tobias Wolff says: "Because I don't type, I can't work any faster than I think." And that sheds light on Wolff's style, which maintains a stately pace even as the action is speeding up.

Perhaps the most surprising finding, in the practical realm, had to do with computers—how many writers feel ambivalent or hostile toward them, or, like Wolff and Bloom, don't use them at all. This was especially the case among those self-conscious or analytical about style. The physical effort involved in using a typewriter or pen provides for them, a helpful speed bump in a word's passage from the brain to the page; word "processing," nearly effortless, lacks a necessary friction, as well as the tactility common to all handcrafts.

Handmade versus machine-made: the opposition clearly pertains to prose style. A handwritten text contains (often literally) its composer's signature, and there exist professionals who claim to be able to discern much if not everything about a personality from a single handwriting sample. Typewritten texts have a standardized look, but still, the imprint of a letter on the page is a function of personal touch. Holding a typescript in your hand, you can sense the physical presence of the writer as you read his or her words. But on a computer screen or a "printout," everyone's words look mass-produced and identical.

Certainly, many writers compose directly on the computer, but they tend to play Dostoyevsky to the previous group's Flaubert: putter-inners more interested in sense than sound rather than taker-outers who agonize over the just word. For them, ease of keyboard composition is a computer's best feature, letting the process become a modern version of nineteenth-century spiritualists' automatic writing, the fingers wired to the soul.

That in itself is a danger. When the words come too easy, consciousness streams, and not even the most flagrant egotist would (or should) want consciousness transcribed on the page. James Wolcott says:

> Editors tell me they see many more run-on sentences, and that's because of the computer. Sentence rhythm has been slackened to the point where there aren't any rhythms anymore. Also people have gotten wordier, because even though it's easier to edit on a computer, it somehow looks completed once it's on the screen, so there's a sense that, "Geez, I said it all, I'll just let someone else edit it."
>
> Today, because of computers and the Internet, a lot of people cultivate a very digressive style. David Foster Wallace will interrupt in the middle of a piece with a long digression, or a list. I can't do that—I feel it's kind of ego-tripping. "Look how I can analyze the secret life of Buddy Sorrell on the *Dick Van Dyke Show*"—that kind of thing.

Several writers made a distinction: they write on a computer for journalism and book reviews, but in longhand or on a typewriter for books. The journalistic piece work does not demand so much distinction in the way of style, and so can be trusted to the word processor. Jonathan Raban:

> When I write a piece, say, for the *New York Review of Books*, there's a readily available voice I use. It's a public convention, the voice of literary academia, a sort of overdignified tonal register that is instantly accessible. Of course, one tries to inflect that voice with as much of your own tone as you can to make it your own. If I could quantify, it would be something like eighty-four percent of the sentence is already created by the public convention; sixteen percent is the particular twist or inflection I can give it. I have a strong sense that writing those kinds of pieces, which I greatly enjoy doing, I'm propped up entirely by this public world.

And for some, even at this late date, the jury is still out. Fay Weldon told an English newspaper:

> I've only recently begun to use a keyboard. It happened because I read one of my own stories in an anthology of mostly American writers, and my handwritten piece seemed gnarled and twisted compared to the easy flow of the other writers who I realized all used computers. So I decided gnarled and twisted was not the path of the future. I've yet to see if it makes much difference to my style.

Writers of all kinds have a lot to say about the tools of the trade but are a bit closemouthed about the moment of composition itself, which is intimate and mysterious for even the most practical-minded. It can be painful as well, as witness the frequency with which images of pregnancy and childbirth are applied to the simple act of extracting a word from your head and affixing it to a piece of paper. Camille Paglia says: "The process of writing is absolute torture. I just have to get it down, even though it sounds terrible. It is an incredible relief to get to the last sentence."

The first words down are like a block of marble for the sculptor: raw material. The content, or much of it, comes blurting out in the first draft. (Kurt Vonnegut once wrote that this appalling stuff sounds as if it were written by someone named Philboyd Studge.) Style is usually clarified and intensified in the process of revision, which was not too traumatic for my interviewees to talk about. As a matter of fact, many described the exercise as downright enjoyable. Paglia says, "The ecstasy is going over it, getting rhythm and voice into it." Joyce Carol Oates put it this way: "The pleasure *is* the rewriting. The first sentence can't be written until the final sentence is written. This is a koan-like statement, and I don't mean to sound needlessly obscure or mysterious, but it's simply true. The completion of any work automatically necessitates its revisioning."

Here are glimpses of how some writers approach the nuts and bolts of their craft.

Preparation

CRISTINA GARCIA: I have a poetry bookcase in my bedroom, and I will choose a book randomly. It's like an *I Ching* thing—I will intuitively pick out a book. I will

check off things that I like, put them in brackets, and write it out in my notebook. The physical exertion of writing it in my notebook is important. Something in the process will get me started. And I have a superstition. Whatever I am working on, I will tuck into a book of poetry, so it won't be unprotected.

GREIL MARCUS: When I'm writing a book, I'll go on long walks all around Berkeley and compose in my head. I don't tend to take a lot of notes. When I do, I don't tend to look at them. I don't make an outline—I don't know how. I write a lot about mystery, about what makes culture alluring, and I want to capture some of that in my writing.

CAMILLE PAGLIA: I take copious notes before I even start writing. I try to empty my mind. I'm always jotting—I don't go anywhere without a notebook. I'm always trying to catch the thought, get it down. Then I look at the notes and annotate them further.

Composition

ANDREI CODRESCU: For me, writing is almost ahead of the process of thinking, because my way of thinking about something is sitting down and writing about it.

The physical posture in front of the typewriter is important. When you're writing a newspaper article, you simply don't have the same physical posture that you do when you're writing a poem. At least I don't. It's almost like you have to be *straighter* because there's a larger audience.

Background noise is fine, people talking or whatever. I always love it, because I started writing on the kitchen table in Romania when was a kid. My mother always had her girlfriends over and they were always talking, and just the sound of female voices going on and on about something was like a warm bath, I love it.

JONATHAN RABAN: I studied literature and taught it, and I think that has helped make me into an awkwardly self-conscious writer. I'm lucky if I write five hundred words a day. I spend most of my time posting rejection slips to myself because I can see that a particular sentence might look like somebody else's sentence. I have to make it mine, and I have to fight quite hard. The causes of dissatisfaction with a sentence are so multitudinous that you couldn't

possibly begin to list them. The ailments of a car are nothing to the potential ailments of a sentence. A sentence is like a human body—it's got a million different ways in which it can go wrong, or fail to serve you when you want it to.

But what helps is that once you get into a voice, once you've set a certain tone for the writing, you don't have to keep yoking it up, like a pair of oxen. The stylistic felicities, the particular words and phrasing, just sort of happen because the machine to generate them is there.

TOBIAS WOLFF: I hit a lot of wrong notes to hit the right one. There's a tuning fork that you hold up to your ear. At this stage of my writing life, it's much more hearing harmonics, testing sentences against the register.

In *This Boy's Life*, I was after something as natural, capacious, expressive as possible, that would account for the adult character without having to give information about him. The person is this voice. That's where everything important is to be found. I couldn't use a flat, tense voice. In Coetzee's memoir, he can't escape that detached, arid quality. He had to find a way to infuse it with emotion, and it was to write the memoir in the third person.

GISH JEN: I'm a very intuitive writer. I mostly either feel the voice I'm in is releasing me or not. When I feel it's not releasing me, I don't experience that as a "difficulty." It's like looking for the wind when you're sailing. It's not difficult not to have wind. You just move the sail till you find it. You try something out. I have an experimental cast of mind. I fiddle. If it's really not working, you abandon it. You can sort of tell because you're bored. If I'm bored, I stop. If not, I continue.

MARGARET DRABBLE: If it's all right, it's all right. Sometimes whole paragraphs or pages come out absolutely fine, and they come out very fast, which I'm sure is how Dickens used to write, just very, very fast. They're fine and you don't need to look at them. But then there are other bits, where what you were trying to do hasn't worked out or that sound clumsy. And sometimes if you work and work and work at a passage, you realize in the end that there's something deeply wrong with it, and you'd better just throw it away.

DAVE BARRY: I can take a whole day to think of a topic. I finally will get one and I'll get maybe a sentence and a half written, but if there is a good

enough intro or a good enough joke, I'll consider that a good day's work. I'll expect to finish that the next day, but I won't always succeed.

I'm a very slow writer, a constant rewriter. Humor is two things: the joke and the timing. I'm fanatical about whether to use *but* or *although* because of the timing. Or should I change a number like 853 to a number like 2,040? Which is funnier? Which one is big enough to be really stupid, without being too big? I spend a lot of time thinking about things like that.

ELIZABETH MCCRACKEN: Early on, I teach myself to think like the character. The first line is the chimney. Once you get down it, the voice is pretty effortless. Half the things I write are because of clever first lines. If I wanted any literary fame, it would to be in some quiz in the back of a magazine about famous first lines. I never wanted to start a book, "It was June" or something like that. All my novels have these grand entrances.

After I've been writing in the voice and the character for a while, it begins to get a little claustrophobic, how intimate the narrators are. That's when I try to step back a bit and put in a "poetic" passage, with metaphorical, literary language. That's the only time I'm very aware of making stylistic choices. It's almost like I can see what I'm writing projected on a wall.

CYNTHIA OZICK: Until I perfect a sentence, I'm not allowed to go on to the next sentence. And I don't allow myself to go back to the beginning to accommodate where I am now. Therefore I'm in a trap. I have to work something out in the current sentence so there's no need to go back and fix the antecedent action. Then, when you get to the next sentence, it's a kind of enjambment, if that's the word. It *must* respond to the previous sentence—otherwise, you get no cadence. To write sentence five, you have to read over sentences one, two, three, and four, to make sure your rhythm is constant. And if you go away for a week and come back, you have to read over and over and over to catch that tone.

It's so physical. There are these three fingers that hold the pen, and there is the ear. Of course, it's all ear.

Tools

DAVID THOMSON: I got a computer about three years ago, but I still write books in longhand, before transferring them to the computer. I'm not deeply

impressed with the word processor, but it helps me see when something I've written is overly complicated. Simply "disappearing" something you loathe, I find appealing.

ANDREI CODRESCU: I absolutely feel that there is a significant transition from the intimacy of handwriting, an almost preadolescent, intrauterine sound, to the public voice of the typewriter, where you make a lot of noise and people hear you and it is also the assertion of sexuality and adolescent here-I-am kind of thing. I had my first computer in Baltimore, in 1984. The thing looked like it came from a bunker. I think that after the typewriter, the computer is something of a return. The typewriter belongs to the era of revolution and the dark basements where they printed illegal manifestoes. It's a loud, clunky thing. When I discovered the computer it seemed like I returned to the intimacy of handwriting. It's quieter, and you write with light.

The problem with the computer is that you lose the bottom of the page. On a typewriter, a poet can make something that has to do with the frame of the page and the length of the line. You know what it looks like, but not on the computer. There is also the problem of mistakes. On the typewriter you have to take them out with Wite-Out, so in a sense you have a record of your mistakes. On a computer you eliminate them immediately, so you're not conscious of them. I mean, they're gone without a trace.

GREIL MARCUS: When people started using computers, I developed a fetish that I would never use a computer, that I would stick to the typewriter—but that I would always turn in absolutely clean copy, with no Wite-Out or cross-outs. In *Mystery Train*, there was nothing not written twenty times, till I could say I wasn't ashamed of it. I would write it again and again till it sounded like it was off the top of my head.

I started using a computer in '98. Once I did, I never touched a typewriter again, to my absolute shock.

CYNTHIA OZICK: It's all longhand. I write quickly. I can't read it, I write so fast. I have a pen that's called an Expresso that I have to send away for because Staples doesn't carry it anymore. I think they're about a dollar ninety-five each. It's a felt-tip, very fine, something like a fountain pen. I used to use a fountain pen, but now it seems klutzy to me, like a typewriter. The Expresso is black, it sort of flies out of your fingers. It makes me feel like I'm thinking with my hands.

JOHN LUKACS: My procedure has always been to type a first draft that was almost illegible because of all the corrections. I would retype it, then give it to a typist to put on a computer.

You come at a historic moment when I have failed in the courage of my convictions. I gave in, I was a coward, I bought a computer last week. I was having trouble getting ribbons for my typewriter, and I can no longer find a repair shop.*

JAMES WOLCOTT: I used to write in longhand, then type it, but that would take so much time. Then I eventually stopped writing in longhand, but the typing exhausted me. I couldn't sit and type out a rough draft, so I was whiting out, erasing. I would tear a hole in a page, then have to retype the whole thing. Now I write on a computer, but I am really conscious of trying not to be slippery.

CAMILLE PAGLIA: I have to write longhand. When I wrote *Sexual Personae*, I didn't even *have* a computer. Now I have one and I use it for business letters and things like that, but I find it impossible to get my own style from writing on a computer. I like to be able to turn the pages and look back. The actual movement of the hand and arm are important, and the cross-outs.

I believe that the computer has really started to homogenize writing. It's helped people with writer's block, but everyone is beginning to sound alike. It's so easy to move paragraphs around that there's no longer the slightest regard for paragraph construction. It's so beyond me—the idea that one could actually move a paragraph to another position.

Revision

JONATHAN RABAN: The reason I don't use a computer for my books is that with a computer is it's so easy to correct what you know you want to change. On a typewriter you pull the page out and retype words that you thought were perfectly okay the first three or four times, and for me it's often only on the third or fourth time of typing a sentence that I realize, *This sentence is shit.* And when I know when I need to change a sentence, I work my way down the page in order to get to it, and as I do I make changes along the way. Only working with a typewriter forces you to do that, so that most pages go

* About a year after our interview, Lukacs told me he had given away his computer.

through several drafts, but once a page is done, it's—as far as I'm concerned—finished. I get to the last page and that's what goes to the publishers.

I envy hugely most of the writers I know, who scribble away at a first draft, taking no time at all, writing a book in three months, and then sit down and redraft. But I cannot do it. I'm a slow, self-conscious writer and I fiddle around with sentences endlessly until I get them right.

I like books that have an organic development of their own, so that the reader and writer both start in the same place in the same first sentence, and the books develop; things happen that surprise both writer and reader. They veer off in unexpected directions. If I were to redraft a book, I'd know everything that was going to happen. I write books for the same reason people read them, which is to find out what happens next, and if I started in at page one of a second draft, I'd know all too well what was going to happen next. I'd never get through it; the labor would be inconceivably boring.

JUDITH THURMAN: I am a very stupid smart person. I never know what I know before I say it, or say it well. I have to live with the worst drivel. My first drafts bear no relation to the final product. I'm a very slow writer, and my *New Yorker* pieces put me in a panic because of the deadline. I start throwing thoughts at the page. Out of that will come a few decent lines. That will be a starting point. I will do twenty drafts, all on the computer, label them a, b, c, d, e, etc. Then when I finally have something readable, I'll print it out and go from there.

When I rewrite, I'm always taming the exuberance of the imagery. I am trying to make the prose work harder. Each word has to work as hard as possible.

TOURÉ: I look at it like popcorn. In the first draft, you lay out the kernels. They're small and hard. That's the general direction you want to take. And then you put heat to it. Can this sentence be better? Can this word be better? Can we take an eighty-year-old word that has a certain weight and use it in a slightly new way? This part of the sentence is not doing enough. Instead of one word, we'll have three, or twenty. It becomes an improvisational thing.

That's when you put the style to it, the intellectual heat to it. That's when it becomes popcorn. Each part of the sentence explodes.

DAVE BARRY: When I'm revising a column, I probably take out the words *really, actually,* and *very* more than any three other words. Those three words will appear in virtually every sentence in the rough draft.

BILLY COLLINS: I write quickly—I can finish a poem in forty-five minutes, sometimes less. Then you go back to make it dance a little better. Eighty percent of revision is rhythmical—making changes to make the right music. Eventually, I go to the computer—you can look and see the lines that don't work. You move furniture.

ANN BEATTIE: I have to admit that I might profit by revising more *before* I hit the keyboard. Your mind locks on your first way of presenting things, and once recorded, it's not as easy as you might think to erase or change. My husband is a painter, and while I wouldn't want to stretch the analogy, as a nonpainter I can look at a canvas and assume that something that looks right is "completed," whatever that means. Then, the next day, he'll have painted the sun a different color, and that also will work, or even seem an improvement, but more often than not, I remember the first sun, and try to figure out why he changed it. And sometimes, tantalizingly, some of the color of the original peeks through, though it is differently incorporated in the whole.

Sometimes, though, I've felt that the smallest revision has made everything come into sharp focus. One moment I remember is the revision of the short story "Skeletons," where I'd written something like, "his need for them was never as hidden as he'd thought." Perfectly okay line, but then the word *masked* came to me, and it became, "never masked as well as he thought." That was a big improvement because the whole story, metaphorically and on the surface, has involved various masks. It's just one word, and it may have done more to make the story three-dimensional to me than to the reader, but I think you really have to find a way to convince the reader that you, the writer, have absolute conviction about what you're saying—even word by word.

ELMORE LEONARD: I have a good time when I'm writing, making it work the way I want it to work. I don't write drafts—I rewrite as I go along. Every day, I'll start maybe four or five pages before I stopped the day before. I'll go over it, and I might add a bit of business, a drink, a cigarette.

TOBIAS WOLFF: Often I'll make a change because I've been overreaching for rhetorical effect. Or sometimes I'll change it the other way because I've come off like a pretend man of the people, with too much easy irony. I try to

read it as if someone else wrote it. I'll look for rhythm things: sometimes the sentences are too lush, sometimes too choppy.

If I finish with a new paragraph or two, I'm lucky. It's not a very efficient way to compose.

ANNA QUINDLEN: If you have a discernible writing voice, you must beware of your own tics. I use *of course* too much, and the word *seem* to cover up my failure to commit, and sometimes my sentences are so baroque that they leave me breathless, which is why I read everything aloud when I'm done with it, so that I can tell intuitively where it diverges from my natural voice.

CYNTHIA OZICK: When I look at one of my manuscripts, there are so many cross-outs. It will soon be the case that everyone writes on computers. That will be such a tremendous loss, not to be able to go to a library and look down through the glass and see what great writers have crossed out, and their first thoughts. You will never see anybody's first thoughts. It is really a crime against mind.

A postscript to this chapter: It is not the case that words go directly from the author's pen or computer to publication. At some point or other, they come under the eye of an editor, who has license to fiddle with them—to the detriment, the benefit, or simply the alteration of style.

Rare is the writer who accepts an editor's ministrations with grateful equanimity. Indeed, at any meeting of two or more writers, the conversation will eventually turn to how editors flattened, deadened, slicked up, or otherwise ruined their prose. Some of these changes stay in the mind an awfully long time. The second piece of writing I ever published in a legitimate periodical was an essay about pickup basketball. It described the convention of getting to play another game if your team won but having to sit out several games if your team lost, and it contained the sentence: "If collegians play for glory and professionals for money, we played for a chance to play." I was pleased with that sentence. When I picked up the magazine, I saw to my horror that what had come in as me had gone out as Philboyd Studge. The editor, apparently following some dumb rule about only using *if* as a hypothetical, had changed the passage to read: "On the whole, collegians play for glory and professionals play for money. We played for a chance to play." "On the whole"! Twenty-seven years later, the flatness of it still rankles.

Some writers dread the editing process because it feels so intrusive. Camille Paglia says:

> Writing is my vocation. It's so private, so identified with my physical self, that I can't imagine showing it to anyone. The copyediting process can be extremely traumatic. You might as well take a scalpel and cut a bunch of flesh out of me.

But on occasion, working with a particular editor or adapting one's style to the demands of a magazine can be beneficial. Once in a while, writers will even admit this. Jonathan Raban says:

> I wrote a lot for a magazine called the *New Review*, which was edited by Ian Hamilton. There was no house style at all, but it had the personality of its editor, who was both hugely enthusiastic and encouraging and capable of scowling sardonically at what he thought was phony. Hemingway famously said, "The most essential gift for a good writer is a built-in, shockproof shit detector," and that was what Ian provided for us.
>
> I wrote this long piece for him about one of those organized quasi-family Christmases for people whose children have fled the nest, where they dress up and put on funny hats and have party games at this hotel in Monmouth in England. I described how every so often I'd escape from the hotel, where I felt like a prisoner, and how I would moodily walk along Monmouth Beach "kicking pebbles under a gunmetal sky." I remember Ian's comment when he saw my typescript: "Funny how everybody's skies are colored gunmetal this year."
>
> That was one of the more crushing remarks ever made to me.

Greil Marcus liked the change in his own writing when he went from *Rolling Stone* to *Creem* magazine in the early 1970s:

> At *Rolling Stone*, we knew grammar. *Creem* was much crazier. I felt like I was writing for the ideal reader—the other editors, who were Dave Marsh, Lester Bangs, Craig Carpell. It made you want to do better than you ever did before. It was so much fun to be surrounded by all these unforgettable voices.

Adam Gopnik and Judith Thurman both had the daunting experience of coming to the *New Yorker*, with its venerable house style, indefatigable fact-checkers, and stern copyeditors (exemplified by Eleanor Gould Packard, the legendary "Miss Gould," who kept the commas for more than five decades and was famous for marking up galleys to within an inch of their lives). Gopnik, who had been a graduate student in art history, found doing journalistic art criticism difficult at first, but was helped by editors Charles "Chip" McGrath and Roger Angell:

> The natural tone in graduate school is argumentative, and one result of that was my sentences tended to have a lot of *but*'s in them. Chip McGrath said to me, "You have enough *but*'s in here to form six human beings." He taught me to write with *and* instead of *but*. Doing that leads to a somewhat disingenuous stance—you're still being argumentative, but it's disguised as a train of linked observations. I became more attractive to readers.
>
> Roger taught me to tone things down. He said, "If you're going to surprise people with an idea, tell them. Don't put all your goods in the store window. You don't need sixteen riffs, telling them not only your main point but all your other ideas as well. Ballplayers learn to position themselves. Take the reader into your confidence, rather than seeing him as an opponent."

The transition wasn't as difficult for Thurman; she had been there before:

> My mother was a high school English teacher, and when I was a kid she used to tear apart my compositions with scissors and a glue pot. That made me into a ruthless self-editor. When I came to the *New Yorker*, I was determined to have the cleanest Gould galleys of any writer, and I did. Miss Gould was my mother.

Generally speaking, editing is less intrusive and extensive in Britain, where a subeditor might capitalize a word (or might not) but certainly wouldn't presume to interfere with the writer's style. In the United States, commas and identifications ("Shakespeare, the English playwright"), are blithely inserted, to preclude the possibility that some reader, somewhere, will not fully and accurately grasp every word in the work. As David Thomson says, "British editing trusts the writer a bit more." And, one might add, the reader. Peter Carey started out with the British system in

his native Australia, but now that he is based in New York he has had to contend with the American one, in the person of his editor, Gary Fisketjon. He has to admit that it's not half bad:

> If I had to endure him thirty years ago, I would have shot him, if I'd been brave enough. He takes his little green pen and goes through every sentence. I'm old enough now to recognize he's not there to take anything away from me. I actually had a good time. I'd look at his suggestions, one by one, saying to myself, "Yes, yes, yes, fuck you, fuck you."

Interlude
Blindfold Test

In my opinion, the greatest continuing feature in American magazines is *Down Beat*'s "Blindfold Test." Every month, the magazine sits down a musician, composer, producer, or critic and plays a handful of unidentified recordings. The testee is asked to identify or at least make an educated guess as to the musician(s) on each cut. The results are consistently fascinating.

I attempted to do something similar in the realm of words, courtesy of three smart, perceptive and widely read writer friends of mine, Bruce, Sam, and Clare. Bruce and Sam are journalists; Clare writes fiction. All of them agreed to come to my house one Sunday evening and be guinea pigs.

Beforehand, I asked them to familiarize themselves with three pairs of columnists at the *New York Times*: William Safire and Maureen Dowd on the op-ed page, A. O. Scott and Elvis Mitchell on movies, and book critics Janet Maslin and Michiko Kakutani. When they arrived, I sat them down in the living room, fortified them with Tostitos, apple pie, and the beverage of their choice, and handed them unsigned photocopies: Safire and Dowd on George W. Bush, Scott on *City by the Sea*, Mitchell on Jackie Chan's *The Tuxedo*, Maslin on Michael Chabon's *Summerland*, and Kakutani on Zadie Smith's *The Autograph Man*.

Everybody correctly I.D'd the op-ed writers. Dowd's lead sentences were probably a giveaway:

> They rule the world ruthlessly and insolently, deciding who will get a cold shoulder, who will get locked out of the power clique and who will get withering glares until they grovel and obey the arbitrary dictates of the leaders.
>
> We could be talking about the middle-school alpha girls, smug cheerleaders with names like Darcy, Brittany and Whitney. But, no, we're talking about the ostensibly mature and seasoned leaders of the Western world, a slender former cheerleader named W. and his high-hatting clique.

One of Dowd's trademarks is referring to Secretary of Defense Donald Rumsfeld as "Rummy" (possibly to avoid having to use *Times* style and

refer to him as "Mr. Rumsfeld"). But more generally, as Bruce observed, "She's more apt to play-act." Sam said, "I think of her as Maggie the Cat in *Cat on a Hot Tin Roof.* She's in your face."

Although Safire's piece, suggesting a possible rift between former President George H. W. Bush and his son President George W. Bush, had one playful literary allusion (saying that if there were any serious dispute between the two Bushes, "Barbara Bush—a nonfictional Ma Joad—would grab the scalps of her husband and son and knock their heads together"), everyone agreed that it read much more like straight journalism. Clare said, "His style is an antistyle." She pointed out that one of his linguistic tics is the rhetorical question (five of them in the one piece, compared to zero in Dowd's.)

Everybody correctly named the movie reviewers as well. For Clare, the "incongruity of the metaphor" in Mitchell's lead was a giveaway: "You can tell how recent one of Jackie Chan's movies is by the size of his nose. Gauging its spread is like counting the rings in the core of a tree: if it looks as if he has broken it one more time, you know you're catching something newish." (The phrase "it looks as if he has" instead of the more colloquial "it looks like he's" is the only un-Mitchell-like note: the group suspected it was the work of a *Times* copyeditor.) Sam focused on Scott's review, saying his "lucid" and "intelligent" prose suggests a "clear mind" and "someone who knows what he wants to say." Bruce noted his predilection for long periodic sentences, such as "The city [Long Beach] has been transformed into a bleak purgatory of broken windows, abandoned building and pervasive hopelessness by a force more gradual than military invasion: like so many other once-idyllic spots, it has apparently fallen victim to the curious restlessness that conjures glittering cities out of the air and then, abruptly, abandons them to ruin." Clare observed that Scott was "a critic's critic" and guilty of some of the "clichés of criticism." She said that in looking up his work on the Internet, she had noticed him using the word *avatar* again and again.

The book reviews produced the first incorrect guess: Clare on the *Summerland* review. She correctly noted that the last paragraph, which said that the book lacked "overarching coherence" and seemed "rudderless and overwrought" had the kind of strong negative judgment, expressed in adjectives, often seen in Kakutani's work. But the author was

Maslin. Bruce correctly named Kakutani as author of the Zadie Smith review, the giveaway for him being a 61-word "baroque, ruminative" sentence. "Janet Maslin uses short declarative sentences," he said. "She could write sports. Michiko Kakutani could not." For Sam, two phrases were tipoffs: Maslin saying that *Summerland* was "mighty cute" and Kakutani that Smith's previous book, *White Teeth*, was "one of the most remarkable debuts in recent years." "That 'one of the most remarkable' is a book-review cliché," he said. "She's got the form mastered."

Next we moved to literature. I handed them a page with a paragraph from two books. The first:

> In the silence, Lily had a clear perception of what was passing through his mind. Whatever perplexity he felt as to the inexorableness of her course—however little he penetrated its motive—she saw that it unmistakably tended to strengthen her hold over him. It was as though the sense in her of unexplained scruples and resistances had the same attraction as the delicacy of feature, the fastidiousness of manner, which gave her an external rarity, an air of being impossible to match. As he advanced in social experience, this uniqueness had acquired a greater value for him, as though he were a collector who had learned to distinguish minor differences of design and quality in some long-coveted object.

The second:

> Nothing in fact was stranger than the way in which, when she had remained there a little, her companions, watched by her through one of the windows, actually struck her as almost consciously and gratefully safer. They might have been—really charming as they showed in the beautiful room, and Charlotte certainly, as always, magnificently handsome and supremely distinguished—they might have been figures rehearsing some play of which she herself was the author; they might even, for the happy appearance they continued to present, have been such figures as would, by the strong note of character in each, fill any author with the certitude of success, especially of their own histrionic. They might in short have represented any mystery they would; the point being predominantly that the key to the mystery, the key that could wind and unwind it without a snap of the spring, was there in her pocket—or

rather, no doubt, clasped at this crisis in her hand and pressed, as she walked back and forth, to her breast. She walked to the end and far out of the light; she returned and saw the others stiff where she had left them; she passed round the house and looked into the drawing-room, lighted also, but empty now, and seeming to speak the more, in its own voice, of all the possibilities she controlled. Spacious and splendid, like a stage again, awaiting a drama, it was a scene she might people, by the press of her spring, either with serenities and dignities and decencies, or with terrors and shames and ruins, things as ugly as those, formless fragments of her golden bowl she was trying so hard to pick up.

Sam guessed that number one was early Henry James and number two was late Henry James. "The first one reads like good James and the second like bad James," he said. "By the end, he was dictating his books, and his sentences were all over and rambling." Sam was half right—number 2 is by my estimation the *shortest* dialogue-free paragraph in James's final novel, *The Golden Bowl*—but, impressively, Clare identified number 1 as from *The House of Mirth*, by James's disciple Edith Wharton. She said, "The reflection of the interior is similar, but Wharton's sentences are clearer and more straightforward. Plus, James doesn't 'get' women."

The next grouping contained quotes from books by three canonical crime writers, each known for his style: Dashiell Hammett's *The Dain Curse*, Raymond Chandler's *The Long Goodbye*, and Elmore Leonard's *Pagan Babies*. It stumped everybody—not surprising, once it was revealed that none of the three guessers was familiar with any of the three writers. Bruce drew a blank on the Hammett; he guessed that the Chandler was written by Raymond Carver and that the Leonard, with its plain language and references to Chicken Delight and Magic Marker, by Bobbie Ann Mason (interesting, because Leonard has named Mason as one of his favorite writers). Sam focused on the last sentence of the Chandler excerpt—"It was pretty obvious that that buttons in the prowl car were about ready to drop the hook on him, so I went over there fast and took hold of his arm"—and said it sounded like Garrison Keillor's faux private eye, Guy Noir, who, of course, is a *takeoff* on the hard-boiled private dick created by Chandler and others.

A similar phenomenon occurred in the next grouping, nonfiction passages by celebrated stylists: an S. J. Perelman humor piece (opening sen-

tence: "On a balmy summer evening in Los Angeles some years ago, heavy with the scent of mimosa and crispy-fried noodles from the Chinese quarter, I happened to be a member of the small, select audience of cocaine peddlers, package thieves and assorted strays at the Cozy Theater that witnessed the world premiere of a remarkable picture called *The Sex Maniac*"), Vladimir Nabokov's memoir *Speak, Memory* (opening sentence: "As my memory hesitated for a moment on the threshold of the last stanza, where so many opening words had been tried that the finally selected one was now somewhat camouflaged by an array of false entrances, I heard my mother sniff "), and a 1948 E. B. White "Notes and Comment" piece from the *New Yorker* (opening sentence: "Like radio, television hangs on the questionable theory that whatever happens anywhere should be sensed everywhere"). I believe that anyone who knows these writers well would be able to identify their work. Sam and Bruce knew White and named him, Bruce noting his "quirky sensibility—he was bemused by everything." (I would also tag the words *hangs*, *questionable*, and—especially—*sensed* as White-esque.) Nobody was on intimate terms with Nabokov or Perelman. The former drew a blank, whereas only Clare had a guess for the Perelman piece—Woody Allen. It was a good guess: at times Allen appears to be so heavily influenced by Perelman that he is channeling him.

The last group was six short passages from recent American fiction: Raymond Carver's short story "Careful," Anne Tyler's novel *The Ladder of Years*, John Updike's *In the Beauty of the Lilies*, John Irving's *A Widow for One Year*, Joan Didion's *Play It As It Lays*, and Cormac McCarthy's *Cities of the Plain*. Bruce named Carver, noting the simple language (the 22 sentences of the excerpt contained only two words of more than two syllables: *pretended* and *position*) and the subtle but powerful sense of despair. The Tyler was a very unprepossessing passage, but Clare guessed correctly, noting a quietly lyrical quality in the description of a character lying in bed and listening "to the sounds from outdoors—the swish of cars, the chirring of insects, the voices of the children in the house across the street."

Nothing in the Updike passage shouted Updike's name, and his only fingerprint on it (in my view) was the meticulously lush description of a character's bedroom: "Ornate perforations on the heater's top projected a wide wavery image, an abstract rose, on the seamed ceiling of plaster-

board, so roughly slapped-up some of the joint tape drooped down." Sam guessed Ann Beattie—interesting, again, in that Beattie was heavily influenced by Updike. The only clue to Irving's identity was the four italicized words in just five sentences (one of them: "When he turned to look at his introductory speech, he saw that *all* his handwritten revisions were erased or blurred beyond recognition, and that their original typescript, which was not offset against a *pink* background, was notably less clear than it had been"). Nobody picked up on it; Clare ventured Jonathan Franzen.

The trio had all read *Play It As It Lays*, but too long ago to register Didion's longeurs, and the McCarthy passage drew a blank as well, perhaps because it was uncharacteristically controlled and subdued. Everyone agreed it was good stuff—"He sat beneath a concrete overpass and watched the gusts of rain blowing across the fields. The overland trucks passed shrouded in rain with the clearance lights burning and the big wheels spinning like turbines"—and everyone said *Cities of the Plain* was going right on their reading list.

CHAPTER VII

Consistency and Change

I stopped writing because I was repeating myself," Dashiell Hammett
said. "It is the beginning of the end when you discover you have
style."

Hammett's comment (made in a 1956 letter) suggests a dilemma. On
the one hand, one wants to have a distinctive style: the mark of a Grub
Street hack, after all, is the ability to change, chameleon-like, so as to
blend in to whatever publication or genre is offering an assignment. On
the other hand, as Hammett recognized, a strong style brings with it a set
of difficult questions. Will the style, forged to meet the needs of a particu-
lar personality at a particular time of life addressing particular themes and
demands in a particular genre, still be effective the next time out? And if
so, how long will the magic last? Maybe most important, how are you
expected to figure out that it's time to make a change?

These questions confront all serious writers. Because they are so
thorny, the path of denial and persistence, with its sad attendants—man-

nerism, calcification, predictability, and self-parody—will always beckon. John Steinbeck said, "When a writer starts learning his craft everything is difficult and everything is fresh. Once he develops the technique, the technique starts choosing the subject matter. Pretty soon you know how to trick the audience. You are no longer the master of your own work."

There is a also a danger in changing too much: It seems clear that the more distinctive, idiosyncratic, self-conscious, or deeply felt the style, the greater the danger. Hemingway's style was all of those things. When it appeared, it seemed a kind of miracle—original, eloquent, and absolutely compelling. But before long it became a burden. Its need for care and feeding retarded his growth as a writer, and its booming footsteps drowned out whatever he might have had to say. By the end of his writing career, Hemingway was a shell—an encrusted style behind which lay pretty much nothing.

John Middleton Murry wrote that in Henry James's late books, "technique began to assume a life of its own." What had occurred, Murry thought, was "hypertrophy of style. It has a sort of vitality; but it is the vitality of a weed or a mushroom, a vitality that we cannot call precisely spurious, but which we certainly cannot call real."

I have in front of me a just-published (in 2003) book by Hunter S. Thompson, *Kingdom of Fear: Loathsome Secrets of a Star-Crossed Child in the Final Days of the American Century*. In the preface he writes:

> I like this book, and I especially like the title, which pretty well sums up the foul nature of life in the U.S.A. in these first few bloody years of the post-American century. Only a fool or a whore would call it anything else.
>
> It would be easy to say that we owe it all to the Bush family from Texas, but that would be too simplistic. They are only errand boys for the vengeful, bloodthirsty cartel of raving Jesus-freaks and super-rich money mongers who have ruled this country for at least the last 20 years, and arguably for the past 200. They take orders well, and they don't ask too many questions.

Thompson wrote that way in 1973, too. Then his self-conscious (not quite to the point of self-mocking), drug-fueled hyperbole and paranoia was sulphurous, funny, and perfectly appropriate to the times. Today, though one can admire him for sticking to his guns, in two senses of the phrase,

the spectacle is a bit embarrassing. Everything changed and he is still fulminating, like the guy who keeps shouting after the music stops.

Another pioneer of the "new journalism," Tom Wolfe, put more thought and effort into devising a second act to his career. It is hard to imagine a style and a period as well-suited to each other as were Wolfe and the 1960s. It was an outrageous decade, and every italicized word and exclamation point of Wolfe's prose communicated outrage—sometimes delighted outrage, to be sure, but outrage nonetheless. Inevitably, the moment ended, and Wolfe was canny enough to change gears when it did. After *The Right Stuff* (published in 1979, but many years in the making, and a chronicle of the astronauts of the early 1960s), he spent a decade or so issuing polemics on modern art and architecture and other scandalous manifestations of contemporary culture. Then he turned to fiction in the form of two best-selling page-turners, *Bonfire of the Vanities* and *A Man in Full*. Though traces of the old Wolfe are visible in them, the volume is toned way down. Style is not the main means of communication (and object of admiration), as it was in his early work, but an instrument to serve the purposes of plot, character, and societal mise-en-scène.

Wolfe's shift is an example of something that happens in many writers' careers, when they consult a roadmap, put on the directional and make a stylistic turn. Rarely is it a hairpin turn or radical shift; Hemingway doesn't become Faulkner, and Faulkner doesn't become E. B. White. Instead, the writer bears right or left—the kind of adjustment a sailor makes when he realizes he's drifted off course. In his book *The Clockwork Muse: The Predictability of Artistic Change*, psychologist Colin Martindale asserts that the evolution of both artistic traditions (say, French poetry) and individual artists' working lives is a function of the pursuit of "increasing arousal potential." That is, when a poet, composer, or artist begins to feel that he or she or all his or her contemporaries are saying the same or similar things in the same or similar ways, there is a conscious or unconscious realization that it is time to make a change.* Martindale unearths a fascinating 1650 quotation to this effect from Thomas Hobbes:

*Martindale makes it clear that his theory only applies to the high arts, not to the popular arts, where sameness is famously valued. One of the limitations of the theory is the fact that it is difficult if not impossible to make such an absolute distinction. That is, almost all artists worth caring about seek some mixture of aesthetic achievement and popular recognition.

> For the phrases of poesy, as the airs of music, with often hearing become insipid; the reader having no more sense of their force, than our flesh is sensible of the bones that sustain it. As the sense we have of bodies, consisteth in change and variety of impression, so also does the sense of language in the variety and changeable use of words. I mean not in the affectation of words brought newly home from travel, but in new, and withal significant, translation to our purposes, of those that be already received; and in far fetched, but withal, apt, instructive, and comely similitudes.

Martindale puts forth two ways artists deal with this challenge, one of which, suggested by Hobbes, is stylistic change. The other is a change in content: what Martindale calls "deeper regression," a kind of Jungian channelling of "primordial" themes and images. He constructs sophisticated computer programs and impressive graphs showing that this indeed is what happened to Shakespeare, Dryden, Rembrandt, Beethoven, Wordsworth, Yeats, and Picasso.

Writers themselves, naturally, don't put the matter in quite these terms, but often from what they say you get a similar idea. Raymond Carver, who made his name with his spare short stories, told interviewers that with "Cathedral" and subsequent works were "fuller, more generous somehow" than what had come before: "I went as far as I wanted to go with reducing the stories to bare bones minimum."

From the beginning of his career in the 1950s through the early 1980s, Harold Bloom was a high academic critic, writing such abstruse books as *The Visionary Company: A Reading of English Romantic Poetry*, *The Anxiety of Influence: A Theory of Poetry*, and *The Breaking of the Vessels*. In 1982, he took on the task of writing the introductions for the Chelsea House series of literary classics, intended for high school students. He estimates that over the next six years, he wrote about 400 of them (he has since done hundreds more), and, he says, the experience had a profound effect on the subsequent books he has written for adults, such as *Shakespeare: The Invention of the Human*, *How to Read and Why*, and *Genius: A Mosaic of One Hundred Exemplary Creative Minds*. Bloom says: "It changed my writing. I forced myself to de-esotericize myself. It probably taught me how to write. I have made the conscious effort to write in a more straightforward and accessible way. I go out of my way

every time I write a book to make clear that I don't want a single academic to read it."

Writers can take two or more such turns in the course of a career. Two chapters ago, I quoted Margaret Drabble on how she came to write her early novels in the first person. For her fourth book, *Jerusalem the Golden*, in 1967, she made a shift. Drabble says: "I just thought it was more adult to write in the third person. I found writing in the first person quite easy, and obviously you can't go on doing what is easy all the time. And I did find it quite difficult, to begin with, because of the problem of having to impersonate other people."

But eventually, the third-person style Drabble forged seemed inadequate to the challenge of confronting the social changes of the 1970s and 1980s. She says:

> I just looked at *The Needle's Eye* [1972], the very last paragraph—it's a paragraph of such heart-rending optimism—and I just couldn't believe that I could have written such a thing. It's a scene where the character is in a part of working-class London and she's covered in red paint, all battered, and it's a sort of symbol of the joys of the common life. Absolutely no irony at all—a pure moment of faith and hope. You really couldn't write that now, because urban life has deteriorated beyond any hope of getting better. Things are more angry, detached. I can't use that voice; that voice is gone. I can only use it when I think of things that have nothing to do with the contemporary world. Otherwise, you have to put in irony, you have to put in a sense of failure or a sense of anger.

Drabble's solution, beginning in her next books, *The Realms of Gold* and *The Ice Age*, was to infuse her prose with a little of that irony, in the form of what she calls "the dismissive or subversive voice." It's a distinctive tone that periodically appears in her fiction, in the form of rhetorical questions, present-tense verbs, direct address to the reader, experiments with point of view, and admissions of authorial uncertainty. In her 1995 novel *The Gates of Ivory*, she tells of two characters, Robert and Esther,

> sitting in a backstreet sandwich bar, drinking black coffee from thick white cups and sharing a cheese and pickle roll. What are they thinking about? From here, it would be hard to say. Their heads incline seriously together,

and they are deep in conversation amidst the clientele of van drivers and motorbike dispatch riders. Are they discussing the inflated prices of British Impressionist paintings? Are they planning a trip to the École Française d'Extrême-Orient, or to the Queen of Novara at Pallanza? Are they speaking of Robert's ex-wife Lydia Wittering, who has broken an arm playing polo? Are they speculating about the rumoured arrival of Simon Grunewald? Are either or both of them having an affair with the mysterious woman in white? Are either or both of them thinking of Stephen Cox?

Whatever the text of the subtext of their conversation, here, from this side of the smeared plate with its scribbled legend of sandwich fillings, they seem united, intent.

Drabble says:

> It's as though there's some kind of person in me who wants to say something quite harsh at certain points. It almost pops up of its own accord, as though there's some person in me who can't bear it anymore and wants to say something quite unkind or sharp.
>
> It's getting more pronounced as I get older, I think, this sort of detached aggression. It's a bit of aggression towards the reader as well, at times, a mixture of an invitation to collaborate and a slight belligerence. A sort of "If you don't like it, well, go read something else" attitude I sometimes feel.

It is quite possible, of course, to make more than just a few shifts in style in the course of a career—to go whole hog and elevate constant change into an aesthetic principle. Robert Louis Stevenson, in his essay "A Note on Realism," put this forward as the mark of a true Artist. He noted that the process of creating a style requires "extreme perplexity and strain." As a result,

> artists of indifferent energy and an imperfect devotion to their own ideal make this ungrateful effort once and for all; and, having formed a style, adhere to it through life. But those of a higher order cannot rest content with a process which, as they continue to employ it, must infallibly degenerate towards the academic and the cut-and-dried. Every fresh work in which they embark is the signal for a fresh engagement of the whole

forces of the mind; and the changing views which accompany the growth of their experience are marked by still more sweeping alterations in the manner of their art.

Had Stevenson lived another decade, he would have been around for the start of an artistic career that proceeded in exactly that way: Pablo Picasso's. Stanley Crouch says: "The length of Picasso's shadow crossed other art forms. He was once asked what style he was after. He said, 'God is really only another artist. He invented the giraffe, the elephant, and the cat. He has no real style. He just keeps on trying other things.' What Picasso was saying was that *he* would prefer to be like a deity."

It's not necessary to aspire to those heights to see the appeal of continually reinventing one's style. Norman Mailer, whose books vary wildly in tone and technique, took a utilitarian view, saying in an interview, "Preserving one's artistic integrity is not nearly so important to me as finding a new attack on the elusive nature of reality. Primarily, one's style is only a tool to use on a dig." As was noted earlier, Jonathan Raban makes a concerted effort to fashion a distinct "strategic persona" and style for each book. He says:

> One of the reasons I so admire William Golding is that he didn't just write ten versions of *Lord of the Flies*. Each of his books might almost be by a different author, though there's a guiding intelligence and passion in each of them, and there is a line of Christian theology that runs through them that's Golding's own. But people could never quite get the measure of Golding because he surprised his readers with each book, and now he's remembered largely as a one-book man.

The downside of this kind of approach, as Raban suggests, is in the area of marketing. Stylistic zig-zagging dilutes the brand. David Thomson says, "One of the things that gets in my way is that I keep changing the voice. It damages my career prospects. There's no sense of picking up an author we can trust."

Writers who are distinctive but not head-turningly so rarely make noticeable stylistic shifts. They are the stronger essayists and journalists

and critics and historians, and the fiction writers in the realist tradition—say, an Anne Tyler or a Nick Hornby—who, though no less insightful or artful than their ostentatious colleagues, are more interested in story and character than in language. Their style is a reflection not of an aesthetic strategy but of a perspective on the world. Common sense tells us that men and women change over the course of a lifetime, and psychologists confirm it. One recent study looked at personality change in a group of adults who had been periodically surveyed over four decades and observed visible difference in every one of the 20 traits measured.* And if a writer's interests, inclinations and reactions are different at 60 than at 30, that cannot help turning up in style.

But the change is evolutionary, not revolutionary. If it has a shape, it is a gentle curve, like a banana. Discerning critics will notice a shift, but it may escape readers and even the writers themselves, except for reflective moments when they pull down old books and tearsheets and put themselves in shoes they long ago discarded. John Lukacs says, "The most important thing is that I've gotten more Anglo-American—more terse, more direct, more condensed. Now it's too condensed. There's a loss there, because it probably escapes more people, but what can I do?"

As with other elements of style, change and continuity are to some degree beyond the writer's control. John Updike says:

> I usually begin a new project excited by the idea of *not* sounding like Updike—*Rabbit, Run,* for instance, was an attempt to provide a prose more freewheeling and uninhibited than that in my *New Yorker* stories, which in general have an *en brosse* quality, sticking up in little points. When I began to write *Rabbit, Run* in the present tense, it was a conscious effort to escape the me who writes in the past tense and tends to get mired in elaborate backwards-looking syntax. With *Rabbit* and his subsequent brothers, there was little looking back, just an impressionis-

*Helson, R., Jones, C., & Kwan, V. S. Y. (2002). "Personality Change Over 40 Years of Adulthood: Hierarchical Linear Modeling Analysis of Two Longitudinal Studies." *Journal of Personality and Social Psychology, 83,* 752–766. Applying the California Psychological Inventory (CPI), the authors found the most marked increases in self-control and good impression and decreases in flexibility, social presence, empathy and self-acceptance. Independence increased until the subjects were in their fifties, when it began to decrease, while responsibility followed the opposite pattern, decreasing until middle age, after which it started back up again.

tic momentum and a fresh grasp of the language; lots of sentences that would be ordinary in past tense take on a hasty poetry in the present, even the "he says" expresses something different.

And so forth, story to story, book to book. The Mandarin explosions of *A Month of Sundays* and *The Coup* sought relief from the drab Rabbit terrain. In *Seek My Face*, I tried to write the way Jackson Pollock painted, in long stringy loops.

Nevertheless, there will be a sameness due to the limits of a single personality. One's effort as an artist is to extend those limits as much as possible. When I read my old prose, usually aloud before audiences, I am aware of phrases I would not use now, things I have forgotten I ever knew, imitations of Proust and Henry Green that would not be so naked now, but in general I am comfortable. Like a real voice and body, changes occur—but organically, within one identity.

Not infrequently, a writer's evolution is *away* from style—toward putting less emphasis on manner and more on matter. The urge for differentiation and self-display lessens, replaced by an urge to get to the heart of things. Stanley Crouch says, "The farther along I go, the less I know if style is important at all. In *Moby-Dick*, it's almost as if Melville is saying, 'You don't need a style, you only need an objective.' In *Ulysses*, the argument of the book is with style." And Tobias Wolff says:

> I used to be much more confident in my judgments, both moral and aesthetic. The edges got worn down. As a young writer, I used to talk about style in isolation: Hemingway's style, Conrad's style, Nabokov's style—the way they put sentences together. I've come to realize that we have to grow into these things. I'm looser in my approach to it. When I write, I try to listen for something that's more natural to me. I'm 56, and for better or worse, I have this voice. When it sounds unnatural, I change it. Making a conscious attempt at "style" could dislocate the tone from my natural timbre.

The precise nature of the development is less important than that it should happen at all, and in an organic fashion. Like a shark, a writer has to move to stay alive. After a long stint as a critic for the *Village Voice*, with frequent contributions to the *New York Review of Books*, the *London*

Review of Books, and the *New Republic,* James Wolcott joined the staff of Tina Brown's *New Yorker* in the early 1990s. He says that after his first few pieces appeared,

> people said, "You're not you yet." I didn't know what to say to that. A lot of people seem to want you to write the way you did when they first discovered you. That would mean you hadn't changed in twenty years or so, which would not be so attractive. I look back on earlier pieces of mine and think they were too jokey. Certain all-out attack pieces I used to do, I feel it's too easy.
>
> Sure, there are writers who write the exact same way they did when I first read them. That seems so stunted and narrow. The effect they have is someone who loves to hear himself talk and never goes any deeper than that. They write as if they're holding forth at a cocktail party, basically telling you how brilliant they are and not listening to a word anyone else says.

It's possible to have an opposing stance: that having mastered or perfected a style, the writer has the prerogative to cling to that style—forever, if so desired. Billy Collins says:

> Dickinson, Donne, Whitman—they all do the same thing over and over again. If you end up repeating yourself, that's a small price to pay for a distinctive style. And as readers, in our hearts we like the repeaters best of all—they're playing a song we recognize. As for me, if my style doesn't develop at all, if I end up playing the same tin whistle, that won't bother me at all, as long as I can keep writing "A" poems.

CHAPTER VIII

Style According to Form

C ritic Roman Jakobson said that language has two basic functions: the communicative and the poetic. Strictly communicative writing includes business memos, instruction manuals, news articles, college textbooks, scientific papers, and government statutes: text whose object is imparting data. Strictly poetic writing is, well, poetry. The functions have an unmistakable correlation with style: to the extent a speaker or writer is communicative, the emphasis in on matter, so that a transparent, anonymous, middle style is expected and appropriate. To the extent he or she is poetic, the emphasis is on manner, so that a distinctive style is an essential, perhaps the most essential, part of the project of writing. This chapter takes a look at the way style works in different kinds of writing, starting with genres that are just the least bit poetic and ending with, well, poetry. (I place the genres in this order for the sake of convenience and argument, and understanding that there is no shortage of highly personal biographers, relatively anonymous poets, and other exceptions that

prove the rule.) In each case, some introductory remarks are followed by in-depth testimony from a notable practitioner.*

Persuasive Writing

I use the old-fashioned term *persuasive writing* to encompass op-ed columns, old-fashioned essays, writing-class assignments, and legal briefs and opinions. It may be surprising that I have put it all the way at the communicative end of the scale. I have two reasons for doing so. First, its representative in these pages, Justice Stephen Breyer of the U.S. Supreme Court, is a passionate believer in self-effacing stylistic clarity. Second (as Breyer recognizes), it's often the case that opinions are more forcefully and persuasively communicated when the personality of the expresser is removed. Personality is by definition singular. In making a didactic point, by contrast, the emphasis should be on dispassionate evidence and universal logic, so that ideally, the argument should seem lucid and self-evident. Generally speaking, style will cloud the waters and shift the focus of the piece *away* from the issues at hand, toward something literary or personal.

Needless to say, many opinion writers are very distinctive stylists, including (to name a few) Molly Ivins, Maureen Dowd, William F. Buckley Jr., H. L. Mencken, E. B. White, and Breyer's colleague Antonin Scalia, who wrote the following in just two paragraphs of a recent dissent:

> This is an astonishing exercise of raw judicial power. . . . What a wild principle of reinterpretation the Court today embraces. . . . I would not subscribe to application of this deformed new canon of construction even if there were something about "clerical error" that made it uniquely insusceptible of correction by the means set forth in the statute. . . . By taking the responsibility for determining and remedying the error away from Congress, where the statute has placed it, and grasping it with its own hands, the Court commits a flagrant violation of separation of powers.

*The testimony is from my interview (or, in the case of Clive James, e-mail correspondence) with that writer, rendered into monologue form.

I'd offer Scalia's declarations as evidence of the proposition that a "stylishly" expressed opinion can be entertaining and revealing of the writer's personality, but not particularly convincing.

Stephen Breyer was born in San Francisco in 1938 and graduated from Stanford University and Harvard Law School. He was a judge on the U.S. Court of Appeals for the First Circuit from 1980 until 1994, and since 1994 has been an associate justice of the Supreme Court of the United States. From *Bush v. Gore*, U.S. 98 (2000):

> . . . I think it not only legally wrong, but also most unfortunate, for the Court simply to have terminated the Florida recount. Those who caution judicial restraint in resolving political disputes have described the quintessential case for that restraint as a case marked, among other things, by the "strangeness of the issue," its "intractability to principled resolution," its "sheer momentousness, . . . which tends to unbalance judicial judgment," and "the inner vulnerability, the self-doubt of an institution which is electorally irresponsible and has no earth to draw strength from." Those characteristics mark this case.
>
> At the same time, as I have said, the Court is not acting to vindicate a fundamental constitutional principle, such as the need to protect a basic human liberty. No other strong reason to act is present. Congressional statutes tend to obviate the need. And, above all, in this highly politicized matter, the appearance of a split decision runs the risk of undermining the public's confidence in the Court itself. That confidence is a public treasure. It has been built slowly over many years, some of which were marked by a Civil War and the tragedy of segregation. It is a vitally necessary ingredient of any successful effort to protect basic liberty and, indeed, the rule of law itself. We run no risk of returning to the days when a President (responding to this Court's efforts to protect the Cherokee Indians) might have said, "John Marshall has made his decision; now let him enforce it!" But we do risk a self-inflicted wound—a wound that may harm not just the Court, but the Nation.
>
> I fear that in order to bring this agonizingly long election process to a definitive conclusion, we have not adequately attended to that necessary "check upon our own exercise of power," "our own sense of self-

restraint." Justice Brandeis once said of the Court, "The most important thing we do is not doing." What it does today, the Court should have left undone. I would repair the damage done as best we now can, by permitting the Florida recount to continue under uniform standards.

I have two favorite quotes about style. The first is from José Ortega y Gasset: "Clarity is the courtesy of the philosopher." And the second is a French saying, "When one thinks well, one expresses oneself clearly and the words come easily."

I try to write clearly. I assume that my audience is not just lawyers and judges. Still, my first objective nonetheless is to write so that the judges, who must apply what I write, can understand me. Lawyers must be able to use the opinions and explain them to the clients. But the court has a broader audience. The public must also understand why we have reached our conclusions. Ideally, an opinion is also written for the lay members of the general public who will take the time to try to understand it.

Sometimes an opinion demands special effort to be clear. An opinion in a major civil liberties case, for example, will be read by average citizens as well as newspaper reporters, lawyers and judges. Even in complicated matters, one must be concise. But it's important to explain technical matters clearly—more than technical matters may be at stake. For example, in writing a dissent in *Verizon Communications Inc. v. FCC* [535 U.S. 467 (2002)], I tried to explain some extraordinarily complicated concepts in a very simple way. I'm not sure that I was completely successful, but I put effort into doing so, and I think it was worth it.

My writing process is quite regimented and disciplined. My law clerks first write a fairly lengthy memorandum or draft. I take that and then go back and reread the briefs. Afterwards I sit at the word processor and write an outline. I make notes and references in the outline to other documents in which I've written down notes to remind myself of one fact or another, or to refer to a particular page in a brief. I then use the outline to write a first draft of the opinion. When I give that draft to my law clerks, I often say, "I want you to rewrite this so it makes sense." They then rewrite it. Inevitably—and I can't tell you why this is so—when I get the draft back from my law clerks, I look at it and say, "This isn't really very good. They must have ruined it." But I may discover that the parts I'm most displeased with are those that I wrote myself.

In any case, at this point I cast the draft aside. So there I am, back at the word processor, starting once again. Generally, when I'm done with this second draft, I will be reasonably satisfied. I'll give it to my law clerks again, and they edit it. When I get it back, I edit it some more. It is an interative process. It typically takes me two drafts to translate my thoughts into an understandable written form. Once I've reached that stage, I can try for better phrasing. But no matter how much I might try, I could never, like P. G. Wodehouse, simply put pen to paper and compose a beautiful draft. The fact that Proust went over every sentence many times is consoling—despite my quite different results.

There are a few identifiable characteristics of my writing style. I try to list the relevant issues at the beginning of the opinion, just as I learned to do in my high school Latin class. I also try to summarize concisely the facts of the case in a way that tells a comprehensible story. I leave out extraneous facts to make the opinion more readable. If you keep to the key matters that are likely to be relevant later on, readers will find the opinion much clearer.

I then try to tell my audience what conclusions I will draw. My goal in the opinion is not to prove that my result is the only possible one, but to set forth clearly what *my* reasons are for reaching that result. My job in this part of the opinion is to articulate those reasons—my reasons—as well as I can.

Next, I consider the best arguments against my view. I set forth the arguments clearly, casting them in the best possible light. Then I say why those arguments—in all their glory—are ultimately nevertheless inadequate. If, in dissent, I think the majority is wrong, I will not say, "That argument is terrible." I am more likely to say instead, "The majority seems to be construing the matter this way, but I am bewildered. How is it possible to view it that way? I do not understand."

In writing, one must understate. Conversation invites overstatement. If I made an overstatement while teaching a class, the students would know I was exaggerating for rhetorical effect. They would think it was funny, and they would be much more likely to remember the substantive point. That is not true with words put on paper.

I frequently use words like *ordinarily* and *normally* in my writing, because there are always qualifications to any set of facts or circumstances. If you start using caveats or qualifying your statements in an

opinion, the opinion becomes too complex and the audience often loses track of your point. My law clerks will sometimes say, "What about this scenario or that other scenario that's contrary to your basic point?" And I'll respond, "I did not say 'absolutely'; I said 'normally.'" If possible, I'll try to use metaphors. Metaphors suggest the point and explain while leaving room for development.

I respect other writing styles that are different, yet effective. Justice Scalia, for example, has a dramatic approach. He is colorful and he doesn't misplace his metaphors; he always has a good reason for using them as he does. I also very much admire Judge [Richard A.] Posner, who writes extremely well and with great clarity.

In my opinions, I try to aim for a conversational quality—not the way I speak, but how I would *like* to speak. I've discovered by looking at transcripts of oral arguments that my conversational words—as written without conversational pauses—appear inarticulate. At oral arguments in a recent case about extending the term of copyrights, the Solicitor General said that eighty-year-olds might find the copyright extension attractive because their grandchildren would be guaranteed royalties. I thought I had said this in response: "Do you mean to say that Verdi, when he composed *Otello*, was likely attracted by the possibility of three or four more cents for his grandchildren? I think not." That is what I thought I said. What I did say, according to the transcript, was "So you think, say, Verdi, *Otello*, Verdi, *Otello*, eighty years old, the prospect of an extra twenty years way down the pike would have made a difference?" The Solicitor General responded to what I *thought* I had said. He understood my point, I suppose, because it was a logical point. And he probably thought I had said a complete and intelligible sentence, but when one looks at the transcript, I certainly had not.

In line with my effort at instilling a conversational quality to my writing, I follow the example of Justice Arthur Goldberg (and Judge Posner) and do not use footnotes. I believe most footnotes are distracting. The purpose of a citation in a court argument is not to prove what your source was but to add to the argument. If it doesn't add to the argument, don't put it in. So I place citations in the text. If I removed all citations from the text and put them in footnotes, the article or opinion might read better because the flow of argument wouldn't be interrupted, and one's eyes wouldn't be distracted. I don't do that, because I

want to use the cited case as part of the statement I am making. There
are instances in which the absence of footnotes becomes awkward—
requiring me, for example, to reproduce a statute in an appendix at the
end of the citation instead of placing it in a citation. But I think it's better
for me to maintain the rule against footnotes. It sets a good example.

I pay special attention to the very beginning and very end of an opin-
ion, stating the heart of the matter, because I know many people only
read the first or the last paragraph. In my dissent in *Bush v. Gore*, which I
knew would be widely read, I tried to make a forceful statement at the
end. I wanted to summarize my basic view of the issues, and I felt I had
better put that summary in a place where people would notice it.

Finally, in writing an opinion, it's important to be economical. People
will not read long opinions. The genius of Justice Oliver Wendell Holmes
lay in his ability to convey meaning succinctly.

Narrative Nonfiction

The category of narrative nonfiction encompasses journalism, history,
and biography. They all involve conveying masses of information, and, as
you would expect, a clear, unobtrusive—a "transparent"—style is valu-
able and valued in all of them. David McCullough is probably the most
popular biographer and historian at work today, and, no less than for his
thorough research and thoughtful insights, he is esteemed for his crys-
talline prose. Similarly, what popular journalists, historians and biogra-
phers such as Richard Preston, Seymour Hersh, Doris Kearns Goodwin,
Joseph Ellis, Bob Woodward, Robert Caro, and James Stewart bring to
the table is information and interpretation. Their manner of writing is
successful insofar as it is "transparent," unsuccessful when it obscures the
facts or the narrative, or makes the reader aware that he or she is reading.
On the other hand, Edward Gibbon, Thomas Macaulay, Winston
Churchill, Joseph Mitchell, A. J. Liebling, Tom Wolfe, John Lukacs,
Simon Schama, Edmund Morris, John McPhee, Calvin Trillin, Susan
Orlean, and many others have shown that there is plenty of room in these
genres for individual style, even to the point where it may overshadow the
data it is conveying.

Even the most pronounced stylists have to play a game of peekaboo
with the data: alternately hiding behind it and upstaging it. Richard Lan-

ham frames this as a back-and-forth between unself-consciousness and self-consciousness and writes, "The great texts in Western literature have . . . sought for peace in governing the oscillation rather than shutting it down. Thucydides was the first of these and he set down the archetypal pattern of Western narrative structure, the alternation of historical event and formal speech about it, of an unself-conscious and self-consciously rhetorical style." Judith Thurman, author of comprehensive biographies of Colette and Isak Dinesen, says, "Writing a biography is like a high tension wire (the narrative) between pylons (the moments of concentration and analysis)." A nice thing about that metaphor is that it allows for individual difference: some writers will only erect two pylons, at the beginning and end, whereas others put them up all over the place.

\mathbf{B}orn in 1955 and a graduate of the University of Michigan, *Susan Orlean* started her career as a writer for an alternative weekly in Portland, Oregon. She later was on the staff of the *Boston Phoenix* and the *Boston Globe*; since 1987 she has been a staff writer for the *New Yorker*. Her books include *Saturday Night*, *The Bullfighter Checks Her Makeup* and *The Orchid Thief*, the story of renegade plant dealer John Laroche and the basis of the film *Adaptation*. We spoke at her apartment on the Upper West Side of Manhattan. From *The Orchid Thief*:

> A few days after Laroche and I went to the orchid show in Miami I drove to Hollywood [Florida] to visit him at his nursery. I turned on the car radio and tried to find a music station I liked but ended up listening to a talk show about how to keep pet snakes and iguanas happy, and when that was over I listened to an hour-long infomercial for some money-management audiotapes. The announcer had a big, hollow voice, and every few minutes he would boom, *"My friends, you are about to enter the promised land of financial independence!"* I drove past Carpet-Marts and Toy-Marts and Car-Marts and the turnoff for Alligator Alley and a highway flyover that leads to the stadium where the Super Bowl is sometimes played, and past signs for all those dreamy-sounding Florida towns like Plantation and Sunrise and Coconut Creek and Coral Springs. The highway median was a low-lying cloud of pink hibiscus bushes. The shoulders were banked with broom grass and sumac and sneezeweed and penny-

wort, and the road itself looked as if any minute it might just crack and buckle and finally disappear as things grew over it and under it, pushing the roadbed away. As it is, amazing things live on the highway now. Laroche once discovered a rare orchid species growing along an I-95 offramp, and so far no one has found it growing anywhere else in the world.

Writers I've loved, I always felt I could tell you exactly what they're like, even if we've never met and they don't even write that much in first person, because there's some sense of being that kind of permeates the stories. It's the style, the way they tell you about the world, that implies something about character. I always felt that way about John McPhee. Reading him, I would think, *I know who he is.* It just felt to me that there was a being that inhabited the stories. When I met him, he was exactly what I expected.

I was one of these kids who was told I was a good writer from the time I was little. Up to college, my inclination was to write purple prose, with lots of description. Then it was process of unlearning that. The writer who most hypnotized me as a reader was Faulkner—when you read a lot of him, you feel you can't even think in your own syntax. I wanted to produce the same effect. In high school, I read Tom Wolfe's *The Electric Kool-Aid Acid Test.* I carried it around with me for months. It electrified me, no pun intended. I thought in the same rhythms he was writing in for months. At that time, when I first started writing, everybody who was my age and starting to live was drawing from that: the playfulness, the fooling around with voice within the piece, the irreverence.

When I was a sophomore in college, a friend gave me a subscription to the *New Yorker.* It was such a revelation to me. More than anything else, it was the idea that here, people were writing about other people. I loved reading it, and the sound of it. Also at college, I learned that daily journalism wasn't for me. I took one journalism course at Michigan and dropped out immediately. There was this incredibly gung-ho daily newspaper, but I never cared about knowing things first. I just didn't care. Even now, I don't even care if I'm not the first one to write a story. I know that I'm going to write it in a way that no one else would.

In my head I always heard the way I wanted pieces to sound. Even at my first writing job, I had some sense I drew from having read so much

fiction—you read a great novel and you begin living it—I had in my head this idea that I wanted to create a feeling when you were reading the piece, that you would be feeling in body as much as absorbing it intellectually. It had to do with rhythm and words. I felt that from the very beginning I needed to have an active relationship with the person reading the piece. This game of seduction, and revealing, and teasing them on. I've always been attracted to stories that don't automatically seem like they're worth reading, where the writer is saying, "I want you to read this. I know you don't want to. I'm going to pull you in, throw a few crumbs."

My very first editor in Oregon emphasized the need to think, to think about what you're trying to say. When you've been told as a kid you're a good writer, you're not writing from facts. He said, "Report, and then do more reporting, and then do a little more reporting, and then maybe you're ready to write." Even now, if I'm having trouble writing a section of a piece, it's almost always because I haven't done enough reporting. I don't know enough—don't know what I want to say. I really depend on my appetite and curiosity.

To find your voice, unless you're a crazy genius, you work your way through a bunch of phases. At one point, I was committed to writing the tightest transitions in the world—every sentence was locked in, like that kind of carpentry that dovetails a joint into the next. No one could edit me because every sentence connected so intensely to the next. I used to do lots of paragraph breaks. I really loved coming up with the clever transition, kicker to one paragraph, draw into the next. Now when I see that, I react so negatively. It seems so phony to me. I had to learn to deconstruct a little bit. As I got more confident and grown-up, I felt that I could keep people paying attention, or bring them back in, not just by locking each sentence to the next but by putting in an aside, like saying, "By the way . . ."

What was happening was, I was moving more towards writing the way I talk. I began to think of writing as being like telling a story at a dinner party, learning to use timing, how much detail to tell, how much not to tell. It was theater. There was a period where friends would comment how much tighter the pieces *used* to be. I was moving towards something that was subtler, a little braver.

[Former *New Yorker* editor] Tina Brown once said to me, "As a writer,

you do a high-wire act. It's all execution. It's a dare. You're going out on this thin idea. People can't take their eyes off of you—are you actually going to pull it off and get to the other side?"

When I teach, I tell students, when you're telling a story to a friend, you never have any trouble thinking what comes next. You *know* what comes next, so why shouldn't it be that way when you're writing? And you don't tell stories in a completely orderly way. You tell them in these sort of blurts and spurts. You bridge things together, then you backtrack and describe somebody, then you go forward with the story. If you're a good storyteller, people stay with you that whole time. As a writer, I want to move closer and closer to that. I imagine I have an audience that keeps thinking they want to catch a train, and I keep saying, "Wait, let me tell you the rest of the story."

I read my pieces out loud when I'm writing, and if something doesn't sound like a natural sentence, I take it out. If something's too boring for me to read out loud, I take it out. If *you* find it too boring to read, just think how boring the reader's going to find it.

When I first started writing at the New Yorker, I would imitate the writers I admired the most. It felt like wearing someone else's clothes. I could ape the sort of tone of voice, and almost caricature the style. Ian Frazier was the classic—his style seemed so evident that you're tempted to imitate it more than a subtle voice. I remember when my editor, Chip McGrath, took out a Frazierism. He said, "I know what you're trying to do. It's not a bad thing, except it's not you." I was really embarrassed, because I felt I had been caught in my mom's high heels or something. His point was that you go through the imitating into your own voice, and you have to be careful that you don't get stuck in the phase that you're imitating.

Chip was very important. He was the first person who I worked with at the New Yorker, and he embodied that sense of not doing the formulaic stories, without billboard paragraph and a cute, clever lead and a cute, clever closing. There was a real abhorrence for the phony conclusion kind of conclusion. I would turn in the piece, and Chip would say, "I loved it, but I'm just going to cut out the last paragraph." And I would have spent *hours* crafting this little bubble of a conclusion. The result was that everything ended on a little bit of an off-kilter note. At first I found it so bizarre, then I found myself liking the slight jarring end without really an end.

When I was starting *The Orchid Thief*, I thought, *Is it the most boring thing to start a book, "John Laroche is a tall guy"?** And then I thought, I kind of love that. It is the way people talk, and we've shied away from really simple, plain language like that. I like mixing formal and informal language. It's a sort of life philosophy of mine. It's the way I dress, decorate my house—it's really of a piece. I love the thing that's extravagant and gorgeous, and also the thing that's so plain that it knocks you cold in its absolute plainness. I don't care if a word like *tall* is used so often that it's devalued—because then it becomes revalued in a way.

There's a passage in *Orchid Thief* where I describe what's on the radio while I'm driving. I have a very strong memory of working on it for a long time. I was trying to convey to the reader this strange cock-eyed world that Florida seemed to me to be, and by extension, how strange and cockeyed the whole world is, Florida being an intensified version. I wanted to return to that in the book often. What attracted me to the book originally is knowing the area. My parents have this typical tidy condo, and three miles away, there are these iguanas and wild things happening. And that's kind of what the world is like—this fractured place where you feel you know your world. But an inch outside your world everything is different. As a writer, I'm always saying, come with me one inch outside your zone of comfort and let me show you this other place. These sections where I'm just describing passing through layers of Florida were very important. Doing them as a list in a way reflected the experience of driving, things whipping past you.

I used to have a fetish for lists. I would rarely write a piece that didn't have several. It got to the point where my editor would say, "You can have three, but not six." Sometimes I like purely unadorned accumulation of facts, saying to the reader, "I'm not going to trick this up, I'm just going to lay it out for you." I like playing with the rhythm in a list. Sometimes it's fun to write one and see if you can tease people to read the whole thing. Maybe it's a kind of way of looking at the world, of seeing just the accumulation of data. It surrounds you, sometimes overwhelms

* The first sentence in the book, as completed, reads, "John Laroche is a tall guy, skinny as a stick, pale-eyed, slouch-shouldered, and sharply handsome, in spite of the fact that he is missing all his front teeth."

you. It can be revealing—you run a list of what a clown carries in his suitcase, and it's very funny.

I never thought I would be as present in the book as I ended up being. But so much of the logic of the story only held together if I was there as your guide. The disembodied tone of an omniscient narrator seemed wrong to me. The publisher wanted to put in more details about myself—they said that the reader is going to wonder where you live, and so forth. I thought it didn't matter, but I finally caved in and made a few specific statements. I thought I was already present spiritually. I didn't want to characterize myself too much—people are legitimately sick of writers talking about being writers. There were certain things that happened that I ended up not putting in the book. As interesting as they were, they took you too far away; you risked making people impatient. I admire Joan Didion so much. Sometimes I wish I had more of a natural ability to talk personally, the way she does. But ultimately I don't want to, so I don't. And the truth is that my pieces are so fundamentally subjective that I feel like I'm in them even if I'm not.

And people who've read my stuff feel intimate with me. When I do a reading, people come up to me, and their manner is always that we're friends. Sometimes that becomes a little uncomfortable. Even though Joan Didion tells you more about herself, I don't think people would come up to her that way. Sometimes I wish I could write in a way that it is a little more haughty and frosty and off-putting. But it's a good thing that I can't—if I wrote that way, it would be an affectation.

Fundamentally, the most interesting writers are the most interesting people. I don't think it would be possible to be an interesting artist without having a complicated, intriguing way of looking at the world. All you're really doing is conveying that. It's not technique. You can improve technique, tell yourself to think harder about choices with words and structure, read things and have new ideas. But you can't do anything about that fundamental.

Fiction

Of all the forms, the toughest to nail down stylistically is fiction. Can something that contains both Beckett's *The Unnamable* and King's *Cujo* even be *considered* a genre? I've placed it next to narrative nonfiction

because fiction also has heavy lifting to do: in its case, serving the needs of plot and scene and character and theme. Evelyn Waugh's view of fiction was true to Judith Thurman's pylon metaphor: he advocated sections of narrative written to conventional standards punctuated by moments when the author steps forward. In the former, he maintained, the most unobtrusive language was best, up to and including (gasp!) clichés:

> I think to be oversensitive about clichés is like being oversensitive about table manners. It comes from keeping second-rate company. Professional reviewers read so many bad books in the course of duty that they get an occasional unhealthy craving for arresting phrases. There are many occasions in writing when one needs an unobtrusive background to action, when the landscape *must* become conventionalized if the foreground is to have the right prominence. I do not believe that a serious writer has ever been shy of an expression because it has been used before. It is the writer of advertisements who is always straining to find bizarre epithets for commonplace objects.

John Irving has a similar theory, with the added wrinkle that the most distinctive voice—he calls it "the storyteller's voice," and though he casts it generically, he is really referring to a distinctive sound of his own—needs to be strongest at the beginning of a novel and at the beginning of chapters. In an essay for the book *Voicelust*, Irving wrote:

> At the start of any story, at the introduction of any character, the narrative voice must take a firm grip on the reader and not let the reader's attention wander; the voice, in the beginning, is full of promises—full of bluffing, full of threatening, full of hints. What the voice seeks to establish is a situation in which the possibilities for good stories are rich; the voice also needs to establish a character, or characters, to whom good stories can happen—people who seem vulnerable enough to have big things happen to them, yet sturdy enough to withstand the bad news ahead. What I always try to hear in the narrative voice is the sound of a potential myth, a possible legend. . . .
>
> When a story has developed, and—as importantly—its characters have been developed, one can afford a flat, matter-of-fact tone to the narrative (a less dense, less parenthetical style).

In his book *The Art of Fiction*, John Gardner made a useful distinction between what he called "realities narratives," which demand a near-transparent style, and "tales," for which a "high style" is appropriate. He initially was an adamant proponent of the former, and continued to insist that the story should take precedence over the storyteller, dismissing Hemingway, Faulkner, and Thomas Wolfe as "bardic incantatory writers." But, as he described in an interview with the *Paris Review*, over the course of his career he learned to make a place for voice:

> It has always seemed to me that the main thing you ought to be doing when you write a story is, as Robert Louis Stevenson said, to set a "dream" going in the reader's mind . . . so that he opens the page, reads about three words, and drops into a trance. . . . I used to think that words and style should be transparent, that no word should call attention to itself in any way; that you could say the plainest thing possible to get the dream going. After I read some early [William] Gass—"The Pederson Kid," I think—I realized that you don't interfere with the dream by saying things in an interesting way. Performance is an important part of the show. But I don't, like Gass, think language is of value when it's opaque, more decorative than communicative.

John le Carré, John Updike, Kingsley Amis, Richard Russo, William Trevor, Alice Munro, Anne Tyler, and Iris Murdoch—not to mention Waugh, Irving, and Gardner—all traffic in realities narratives. Pretty Good Readers will, nevertheless, be able to recognize their styles: these writers all have characteristic and largely unconscious narrative voices, much like good essayists and critics. Fiction writers with less skill and less experience often find style an extremely tricky proposition in third-person fiction. Pure "transparency" is as much an illusion as it is in any other form of writing, but—more so than nonfiction, where writers rarely forget they have the floor—it's easy in fiction to overlook the fact that *someone* needs to be telling the story, and to revert to an oblivious, unsure or inconsistent voice. When you are omniscient, you are playing God—but who knows what God sounds like?

One always-present option is mindlessly appropriating preestablished models. This is the way of professionals like Michael Crichton or John

Grisham, whose wooden style seems appropriate and maybe necessary for the job at hand. In Robert Alter's apt description, "A good deal of best-selling American prose . . . is written in a mode one might call Standard Contemporary Novelistic, representing, I would guess, a homogenization and formulaic reduction of certain features of robust and muscular style introduced in the twenties and thirties by Hemingway, Dos Passos, Farrell, and others." The same thing takes place in the higher realms of prose. That is, a savvy reader can pick up any number of "literary" novels and short stories and (depending on the decade) hear the unmistakable cadences of Donald Barthelme, Thomas Pynchon, Ann Beattie, Raymond Carver, or David Foster Wallace.

Of all forms of fiction, style is easiest to conceive (if not to execute) in the first person: it is, simply, the voice of the character telling the story. Though always a prominent strain of American fiction, first-person narratives have been especially popular since 1951—that is, since the publication of J. D. Salinger's *The Catcher in the Rye.* It's an appealing form for a conversational age and for writers, like Salinger, who have a sense of themselves as actors or performers. Elizabeth McCracken says:

> I took three and a half years of playwriting at college with Derek Wolcott. I was good at monologues. Dialogue was a disaster. Both my novels are in the first person, and so are all but one of the stories in my short-story collection. I think I've chosen to write in the first person so I can put on somebody else's mask, and not write about myself. The third person is really about you. It's a struggle for me; something about it is antithetical to my nature.

A kind of subset of the first person is point-of-view writing, where the style of the prose reflects the personality and is expressed in something like the voice of the character in the spotlight at that moment. Joyce Carol Oates said in an interview:

> The character on the page determines the prose—its music, its rhythms, the range and limit of its vocabulary—yet, at the outset at least, I determine the character. It usually happens that the fictitious character, once released, acquires a life and will of his or her own, so the

prose, too, acquires its own inexplicable fluidity. This is one of the reasons I write: to "hear" a voice not quite my own, yet summoned forth by way of my own.

Dialogue in fiction is a special challenge if the writer is interested in maintaining a notable style. The characters aren't really supposed to sound exactly like the author's exposition (Hemingway and James notwithstanding); so to the extent that they are chattering, the style of the author gets dissipated. This is not a bad thing. Novelists such as John O'Hara or Richard Price, who favor a lot of talk and render it variously and well, are like playwrights or (in the case of those who favor the present tense, like Ann Beattie) screenwriters of the page. Their own style is subservient to the sound of the characters' talk. Conversely, the more distinctive and assertive stylists among fiction writers tend to go easy on dialogue (just as journalists with strong styles resist using too many quotations). Margaret Drabble says: "People have sometimes asked me why I have never written successfully for the theater. It's because I need a lot of exposition, I need a lot of interior monologue, I need description. I can't actually do dialogue just as dialogue; it has to be the result of everything else that's happening."

Michael Chabon (pronounced "SHAY-bahn") was born in 1963, in Washington, D.C., and was educated at the University of Pittsburgh and the University of California, Irvine, where he received a master of fine arts degree in creative writing. He is the author of the short-story collections *A Model World, and Other Stories* and *Werewolves in Their Youth: Stories*, and the novels *The Mysteries of Pittsburgh, Wonder Boys, Summerland,* and *The Amazing Adventures of Kavalier and Clay*, winner of the Pulitzer Prize for fiction in 2001. We spoke in his office, a refurbished garage next to his house in Berkeley, California. From *The Amazing Adventures of Kavalier and Clay*:

> Houdini was a hero to little men, city boys, and Jews; Samuel Lewis Klayman was all three. He was seventeen when the adventures began: big-mouthed, perhaps not as quick on his feet as he liked to imagine, and tending to be, like many optimists, a little excitable. He was not, in any conventional way, handsome. His face was an inverted triangle, brow

large, chin pointed, with pouting lips and a blunt, quarrelsome nose. He slouched, and wore clothes badly: he always looked as though he had just been jumped for his lunch money. He went forward each morning with the hairless cheek of innocence itself, but by noon a clean shave was no more than a memory, a hoboish penumbra on the jaw not quite sufficient to make him look tough. He thought of himself as ugly, but this was because he had never seen his face in repose. He had delivered the *Eagle* for most of 1931 in order to afford a set of dumbbells, which he had hefted every morning for the next eight years until his arms, chest and shoulders were ropy and strong; polio had left him with the legs of a delicate boy. He stood, in his socks, five feet five inches tall. Like all of his friends, he considered it a compliment when someone called him a wiseass. He possessed an incorrect but fervent understanding of the workings of television, atom power, and anti-gravity, and harbored the ambition—one of a thousand—of ending his days on the warm sunny beaches of the Great Polar Ocean of Venus.

There's a line from *Wonder Boys*—"Above all, a quirky human voice to hang a story on." To me, that's it. Not just as a writer, but as a reader. That's what I have responded to my whole life in fiction is a voice—a strong, identifiable, interesting, intelligent voice telling a story. The first thing I can put my finger on is reading Ray Bradbury's story "Rocketman" when I was eleven. As I was reading it I found the language began to affect me. I was stopping, going over and rereading the sentences, thinking, that just *sounds* good. His lyricism gets a little too much sometimes, but he had this image of a family going for a drive in Mexico. The engine overheats, they stop and open the hood and all these butterflies get trapped in the grill. I remember thinking, *Wow, that's really good* writing. I realized he was *trying* to write this way, that he was choosing his words to have an effect.

I always loved words. I used to read the dictionary for fun in the bathroom, checking out the synonyms, the antonyms, the etymology. There's no question, writing is improved by etymology. Sometimes I coin a word—and find out *there's already such a word*. I've thought of teaching a sort of paying-attention-to-language class, talking about the roots of metaphor and so forth. Almost every other art requires you to be more knowledgeable about materials—in ceramics, for example, you have to

know the chemistry and physics of everything that goes into it. In the early days of the United States, the level of discourse was so much more elaborate. There was a greater sense of language and writing. Adams, Jefferson, Madison—their writing would echo of Cicero's oration, which they had to memorize at school.

I had a high school crush on Henry Miller. That's all he is, really, is a voice just endlessly yammering—saying, "Here is what I think about everything." I went through John Updike and Donald Barthelme phases. It was always writers with diction and word choice and sentence structure. Plot has always been secondary, and character.

When I was studying writing in college and grad school, minimalism was king. Carver, Bobbie Ann Mason, Joy Williams. I loved Carver, responded to him immediately, though I never would want to write that way. He has a very strong voice, and very funny. I always thought his humor was underrated. I was very much aware of minimalism, but I was following another path. I would read Barthelme, who would lead me to Calvino, then Borges, then G. K. Chesterton. I was in that area where writers are teachers and you let them instruct you on who to read.

I first started figuring out what voice was towards the end of college. There were two strands. The first was slightly academic—Borges, Thomas Mann in *The Magic Mountain*. I loved getting caught up in those elaborate sentences; getting to the end of one was a pleasure. The other strand was Barry Hannah—compressed, elliptical, colloquial, highly imagistic, skewed fiction. He writes sordid first-person narratives about trashy people, yet the word choice and imagery was lush and surprising. I tried to find a way of blending the two—mixing up formal diction with slang. I tried writing a story about punk rockers in Pittsburgh as if Henry James had written it. Part of the appeal of this mix is that it's reflected in the way I speak and my friends speak. I feel I'm capable of discoursing at some length on weighty topics, but I fill it with *ums* and *ahs*, with slang and profanity. As time went on, the amalgam of conversational speech with a literary element has been the most common element of my writing, even in a third-person book like *Kavalier and Clay*.

I found Bloomsbury and Conan Doyle. I wrote lots of pastiches and imitations of people like Woody Allen, Perelman, James, Nabokov, Henry Miller, God help me. Adopting other voices, you find elements you really respond to. Then you take that and move on to the next writers.

I loved Pynchon, early Barth, Coover. The idea that it's all a big game. We'll peel off all the layers of fat and ornament, and show you it's all a bag of tricks. They were saying, "We don't expect you to *enjoy* the illusion." The minimalists came after the scorched earth exercise, the shattering of all illusions. It was impossible to ignore Barth's point, but I decided to go on anyway. I decided that even though you and the reader know it's a bunch of tricks, it doesn't diminish the pleasure one bit. I'm very strongly aware of a nineteenth-century legacy. Everything else aside, it's essential to draw the reader in, keep the reader's attention till the end. It has to be entertaining on several levels.

If you're a lens with a particular grind, with warps and bumps, the writers you like are lights that can shine through that lens. Different lights are going to reveal different aspects. You end up with a map of your own lens—the things that come up again and again.

First person comes much more easily to me than third person. Maybe that's true of most writers. I feel that I have immediate access to a character's perceptions and emotions and personality, to his way of speaking. It's such an effective way of characterizing someone. It's so quick. When it came to my first novel, I didn't think about it very much—it seemed like the path of least resistance. Plus, I started it immediately after having read *The Great Gatsby* and then *Goodbye, Columbus*. Both are strong, memorable first-person narratives, and both take place over the course of a single summer. They had a retrospective quality—as if you're saying, "Looking back, this is the summer that made all the difference." I hit on the tone fairly quickly. A little hyperbolic, a little show-offy, lyrical, kind of larky sort of tone.

Then I tried to write a third-person novel. It was called *Fountain City*. I was trying to write a kind of bildungsroman, about a callow youth who had experiences, who would mature and grow. I felt there should be a certain amount of ironic distance. I was thinking of books like Balzac's *Lost Illusions*, about callow youths who take on the world. Those tend to be written in the third person. Or even in Jane Austen–like irony. It proved in the long term to be a fatal decision for that book. One of the things that were primarily wrong with the book was that I never connected with the main character. I never got a handle on who he was. It always felt very remote—I blame my failure to grasp how the third person would work in a book like that.

I blew five and a half years of my life on the book. After I finally gave up, I made the deliberate decision to go back to Pittsburgh and the first person, and an even more restricted narrative frame, of a weekend. As soon as I started writing, the voice of Grady Tripp just came. The first sentence of *Wonder Boys* is the first words I wrote: "The first real writer I ever knew was a man who did all of his work under the name August Van Zorn." I just went from there. I wrote the first draft in seven months. I felt I had immediate access to Grady Tripp, to his mind and emotions, his perceptions, and that I could communicate them directly. Also, I liked the self-irony—it worked better than the irony in the unfinished book. No one's more aware of his own limitations than Grady. He makes self-deprecating remarks, which is a very different thing from having narrator make deprecating remarks. I feel like that book would have been a harder, cooler, Waugh-like humor in third person. You get a kind of affection because he's self-critical.

With *Kavalier and Clay*, I knew from the start that I would have to do it in the third person. I had this moment of trepidation. "Oh, shit, I already tried this. What if I'm just a first-person writer?" Possibly because there was such a strong historical and cultural context, the narrator was much easier to imagine than the narrator of *Fountain City*, who had to create an entire world. I got some of the tone from *New Yorker* "Talk of the Town" pieces from the thirties and forties. They had this omniscient quality: "We're perched in this tower and can see everything from New Lots to Hoboken."

But a lot of it I figured it out along the way, draft to draft. The fundamental question for me is always, Who's talking? Is it one of the characters? Who is telling the story? What kind of intellectual apparatus do they have? I ended up with a retrospective omniscience, almost pseudo-scholarly, with all the footnotes. The narrator's voice was similar to Joseph Ellis in *Founding Brothers*. That helped me in my fundamental task, which was to establish Kavalier and Clay as real people who really lived. The narrator could do that, then dip into all different points of view, including entering the world of the comic books themselves.

Whatever I'm writing, whether it's a novel or a short story, I try to hit on the voice as quickly as I can. I will keep hammering away at the first sentence till I hit that tone, the sense of rightness that's very intu-

itive. Eventually, this reflexive feeling dissipates, and I don't have to think about it anymore. It becomes about work, about finishing.

It becomes a bit like modulating flow, as if the narrative is a kind of gas. I want to keep it the same way as in the first sentence, one sentence at a time. I'll read the individual sentences over and over to myself. If I feel like I've lost the thread of what I'm doing or if I've lost the voice, the sense of who's talking, I will read out loud and see how that works. The way I work is that I type up a sentence, look at it, read it, move parts of it around, look at it again. If I don't like it, if it's too antagonistic, pseudo-erudite or too whatever, then I'll delete it and I'll start again.

I had a writing teacher at Pitt named Eve Shelmutt. She said we had to throw away our pencils and pads, and had to write at a typewriter. She thought that only the neutral typeface of a typewriter would allow for dispassion, so we could look at our writing critically. We had to roll the paper in, type a sentence, then put in fresh paper. One sentence at a time. It actually worked. It forced me to incorporate rewriting into the writing process. Writing is rewriting. She invented word processing before word processors.

Fiction is concerned with illuminating states of consciousness. That can be overdone. But I would never want to dismiss that element of literature. I read to get into somebody else's brain. It ties into escape, and that whole aspect of *Kavalier and Clay*. The ultimate prison is your skull. To me, Proust is an escapist.

Right now I'm working on the screenplay for *Kavalier and Clay*. It has an enjoyable problem-solving quality. But I miss the voice.

Personal Essays, Travel Writing, Memoir, Criticism

In my mind these forms, for all their difference, belong together at the next spot in the continuum of communicative to poetic writing. (As a result, I stack their representatives, Nicholson Baker, Jon Pareles, and Clive James, on top of each other like the layers of a triple-decker sandwich.) Just as in first-person fiction, we get the sense that a person is standing behind the words. Only in this case it's a real person, and the reader is always conscious of the tone of his or her voice. True, there are exposi-

tional chores to carry out—plot summary, quotation, description, factual background, or narrative—but the better the critic, essayist or memoirist, the more economically they are performed, and the more consistent this material is with the style of the entire piece. And the style—more even than the opinions or feelings it expresses—makes readers feel they are listening to someone who is dull, witty, eccentric, mean-spirited, wise, decent, or possessed of any other quality. There is no getting around this. Writers in these genres who wrap themselves in the middle style, hoping it will grant them the power of invisibility, find that it actually reveal them as conventional, cautious, and timorous. So better to accept personality—indeed, to revel in it. Think of Jonathan Raban, Paul Theroux, Rebecca West, and Bill Bryson describing the same Egyptian bazaar. Their accounts would be wildly and entertainingly different—and all because of style.

There is an odd corollary to the importance of style in these forms. I would say that the true signature of the writers, and the ultimate gauge of their worth, can be found in their descriptions and characterizations *of* style—whether of themselves, the people they encounter, or of literature, dance, theater, music, painting, movies, or cooking. I can't explain why this is true, only to suggest that the more acutely one is aware of style in the world, the more carefully one will likely attend to it in one's own work. Take a look at this passage from M. F. K. Fischer's memoir *Long Ago in France*, about the meals served by her landlady when Fischer, as a young student, lived in Dijon:

> The kitchen was a dark cabinet perhaps nine feet square, its walls banked with copper pots and pans, with a pump for water outside the door. And from that little hole, which would make an American shudder with disgust, Madame Ollangnier turned out daily two of the finest meals I have yet eaten. But cooks found it impossible to work with Madame Ollangnier, impossible to work at all. She was quite unable to trust anyone else's intelligence, and very frank in commenting on the lack of it, always in her highest, most fish-wifish shriek. Her meals were a series of dashes to the kitchen to see if the latest slavey had basted the meat or put the coffee on to filter.
>
> She could keep her eyes on the bottle that way, too. All her cooks drank, sooner or later, in soggy desperation. Madame took it philosophically; instead of hiding the supply of wine, she filled up the bottles with

water as they grew empty, and told us about it loudly at the table, as one more proof of human imbecility.

The description of the kitchen is a technical task, and impersonal; if you came across that first sentence in Orwell's *Down and Out in Paris and London*, which also deals with French cooking circa 1929, you wouldn't blink. But nothing that comes after it could have been written by anyone else, least of all Orwell.

Martin Amis's collection of critical essays, *The War Against Cliché*, is a case study of the principle as it applies to literary criticism; style is the subject of all the best bits. In the course of fewer than 100 pages, Amis refers to Robert Bly's "twinkly demotic"; says Bill McKibben "lacks weight of voice" and is "a puzzled and guileless presence; his thumbprints and inkspots, his false starts and rethinks, are in the margin of every page"; calls Andy Warhol's voice "this wavering mumble, this ruined slur"; refers to "the hobbyist brio of [Angus] Wilson's prose"; calls Iris Murdoch's style "a hectic, ragged thing," with "needless emphases and train-wreck adjectives"; says that J. G. Ballard's prose is "simply the rhetoric of an obsession, as dense, one-colour and arbitrary as the obsession requires it to be; offers that "when Anthony Powell writes a phrase like 'standing on the landing' you feel that it is the result of mandarin unconcern or high-handedness"; and says that V. S. Pritchett's prose "is quirky and nostalgic in its devices. He continues to write in a style that has not noticed the regularizing, the tidying-up, that accompanied the concerted push towards naturalism in the middle of the century. His punctuation is tangled, hectic and Victorian."

Because this is just too fun to stop, I offer a longer, more admiring excerpt about a single writer: John Updike on J. M. Coetzee's autobiographical novel *Youth*, which has the bonus of quoting Coetzee on *another* writer's style:

> Coetzee, with his unusual intelligence and deliberation, confronted problems many a writer, more ebulliently full of himself, rushes past without seeing. His eventual path, via Beckett and the purity of mathematics, was a kind of minimalism, a concision coaxed from what he felt was his innate coldness. While he was still in Cape Town, his taste moved from Hopkins and Keats and Shakespeare to Pope, "the cruel precision of

his phrasing," and, even better because wilder, Swift; he feels "fully in accord" with Pound and Eliot's attempt to bring into English "the astringency of the French." In one of his courteous, admirably thorough reviews, Coetzee remarks that Doris Lessing "prunes too lightly" to be a great stylist, and his own paragraphs and plots feel sharply pruned, at times as brutally disciplined as Parisian lime trees.

Nicholson Baker was born in 1957 and grew up in Rochester, New York. His novels are *The Mezzanine, Room Temperature, Vox, The Fermata, The Everlasting Story of Nory*, and *A Box of Matches*. His nonfiction books are *U and I, The Size of Thoughts: Essays and Other Lumber*, and *Double Fold: Libraries and the Assault on Paper*, which won the National Book Critics Circle Award in the general nonfiction category in 2001. He founded and currently directs the American Newspaper Repository, a collection of nineteenth- and twentieth-century American newspapers. We spoke at his home in South Berwick, Maine. From *U and I*, a chronicle of Baker's obsession with John Updike:

Halloween is taken extremely seriously in the town where I live: there is a Halloween parade on Main Street at which policemen enthusiastically tamper with through traffic, and hundreds of children visit every fit house, and the local medium-security prison advertises to X-ray all bags of candy for harmful objects until 11:00 PM on the big night. My wife told me about the X-ray ad (which she had seen in the local free weekly) the morning after, and I was crazy with regret. If John *Updike* were thirty-two years old and living in this town, I thought, he would have known beforehand about that incredible X-ray offer and he would have driven up there with his kids after going trick-or-treating with them and he would have talked affably with the prison guard about some of the concealed weaponry the guard had found in gifts to prisoners and whether there had ever in fact been any adulterated candy of any kind detected locally or whether it was simply a mythical precautionary thing intended to demonstrate the prison's wish to contribute in whatever way it could to the happiness and welfare of the community in which it found itself, and Updike would have slyly looked around and caught a little flavorsome garniture of the X-ray room, perhaps a sign whose text would look funny in small caps, and he would

maybe have jotted down a few comments his kids made as the image of the nuts in the miniature Snickers bars and the internal segmentation in the Smarties packets appeared on the gray screen, and then he would have driven home and in less than an hour produced a nice *Talk of the Town* piece that worked understatedly through the low-grade ghoulishness of driving to a medium-security prison to have your children's Halloween candy X-rayed for razor blades, in an epoch when apples were so completely not a Halloween treat anymore, and when all candy bars had tamper-evident wrappers. No, no, worse than that: he wouldn't have done it when he was thirty-two; he would have done it, better than I can do it now, when he was *twenty-five*. At thirty-two it would have been beneath him, too easy, too reportorial, too much of a typical Talk piece, whereas for me, I thought, it has the feeling of an outstanding topic, full of the exciting timeliness of nonfiction magazine writing. *I*, at thirty-two, had missed the story completely; the only piece (I dislike that journalismoid word "piece," and yet it slips in all the time) I could possibly do was one about wanting to have written a bright little prison-visit piece: that is, about the adulterating of innocent children's holidays by the writer's hyperreceptivity to newsworthy small-town touches—and who would want to read that?

Getting it to sound right is always the big, crucial thing. When does it sound like me, but not like an imitation of me? Unless you've gotten the voice right in the beginning, the whole enterprise is hopeless—every other paragraph is going to lurch around, bumping into things. Once I manage to get the first couple of pages to move along, all my notes start to chirp and I'm happy.

Before that happens, I have the unpleasant feeling of being in charge of many drawers and cubbies full of useless unrelated stuff. There's a French way of doing a book, or there was when I was a student, where everything's in fragments. You celebrate disjointedness because life is like that. For a while it was kind of in vogue in American writing too—books were composed of little scraps, tiny paragraphs, numbered sections. But I like books to be the way I think events truly are, linked together, all part of one longer continuous thread.

I know I'm going to sound like myself whether I like it or not. There's nothing you can do—you can't take some chemical or read some book that will change you into a different kind of writer. I've seen writers and

journalists fall under the spell of somebody and write strangely for a couple of months. But they go back to their own ways because their own ways are inescapable.

Each book you publish becomes a layer of novel usage—novel for you, that is—that you can't repeat. When I sense that I'm getting too close to something I've done before, I try to squirm off in a different direction. I probably waste a lot of effort doing that, squirming away. A given word can become your enemy—I wrote about this in *U and I*. Once it was your most precious word, and you placed it prominently in the display window. But then it started to pop up on all sorts of inopportune occasions. Now you have to keep in your mind not to use it, not to succumb. And of course you have the whole literary tradition telling you that you must avoid doing certain things—you can't use the word *crap,* much as you'd like to, because then it will sound like Salinger. So it can get complicated. And yet the joy is that the narrowing down forces you to discover some other avenue, some other spring in the mattress, not only of vocabulary but of rhythm.

I like Victorian prose writers, or even pre-Victorians like Thomas De Quincey and Edmund Burke—people who went for long unkempt sentences. As a kid I liked complicated steam engines, with lots of moving parts, and that's something I try to carry into my sentences too; you can see flywheels and belts and levers. But really it's not quite so mechanical as that sounds. I almost never say, "Okay, I'm going to write a long sentence right here." Rather my short sentence starts to sprout secondary growths as it's going forward, and little bits of it unfurl and they in turn reveal other bits that germinate, and suddenly I've got something that's out of control, unwieldy, and I have to do just as the grammarians advise and break it in half. That can be an agonizing moment, deciding whether to bring out the big chisel or put your trust in a semicolon.

Something else about writing, which I talked about in *U and I*. If you start with a pared-down style, you're giving yourself nothing to pare down from. It seems more natural to me, and more fun, to write as richly as I actually want to write and figure that later on I will tire of the finery and write with a hard-won austerity. If you live in a ritzy prose style for a few decades, you may begin to feel the need to pull down the plaster cornices.

For my first book, *The Mezzanine,* I hand-wrote a few sections at restaurants, I used a manual Olivetti typewriter at home, and I used a

word processor at work—I was working as an evening-shift word processing operator at a law firm. In 1985, I bought a Kaypro computer, and I liked it because I could turn the screen's brightness down with an old-fashioned dial like a volume dial, so that I could barely see the words as they appeared. I seem to need some degree of sensory deprivation as I'm writing: back then I would turn the lights off in the room and hook up the keyboard to the computer with a twenty foot telephone cord, so that I could sit across the room and see not paragraphs but faint gathering green spectral presences floating in space.

I do love typing—I just love it. Thinking and typing. I worked with this woman in a secretarial pool who said, "Typing is the love of my life." I know exactly what she meant.

I write every day, and most of it is really not at all good, but I do try to file it away in different manila folders, hoping that there will be some biological change or some composting process that will take place between the two manila leaves, that will make the contents fuse together. I do less filing these days than I used to. From time to time I go through a folder and make little check marks or circles around a few passages that seem to be worth keeping and try to remind myself why I started that folder in the first place. And then I forbid myself to look at the notes and instead I write about the subject straight out of my head, afresh. That will either work, or it won't, and if it doesn't, it becomes a further set of pages, a further thickening of the file. At some point I finally find a way to begin a book with the right kind of appealing forward impetus, and the momentum generates its own static cling and empties the folder for me.

Often a book has a built-in deadline, which is that if I don't write it right then, I'll forget how everything that I want to include fits together. In the case of *The Mezzanine*, all those thoughts about escalators and date stampers and whatnot were part of what I'd been doing for a living, and when I stopped riding the escalator every day and instead began writing about it, I could feel the experiences start to break up and dissolve in my memory. That feeling of losing what I've lived, and losing it so fast—that more than any editorial deadline or financial pressure has given me the oomph I've needed to finish books.

I wrote *The Mezzanine* with a great rush of joy in the first person and then I wrote *Room Temperature* in the first person as well. I felt that I definitely couldn't do another book that way. And then I thought, *Well,*

the heck with it, I will because I want to. So *U and I* is in the first person as well. It's my most autobiographical book, it's the book that's truest, that could well be my best book.

When I first see them set in type, my sentences sometimes seem to have Scotch tape and barnacles and wires and alligator clamps hanging off them. Then there's a hosing-off period—memory smooths each sentence, wears it down. After a few years it becomes stone: the sentence that always was. When I look at a book that I've written a while ago, my first reaction is, What a miracle. Not that it's miraculously good, just that it miraculously exists. I can look across the room now and see that there is a small pile of books that I have evidently written. It startles me. I think, *How in the world did I ever manage to put all those words together?*

A native of New Haven, Connecticut, *Jon Pareles* graduated from Yale in 1974. He was a freelance rock writer and critic until 1977, when he took a job as an editor at *Crawdaddy* magazine. He subsequently worked at *Rolling Stone* and the *Village Voice*. He has been a rock critic for the *New York Times* since 1982, and the chief popular music critic since 1988. He is the author of *The New York Times Essential Library: Rock Music*. We spoke at a Greenwich Village coffeehouse. From "Songs in the Same Key with Just a Few Guitar Licks," the *New York Times*, October 3, 2000:

> Boubacar Traoré, the Malian singer and guitarist who performed on Thursday night, could give austerity lessons to Minimalists. Mr. Traoré played an entire set of songs in the same key, each built around just two or three vocal phrases and a handful of guitar licks. The only accompaniment came from Sidiki Camara tapping a calabash with sticks and thumping it with the heel of his hand.
>
> But the songs conveyed neither renunciation nor scarcity. Mr. Traoré made their self-imposed limits into a universe: a place to dance, to lament, to make his guitar tickle and bite. His voice had a kindly tone with a mournful undercurrent as he sang about a lost love or friends he left behind. And his intricate guitar parts, mostly played with thumb and forefinger, could turn a two-chord vamp into a three-dimensional matrix of bass lines, upper-register replies, melodies shared with the voice, obstinate trills and high, light offbeats, with the calabash clicking along.

Most songs ended with long fade-outs, achieved without a volume knob, in which rhythms, vocal lines and guitar parts let their inner workings glimmer before disappearing into silence.

It's not naive music. In the 1960's Mr. Traoré had a rock hit in Mali, "The Mali Twist," then turned to day jobs and an expatriate's life in Paris. When he was rediscovered in the late 1980's he had created a different hybrid music. He reached back to traditional music from Kayes, in the Khassonke region of northwestern Mali, where he was born; he was also aware of the blues, another style that makes bare-bones structures eloquent.

At Joe's Pub, a few of Mr. Traoré's songs used spiky blues licks and tempos as deliberate as slow Delta blues; one from his new album, "Macire" (Harmonia Mundi), toyed with flamenco guitar lines and quasi-Moorish modal scales. The others, with sharp, staccato picking, made the guitar sound closer to traditional West African harps and balafons (marimbas). The music was swinging and hypnotic, doleful and soothing, rooted and personal, as it transmuted basic elements into profound incantations.

I don't know if I'm a natural writer, but I'm a natural editor. I'm a Strunk and White person. My copy comes in clean. Plus, I am inclined to write short. I learned concision from rock lyricists. There is an aesthetic that says do it in three minutes and get out. I am not Wagnerian. I am Chuck-Berryan.

I'm personally addicted to live performance. Records are piling up in my office even as we speak. They're dull, because they'll be the same next week. But at a concert, there's always some feeling you saw a unique moment. When I started doing this, I thought, "Just the music, not the clothes, not the audience," which was totally wrong. It's essential to be aware of the reaction of the audience. It doesn't happen behind a screen. You're in it, and I do want to convey that. Everything is part of the performance. It may be that as I'm getting older I'm seeing more contradictions in the world. But every concert is vastly more complex than what I can explain, especially in four hundred words. So the gig is to get as much in as I can, and sort it out.

I was a music major at college. I started playing piano when I was six, and the flute when I was eight. My parents thought I was Mozart, but I wasn't. I didn't have the discipline to practice five hours a day, so I drifted

into composition and musicology. Now I think what I do is something like being an ethnomusicologist of current music. I can write music notation, plus I have perfect pitch, so that unlike any rock critic I know of, my notebook is filled with the riffs. It's like taking dictation.

Drummers are my style guide. I always want to think about rhythm. If you listen to a drum solo that repeats the same beat, it's dull. You want something that surprises you, with some variation, snappy ending. Consciously try to put the most important word of a sentence at the end—it's a punch word, like a punch line.

Music is notoriously prone to clichés and stock phrases. They're all in my head, and I really try to avoid them. I will never call music from New Orleans "gumbo." I very rarely or ever use the word *beautiful* even though there's a lot of beauty in what I cover. The word itself just rings the thud meter for me. It's either too strong or too clichéd for me to use. I try not to use the word *liquid* or the many flowing metaphors that are perfectly appropriate for music. It's been overdone. I'm really inhibited! If you look at my stuff on LexisNexis, I'm sure all these words will creep in somewhere, because the other great inspiration is the clock—if my review isn't done at three o'clock, I'm a dead man.

I want everything to be vivid. When I'm doing the first draft of a piece, I will write "verb to come" or "image to come" if I can't think of something good enough at first. I try to use lots of verbs. Music's really active, music is an action in time, and so it should be a verb if at all possible. Adjectives are a distant second. Music affects your mind and your body—it's a verb. An adjective is for something static. If I were describing paintings, I'd use more adjectives. Nouns are important too. In the Boubacar Traoré review, I talked about the "calabash clicking along." A calabash is really a gourd, but I like *calabash* better. It's onomatopoeia, and the "clicking" gives you some alliteration.

David Bowie's guitarist, Reeves Gabrels, once said people's attention spans are really short now, so he has to do something every few minutes to get their attention. I identify with this. I put in lots of contrasts, like pairs of contrasting adjectives. A lot of the music I cover is all about contrasts, really. One of the beauties of African music is that it's happy and sad at the same time. Spirituals—out of utter tribulation is redemption. Jazz, where you can be bluesy and celebrating and sexy. It's multilayered music. I try to convey that with the adjectives that I do use.

I consider myself a reporter, and the temptation in a review is to do the details—I saw this, I saw that. I'm always trying to police myself, to say *why* it's important. Donald Barthelme was one of my heroes. The man could make an entire story of a list. There is always a tendency to make lists, in journalism and in general. I could list songs, I could list instruments. I hate it and I try to fight it. I want to tell people why they're reading the list first. If you watch a movie, there are closeups and long shots. A movie all in closeups would be boring, or Warhol. I like to touch down and bounce up.

I try to hover between the spoken and the literary. I do have a lot of contractions. In revision, I take out as many semicolons as I can. I love parentheses, and some of those go too. The other thing that comes out is the word *seem*. I'm a critic, godammit—it shouldn't seem, it should be obvious. *Rathers, somewhats, quites.* There's no need for ninety percent of qualifications, especially in a short piece. When I started writing for the *Times*, someone complimented me by saying Vincent Canby and I were the only ones that didn't sound like we had an English accent.

I loved Canby. He had such seemingly casual, deeply erudite quality about him. My other model was Robert Palmer, my predecessor at the *Times*. He was a total natural. I saw him walk in, type in a review and walk out. My jaw was down to my knees.

I try to learn from what I write about. I shouldn't be too serious, because rock is a big joke. I take it seriously, but don't take myself too seriously. It's stupid a lot of the time, but there's a virtue in that. It's like David St. Hubbins said in [*This Is*] *Spinal Tap*: "There's such a fine line between stupid and clever."

I guess I'm always writing about flux—maybe too much. It's never a still photo. I love changeability. In classical music I was a big fan of Bach and the Renaissance, but in theory I'm more of a romantic. I was a math major for a year before I went back to music. And I love order and structure and analysis, but my instincts lead me as I get older and more mature to the rhapsodic. I love the volatility.

Music, in my estimation, is everything. It's your romance, it's your food, it's your culture, it's history, it's psychology. Any concert will have all those tendrils in them, and you can follow any single one. It's infinitely deep. It's a signal system. You pick up the traces. I should ideally convey that it's as simple as somebody trying to get the girl to dance with them,

and as complex as somebody trying to reach God or change the world. In Egypt there was a shaman called the haruspex that did divination from entrails. That's what we're doing. It's all the entrails of the same animal. Comedy will reflect something, movies will reflect something. I like pop cause it's faster. Movies are going to happen a year later, TV six months later, pop two months later. It's all the same cultural id. It's all the same desires that no one is expressing directly. That's what you want to show people.

It should always be visceral. People don't go to hear the theory, they want to have the feeling. I don't want to be at such a remove from it that I forget to have good time. There's an Ornette Coleman album called *Dancing in Your Head*. I think that's what critics do. My joke is that rock critics are the people who went to the high school dance and were listening to the band. I can't dance worth a lick. I'm a hazard on the dance floor. But I'm dancing in my head.

B orn in Sydney, Australia, in 1939, *Clive James* has lived in London since the early 1960s and has published many volumes of poetry, fiction, literary criticism (most recently *As of This Writing: The Essential Essays, 1968–2002*), memoir, and song lyrics. He was the television critic for the *Observer* from 1972 till 1982, and his pieces were collected in *Glued to the Box* and other books. Since the early 1980s, he has been one of Britain's best-known television personalities, as the host of *Saturday Night Clive* and many other series, specials, and documentaries. We communicated by e-mail. From "On His Death," written in 1973 and reprinted in *First Reactions*:

> I was born in the month after Auden wrote "September 1, 1939," and saw him only three times. The first time, in Cambridge, about five years ago, he gave a poetry reading in Great St. Mary's. The second time, on the Cambridge-to-London train a year later, I was edging along to the buffet car when I noticed him sitting in a first-class compartment. When the train pulled in, I waited for him at the barrier and babbled some nonsense about being privileged to travel on the same train. He took it as his due and waved one of his enormous hands. The third time was earlier this year, in the Martini Lounge atop New Zealand House in London, where a recep-

tion was thrown for all of us who had taken part in the Poetry International Festival. Auden shuffled through in a suit encrusted with the dirt of years—it was a geological deposit, an archaeological pile-up like the seven cities of Troy. I don't think anybody of my generation knew what to say to him. I know I didn't. But we knew what to think, and on behalf of my contemporaries I have tried to write some of it down here. I can still remember those unlucky hands; one of them holding a brimming glass, the other holding a cigarette, and both of them trembling. The mind boggled at some of the things they had been up to. But one of them had refurbished the language. A few months later he was beyond passion, having gone to the reward which Dante says that poets who have done their duty might well enjoy—talking shop as they walk beneath the moon.

In Australia in the late fifties, when I was an undergraduate at Sydney University, the youngest member of a small group of would-be writers who passed books around, my master spirit as a stylist was George Bernard Shaw. Not so much the plays as the prefaces, and not so much the prefaces as the criticism, set my standards for the flow and brio of prose. Until he got garrulous in old age—by no concidence, that was also when he got insensitive—his prose was always much more concise than he was given credit for. Orwell called him a windbag but not without reading everything the old man had written. I still think the six volumes of the Standard Edition, which consist of *Music in London* and *Our Theatres in the Nineties*, are the greatest single critical achievement in the English language. Even at the time, however, I realized that the challenge would be to appropriate his effects without sounding like an imitator. I tried to avoid the knowingness that infected his tone: he worked from a position of sophisticated experience, so I tried to work from the position of the permanent tyro, which is the way I feel naturally anyway.

I got into the useful habit of following up on tips in the ancillary writings of a hero: for example, if Edmund Wilson mentioned Mencken in passing, I would find out who Mencken was. Eventually I found his style too wilfully forced in its pizzazz, but I was permanently influenced by the way Mencken got the vocabulary and the details of common life into his political reports, thus founding a sparkling amateur tradition that made Walter Lippmann's supposedly professional commentaries look moribund, strangled in their own good connections. Mencken, in my view,

was the start of everything in America's version (I say America's version because in Britain the heritage goes back to Hazlitt and beyond) of the literature that happens somewhere between literature and journalism. There was no Australian equivalent tradition when I was young.

With Scott Fitzgerald, whose *Crack-Up* essays bowled me over, I wanted the element of personal confession without the romanticized nostalgia. I have always liked nostalgia, but not as an indulgence: I like the hard edge made possible by admitting that what's gone is gone, and the fun of admitting that I once liked it. Even today I can still recite the last paragraphs of *The Great Gatsby*, and as soon as I read them I formed the determination to work at a paragraph until it transmitted a poem's air of inevitable word-order. I was put on to Fitzgerald's essays, again, by Edmund Wilson, who became a lifelong model in everything except his prose. He had no particular rhythm, and in old age grew quite careless of his sentence construction: his great virtue was clarity, principally obtained by saying one thing at a time. It was a useful chastening for my own tendency to say everything at once. Given the choice of an over-loaded sentence and one that says too little for its length, however, I would always choose the former, although to avoid the choice is the whole trick.

The man who taught me to load a sentence with cultural references and wisecracks, both at once, was S. J. Perelman. Before I left Australia, I had read everything he had written and possessed every book except the ultra-rare *Dawn Ginsberg's Revenge*. There were, and still are, whole passages of Perelman that I can recite. I avoided aping him by a simple reversal. His basic technique was to write a joke and load it with culture, thus to make the reader feel clever. I wrote about culture and lightened it with a joke, thus to make the reader feel funny. Later on, in Fleet Street, when I was writing about television every week between 1972 and 1982, I was essentially employing the compound style that I lifted from Perelman, and that I disguised by rearranging the elements.

We all read the Americans avidly: we had the British culture officially, and the American as our school's-out secret. One of the sweetest things about reading *The Catcher in the Rye* was that the professors hadn't. It was like sneaking off to see "Rock Around the Clock." When I first read the phrase "as cold as a witch's tit" I saw my whole life before me. It wasn't the calculated obscenity, it was the conversational timing.

Among the expatriate pleiade that later became collectively famous—Robert Hughes, Germaine Greer, Barry Humphries, and, dare I say it, myself—Hughes was the only one I knew well at university. Most of my literary friends were destined for other careers. I should have realized that at the time, but had not yet learned to spot the difference between the fan and the performer: the fan reads for enjoyment, whereas the performer reads to learn.

The accepted influence on the prose of my generation of Australians was the great war correspondent Alan Moorehead, whose many books Hughes has, very rightly, praised at length. At one time or another, and especially in recent years, I read all of Moorehead—the *African Trilogy* is particularly fine—but I doubt if I was ever influenced by him as I once was, almost fifty years ago, by the first few chapters of Russell Braddon's *The Naked Island*, in which he wrote about Sydney with an unforced vividness it had never been treated to before. When I came to write *Unreliable Memoirs*, it was undoubtedly Braddon's play of light and water that I had in mind. Braddon has zero literary status now, even within Australia, and indeed there was nothing particularly striking, in the literary sense, about the way he wrote, except that it didn't sound like writing. It sounded like speaking, which is my continuing ideal.

In addition to the American stuff, I myself was keen to absorb the modern British tradition of light-touch aesthetic journalism that culminated in the books of Osbert Lancaster: *Draynefleet Revealed* remains, even to this day, my ideal of the Kleinkunst masterpiece that has no reputation except among connoisseurs. I borrowed my first Lancaster books from Hughes and had memorized them all before I left Australia. Hughes himself, in his art criticism, was crucially influenced by Lancaster's seemingly effortless, set-designer's strategy of building up a verbal picture out of a few precisely observed but lightly sketched architectural details.

In *Drayneflete Revealed*, incidentally, the maraschino cherry on the fruit sundae is "Crack-up in Barcelona," the best parody of Thirties poetry ever written. Hughes and I can both quote it from end to end, although not when we are together, because each shouts down the other. Like his eye, Lancaster's ear was infallible, although not for his own dangling participles: a quirk that Evelyn Waugh occasionally shared,

and which Anthony Powell had like a disease. It was because of too much Latin at school: the ablative absolute got into their English syntax.

The formative stage is the interesting one, but very hard to be introspective about, because you took too much in at the time to analyze it properly later. When I was doing my national service in the army, there was a drawling, grunting, lead-swinging lance-corporal called Grogan who could make me laugh just by the way he timed his pauses. First the long, slow drawing back; and then, and only then, the crack of the whip. For all I know, he was the biggest influence on my style; and he never wrote a thing, or was heard of again.

When I got to England, I spent three years down and out in London, before going to Cambridge, so Orwell was appropriate reading. From Orwell's essays I received a long lesson in how to balance one sentence against the next within the paragraph, always preserving speech rhythms even when the sentence was cantilevered over three or four clauses. As one gets older, one is influenced less. I think the world of Gore Vidal's plain style, but it never influenced me in the way that, say, Kingsley Amis's did: I had to fight hard to avoid sounding like Amis, especially in his criticism. The same applied in the case of Larkin, whose critical prose enchanted me as much as his poetry. Even today, such dazzling young polymaths as Anthony Lane and Adam Gopnik would disable me if I allowed myself to echo their easily omniscient tone. Did they suck encyclopedias in the cradle? Luckily age works like an armour plate.

Kenneth Tynan affected me deeply, less as a role model—I never wanted to be a theatre critic—than as a stylist. It should not be forgotten that the Fleet Street tradition of the media-criticism column was very strong before Tynan got there. I myself, in my television column, had Paul Dehn's and Penelope Gilliatt's film columns in mind, and they in turn were in a line that went back to C. E. Lejeune. But there could be no doubt that Tynan set a new standard for putting his own literary personality at the centre of the event, as if the proscenium, far from separating the auditorium and the stage, joined two stages. His first book, *He That Plays the King*, I practically got by heart. His reviews were often more dramatic than the plays they reviewed, and I tried to keep the same rule in my television criticism: make it a better show than the shows. My years in Cambridge Footlights helped me there: when I came to write a regular 1,000-word television column for the *Observer*, I was

able to use many of the tricks of variation and compression that I had learned on stage. Tynan spotted what I was up to, and he took a flattering interest in my writing. In his last year alive, when he was cohabiting with an oxygen cylinder in one of the Los Angeles canyons, we had a long argument about Hemingway. Between drags at the face-mask, he read aloud one of Hemingway's passages about the Gulf Stream absorbing all the garbage thrown into it and still running clear within a few miles. I took it at the time as a wish-fulfilllment: Tynan was reminding himself of what it had been like to breathe cleanly.

That being said, however, I would list Hemingway near the top among the stylists I did my best *not* to echo. Once submitted to, his influence is hard to shake: not even Mailer could fight his way free without a struggle. (Nobody has ever survived copying Mailer, either, and the same applies to Salinger and Roth, both of whom I love, but have never made the mistake of trying to echo.) I admired Cyril Connolly, especially in the parodic mode best showcased in *The Condemned Playground*, but his claims to omniscience were patently false: I learned from him, by negative example, the necessity and good manners of acknowledging your limitations. I was powerfully attracted to Terry Southern's journalism as collected in *Red-Dirt Marijuana*, but luckily his mannerisms were few and easily staved off. Later on I wondered what the Hunter S. Thompson fuss was all about: Southern had already done all that, and done it on the quiet. But of course it's the noise, and usually the noise of a blatant chromium exhaust pipe, that attracts journalists to write about other journalists: they want to write about personal mannerisms, the very thing I think should be avoided, because stylistic quirks are predictable, and predictability is the enemy. Stunt writers like Tom Wolfe came too late to attract me even momentarily towards their tone, although the younger commentators in England were quick to assume that my own eclectic strategies, if not my style, must have been reacting to Wolfe in some way: they knew nothing about the tradition he came from. A young English journalist who interviewed me in the 1980s had never heard of A. J. Liebling (to whom Wolfe paid due homage) and when I mentioned Mencken's name he asked me how it was spelled.

Incidentally, I am still on my knees to Liebling after all this time. In his first Wayward Press collection there was a piece on Colonel McCormick and the *Chicago Tribune* that gave me the tip on how a pub-

lic figure, without being belittled, could be employed as a clown. The secret was to give him even more importance than he claimed. In Liebling's reports, the Colonel made a stately progress, like a king. Liebling could make you laugh just by the way he copied down the names of professional wrestlers. He could make you laugh because he never made the mistake of speaking in a funny voice; and, after reading him, neither did I. To the extent that I could rig the circumstances, I never tried to be funny in a funny context: only in a serious one. Humour as an exclusive genre I simply loathe. I don't even much like the wit that parades itself as wit. Dorothy Parker's epigrams I always found less interesting than the comic points made in her short stories.

A lot of the people I regard as stylistic influences never wrote in English. The supreme exemplar would be Alfred Polgar, the greatest of essayists in the German-speaking countries up until the Anschluss [Hitler's 1938 annexation of Austria], after which he went into frustrating exile in the U.S. Polgar, for me, is the magician: nobody could pack so many detailed perceptions tight together while still making the argument flow. I have often thought of doing a selected translation but it would not be easy to do Polgar justice: not so much because my German isn't good enough, as because I still have some way to go with English. Kurt Tucholsky called Polgar's sentences "filaments of granite." If anybody ever said that about mine, I would be very pleased.

In French, my models are Camus, Raymond Aron, Jean-François Revel, and (for the way he could write about sport, art, and ordinary life all at once) Jean Prevost, who was killed in the Resistance, thereby leaving a clear field for the suffocating punditry of the Sartreans. (Considered collectively, the French literary theorists provide the most conspicuous example of everything I try to avoid as a writer.) In Italian, Eugenio Montale's criticism—and especially his music criticism—is the model. And so on. Naturally one does not get the techniques of writing an English sentence from foreign writers: but a foreign writer's practical approach to a subject can be a useful vade mecum. Does he get an example in first, before launching his argument? How does he place his quotations? Does he tag a paragraph with his best maxim, or does he throw it away on the way in? It is too often said that imitation is the sincerest form of flattery. It isn't: imitation is a form of theft. The sincerest form of flattery is to appropriate another writer's strategic and tactical discoveries

while leaving his tone untouched. Ideally, only he will be able to spot that he has been robbed, and he will not press charges.

The influence of shared conversation on individual style is necessarily underrated because it is impossible to measure, and people rarely admit it when they have pinched things. At the time when Martin Amis, Julian Barnes, Christopher Hitchens, and I were lunching together every week, the pearls bounced all over the table. I can't remember stealing anything, although I might have indirectly. I can certainly remember being stolen from. I once described my little daughter as being so short it was a wonder her legs reached the ground. The phrase turned up in one of Martin's novels. I also opined that going to bed with two women must be like going through a car-wash. Julian got hold of that one. There was no acknowledgment in either case, and I eventually realized that I was playing in a crap game with spotless dice. But when you consider how much got said between us over the years, and how little got recognizably transferred from one player to another's pocket, I suppose influence came down more to rhythm than figures of speech. Rhythm and compression. Expansiveness was not tolerated, and the anecdotal tendency was firmly stamped on. A story had to be told in a few phrases or not at all—except by Hitchens, who developed a technique of interrupting his own stories with elaborations which were each successively more entertaining than the story itself, a stunning instance of assembling architecture out of decoration.

Finally, all the influences in the world serve only to refine your given qualities, which have mainly, I am convinced, to do with rhythm and tonal control. The first of these is a simple matter: either you've got it or you haven't, and if you've got it, all your admirations are only to set it free. The second is the most complicated thing there is, and I don't see how it can be obtained except as a distillation of all the voices that attracted your attention while your own voice was coming into focus.

I work on the assumption, or let it be the fear, that the reader will stop reading if I stop being interesting. The best reason not to overdo the hoopla, then, is that the result would lack interest: an excess would be even worse than a deficiency, because it would look nervous, and nervousness, in prose as in seduction, repels. Otherwise, I try to make every sentence in an essay as attractive as the first. This is the main reason why I find American magazines so difficult to write for. Acting as

journals of record, they have a habit of injecting pellets of factual material without reference to the writer's rhythm. No doubt it is a service to the little lady in Dubuque or the barber from Peru, but for the writer from Australia it is a disaster, because it breaks the grip. The grip, gently but firmly applied to the reader's collar in the first sentence, should drag him inexorably through to the last. Properly done, it can get him all the way from the street to the bar and back out again without his realizing that he has paid for the drinks.

Humor

The project of humor is the statement of more or less familiar truths in comically unexpected ways. That is, it is about style. Like poetry, it is typically expressed in a short form, but it carries a bit more of a burden of communication with the reader; an obscure humorist would find it hard to get published, whereas many obscure poets have won the Pulitzer Prize. Written humor is usually in one of two modes. The first—seen in the work of Dave Barry, David Sedaris, Roy Blount Jr., Sandra Tsing Loh, Nora Ephron, and Bill Bryson, who speaks below—is a kind of transcription of a particularly smart and literate stand-up comedian's routine. Style is critical in the construction of both the comic persona and the comedy. That is to say, the universally known truth that airline food is bad becomes funny only when it is expressed with the right examples, phrasing, exaggeration, timing, and attitude.

The second kind of humor, which I call comic ventriloquism, requires even more attention to style; once upon a time it was widely used in the lost art of parody. But that form has a tough time of it in a dumb-downed age, limping on only in Bad Hemingway contests. Indeed, now that Woody Allen is a highly serious cinematic auteur, the only standout comic ventriloquists are Ian Frazier and Steve Martin. What Frazier brilliantly does in his *New Yorker* and *Atlantic Monthly* pieces is take one of the thuddingly banal voices floating around in the verbal atmosphere—psychobabble, journalese, bureaucratese, academese, *-ese*'s that don't have a name yet—mimic it with precision, and sic it on something totally unexpected. In his "Laws Concerning Food and Drink; Household Principles; Lamentations of the Father," the style is a venerable one, never before applied to this subject:

And if you are seated in your high chair, or in a chair such as a greater person might use, keep your legs and feet below you as they were. Neither raise up your knees, nor place your feet upon the table, for that is an abomination to me. Yes, even when you have an interesting bandage to show, your feet upon the table are an abomination, and worthy of rebuke. Drink your milk as it is given you, neither use on it any utensils, nor fork, nor knife, nor spoon, for that is not what they are for; if you will dip your blocks in the milk, and lick it off, you will be sent away. When you have drunk, let the empty cup then remain upon the table, and do not bite it upon its edge and by your teeth hold it to your face in order to make noises in it sounding like a duck; for you will be sent away.

Bill Bryson was born in 1951 in Des Moines, Iowa, where his father, also named Bill Bryson, was a longtime sports columnist for the *Register*. After graduating from Drake University, he moved to England, where he worked as an editor on the *Times* and other newspapers, and eventually as a freelance writer. Bryson has published 14 books, most of which are either about language (*The Mother Tongue*, *Made in America*) or travel (*A Walk in the Woods*, *In a Sunburned Country*). In 1995 he moved back to the United States with his English-born wife and their four children, settling in Hanover, New Hampshire. (He has since moved back to England.) We spoke over breakfast at Lou's Restaurant in Hanover.

The following is from *Notes from a Small Island: An Affectionate Portrait of Britain*. Here, on a visit to Dover, Bryson is recalling his first days in Britain in 1973, when he had the misfortune of staying at a guest house there "owned and managed by a formidable creature of late middle years called Mrs. Gubbins."

Over the next two days, Mrs. Gubbins persecuted me mercilessly, while the [other guests], I suspected, scouted evidence for her. She reproached me for not turning the light off in my room when I went out, for not putting the lid down on the toilet when I'd finished, for taking the Colonel's hot water—I'd no idea he had his own until he started rattling the doorknob and making aggrieved noises in the corridor—for ordering the full English breakfast two days running and leaving the fried tomato both times.

"I see you've left the fried tomato again," she said on the second occasion. I didn't know quite what to say to this as it was incontestably true, so I simply furrowed my brow and joined her in staring at the offending item. I had actually been wondering for two days what it was.

"May I request," she said in a voice heavy with pain and years of irritation, "that in future, if you don't require a fried tomato with your breakfast, you would be good enough to tell me?"

Abashed, I watched her go out. "I thought it was a blood clot!" I wanted to yell after her, but of course I said nothing and merely skulked from the room to the triumphant beams of my fellow residents.

After that, I stayed out of the house as much as I could. . . . Within the house, I tried to remain silent and inconspicuous. I even turned over quietly in my creaking bed. But no matter how hard I tried, I seemed fated to annoy. On the third afternoon as I crept in, Mrs. Gubbins confronted me in the hallway with an empty cigarette packet, and demanded to know if it was I who had thrust it in the privet hedge. I began to understand why people sign extravagant confessions in police stations. That evening, I forgot to turn off the water heater after a quick and stealthy bath and compounded the error by leaving strands of hair in the plughole. The next morning came the final humiliation. Mrs. Gubbins marched me wordlessly to the toilet and showed me a little turd that had not flushed away.

We agreed that I should leave after breakfast. I caught a fast train to London, and have not been back to Dover since.

One of my father's lifelong hobbies was tracking down the derivation of baseball words, especially ones that have entered general usage, like *rain check, southpaw, straight out of left field*. He developed a substantial library of books about language. I inherited an interest in language, and also the library. He had a good collection of books by people working from, say, 1910 to 1940, so they became my big influences. P. G. Wodehouse, Fitzgerald, Hemingway. I loved S. J. Perelman because of that elegance. He was everything that a kid in Des Moines, Iowa, wanted to be. Robert Benchley was hugely influential; my dad had all his books. I loved his silliness, the sense of seeing the world as others don't see it.

Newspapers were the family business. My mother worked for the *Register*. My brother worked there too, and later for the Associated Press. Plus, English was the only thing I was ever any good at in school. It

never occurred to me that I would ever make my living in any other way than fooling around with words.

I worked part time after school and on weekends at the *Register*, starting at my sixteenth birthday—answering phones, getting coffee, dividing up wire stories. Little by little they gave you responsibility, and I started covering high school football games. I worked on the copy desk, which was kind of unusual for a kid, but I found that I really enjoyed it. I did it all through high school and college. Eventually I was going to college and working full time, which was murderous but lucrative.

Working at newspapers, especially working as a copyeditor, is really, really good training for other kinds of writing. You learn not to waste words. Right now I'm working on a writing project where I've been reading a lot of textbooks, scholarly type books. I keep thinking, *Get to the point. There's a story here.*

When I first started living in Britain, all the differences between British and American English were quite interesting to me. There was so much nuance you wouldn't have been aware of if you haven't lived in another English-speaking country. And the way journalism was done was so different. In the U.S. we have the inverted pyramid, which tells you to put the most important things at the beginning of the story. My favorite marginal comment from my years in Britain was when I was working as a subeditor at the *Times*: "If you have to cut this, cut from the top, because all the good stuff is at the bottom." I almost had that framed. This was the same writer who on a Sotheby's story wrote acres of bilge, then in the last paragraph put in that the sale of such and such "was unable to go forward because it was stolen over the weekend."

Living on a small provincial income, I started doing magazine articles in my spare time as a way to make some extra money. I realized that something that gave me an edge was that I could write amusingly. This also meant that I was asked to do observational stuff, so I wouldn't have to leave home. When you find something you're good at, you tend to cultivate that. I can't do anything else, so this is it. Clearly, I wasn't going to be a heavyweight thinker or write the most lyrical prose you've ever seen. I could never be an investigative journalist—I would be creamed by the opposition every time. If I was going to make a living at writing, this is what I could do.

One of the things that made me fall for Britain in a big way was the

humor. I remember instantly responding to it. There were types of jokes that I had never heard growing up in Iowa. The Monty Python, *The Goon Show*, off-the-wall, and the deadpan, dry understated. I started playing around with those kinds of jokes; it seemed very sophisticated, Noel Coward to me—a kind of classiness. The British really do love to be funny. It's a quality that they cultivate and that they admire in people.

I get accused from time to time of being very mannered, of intentionally using Britishisms, but it's me. It's become completely natural. I'll write *advert* instead of *ad* not because I've decided to have a moment of Englishness but because I've forgotten that Americans don't say that. My kind of device for writing is to be as natural as I can, and not to reflect on these things. I know that you might expect an editor to change that, but the terrible thing about success is that people stop editing you. Also, I am a little remote from the American language. Even though we've been back for six years, I still live in an English household, and because I work at home, I don't see many people. You will probably constitute ninety percent of my actual American conversation this week. Most of the rest of it will be with an English wife and kids. I don't watch TV much, only the Red Sox. I don't listen to radio, and I've only recently and reluctantly gone online.

I fuss over words. I like writers who really care about choosing the right word at the right time, and the right rhythm, to really make a piece of text work. The person I first learned that from is J. D. Salinger. I was fourteen, fifteen, reading *Catcher in the Rye* and all his other stuff. His descriptive passages—the way a person's face is reflected in the mirror, or the way a tablecloth hangs, or sunlight falls—sometimes seems labored, but it doesn't matter, because at the time it was such a revelation that you could take language and use it in such a precise way. It's something I still admire when I see it done by the Julian Barneses and John Updikes, who can take a thing and make it perfect.

Endlessly fussing is the only writing trick I know—never being quite satisfied. My anal quality is such that I cannot not write in consecutive order. That is, I can't skip ahead to chapter four—I have to get over this hump, sentence by sentence, chapter by chapter. But I do allow myself to go back—to fuss and fiddle over something that was good enough to move on but not quite there yet. The thing that occupies me the most is trying to get jokes right. It's so much a question of timing—the right

word is so important. Only two or three times in all the years I've been writing did a joke just sort of pop into my head. Most of the time you know it's there, but you've got to fuss over it endlessly.

The first time through, I'll have a lot of parentheses and dashes. They're effective, but they can become intrusive and a little manic as well. You realize that it would work better as two sentences anyway. I find it helps a lot to print things out, to take them to another place and read them. You find typos—somehow the moving around can be productive. Sometimes I'll put it in my back pocket, and never even take it out of my back pocket, but just kind of walk it around.

I think you do have a duty to engage and hold the reader. The one thing I'm thinking about all the time in anything I write is *Is this keeping the reader with me? Is this interesting? Is this worthwhile?* So many writers seem not to care about those things. Travel writing tends to be terribly self-indulgent; the author's feeling seems to be *Well, I had this experience and I enjoyed it and I'm going to tell you about it, and really kind of fuck you whether you like it or not.*

I write like I'm writing a letter to my brother or a good pal, and we're talking in a way that's informal and acquainted. We already know each other. What I didn't realize until after I'd done this a few times is how many people read the books and think we really are acquainted now. They want to come and see me. The number of people who write and want you to come and travel with them is really amazing. They're written in a personal way, and a number of people don't realize that it can't really be personal.

The *I* in my books is not me, really. Or it is, but only a relatively small part of me. It's a sort of alter ego, I suppose. I'm there in the service of comedy in the books; I'm talking about the things I do that are stupid. I actually do those stupid things—I do get lost, say embarrassing things, unwittingly suck on a pen and get ink all over my face. What I do in a book is focus exclusively on those things. Everything that's in there is true. If I say I was locked out of my hotel in England, that's true. But humor involves measure of hyperbole, so the things that make you laugh are because I've inflated it. I didn't really roll three and half miles down a hill. I did have a fall, but actually stopped after around four feet. Huge amounts are left out.

My approach has changed somewhat over the years. There are cer-

tain things I've intentionally tried to do to give my books more sub-
stance. I've made a conscious decision to reduce the number of jokes.
Constant humor is hard to sustain—there's a reason stand-up comics
only do forty minutes. You can only laugh intensively for so long. A mis-
take I was making in the early books, and a lot of people make, is not
realizing people can't keep that up for hour after hour when they're
reading, that they need some relief. In my early books you'd be reading
along and sense I'm saying, "This isn't a very good joke, but I've got this
quota to keep up, and it's not too bad, so bear with me, and I'll try to get
a better one in a page or so." I've sort of stopped putting in those hold-
ing jokes; I don't worry that there's three pages and there's not a single
joke in it.

But I don't think I could ever become a serious writer. In *A Walk in
the Woods*, near the end, my companion, Katz, and I have our epiphany on
the mountain. He tells me he is drinking again, everything is going
wrong, we—as it were—kiss and make up. All of a sudden, the book
becomes serious, realistic. It became extremely uncomfortable for me
to write. That was the one part where I felt I had to apologize to the
real guy. Everywhere else I'm teasing him, making fun; everyone who
knows him will know I'm exaggerating. Here, it was sort of like leaving
the camera running when people didn't know, and then using it. But I
had to—that was the climax of our experience together, and I had no
choice. It was the nearest I've ever come to writing seriously about
something that really happened in my life. I don't think that I could pos-
sibly do that on a regular basis. People would become very uncomfort-
able if I did, because it's not what they expect. I could never write a
book about a fight with cancer. That's not me. I have to deal with people
who are prosperous and comfortable and can be the butt of a joke.

Poetry

This book is (obviously) mainly concerned with prose, but it's appro-
priate to spend a little time with poetry because prose becomes less pro-
saic—it develops style—when it has elements of poetry in it. As
Jakobson's terminology indicates, poetry is at the extreme end of the
communicative–poetic scale: it has no "use" other than individual expres-

sion. It follows that poets who don't own a distinctive and distinguishing manner of expression can never make it to the big leagues. Especially in its modern incarnation, poetry is all about style; every word represents a critical decision whose resolution reflects with finality on the poem and the author. As Billy Collins says, "In prose, every sentence could be rewritten 400 ways. A poem is inevitable." The whole verbal apparatus of a lyric poem—rhyme, meter, expectation of metaphor, division into line and stanza, even the concentrated brevity it demands—places the emphasis on manner, not matter. Poets aren't expected to convey data, and haven't necessarily failed even if their meaning is a little or a lot obscure. We understand that their main enterprise is to put an internal colloquy onto the page. As John Stuart Mill wrote, "Poetry and eloquence are both alike the expression of utterance of feeling. But if we may be excused the antithesis, we should say that eloquence is heard, poetry is overheard. Eloquence supposed an audience; the peculiarity of poetry appears to us to lie in the poet's utter unconsciousness of a listener."

Sharon Olds was born in 1942, in San Francisco, and educated at Stanford and Columbia University. Her collections include *Satan Says*, *The Dead and the Living* (winner of the National Book Critics Circle Award), *The Gold Cell*, *The Father*, *The Wellspring: Poems*, *Blood, Tin, Straw*, and *The Unswept Room*. She teaches in the Graduate Creative Writing Program at New York University and was the New York State Poet Laureate for 1998–2000. We spoke in her office at NYU. From "Culture and Religion," in the collection *Blood, Tin, Straw*:

> When the witch flew up to the left right left I
> remembered it—wasn't there something
> sharp which had soared into the sky on a spiral
> like that over Jerusalem? The only other
> movie I had seen, every Good Friday,
> was the Crucifixion documentary,
> noon to three, and wasn't this
> the cloud-cover, from over the crosses,
> their delicate shapes thickened and distorted,

stuck with their grievous human gum,
above them the liquid dart of the witch
streaked. And wasn't the witch's home,
near Oz, Golgotha? Her broom had been the stick
on which they had stuck the vinegar sop, I
recognized it, the same prop, and the
field of poppies, wasn't that
Gethsemane? And the witch wanted
to torture them to death, like Jesus
—blood, tin, straw—what they
were made of was to be used to kill them.

Thinking about voice, my first thought was that it's about identity, recognizability, individuation. But then I thought, no, recognizability is not the point, it's the result—of emotion, movement, kinetic thought, dance, fear, love. It's the result of specific experience filtered through a specific sieve.

Being in high school, trying to dress like the girls I admired, I could never get it right. I still have trouble when I try to dress the way I imagine the others will be dressed. But at one point I came to the realization—whatever "originality" is, part of it may be an inability to understand what the regular way is. People have sometimes said to me, "You're brave." Well, I'm the most chicken person I know. I'm just a bit of a sociopath. As if I tried, but don't get it, about what to do and what not to do.

Like so many of us, I was raised in a tradition of suppressed consciousness. When I was a kid, I thought that "God"—if he cared to—which he did not—would have been able to see everything that I thought. He had made this world and was going to roast it for sheer evil fun. But somehow I got the idea that art didn't belong to God. Since I wasn't allowed freedom of thought (or so I thought), I learned not to know what I was thinking (though I was "allowed" to see what I was seeing.) And now, it's as if, when I'm writing, the God of my childhood can't see what I'm doing.

As a child, through junior high school, high school, college and graduate school, I wrote poems. I wrote a lot in received forms—Whitman long reaches, Dickinson 4 × 4 rubixes, sonnet, sestina, villanelle—and I also tried to make up more constricting forms. Then, in my twenties, I tried to write like Gary Snyder and George Oppen—when I saw some-

thing so beautiful, which also was completely foreign to my abilities, I thought it must be the "right" way to write! I loved Oppen's grammar. It made me feel that my brain was being pulled apart, with no pain. I would diagram his phrases. I tried to write without the sentence and with a lot of space on the page, but it was deeply alien to me.

The day that I picked up my actual Ph.D. diploma, from Columbia, I noticed that I was making a pact with Satan. I later realized it was my own unconscious, but at the time I thought it was Satan, and I said, "I'll give up everything I learned, if I could write my own poems. They don't have to be any good. Just let it be by one person trying not to imitate anyone." (It was an uneven bargain—I had learned very little! I wasn't well equipped to learn that way.)

When I got home that day, and every day after that (in the thirty to forty-five minutes I had free most days), I started writing. I hardly noticed how much I was enjambing, writing over the end of the line. The song was not pausing there. When I looked over what I had written, I saw that there were no commas or periods at the end of lines, not a one. The commas and the periods were in the middle. It was like a tectonic plate shift (to use a California earthquake kid example). Each time I wrote, the lines were configured in that same way.

Some of what I wrote then appeared in *Satan Says*—and it surprised me that people thought it was an angry book! I thought it was fun to sing and tramp tramp tramp along the line and disappear, then show up on the next line. It was the pleasure of music and dance and being alive. It's not that I had anything to say. I don't ever have much to "say." The music of vowel, consonant, syntax is a lot of what's going on for me in reading and writing poems. I love the sentence. Saying that, to me, is like someone on a ship in a storm saying, "I love the anchor." I love the two musical beauties of the sentence and the line moving together. It feels to me like the heart and the lung in their counterpointing to each other.

I was thirty years old when I started writing anti-end-stopped. But when I was fifty, I saw that the "style" I had "made up" that day was the four-accent line, and the four-line stanza, of the hymns I was raised on in the Puritan church. I was annoyed—I wanted it to be something new. But I'd been hearing those rhythms before I was born.

I never thought I could be a part of a poetry world—a Gary Snyder–George Oppen world, a Muriel Rukeyser–Gwendolyn Brooks world, a

teaching world. But my first book being taken by Pitt gave me a little hope. Then I noticed later that the second book was toned down, as if I suddenly thought, *Oh, my God, am I going to be able to sit at the table? I'd better behave!* Then with the third one, *The Gold Cell*—it's as if I thought, *Oh, come on, sometimes it's not right to behave, and anyway you don't want to.*

Maybe in the last five years I have been a little less unsubtle. Without getting *too* subtle. I hope.

Voice: I hope to better avoid adjectives, elaborations, elaborateness. If it sounds pretentious, phony, arty, I have doubts about it. But I love some fancy words. I remember a period when I decided I would not let any more of them into my poems. I was at ShopRite, pushing a cart, looking at another woman pushing a cart. I thought of a word I had used and thought, *What if she didn't know that word? Would she see it as an angel (or devil) at the gate with a sword?* So I began to use many repeated plain words. But eventually I thought, *I don't care—I'm crazy about those fancy words. So I'll go to hell.*

I love words with a lot of consonants. If you print out all the five vowels, they have six points—serifs—total. But *x, k* and *t each* have four points, like a young boy deer. To me, a word with a lot of consonants feels like a twig, like walking on the underbrush in moccasins, in the world before there were streets.

When I'm writing, sometimes it's as if I'm food gathering. I'm foraging for berries (some four-footed or four-winged berries), looking, hunting—as if I think it could be of value to make a flawed "copy" of ordinary life, like a dollhouse. I don't feel like I'm taking one person's experience and sharing it with somebody who hasn't had it (although that could be sometimes what it is). When writing, I don't think we're thinking of a reader, though maybe we're secretly hoping there'll be one. When I'm writing a poem, I feel as I do when I'm drawing, but I don't feel that someone is looking over my shoulder.

Lined grocery-notebook paper with a black Bic Medium ballpoint— that's my set of tools. I type up the poems I like on a manual typewriter. I love the smoothness of the ballpoint. It almost makes me shudder to think of a fountain pen. Like a *Blair Witch* twig.

I love the craft of writing, and typing things up. Writing feels so pri-

vate to me. I like that feeling—I don't think I could write on a screen where what I was writing, first draft, might be seen by others. I love the godless solitude of the initial "creation." I feel like I'm being carried around in a basket—woven of something like seawater—and of language, of music, of mortal solitude.

Online Writing

Here's a coda, placed in the concluding spot not because online writing is strikingly poetic or welcoming to individual style, but because it is so beguilingly up for grabs. In its heady early days, the World Wide Web promised to offer a wide world of style choices. A thousand fonts, illustration of all varieties, any imaginable conception of a page's appearance were at an author's fingertips—and all of those things, one imagined, would have a massive impact on the feel, the sound, the style of a piece of text. A decade or more later, even more bells and whistles are available (the actual *sound* of bells and whistles, for instance), but they're acknowledged to be part of a separate discipline, having less to do with writing than with design. Online writing has, instead, followed the example of e-mail. It will likely be presented in a font, a type size, and a column width, and against a background color, that experience has found to be visually pleasing. Maybe there'll be a photo in one margin. But generally the presentation is plain vanilla. The style is in the words.

Anyone who gets and receives e-mail—that is, pretty much anyone—knows this is a genre with plenty of style, comparatively little of it typographic. Sure, there are those smiley-face emoticons, and the practice of writing "U R 2" instead of "You are, too," and the people who write in all lowercase, which has always struck me as similar to wearing pajamas in public (seriously strange when you're meeting a friend, seriously unhinged when you're conducting business). The striking thing, however, is how much personality comes through even when the capitalization and typography are strictly standard. This is because e-mail has worked a legitimately new variation on the relationship between writing and speech. I made the point in Chapter III that all styles negotiate a compromise between these two forms of discourse. In the middle style, the style

we don't notice, they're carefully balanced. E-mail is firmly on the side of speech. So thumbs up to slang, brevity, and contractions; thumbs down to long words, sentences, paragraphs, and texts.

This is not an unalloyed good. In some of its manifestations, all spawned by the e-mail culture, online writing takes the worst qualities of speech—the ad hoc, extemporaneous nature of it—and gives them a permanent home in cyberspace. So the Web—the bulletin boards, the blogs, the home pages, and so forth—is home not only to "U R 2" but to truly extraordinary sloppiness, misinformation, disinformation, exclusionary inside jokes and inside references, barbarous abbreviations, ad hominem attacks, and rants that make Hunter Thompson look like Miss Manners.

The good stuff, though, is truly good, and in unfamiliar and sometimes exciting ways. Most of us have had the experience: starting to e-mail back and forth with a friend and discovering that he or she is a really good writer, somehow able to replicate or conjure up in the written word the sound of their conversation, the sense of themselves. As Michael Kinsley points out, letter-writing gets talked up a lot, but it had more or less been killed by the telephone long before e-mail came into the picture. In fact, e-mail has *revived* written communication—funny, cutting, above all *personal*, with rhetorical notes that can be played not only in the text but in the subject line, the salutation, or an attached link. In its receptiveness to quirky individuality and typography, and its brevity, e-mail sometimes resembles lyric poetry.

The best writing that's posted on the Web for all the world to see has a bit of this quality, and some others besides. One of the most evident is an almost palpable freedom. For something to be published in a newspaper or magazine or as a book, all kinds of people have to make all kinds of decisions: is it acceptable and appropriate for the publication, will it be confusing or offensive, does it need to be edited, and if so, how much? Although Web magazines like *Slate* and *Salon* operate on something resembling the traditional model, most Web writers publish what they want when they want, simply because they find it interesting. It's significant that it's free in the other sense as well: no charge. Web writers don't ask a quarter and don't give a quarter, and you can feel this in their style; it lacks what we're used to in print, an implied obligation to justify and explain. As noted, this leads to more top-of-the-head blustering and bloviating and self-indulgent navel-gazing than anyone should be exposed to. But it also produces some

captivating material. Since 1997, *Minneapolis Star Tribune* columnist Jim Lileks has been chronicling, every weekday, his opinions, his comings and goings, the toddler he now spends his days with, his affection for the computer game SimCity, in a Web site he calls *The Bleat* (www.lileks.com). By my informal count, he writes about three times as many words for *The Bleat* as he does for his newspaper column. It is audacious for him to expect anyone to care that much about his actions and reactions; perhaps because of that, we do. In the *Julie/Julia Project*, accessible as I write at http://blogs.salon.com/0001399/, Julie Powell describes in great and somehow beguiling detail her attempt to prepare every recipe in Julia Child's *Mastering the Art of French Cooking*. There would be no room for this "deranged assignment" (Powell's term) in the world of print, a fact that reflects poorly not on the deranged assignment but on the world of print. Room is the one thing the Web has plenty of; a function of its Borgesian capaciousness is that one comes upon unexpected subjects approached in unexpected ways.

Nancy Nall writes a column for the *Fort Wayne News-Sentinel* and also a five-times-a-week posting to her Web site, www.nancynall.com. In 2002, columnist Bob Greene was forced to resign after news came out about a sexual indiscretion. Nall wrote a blistering post for the site that named the

> three things everyone [in the newspaper business] tells you about Bob Greene. Number one: he's a hack. Number two: he's a horndog. . . . Did I say three things? I was wrong. The third thing you learn with your own eyes: This man wears the second-most preposterous toupee in the history of hairpieces, bowing only to Jim Traficant's. They all tie together, in my mind. The horndog requires the hairpiece, which is sort of a metaphor for his hack-ness, his false, treacly, icky prose that only fools the willfully blind.

This would never have found a home in a mainstream printed medium. It hit a guy when he was down and seemed to take some glee in the blow; it had rantlike qualities; it was . . . *unseemly*. Yet at the same time, it was good. The emotion, the conviction, the verve, and, yes, the word *horndog* all are not found *enough* in print. Jim Romenesko included a link to the post on his very widely read media news Web site, and Nall—whose page had previously gotten 130 or so visitors a day—suddenly was in the spot-

light. She received a flattering e-mail from a *Chicago Tribune* editor who asked to see some of her columns. A few days later the editor e-mailed her: "I'm disappointed. There's nothing here that matches the tone or voice of your Web page." Nall was disappointed, too, but she had to acknowledge, as she wrote in an essay some months later, that the editor was right: "In print, I'm more likely to pull punches, equivocate, wring hands. But on the Web, I use stronger language. I run rings around the big ship in my inflatable rubber Zodiac boat."

In an e-mail to me, she observed:

> The more I think about it, the more I'm convinced that the voice of the web is a matter of audience. The attitude on the web is, "Don't like my page? Go start your own." Because anyone can do it, because the technology is now so advanced that you really don't need any more skills than those involved in web-surfing, it's that easy. That sort of anarchic screw-you frees writers. Sometimes, it frees them in a bad way—to fling applesauce at one another in semi-literate prose. But for a good writer, especially one who's spent a term working for a newspaper, it's positively bracing.

The Web has not and will not either doom or redeem writing. But it has been a medium for some fresh and intriguing styles and voices; as new technology arrives and writers adapt to it, there will be more. It should be a good show. Stay tuned.

Michael Kinsley was born in Detroit in 1951. After graduating from Harvard College and Harvard Law School, he edited the *New Republic* and *Harper's* magazine and for six years was a host of CNN's *Crossfire*. In 1996 he became the founding editor of the Microsoft's online magazine *Slate*, stepping down in 2002. He currently writes columns for *Slate* and *Time* magazine. We spoke in 2001 in his office at Microsoft's headquarters in Redmond, Washington. From "Pious Pair," www.slate.com:

> Back when I was a co-host on CNN's Crossfire, Joe Lieberman and John McCain were known as "7:15 guys"—meaning that the producer could call either of them up at 7:15 p.m., and they'd be on time for a live

show at 7:30. (At least, unlike another current senator, they asked what the topic was before dropping important affairs of state and rushing over.) McCain once even came back for a partial rebroadcast at 1 a.m. when, for reasons of verisimilitude, they needed the same senator wearing the same shirt.

To say that two members of the Senate are publicity hounds because they like to be on television is a bit redundant (find a shy senator) and a bit unfair (nobody had a gun to my head either). But even among the self-promoters of Washington, Lieberman and McCain stand out for their enthusiasm and their skill. An important part of that skill, of course, is making enthusiasm look like reluctance. Both are fond of the conceit that they are saddened or alarmed or deeply disturbed by whatever matter impelled them toward the microphones that particular day. The image in your mind, though, if you are an irritated fellow senator or even just a lay cynic, is of Joe or John perusing the newspaper over breakfast coffee as if it were a shopping catalog, looking for something to be saddened by today.

Half or a little more of the articles we publish are written more or less exactly as they would have been in print. Frankly, that's because a lot of writers are behind the times. They're not taking full advantage of, or even living comfortably in, the medium they find themselves in.

The other half of what we publish is the voice of e-mail. That has turned out to be, I think, *Slate*'s most significant, possibly only significant, contribution to the development of journalism and the language. The voice of e-mail, at its best, is the reflectiveness of writing combined with the spontaneity of talking.

I think e-mail is a wonderful medium. Nick Lemann, who's more or less my best friend, Jim Fallows, and I and a few other people got on MCI mail very early on, in the very early '80s. I remember that it cost $1.35 per message. Nick and I have been e-mailing each other since. It's probably the intellectually richest relationship I have, even though we don't talk on the phone that much, don't see each other very often at all. It was all through e-mail. It was that experience, more than anything else, that was the inspiration for *Slate*. We felt that if we could replicate this in print, so to speak, we would have something really exciting. We've done it most of the time.

The one thing we've all forgotten about computers is how easy it

made it to edit yourself, to change things. I suspect my e-mail is not only more carefully crafted than speaking orally, I think it's more carefully crafted than letters I used to bang out, because switching a paragraph or rewriting something was so hard. There were all those agonizing discussions, long before the Internet: Were computers making prose better or worse? I think it's pretty much settled. The answer is, Better. People say, "Oh, e-mail has destroyed the culture of writing letters." No one has written letters since the invention of the telephone. E-mail replaced talking, not writing, and it's a lot better thought out than talking. One interesting comparison is to online chat, which represents the *worst* of talking and writing. You type out everything, there's no time for reflection. I can't see any way it's superior to a telephone call.

I know my column is going to be reprinted for a newspaper syndicate, which is a bit constraining. There are times I'd like to throw in a link, but that obviously wouldn't work in a newspaper. Links are part of the style of Web writing, and some of our writers, like Tim Noah, are adopting to it more quickly than others.

There are even more radical things that can be done to develop new styles of writing for the Web, that add something print can't supply. The one we've almost totally failed at is music pieces. An enormous amount of space is spent trying to describe in words things that are essentially nonverbal, and then you give your opinion of it in the space you have left. The Web should obviate that. We've made some headway in this, but it's like pulling teeth to get critics to do it. They end up putting in the links, then describing it anyway. The argument I make is that no one would ever dream of publishing a book review without quotes from the book.

Overall, we're a bit old-fashioned for the Web. If the theory is that on the Web the personal voice is more prominent than in print—people saying, "I'm really pissed off at Ben's blue shirt," instead of, "The problem with blue shirts is . . ."—that's not really what we do. I don't want to read a lot of that stuff. There's plenty of self-indulgence in *Slate*, but the let's-see-how-outrageous-I-can-be first-person stuff, we try to avoid that. In the early days there used to be arguments about what was the true nature of the Web, what kind of voice was true to the nature of the Web, and who was betraying it. We often got accused of betraying it. Sometimes the criticism was right. We had page numbers at first, which

made no sense. But the argument was essentially ridiculous. The nature of the Web is that it's limitless.

There does seem to be one inherent limitation—people will just not comfortably read a long piece on a computer screen. Someone once said a very wise thing to me: that the problem is not the computer, the problem is the chair. In any case, our definition of what a long piece is has had to get tougher and tougher. We started out thinking we could publish up to twenty-five hundred words. We now start to get itchy at about twelve hundred, and even that is extraordinarily long for the Web. That will change when tablet PCs are perfected, and there will finally be a screen you can take to the john.

CHAPTER IX

By Way of Advice

Take a look at two documents handwritten by incarcerated men, nearly eight decades apart:

A Every night when the light goes out I take a long walk and really I do not known how long I walk, because the most of the time I forget myself to go to sleep, and so I continue to walk and I count, one two three four step and turn backward and continue to count, one two three four and so on. But between all this time my mind it is always so full of ideas that one gos and one comes, and the idea of my youth of day I find one of my mostly beautiful remembrance. While I am thinking and walking, frequently I stop to my window sill and through these sad bars and look at the nature into crepuscular of night, and the stars in the beauti blue sky. So last night the stars they was moor bright and the sky it was moor blue that I did have had seen; while I was looking it appear in my mind the idea to think of

something of my youth of day and write the idea and send into letter to my good friend Mrs. Jack in first thing in morning. So here where I am right with you, and always I will try to be, yes, because I am study to understand your beautiful language and I know I will love it. And I will hope that one day I could surprise the feel of my gratitude towards all this fierce legion of friends and comrades.

B [I concluded that] the basic physical framework in which physics operated was inadequate and that so called "free energy" devices—devices that would solve our energy problem and end what is now called global warming and allow for the decentralization of most economic activities—could become a reality. . . .

I quickly combined my newly developed corporate contacts, Andrija [Puharich's] networks and those past "movement" friends able to deal with "magic," into my Network called by some "the internet before the internet existed." . . .

I was soon up to my ears in a multi-pronged intelligence game that is still waiting to be unraveled. . . .

A small subset of the Network soon found itself controlling the "Russian woodpecker"—a signal emanating from Soviet territory that appeared to have mind control properties. . . .

I also began receiving badly translated reports from all over the Soviet Union of psychotronic/mind-control weaponry. Weaponry so chilling that I only shared some of the content, not the actual reports, with two people. . . .

I sat on these reports for more than a year and a half. I spoke . . . about the issue only after I was warned my life was under threat.

At the time of my arrest, I had received over 200 reports, mailed from all over the world, but obviously originating from behind the Iron Curtain. In the summer of 1977, I planned a fact-finding trip that would take me to many sites behind the Iron Curtain.

I was up to my ears in projects: I was in the middle of doing an interview with "Omni"; I was about to conduct a book length interview with Arthur Koestler that would have covered his entire career; I was in negotiation about acting in a play; the day my first life ended, a friend was coming down from New York to speak to me about helping to write and possibly act in a TV series about the 60's.

> All was not to be. I was busted for a murder I did not commit and all
> my work on mind control and free energy became history.

"A" is an except from a 1924 letter by Nicola Sacco, an Italian-born anarchist who had been convicted of robbery and murder (wrongly, it is now widely believed) and would be executed in 1927. *"B"* is from "A Snapshot of My 70s," a nine-page handwritten essay authored in September 2002 by Ira Einhorn, a Philadelphia counterculture figure who fled the country in 1978 after being arrested for the murder of his girlfriend. Einhorn was eventually apprehended in France, extradited, and convicted of the crime.

Sacco, obviously, had not mastered English spelling, grammar, or vocabulary. Yet his errors not only don't impede our appreciation of what he has to say, they further it. His phrasing is distinctive and lucid: "I forget myself to go to sleep," "the idea of my youth of day I find one of my mostly beautiful remembrance," "the feel of my gratitude towards all this fierce legion of friends and comrades." His prose is an instance of what writing aspires to but rarely achieves: the expression of a person's strong feelings in an unexpected, memorable and moving way.

Einhorn is a graduate of the University of Pennsylvania, and, except for one sentence fragment, his passage is "correct." Yet what a repellent piece of self-important claptrap it is. The clichés (one of them—"up to my ears"—used twice), the raging quotation marks, the jargon and catch-phrases, the bathos ("the day my first life ended"), the pathetically self-important puffery ("I was in negotiation about acting in a play"), the empty portentousness, not to mention the science-fiction gibberish: it is amazing how many crimes against writing can be shoved into a couple of hundred words.

Now read a third document, this one a letter to the editor of the *Philadelphia Inquirer*, responding to an article in the paper about a controversy over the phrase *mentally retarded*:

> Many people put the mentally retarded and the mentally ill in the same
> category and this is wrong. Some of the mentally ill can be helped by
> medication. The mentally retarded person is born with brain damage or
> had an accident that caused brain damage and, depending on the severity
> of the damage, he or she may not know right from wrong. However, it

does not matter if you are mentally retarded or mentally ill; everyone should be treated with respect.

I'm a 42-year-old man who has cerebral palsy. I am treated differently because I walk a little funny and talk with a speech defect although most people understand me. There are many people who treat me like a child or as if I am mentally ill or mentally retarded. I have to explain that I have goals, dreams and desires like most people do. I try to explain to people how I became disabled and my experiences. I know some people have closed minds and will always put me into some category, but we must not ignore such people because they can spread their prejudice to others.

I don't know what words should be used to describe the mentally retarded or someone like myself, but regardless of labels, we all need to be treated with respect. To show people respect means to treat people the way you want to be treated.

Many of us may have limitations but we do not want pity or sympathy. I work part-time as a file clerk and I realize I am fortunate to have a job. I want to earn my money and hopefully one day make people aware that the disabled have dreams and desires like anyone else.

Let us say, for the sake of argument, that Nicola Sacco and the man who wrote the letter to the *Inquirer* both have nobility of soul, whereas Ira Einhorn is devoid of it. It is clear, for each of the three, that character permeates writing. Style is the man himself.

That being the case, who could possibly expect to be trained in the elements, the rudiments, or the accomplishments of a style? The classroom and the textbook are fine for learning to play the guitar, master calculus, hit a topspin backhand, or even to banish murkiness and dangling participles from one's prose. But style in the true sense wouldn't appear to be subject to such instruction. This certainly was the opinion of Sir Walter Raleigh, who wrote in 1897:

> Style cannot be taught. . . . The greater part of what is called the teaching of style must always be negative, bad habits may be broken down, old malpractices prohibited. . . . The formal attempt to impart a good style is like the melancholy task of the teacher of gesture and oratory; some palpable faults are soon corrected; and, for the rest, a few con-

spicuous mannerisms, a few theatrical postures, not truly expressive, and a high tragical strut, are all that can be imparted. The truth of the old Roman teachers of rhetoric is here witnessed afresh, to be a good orator it is first of all necessary to be a good man. Good style is the greatest of revealers,—it lays bare the soul.

But I'm not about to throw up my hands and leave style to the fates. It is *not* simply a function of the accident of birth and the good luck of inspiration. Certainly, it can't be achieved by any kind of step-by-step guide, but following certain strategies and principles will clear a path for its arrival.

The first measures to take, a sort of hacking away of the overgrowth obscuring the path, involve not writing but its complementary activity, reading. Task one is to train the ear to pick up the strains of other writers' styles. You begin to do this by what could be called *active* reading: reading widely and slowly, and aloud if possible. Choose some writers whose styles appeal to you and chart their careers, noting how their style changed or evolved in response to the needs of different books and the passage of time. Read up on them to find out who they and critics named as influences; read these authors as well, and see if you can identify points of closeness and divergence. Isolate some paragraphs, sentences or words where your writers sounded least like themselves and most like themselves. Figure out why, and evaluate each passage. You could even give them a grade, A to F. That's important because one element of active reading is recognizing that although it may seem so in retrospect, no element in a written work is inevitable. It always represents a choice. And even "classic" authors make bad ones.

In the teaching of style, classical rhetoricians were big on imitation. Benjamin Franklin taught himself to become "a tolerable English writer" by attempting to reproduce, from memory, articles he had read in the *Spectator*; sometimes he would render them in verse, and then turn them back to prose. "By comparing my work afterwards with the original," he wrote in his *Autobiography*, "I discovered many faults and amended them." Imitation is still a staple of traditional training in painting, musical composition, and jazz performance. As a student, saxophonist Mark Turner wrote out John Coltrane's solos, note by note, and practiced until he mastered them; then he moved on to Joe Henderson, Dexter Gordon,

and Sonny Rollins. He explained in an interview with the *New York Times* that he didn't fear being intoxicated by one of the players' style: "By doing it, I knew I would eventually not be interested in it anymore. Also, I noticed that if you looked as someone else who was into Trane, and if you could listen through that person's ears and mind, it would be a slightly different version. That's who you are—it's how you hear."

How about concentrated imitation as an exercise for a writer starting out now? In the words of the old joke, "It couldn't hoit." There's always a value in experimenting with different ways of doing things: after all, you can never really figure out what your own clothing style is till you've tried dozens of outfits on. But I don't believe imitation is an especially efficient use of a fledgling writer's time, the way it was for Mark Turner. Where music and painting can be seen as pure or almost pure style, writing always carries with it a big bundle of meaning; separating matter from manner is messy and difficult. For that reason and others, imitation is extremely hard to do well. Moreover, if we accept style as a reflection of character, sensibility, and personality, then mimicking someone else's will have limited value. As George Lewes wrote in his 1865 book *The Principles of Success in Literature*, "In our day there are many who imitate Macaulay's short sentences, iterations, antitheses, geographical and historical illustrations, and eighteenth-century diction, but who accepts them as Macaulays? They cannot seize the secret of his charm, because that charm lies in the felicity of his talent, not in the structure of his sentences; in the fullness of his knowledge, not in the character of his illustrations." Imagine that you work really, really hard on impersonating Marlon Brando. If you manage eventually to succeed (beyond just screaming out "Hey, Stella!"), what have you got? An ability to sound like Brando, which is great for parties and amateur nights, but not much else.

However, simply as a way of *appreciating* other writers' styles, I would suggest some practices traditionally associated with imitation. In the course of writing this book, I have found that because it forces you to slow down, simply copying a passage is a great way—much better than mere reading—of internalizing an author's sensibility and cadences. (Somerset Maugham says that as part of his self-education as a writer he did this with the prose of Jonathan Swift.) Memorization takes that idea one step farther. Up until the late nineteenth century, when cheap textbooks became

widely available, schoolchildren were routinely required to memorize passages of poetry and prose, and in so doing they tasted, chewed, swallowed, and digested style. Give this a try with authors to whom you're drawn. It will attune you to the literary-speech ratio in their style; it will help you feel their rhythms; it might clue you in to their characteristic clinkers. At the very least, it will help pass the time when you're waiting for a plane to lift off.

Another helpful exercise is reverse imitation. Go to the first page of this book, take the passages from Hemingway, Dickens, Didion, and Barry, and "translate" them, keeping the meaning but expressing them in a way that sounds nothing like the original. Do the same with other strong stylists. Then go back and note the differences between your version and the original. Sometimes the new version will be flat or matter of fact. In some cases, elements of the writer's voice will remain—meaning either that you didn't fully succeed or the bond between what the writer had to say and how he or she expressed it was so strong that it couldn't completely be broken. (Sometimes your version will strike a note that's out of the ordinary but not identifiably from the original author. That could possibly be the beginnings of your own sound; in any case, it's worth investigating.)

All these exercises lead up to the single most important activity for anyone who cares about forging a style: becoming a strong reader of your own work. Only as such can you start to identify, isolate, and extricate the elements of your writing that are *not* your own, that are in fact counter to the whole enterprise of style. This is what Raleigh meant by the negative teaching of style—a brief phrase but a huge endeavor. It involves picking out and picking off the places where you have used an unintended word or incorrect syntax; where you have been unclear or communicated something other than what you wish; where you have unconsciously aped other writers or merely some attitude or tone that's floating in the verbal atmosphere; and, most crucially, where you've perpetrated clichés.

I define *cliché* broadly: the use, either unconscious or in an attempt to write colorfully or alluringly, of hackneyed or worn-out words, phrases, or figures of speech. You can certainly get your point across through clichés; indeed, part of their appeal is the way they allow a nearly effortless, paint-by-numbers communication. (*Cliché* is to *meaning* as *junk food* is to *nutrition*.) But if style, in all its meanings except a superficial orna-

mentalism, has any importance at all, then clichés are deadly. Their first victim is thought. As Orwell wrote in "Politics and the English Language," "modern writing at its worst does not consist in picking out words for the sake of their meaning and inventing images in order to make the meaning clearer. It consists in gumming together long strips of words which have already been set in order by someone else, and making the results presentable by sheer humbug. The attraction of this way of writing is that it is easy. . . . If you use ready-made phrases, you not only don't have to hunt about for words; you also don't have to bother with the rhythms of your sentences, since these phrases are generally so arranged as to be more or less euphonious."

Other casualties of cliché are precision, sincerity, and elegance. In his "Letter to a Young Clergyman," Swift warned against "the folly of using old, threadbare phrases, which will often make you go out of your way to find and apply them, are nauseous to rational hearers, and will seldom express your meaning as well as your own natural words." Schopenhauer characterized this sort of writing as "a vague, enigmatical intermixture of words, current phrases, hackneyed terms, and fashionable expressions," and said that it reads "like a page printed with very old type." And (to explain why I spend so much time on them here), clichés are abhorrent to a distinctive style. How can you sound like yourself if you use the expressions of everybody else?

Schopenhauer wrote more than a century ago, and Swift more than three centuries, but the problem hasn't gone away. Today, much—if not most—writing is animated by cliché. On the principle of looking at most egregious cases first, consider the opening two paragraphs of a magazine article published in the autumn of 2002:

> A year has gone by since terrorists punched a hole in the American psyche, and now Bruce Springsteen, out on the road with his new album *The Rising*, is touring the country like a latter-day tent preacher, delivering his song-stories of post-9/11 redemption as a balm for our wounds. It seems his mission, though he shies from such high-flying notions, is nothing less than the healing of a nation.
>
> So, can he do it? Can a working-class rock-and-roller from Jersey, backed by the aging E Street Band, pick up the broken pieces and help us

all feel hopeful again? Time will tell; the tour is in mid-swing. But anyone who has ever experienced the boost you get from listening to one of Springsteen's soaring songs of salvation—that feeling of resilience and uplift—will put it this way: If any artist can articulate a suitable response to 9/11, it has to be Springsteen. In other words, if the Boss can't save us, who can?

I don't mean to single out the underpaid author of this article as some kind of villain. Clichés are slick magazines' lingua franca, and if the editors of this one had received a submission where every word and turn of phrase was either fresh or straightforward, they probably would have rejected it as unprofessional or illiterate. Even so, this is pretty egregious:

- *Out on the road*: cliché
- *Latter-day*: borderline cliché
- *Balm for our wounds*: cliché
- *Shies from*: cliché
- *Nothing less than*: cliché
- *Working-class*: borderline cliché
- *Rock-and-roller*: cliché
- Calling New Jersey *Jersey*: cliché
- *Aging*: cliché
- *Pick up the broken pieces*: cliché and redundancy
- *Time will tell*: cliché
- *Soaring songs*: cliché (the writer gets a pass on the alliteration)
- Calling a performer an *artist*: cliché
- *Suitable response*: cliché, and bathos to boot
- Rhetorical question (three times in two paragraphs): cliché

The particular sin of this piece is the use of mixed metaphors, which are, as Orwell said, "a sure sign that the writer is not interested in what he is saying." No one who really cared about his or her prose would perpetrate a formulation like *punched a hole in the American psyche*; a moment's reflection reveals that this action is not only impossible but inconceivable.

You may have noted, incidentally, that I didn't call *the healing of a nation* a cliché, even though it's a metaphor and it's anything but fresh. In fact, it is dead, and that's what makes it okay (barely). As Orwell noted (his example was *iron resolution*), when an image has absolutely no juice left, it "revert[s] to being an ordinary word" and loses the sour taste of cliché. The active vocabulary of English is built on these expressions, and it would be a quixotic undertaking to try to write without dead metaphors like *fresh, dead, juice, sour taste, built on,* and *quixotic.*

The Springsteen passage has quite enough live but struggling metaphors to illustrate the perniciousness of clichés. In addition to being lazy, imprecise, and undistinguished, each one emits an unpleasant bleat in the reader's ear. The more of them there are, the louder the cumulative noise; at a certain point the din will drown any merit or distinctiveness the writing might otherwise aspire to.

Clichés are prominent features of *everyone's* first draft, whether we write it down or keep it to ourselves. How could they not be? We hear and read them all the time and our brains are filled with them. The key to avoiding them in the second and succeeding drafts is recognizing them and casting them out. That's a harder job today than it was in Orwell's time. Then, there were just three kinds of figurative formulations: the truly fresh ones devised by the writer; the dead metaphors; and the ones in between, ill but not dead yet—clichés. Current popular writing has a fourth category: newish words and phrases, sometimes invented and sometimes freshly borrowed from the streets, the business world, hip-hop, sports, TV shows like *Seinfeld* or *The Simpsons,* or some occupational lexicon. Popular writers have gotten into the habit of snatching these out of context and applying them in another one, thus livening up their copy. This can make for fun or funny writing, but it represents a risk. The mass media drive the language at such a fast clip today that the sell-by date of these expressions comes very quickly after their introduction. That is, they're usable only briefly before they turn into clichés. After that, an attentive writer imposes and follows a moratorium on their use, broken only when they are pushing daisies.

It was in 1997, I believe, that writer David Simon introduced me to *back in the day,* which he had heard in African-American neighborhoods

of Baltimore while researching his book *The Corner: A Year in the Life of an Inner-City Neighborhood*. Simon said (and I agreed) that it was a wonderful phrase, far more expressive than phrases from which it was clearly derived, *back then* and *in the old days*. In 1997 and even for a year or so after that, a journalist or critic could use the expression with the expectation that it would inject the text with a jolt of street energy and the small thrill of mixing idioms. Ever since, however, *back in the day* has been a cliché, with the slightly pathetic aura of an aging hipster trying too hard. I do not imagine that it will be usable any time soon.

A generalization: All good writers are sensitive to clichés and endeavor to avoid them. However, some writers are more sensitive than others, or are sensitive to different clichés or kinds of clichés. Meghan Daum says she will *never* commit . . . *er* . . . (a fake vocalism to indicate hesitation or waffling) or *don't go there* to print. James Wolcott mentions *my bad* (meaning, "that was my fault") as a borrowing from street lingo that makes his skin crawl; he says, "I would rather use older slang that's still in circulation." The variation is one element of the distinctiveness of style. Whereas a true hack will still be using the Seinfeldian *yadda yadda yadda* or the Gulf War's *mother of all* . . . years after they've gone stale, some of the best slick magazine writers are distinguished by their finely tuned radar for new words and phrases; you get the feeling of them unwrapping each one with delight. (The price they pay is that their stuff has the same life span as a filet of perch.) By contrast, when Wolcott uses a phrase like *creeped out* in a 2003 piece, it's a bit like a jazz musician flirting with the beat by playing just a bit behind it. In this environment, anyone who's meticulous about avoiding all vogue words and catch phrases will, ipso facto, stand out. Greil Marcus says:

> I've learned that one thing a writer has to do is be alive to clichés, to be as fast as you can. When you hear a neologism, that can poison discourse. It can make you sound cool for a minute but stupid for eternity. When you find yourself saying something like *weapons grade* or *take it to the next level*, it *seems* to be saying something, but it isn't. It's a substitute for what you really want to say.

Clichés are relatively less of a danger for some writers. This may be because they have an innate ability to express themselves precisely or

originally, or because they are culturally cloistered, so that few fashionable phrases intrude on their internal discourse. (Bill Bryson doesn't watch television, listen to the radio [except for Red Sox games], surf the Internet, or even converse very much to anyone outside his family.) I can think of only one writer who makes a virtue of clichés. That is Andrei Codrescu, who, in his essays and National Public Radio commentaries, will take a vogue or slightly outmoded expression and roll it around on his tongue (metaphorically while writing, literally while commentating), the better to savor it. His pieces are studded with the likes of *guy, awesome, au contraire, the average Joe,* and *give me a break.* Codrescu gets away with this—indeed, it's one of the charms of his style—possibly because he is a native of Transylvania and we sense that he is not a cliché victim but is a true connoisseur of the oddities and charms of American English.

Revision is all about reading, and you need to be a good reader to hear your own clichés and the other ill-advised compositional decisions you've made. An aid to this kind of close attention, as the metaphor in the previous sentence suggests and as I've repeatedly stressed, is reading aloud. Another helpful self-monitoring drill is to send yourself a copy of all your e-mails that go out to others: as with listening to your own voice on tape, opening and reading your messages can help you "overhear" yourself, the false notes and the true ones. Some of them will go right by you, and so I would recommend finding a writing partner, someone who is also interested in experimenting with style. Better yet, find two. Each of you can be a responsive reader for the others' work. Don't give each other notes about whether your writing "works," whether your themes are valid, your characters believable, or even whether your voice is mellifluous. Those things are all important, and it's undoubtedly helpful to get feedback about them—but when style is the issue, they change the subject. Instead, when looking at the other person's stuff, focus on sentences, or phrases, or words. Where the writing seems tired or clichéd, where the word used means something other than what was intended, where the phrasing is awkward, wordy or grammatically questionable, mark it, and suggest an alternative.

Eventually, you'll become more attentive to the places where your language is flat or dead—where you sound like Kurt Vonnegut's Philboyd Studge. I predict they will congregate around the places where you're not

entirely sure what you want to say. Journalists' worst writing comes at points when they haven't done enough reporting and have to fudge or generalize; critics' and essayists' when they haven't fully worked out their point or are parroting someone else's; novelists' when they haven't done the imaginative work necessary to make types and stock situations into real people doing real things. Hemingway offered some good advice in *Death in the Afternoon:* "Write when there is something that you know; and not before; and not too damned much after."

This work, the clearing of brush to create a walkable path, is never-ending for a writer. But at some point you will become more efficient at the job. The wrong notes will be fewer, and it will be easier to replace them with something better. And you will find that your writing is quiet—without the bleat of clichés, the syrupy strings of bathos, the discordant clamor of infelicity. The quiet is important. Absent all that interference, you can begin to appreciate, for the first time, the multiplicity of styles: how many different ways one can express a fact or idea, and how each one nudges the meaning in a slightly different direction.

The Dutch scholar Erasmus showed his students 150 different ways of phrasing a Latin sentence meaning, "Your letter has delighted me very much." In their book *Classical Rhetoric for the Modern Student*, Edward Corbett and Robert Connors translate some of the better reworkings as follows: "Your epistle has cheered me greatly." "Your note has been the occasion of unusual pleasure for me." "When your letter came, I was seized with an extraordinary pleasure." "What you wrote to me was most delightful." "On reading your letter, I was filled with joy." "Your letter provided me with no little pleasure."

A variation on the exercise would be useful for writers finding their way today, first of all, to remind them of the multitude of choices they have in expressing even a simple thought, and what a different connotation each of the choices provides. As the examples from Erasmus indicate, word choice is always up for grabs (*letter, epistle, note, what you wrote me*), and the thesaurus exists to show the array you have to choose from. Choosing a word is a bracing task. There are shades of difference between ostensible synonyms; unless you are being ironic, you don't want to refer to a "note" when what you received was 27 pages long. Terms such as *missive* and *epistle* also run additional risks: they can make it seem that you're

putting on airs and/or desperately trying to avoid repeating the word *letter* (what Fowler called "elegant variation"). Occasionally, when you are trying on words for size, hunting around for the mot juste, you will find one that in addition to meaning precisely what you want to say, also seems, for some odd reason, to fit exceedingly well. Note it somewhere; it is an example of your style.

The Erasmus sentence is a good drill because it expresses an emotion and deals with the relationship between two people: fertile ground for style. When you really mean and deeply feel what you are saying, you will be more likely to express yourself in a distinctive and personal rather than a generic way. In his book *English Prose Style*, Herbert Read went so far as to say, "The only thing that is indispensable for the possession of a good style is personal sincerity." The territory of feeling lends itself to figures of speech, normally inappropriate for statements of facts unless the facts are extraordinary. You can experiment with the various effects provided by litotes ("I was not displeased"), hyperbole ("Getting your letter made me the happiest man in the world"), irony ("it was definitely the low point of my week"), metaphor ("it was a tonic"), simile ("it made me as happy as a slug on a sunny rock"), and many more. Simplicity is a style and an attitude too. Depending on who you are, who the letter-writer is, and where your relationship stands, "Your letter made me smile" could be a straightforward statement of fact or an expression of emotion so powerful that it surpasses all embellishment. On the other hand, "I was pleased to get your letter" bespeaks a chilly formality that probably augurs difficult times between the two of you.

As you move on to longer writing projects of all kinds, you'll find that *every* sentence offers such a range of decisions about diction and figuration. Once those have been made, another cluster of decisions opens up: paragraph length, sentence length, use of contractions, word order, placement of commas. These would appear to be purely technical, maybe even trivial, but in fact, each choice makes a distinct change in the sound of the prose. If you've been successful in your reading work, you'll start to discern which choices are suitable and pleasing, and which ones are banal and out of place. Some of your decisions will seem to add extra meaning to the surface meaning of the words, or just seem to fit especially well. Pay special attention to these. They are examples of your style. When you were

starting out, they would have been drowned out by all the other noises your writing was making. Now, in the relative quiet, they sing.

Often, these will be the very places your writing partners marked with a red pen. That's why you should always take someone else's comments as food for thought, not gospel. Jean Cocteau said, "Listen carefully to the first criticisms made of your work. Note what it is about your work that critics don't like—then cultivate it. That's the only part of your work that's individual and worth keeping." As Elizabeth McCracken points out, a prudent writer will prune as well as cultivate, or else her or his work will be overgrown with the same cadences, the same words, the same irony or (in my case) rampaging parentheses.

One last exercise. Take an hour (could be a little more, could be a little less) and write a page or so about your father or your mother. Or you could tackle any other subject, as long as you know a lot about it and it means a lot to you. Don't worry about making it an essay with a beginning, middle and end; just concentrate on imparting some true things. Once you've got your page down, transform it, over the course of a week or so. Specifically, take it to extremes, in multiple versions. Try it with no contractions and with contractions at every possible opportunity; with short sentences and complex ones; with one-sentence paragraphs and all in one paragraph; with short Anglo-Saxon words and with long Latinate ones; with literal, straightforward language and with as many metaphors, similes, and rhetorical questions, as much irony and hyperbole and alliteration, as you can pack in. Then experiment a little with compression and slackness. Do one version that's as long as you can reasonably make it and another that's as short as possible, each time trying to impart the same sense.

When you're done, you'll have a lot of really bad stuff. But you'll also have some useful lessons, the first being that no good style, whether relatively anonymous or relatively distinctive, is uniform. It's always going to be a mix of elements, and the key to the style is in the proportion. You'll also have a better feel for the proportions that work best and feel best for you: your style. The most important lesson is that no draft is sacrosanct. Each version you attempt will have some words or phrasing that sounds silly but also at least one revelation: an inadvertent combination of words that expresses, satisfyingly, something you didn't know

you knew. Part of the magic of writing is the sense of discovery: that you're finding out what you want to say in the process of saying it. The writers who offer up the most such moments (which readers can sense, even if they might not be able to articulate it) are the ones with the most distinctive styles. The ones where sentence B can be predicted from sentence A, sentence C from sentence B, and so on, sound prepackaged and bland.

Walter Raleigh thought that because style revealed the soul, it couldn't be taught. You'd probably reach the same conclusion if you thought stylistic distinctiveness signified originality. Few people view the world in a truly singular way, and consequently, it would seem, the best most people can hope for would be a transparent, generic prose style. But that displays a rather harsh and limiting view of human potential. People can change and grow, certainly; then why can't style develop along with them? Poet Donald Hall observed, "A writer of bad prose, to become a writer of good prose, must alter his character. He does not have to become good in terms of conventional morality, but he must become honest in the expression of himself, which means that he must know himself. . . . The style is the man, and the man can change himself by changing his style."

John Lukacs says:

> I'm convinced that style is like taste. That is a very interesting thing, because taste itself, the very existence of taste, denies Descartes's division of the world into subject and object. If style were purely subjective, then it would be deterministic: I write this way because it's the way I am—I cannot do otherwise. But that's not true. Style and taste are also a matter of participation, of *deciding* what one will like and how one will write. Style begins the way fashion begins: somebody admires how the other man dresses and adapts it for himself.

Self-editing as therapy and personal growth: it is not so kooky an idea. Attention to your prose can help you see the places where language helps you to obfuscate or prevaricate or bluster, to indulge in laziness, to hide

behind the conventional wisdom and the conventional stupidity. It can also illuminate the moments when your words let you consort, for a minute, with truth and beauty. Doesn't it make sense that, over the course of a life or a career, you would seek to do less of the first and more of the second? Try hard enough, and your efforts will bear fruit. Spend enough time on the whole project, and one day you are looking at a different person in the mirror.

A personal example: I have a thing for irony. Early on, I read my Hemingway, my Stephen Crane, my Chandler, my Vonnegut, my Didion. I was intoxicated by the less-is-more of these writers, the tough-guy terseness and faux-naïf coyness, the sense of deliberately simple language as expression of and sometimes balm for a hurt too deep for words. But I also sensed that this attraction was potentially fatal. That is, I knew that I had it in me to abuse the irony: to imply more than knew, to claim more than I had earned. These concerns, obviously, aren't only about putting words together. What you think you know, what you really know, what your self-presentation *says* about what you know: if there are more telling ethical issues in the conduct of a life, I don't know what they are.

For 30 years there has been a tension in my writing, sometimes close to the surface, sometimes pretty far beneath it, between the ironic urge and what you might call the explanatory imperative: laying all my cards on the table. Go too far in one direction (I always feel) and the writing becomes smoke and mirrors; go too far in the other and it gets overearnest, literal, and boring. The tug-of-war between the two carries over from the writing to life, and then goes back again.

I feel this tension, if not in every sentence, then at least in every paragraph I write. However, even very good readers of my work might never be aware of it at all. And that brings me to the very last point I'll make about style. Give any literate citizen a blindfold test with a passage from Hemingway and he or she will be able to name the author, guaranteed. Give the same person a passage from Yagoda and a blank will be drawn, guaranteed. The Hemingway style is loud and audible to everyone; the Yagoda style is faint and audible only to Yagoda himself (and maybe a few close friends, relatives, and business associates). But that doesn't mean I don't *have* a style, or that I'm not pretty attached to it.

Anyone who puts pen to paper can have a prose style. In almost every case, that style will be quiet, sometimes so quiet as to be detectable only by you, the writer. In the quiet, you can listen to your sound in various manifestations; then you can start to shape it and develop it. That project can last as long as you keep writing, and it never gets old.

APPENDIX

Interviewees

NICHOLSON BAKER. See page 190.

DAVE BARRY was born in 1947 in Armonk, New York. He was a reporter for the *Daily Local News* in West Chester, Pennsylvania, from 1970 to 1975, and has been a syndicated humor columnist since 1980. Since 1983 he has been based at the *Miami Herald*. He has published many, many books, including *Dave Barry's Guide to Marriage and/or Sex*, *Dave Barry Turns Forty*, and *Dave Barry Is Not Making This Up*. He won the Pulitzer Prize for commentary in 1986. We spoke in the cafeteria at the *Miami Herald*.

ANN BEATTIE was born in 1947 and grew up in Washington, D.C. She has published seven collections of short stories (including *Secrets and Surprises: Short Stories* and *Where You'll Find Me, and Other Stories*) and seven novels (including *Chilly Scenes of Winter* and *Picturing Will*). She has taught at Harvard and the University of Virginia and lives in Charlottesville, Virginia; Key West, Florida; and Maine. We corresponded by e-mail and fax.

HAROLD BLOOM was born in New York City in 1930. He has taught at Yale since 1955 and is now Sterling Professor of the Humanities. His many books include *The Visionary Company: A Reading of English Romantic Poetry*, *The Anxiety of Influence: A Theory of Poetry*, *Shakespeare: The Invention of the Human*, and *Genius: A Mosaic of One Hundred Exemplary Creative Minds*. We spoke in the living room of his house in New Haven, Connecticut.

STEPHEN BREYER. See page 168.

BILL BRYSON. See page 207.

BEBE MOORE CAMPBELL was born in Philadelphia in 1950 and worked for five years as a schoolteacher before turning to writing. She is the author of *Sweet Summer, Growing Up With and Without My Dad*, a memoir, and the novels *What You Owe Me, Singing in the Comeback Choir, Brothers and Sisters,* and *Your Blues Ain't Like Mine*. She lives in Los Angeles and is a frequent contributor to National Public Radio. We spoke by telephone.

PETER CAREY was born in Bacchus Marsh, Victoria, Australia, in 1943 and worked in the advertising business before becoming a writer. He is the author of *The Fat Man in History, and Other Stories* and ten novels, two of which—*Oscar and Lucinda* and *True History of the Kelly Gang*—were awarded the Booker Prize. We spoke in his apartment in Greenwich Village, New York.

MICHAEL CHABON. See page 182.

ANDREI CODRESCU was born in Sibiu, Romania, in 1946 and emigrated to the United States at the age of 20, knowing no English. Nevertheless, he published a collection of poetry, *License to Carry a Gun*, just four years later. Since then Codrescu has written many books of poetry, fiction, essays, memoir, and reportage. He has contributed essays to National Public Radio's *All Things Considered* for more than 20 years and was the star of the 1993 documentary *Road Scholar*. He lives in New Orleans, is a professor of English at Louisiana State University and edits the online magazine *Exquisite Corpse*. We spoke at a hotel outside Baltimore, where he was appearing at a writer's conference.

BILLY COLLINS was born in 1941 in New York City. He has published seven volumes of poetry, including *Sailing Alone Around the Room: New and Selected Poems*. He is a professor of English at Lehman College of the City University of New York, and from 2001 to 2002 was Poet Laureate of the United States. We spoke at the Knickerbocker Bar and Grill in New York.

STANLEY CROUCH was born in 1945 in Los Angeles. His books include *The All-American Skin Game*, *Notes of a Hanging Judge: Essays and Reviews, 1979–1989*, and *Don't the Moon Look Lonesome: A Novel in Blues and Swing*. He was for many years a staff writer at the *Village Voice* and served as Artistic Consultant to Jazz at Lincoln Center. He lives in New York City. We spoke over lunch at a restaurant in Greenwich Village.

MEGHAN DAUM was born in 1970 and grew up in New Jersey. She is the author of *My Misspent Youth*, an essay collection, and *The Quality of Life Report*, a novel, and has contributed to National Public Radio's *This American Life* and *Morning Edition*. She lives in Lincoln, Nebraska. We spoke by telephone.

JUNOT DÍAZ was born in Santo Domingo, Dominican Republic, in 1968 and came to the United States when he was seven. He grew up in New Jersey, graduated from Rutgers University, and studied creative writing at Cornell. He's the author of the short-story collection *Drown* and is working on a novel. We spoke at a Jamaican restaurant in Manhattan, where he lives.

MARGARET DRABBLE was born in Sheffield, England, in 1939. She originally hoped to be an actress and understudied Vanessa Redgrave and Judi Dench at the Theatre Royal, Stratford-upon-Avon. Her first novel, *A Summer Bird-Cage*, was published in 1963; her fifteenth and most recent, *The Seven Sisters*, in 2002. She has written biographies of Arnold Bennett and Angus Wilson and is editor of *The Oxford Companion to English Literature*. She lives in London with her husband, biographer Michael Holroyd. We spoke in her house in London.

CRISTINA GARCIA was born in Havana, Cuba, in 1958, grew up in New York City, and graduated from Barnard College and the Johns Hopkins University School of Advanced International Studies. Before becoming a full-time fiction writer, she worked as a correspondent for *Time* magazine. She is the author of three novels: *Dreaming in Cuban*, *The Aguero Sisters*, and *Monkey Hunting*. We spoke on the porch of her house in Santa Monica, California.

ADAM GOPNIK was born in Philadelphia in 1956. He worked as a magazine and book editor, then joined the staff of the *New Yorker* in 1987. His work for the magazine has won the National Magazine Award for Essay and Criticism and the George Polk Award for Magazine Reporting. His *New Yorker* reports on Paris, where he lived from 1995 to 2000, formed the basis of his book *Paris to the Moon*. He lives in New York. We spoke on a bench in Bryant Park in Manhattan.

CLIVE JAMES. See page 198.

GISH JEN was born in 1956 and grew up in Scarsdale, New York. She's the author of two novels, *Typical American* and *Mona in the Promised Land*, and the short story collection *Who's Irish?* Her story "Birthmates" was included in *Best American Stories of the Century*. She lives in Massachusetts. We spoke in a Cambridge café.

FRANK KERMODE was born on the Isle of Man in 1919 and served in the Royal Navy from 1940 to 1946. He taught at the University of Manchester, the University of London and King's College at the University of Cambridge, where he was King Edward VII Professor of English Litera-

ture. Among his many books are *Romantic Image, The Sense of an Ending: Studies in the Theory of Fiction, Shakespeare's Language* and an autobiography, *Not Entitled: A Memoir.* He was knighted in 1991. He lives in Cambridge, and we spoke in the King's College common room.

JAMAICA KINCAID was born on the island of Antigua in 1949. At the age of 17, she came to New York to work as an au pair. She became a staff writer for the *New Yorker* in 1976 and stayed at the magazine for the next 19 years. Her publications include the novels *Annie John, Lucy,* and *Mr. Potter* and the nonfiction works *My Brother, My Garden (Book),* and *Talk Stories.* She lives in Vermont. We spoke by telephone.

MICHAEL KINSLEY. See page 220.

ELMORE LEONARD was born in 1925 in New Orleans. While working as an advertising copywriter in Detroit in the 1950s, he began writing western fiction and published five novels, including *Hombre,* which was named one of the 25 best novels of all time by the Western Writers of America. He turned to crime fiction in the 1960s and hasn't stopped since. His novels include *Fifty-Two Pickup, Glitz, Get Shorty,* and *Maximum Bob.* He cowrote, with Quentin Tarantino, the screenplay for the film *Jackie Brown,* which was based on his novel *Rum Punch.* Leonard lives outside Detroit. We spoke by telephone.

JOHN LUKACS, born in 1924 in Hungary, emigrated to the United States in 1947. He is the author of more than 20 books, including *Historical Consciousness, or the Remembered Past; Outgrowing Democracy: A History of the United States in the Twentieth Century; Budapest 1900: A Historical Portrait of a City and Its Culture;* and *Five Days in London, May 1940.* Until his retirement, he was professor of history at Chestnut Hill College in Philadelphia. We spoke at his house in Phoenixville, Pennsylvania.

GREIL MARCUS was born in San Francisco in 1945. He was an editor for *Rolling Stone* magazine from 1969 to 1970 and again from 1975 to 1980. He has written or edited many books on music and American culture, including *Mystery Train: Images of America in Rock 'n' Roll Music; Lipstick Traces: A Secret History of the Twentieth Century;* and *Dead Elvis:*

A Chronicle of a Cultural Obsession. We spoke at his house in Berkeley, California.

ELIZABETH MCCRACKEN was born in Brighton, Massachusetts, in 1966. She holds both a master of fine arts degree in fiction writing from the University of Iowa and a master of science degree in library science from Drexel University. Her work as a librarian inspired her first novel, *The Giant's House: A Romance*. She has published another novel, *Niagara Falls All Over Again*, and a collection of short stories, *Here's Your Hat, What's Your Hurry: Stories* We spoke in her apartment in Somerville, Massachusetts, weeks before her move to Paris, where she is currently living.

SHARON OLDS. See page 213.

SUSAN ORLEAN. See page 173.

CYNTHIA OZICK was born in New York City. Her essay collections include *Fame & Folly* and *Quarrel & Quandary*, and her works of fiction include *The Puttermesser Papers* and *Lights and Watchtowers*. Ozick won the O. Henry First Prize Award in fiction in 1975, 1981, 1984, and 1992. She lives in Westchester County, New York. We spoke at the Graduate Center of the City University of New York in Manhattan.

CAMILLE PAGLIA was born in 1947 in Endicott, New York. She received a doctorate in English from Yale in 1974, and since then has taught there, at Bennington College, Wesleyan University and, since 1984, the University of the Arts in Philadelphia, where she is currently professor of humanities. Her books are *Sexual Personae: Art and Decadence from Nefertiti to Emily Dickinson*; *Sex, Art, and American Culture: Essays*; and *Vamps & Tramps: New Essays*. She lives outside Philadelphia. We spoke on the telephone.

JON PARELES. See page 194.

ANNA QUINDLEN was born in Philadelphia in 1952. In 1977 she joined the staff of the *New York Times*, where she was a reporter and wrote the columns *About New York*, *Life in the 30s*, and *Public & Private*. She won the

Pulitzer Prize for commentary in 1992. Quindlen's novels are *Object Lessons, One True Thing, Black and Blue,* and *Blessings.* She lives in New York City. We corresponded by e-mail.

JONATHAN RABAN was born in Fakenham, Norfolk, England, in 1942. He was a lecturer in English at two British universities in the 1960s, and since 1969 has supported himself as a writer. Among his books are *Arabia: A Journey through the Labyrinth, Old Glory: An American Voyage, Bad Land: An American Romance* (winner of the National Book Critics Circle Award for Nonfiction), and *Passage to Juneau: A Sea and Its Meanings.* We spoke at a restaurant in Seattle, where he lives.

DAVID THOMSON was born in London in 1941 and moved to the United States in 1975. He is the author of many works of nonfiction including *Showman: The Life of David O. Selznick, Rosebud: The Story of Orson Welles,* and *The New Biographical Dictionary of Film;* the novel *Silver Lake;* and the unclassifiable *Suspects.* He contributes regularly to the *New York Times* and the *Independent* on Sunday. We spoke at his house in San Francisco.

JUDITH THURMAN was born in Queens, New York, in 1946. She has published two books of poems and two biographies: *Isak Dinesen: The Life of a Storyteller* (winner of the 1983 National Book Award for Biography) and *Secrets of the Flesh: A Life of Colette.* She regularly contributes criticism to the *New Yorker.* We spoke in the garden of her house in Manhattan.

TOURÉ was born in Boston in 1971. He is the author of *The Portable Promised Land,* a collection of short stories, and *Soul City,* a novel. His work has been featured in the *New Yorker, Rolling Stone,* the *New York Times Magazine,* the *Village Voice, Tennis Magazine, The Best American Essays of 1999, The Best American Sportswriting of 2001,* and *Zoetrope: All-Story,* where he won the Sam Adams Short Story Contest. He lives in Fort Greene, Brooklyn. We spoke in his hotel room in Philadelphia, where he was appearing on a promotional tour.

JOHN UPDIKE was born in 1932 in Shillington, Pennsylvania. He is the author of some 50 books of fiction, poetry, criticism, memoir, and drama.

His books have won the Pulitzer Prize, the National Book Award, and the National Book Critics Circle Award. We corresponded by mail.

ABRAHAM VERGHESE was born in Addis Ababa, Ethiopia, in 1955. He graduated from Madras Medical College in 1979 and completed his residency in internal medicine at East Tennessee State University. He obtained a master of fine arts degree from the Iowa Writers Workshop in 1991. He is the author of *My Own Country: A Doctor's Story* and *The Tennis Partner: A Doctor's Story of Friendship and Loss*. He is currently director of the Center for Medical Humanities and Ethics at the University of Texas Health Science Center at San Antonio. We spoke by telephone.

JAMES WOLCOTT was born in 1952 in Maryland. He left college after his sophomore year at Frostburg State College and moved to New York, where he has lived ever since. He was at various times a staff writer at the *Village Voice, Esquire, Harper's,* and the *New Yorker* and the movie critic for *Texas Monthly*. His essays for *Vanity Fair*, where he is the cultural critic, won the National Magazine Award for criticism in 2003. Wolcott is the author of the novel *The Catsitters*. We spoke at a bar on Manhattan's Upper West Side.

TOBIAS WOLFF was born in 1945 in Birmingham, Alabama. He has published four collections of short stories, the novella *The Barracks Thief* (winner of the PEN/Faulkner Award for Fiction), the novel *Old School,* and two memoirs, *This Boy's Life* and *In Pharaoh's Army*. We spoke in his office at Stanford University, where he is a professor of English and creative writing.

CREDITS AND PERMISSIONS

ACKNOWLEDGMENTS

What a pleasure to thank the people who, by various means, helped me research and write this book! You have already met the writers who graciously agreed to share their time, thoughts and experiences. The others are Harold Augenbraum, Julianna Baggott, Russell Baker, Bruce Beans, Jerry Beasley, Barbara Blake, Paul Bogaards, Tim Burke, John Caskey, Andrew Cassel, Barbara Church, Wes Davis, Camille DeAngelis, Marguerite Del Giudice, Pam Dorman, Debbie Durant, Joseph Epstein, Marion Ettlinger, Clare Coleman, David Friedman, Kenneth Gergen, Andrew Giarelli, John Grossmann, Devin Harner, Denis Harper, Virginia Heffernan, Steven Helmling, Ravenna Helson, Carol Henderson, David Hirshey, Martha Hodes, Sasha Issenberg, Dennis Jackson, McKay Jenkins, Eliot Kaplan, Kevin Kerrane, Margaret Kirk, Hank Klibanoff, Thomas Kunkel, Leaya Lee, Thomas Leitch, Ann Lindbeck, Pam McCarthy, John Marchese, Donald Mell, Edmond Morris, Nancy Nall, the late Jack Olsen, Osita Omotola, Debbie Phillips, Ronnie Polaneczky,

Alice Quinn, Alvina Quintana, Lee Robertson, Charles Robinson, Gil Rose, Jeff Rosen, Harris Ross, Linda Russell, Witold Rybczynski, Will Saletan, Zsuzsi Saper, Lauren Schultz, Jeff Seroy, Margaret Simeone, Norman Sims, Paul Slovak, David Smith, Mike Sokolove, Bill Stempel, Robert Strauss, Jean Tamarin, Ed Turner, Rick Valelly, and Ruth Westheimer. A sabbatical leave and a summer research grant from the University of Delaware were immeasurably helpful. I would like to offer special hat-tips to Calvin Trillin, who, along with the dedicatee, demonstrated to me what a great thing a writing voice can be; to Stuart Krichevsky, for the lobster; to Megan Newman, for getting it; and to Gigi Simeone, Elizabeth Yagoda, and Maria Yagoda, for showing me what style means, on a daily basis.

INDEX

Page numbers in *italic* refer to interview excerpts.